GOLEM GIRL

GOLEM GIRL

A MEMOIR

RIVA LEHRER

One World
New York

As of the time of initial publication, the URLs displayed in this book link or refer to existing websites on the Internet. Penguin Random House LLC is not responsible for, and should not be deemed to endorse or recommend, any website other than its own or any content available on the Internet (including without limitation at any website, blog page, information page) that is not created by Penguin Random House.

Golem Girl is a work of nonfiction. Some names and identifying details have been changed.

Published in the United States by One World, an imprint of Random House, a division of Penguin Random House LLC, New York.

ONE WORLD and colophon are registered trademarks of Penguin Random House LLC.

LIBRARY OF CONGRESS CATALOGING-IN-PUBLICATION DATA
Names: Lehrer, Riva, author.
Title: Golem girl : a memoir / Riva Lehrer.
Description: First edition. | New York : One World, [2020]
Identifiers: LCCN 2020012800 (print) | LCCN 2020012801 (ebook) |
ISBN 9781984820303 (hardcover) | ISBN 9781984820310 (ebook)
Subjects: LCSH: Lehrer, Riva, 1958—Health. | Spina bifida—Patients—United States—
Biography. | Artists with disabilities—United States—Biography.
Classification: LCC RJ496.S74 L44 2020 (print) | LCC RJ496.S74 (ebook) |
DDC 617.4/82092 [B]—dc23
LC record available at https://lccn.loc.gov/2020012800
LC ebook record available at https://lccn.loc.gov/2020012801

Printed in China on acid-free paper

oneworldlit.com

2 4 6 8 9 7 5 3 1

First Edition

For the ones who are here:

Douglas Sidney (Dov Shabtai ben Yosef Laib) Lehrer
Meir Eleazar ben Yosef Laib Lehrer

For the ones who are gone:

Carole Sue Doris (Chai Sora Davera bat Simcha) Horwitz Lehrer
Jerome Lee (Josef Laib ben Ze'ev) Lehrer

You are everything to me.

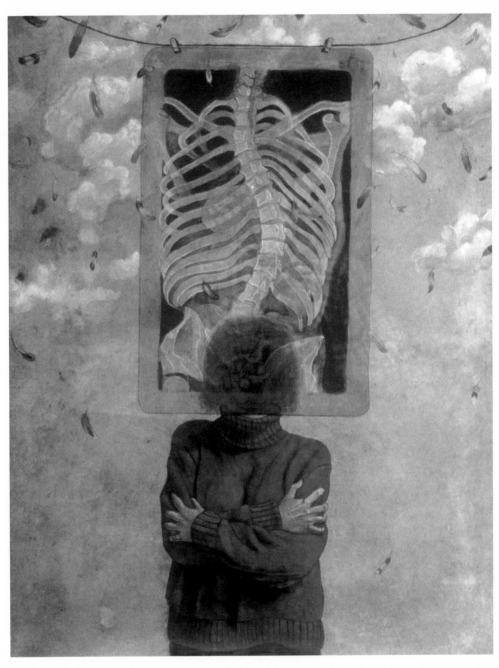

Blue Veronika
1999

CONTENTS

PART TWO

PROLOGUE

The Latin roots of "monster" are *monere,* meaning "to warn," and *monstrum,* an omen, or a supernatural being that indicates the will of a god. "Monster" shares its etymological root with "premonition" and "demonstrate."

My first monster story was *Frankenstein.*

Though this first Creature was more James Whale than Mary Shelley. When we were little, my brothers and I would abandon the great outdoors and race inside in time for the Saturday monster movie matinee. Two hours of ecstatic dread. Of delicious nightmares in chiaroscuro black-and-white.

Every few weeks, it would be *his* turn. I waited for his graceless body, his halting gait and cinder-block shoes. I could recognize the operating room where he was born. I knew he was real, because we were the same—everything that made him a monster made me one, too. We had more in common than scars and shoes. *Frankenstein* is the story of a disabled child and its parent. It is also the story of a Golem.

Humans have told stories of magically animated creatures for thousands of years. Ancient religions from Babylonia and Sumer, to Mexico, Africa, and China, all assert that gods formed the first human beings out of clay. Enki and Prometheus are but two creators who formed a being and gave it life. These days, we have Victor Frankenstein and his

Creature, but long before them, the Jews had Rabbi Judah Loew ben Bezalel and his Golem.*

Golem (*goylem* in Yiddish) is Hebrew for "shapeless mass" and first appears in Psalm 139 of the Hebrew Bible, in which Adam is referred to as a *golmi*. Adam is brought to life by the breath—the word—of God, transformed from inert matter into vibrant life: the first Golem. The difference is that Adam becomes fully human, while Golems of legend never do.

Iterations of this legend date from as far back as the eleventh century, but the most famous version dates from sixteenth-century Prague. The Golem of Prague tells the story of Rabbi Judah Loew ben Bezalel (an actual historical figure, known as the Maharal) and his creation of a living being made of clay. Golems wend through our stories, from Pygmalion's statue to the Bride of Frankenstein to Mr. Data and Seven of Nine; from the Cylons to C-3PO, R2-D2, and Chucky the doll. And, of course, to Gollum himself.

While these are not all Golems, exactly, every creature is made of inanimate material that is shaped and awakened by the will of a master (and nearly every story is of a master—not a mater—a male who attempts to attain the generative power of the female body).

Golems are built in order to serve a specific purpose. Adam, it is said, was built for the glory of God. The Golem of Prague was built to save the Jews from a pogrom. Frankenstein's monster was built for the glory of his maker, and for the glory of science itself. These Golems were not created for their own sake. None given purposes of their own, or futures under their control. Golems are permitted to exist only if they conform to the wishes of their masters. When a Golem determines its own purpose—let's call it hubris—it is almost always destroyed. The Golem must stay unconscious of its own existence in order to remain a receptacle of divine will.

* Many scholars believe that Mary Wollstonecraft Shelley was aware of and influenced by this centuries-old legend, including Paul Root Wolpe of Emory University: medium.com /neodotlife/frankenstein-at-200-the-golem-and-biotechnology-accb33dac3be.

Yet every tale tells us: it is in the nature of a Golem to wake up. To search for the path from being an *It* to an *I*.

In Golem stories, the monster is often disabled. Speechless and somnambulistic, a marionette acting on dreams and animal instinct. In Yiddish, one meaning of *goylem* is "lummox"; to quote the scholar Michael Chemers, from God's perspective, all humans are disabled.

The day I was born I was a mass, a body with irregular borders. The shape of my body was pared away according to normal outlines, but this normalcy didn't last very long. My body insisted on aberrance. I was denied the autonomy that is the birthright of normality. Doctors foretold that I would be a "vegetable," a thing without volition or self-awareness. Children like me were saved without purpose, at least not any purpose we could call our own.

I am a Golem. My body was built by human hands.

And yet—

If I once was *monere,* I'm turning myself into *monstrare:* one who unveils.

PART ONE

In the beginning

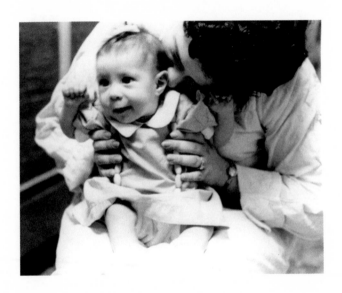

CHAPTER 1

Carole's Story: It's Alive!

She told me my story when she was proud of me. (Look how you turned out!) She told me my story when I annoyed her so much that she folded her arms across her breasts and tilted her eyebrows at me like notched arrows. (Have you forgotten what I went through for you?) She told my story when we had company. (Look how she turned out!) She told my story to every new doctor and nurse who crossed our path.

My mother's stories run through my head like a piece of silver nitrate film.

April 1958

Carole froze, hands in the air, caught in the act of tugging her blouse over her head. Not this—not again, she'd been so careful. Months on bed rest, moving through the apartment like an overfull balloon, afraid to so much as bump the furniture in case it pricked her skin and spilled her contents out onto the floor.

They were spilling now. Hot liquid spiraled down her legs.

She shuffled into the bathroom and waited for the expected release

of mangled tissue. For another baby-that-could-have-been to slide out of her on a torrent of red. She looked down at the floor and, oh God, it wasn't blood—she was standing in a puddle of viscous pink water. Invisible hands twisted her like wet laundry. What a strange thing it is when pain means hope.

Jerry heard her shriek and ran through the bedroom, slid into the bathroom. She yelled, *Honey, I'm in labor,* he shouted, *Where is the suitcase? What do I pack?*—the suitcase that would've been packed and ready to go if things had been happening according to schedule. This day was precisely one month before the due date she'd been given in the obstetrician's office. Jerry drove like he'd never heard of traffic laws. Carole sat doubled over on every towel they owned.

It was all so unfair. She had the kind of sturdy, wide-hipped, large-breasted body celebrated in fertility sculptures since the dawn of time. At twenty-four, she looked able to birth a clan, a tribe, a city-state, while striding through fields with arms loaded with harvest. Instead, there had been three miscarriages in less than two years, followed by eight months of paranoid restraint.

Jerry thought, If this is all there is, just us forever, *dayenu.* It's not that he didn't want children—he did—but he'd almost given up on family life at all. Jerry had married late, at the age of thirty-one, eight years after coming home from the Army. He had been with the 102nd Infantry Division (the Fighting Ozarks)* when they landed at Cherbourg, in September 1944. The 102nd fought their way across Belgium until reaching Aachen, which was where Jerry's foxhole ran out of ammunition. Something possessed him to run across the fields of fire in search of resupply. Miraculously, he made it back unscathed and stayed that way until the next-to-last day of his enlistment. The fleeing German army lobbed mortar shells behind them as they retreated; one blew up and slammed shrapnel into Jerry's face. The Army traded a Purple Heart and a Bronze Star for the shattered jaw and the teeth left behind on the battlefield.

Six months in a hospital in England, then home to Cincinnati with

* http://ozarks102id.org/

a subtly new face and the determination to squeeze the GI Bill for all it was worth. He racked up a CPA degree and dated a little—but being shot in the face doesn't leave a fellow feeling attractive. His sister Ruth just happened to have this friend, a sparkling friend who flirted away Jerry's shyness.

And then—and then, he was married. To a knockout nine years his junior. In silent, black-and-white footage of their wedding, Jerry is levitating while Carole's hands fly and flutter like the spread wings of birds.

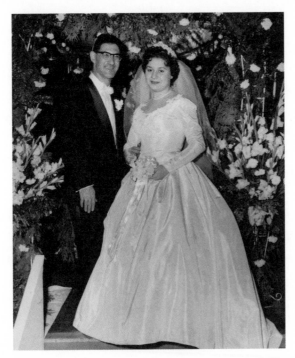

January 2, 1955

But then Carole started losing babies, and sorrow piled up behind her eyes.

Jerry nearly drove up on the sidewalk in his haste to reach the emergency room. The man was usually a bundle of worried tics, gasps, and pronouncements, but he tried crooning *Don't worry, honey, don't worry don't worry*. Silently he told the baby, *You show up now, kid, or I'm com-*

ing in to get you, as his wife's gurney disappeared behind the swinging OR doors.

Labor is labor, hours of pain, but it was a pain Carole welcomed, because every other pregnancy so far had ended with a faster agony and no one to hold. At 6:04 in the morning, the baby was born.

Then all was confusion. Doctors and nurses ran around the room, calling for equipment, as the baby screamed in a way that surpassed the normal trauma of air and bright light. Carole demanded to see the baby, but they'd taken it to a far table.

The baby. Boy? Girl? No one could tell. Carole was told that the lower half of its body was encased in adhesions. The amnion—the inner layer of the placental wall—had adhered to the baby's skin and formed swathes like a mummy's bandages. These had affixed the baby to Carole's uterus, as if her body was trying to keep the child inside the maternal fortress. As if preparing dressings for the surgeries that lay ahead. As if knowing that mother and child would never be much good at separation.

A nurse stepped away, and there it was, her genderless, shrieking infant—an infant with a grotesque red sac protruding from its back. Then Carole knew exactly what the obstetrician was about to say: her baby had spina bifida.

Carole had seen these children for years. Up until this bed-rest pregnancy, she'd been a medical researcher at Cincinnati Children's Hospital, where she'd worked for Josef Warkany, an Austrian physician who had established the field of teratology in America (*teratology,* from the Greek *teratos,* or "monster," is the medical term for the study of birth defects). Warkany revolutionized the medical understanding of the origin of impairments. Among these, spina bifida was one of the most common and the most commonly fatal.*

* Warkany's work eventually earned him the sobriquet "the Father of Teratology." From Warkany's obituary in *The New York Times,* June 25, 1992: "Dr. Warkany's discoveries helped create the medical specialty of teratology, which includes the study of the fetus as well as efforts to cure and prevent the prenatal ailments responsible for much of the infant death rate. He contended that congenital ills should be treated medically just like postnatal

In 1958, no one knew what caused spina bifida, only that it fell within the category of congenital conditions known as neural tube defects. The words *spina bifida* mean "split spine": when a fetus is in utero, the bones and casing around the spinal cord are supposed to fuse and create a tube that houses and protects the spinal cord. If these parts fail to fuse, they leave an open fissure—a lesion—somewhere along the length of the spine, anywhere from the skull to the sacrum. A literal hole in the body. As a consequence, any pathogen entering that hole has access to the brain.

Spina bifida babies are born open to the world.

There are different severities of the condition. The mildest cases, "spina bifida occulta," are those in which the spine remains closed, with minor malformation of one or more vertebrae. This causes little or no injury; often, from the outside, Carole could scarcely tell that anything was wrong with those children.

The most affected are those with spina bifida myelomeningocele, a condition in which a loop of spinal cord protrudes all the way outside the body. The cord is typically embedded in a bulging red sac like a gruesome birthday balloon.

That red sac now protruded from the middle of her newborn's back.

Over 90 percent of such children died before they were two years old. Prevailing medical opinion was that surgeons should leave these children alone until they reached the age of two. If they survived that long, they were strong enough for treatment, but otherwise, they were

ailments. . . . Dr. Warkany . . . was the founding president of the Teratology Society and helped develop the field as a certified specialty."

Carole was part of Warkany's team when he "loaned" her to Albert Sabin for the last frantic days of the race to invent the polio vaccine. At the time, Jonas Salk was Head of Pediatric Research at Children's Hospital. Sabin and Salk had spent years in neck-and-neck competition to invent the oral form of the polio vaccine. Reportedly, she was there, on March 26, 1953, when the announcement came over the radio that Jonas Salk had perfected an effective, injectable formula. According to her, Sabin screamed invective and hurled a full beaker of chemicals the length of the lab, barely missing the frantically ducking heads of his staff. And yet Sabin's vaccine would become the more widely used, being both cheaper and easier to administer.

a waste of medical resources. Parents were advised to cherish their babies for the short time they had. Josef Warkany disagreed with this "ethic."

Carole had never imagined her own child on Warkany's examination table.

The baby actually had a decent weight for a preemie, so an ambulance took it directly across Burnet Avenue to Cincinnati Children's Hospital. Carole's obstetrician let Jerry push his wife across Burnet in a wheelchair plastered with JEWISH HOSPITAL decals. It was a cold day under a cloudy pewter-gray sky; the wind found the edges of her robe as Carole left one hospital and entered the next.

Carole prayed for a surgeon who wouldn't wait until that impossible second birthday, and indeed, they were in luck. Children's had just hired a young, Harvard-trained surgeon named Lester Martin. He was soap-opera handsome—but more to the point, freshly trained in the latest techniques to close a spina bifida lesion.

The breach was between the fourth and fifth lumbar vertebrae, those being the bones at the waistline, between rib cage and pelvis. A lipoma— a fatty tumor—was wrapped around the cord, making the repair exponentially more difficult. Lester Martin cut away the tumorous sac and eased the spinal cord back into the canal, sutured the edges of the dura mater, and crisscrossed the muscles of the back into their proper place. The stitches barely held together in the petal-thin skin of a newborn.

Jerry and Carole sat in the waiting room, hands gripped in a sailor's knot of fingers. They'd picked out names, but what does one call a new person whose genitals are hidden in a shroud? A contingent of Lehrers and Horwitzes had filled the waiting room by the time a surgical resident stepped out of the OR and said, "Your daughter is hanging in there. So far, so good." It seemed that Dr. Martin had removed enough adhesions to reveal her sex.

Jerry cleared his throat. "We're naming her Riva Beth Joan. Rivka

Brina Yocheved." As always, English name first, then Hebrew name. They were naming the baby after her great-grandmother Riva Brina Numark and great-grandfather Joseph Lehrer. Ashkenazi families pull their children's names from the afterlife; children begin life as the phantoms of people they will never meet.*

Everyone in the room understood why she'd been given so many names. In Jewish folklore, the Angel of Death is rather stupid. He wanders the world with his clipboard and paperwork, seeking his victims by name. If a baby is born with an illness, you give it multiple names. This confuses the angel, who scratches his flaming skin and says, "Who is this? Riva? Brina? *I* don't know. Guess I'll come back later." Lucky for all concerned, even God can't get good help.

Carole thought of her colleagues at Children's. She could have used their support now. She might be surrounded by family, but the truth was, none of them understood what a diagnosis of spina bifida really meant. She alone had no comforting ignorance to hide behind as she accepted being this child's mother.

My mother.

For whom, on that day, life itself was all that mattered.

* "Yocheved" is the female version of "Yosef."

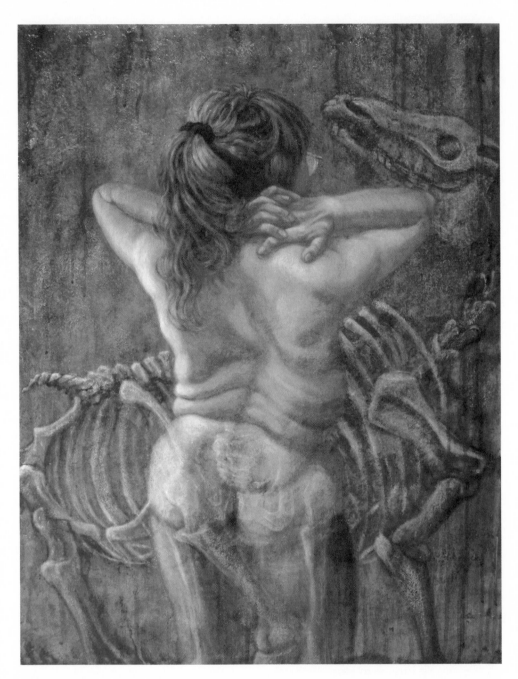

Cauda Equina
2005

Cauda Equina

The medical effects of spina bifida myelomeningocele (SBMM, or MM) are different for each person, but roughly, they are as follows:

Each spinal vertebra has a specific nerve branch (a dermatome). Wherever a lesion occurs—that is, a hole in the spinal column—the nerves nearest the breach are damaged. Muscles, bones, and organs rely on enervation to grow and function. This means they may malfunction or never develop at all. When organs don't receive normal enervation, bowels and bladders may become spastic, nonfunctional, or incontinent. Kidneys are particularly at risk.

Given that neural tube failures happen in the fetal stage, spina bifida can affect almost any form of mammal (for instance, I have a friend who has a cat with SB; it's paralyzed and needs help voiding its bowels). When I was born, techniques to close the lesions had only just been invented; it appears as if the first successful surgeries occurred somewhere in the mid-1950s. Before this period, the mortality rate was upwards of 85 percent. Doctors are only now learning how to treat spina bifida as we grow and age. My own adulthood has only been possible for the last fifty or so years.

Even with a successful closure, the spinal canal may become narrowed and constricted. This can force cerebrospinal fluid up into the head, a condition known as hydrocephalus (so-called "water on the

brain"); the danger is that fluid pressure will squeeze away the space for the developing infant brain. A shunt must be inserted to drain the excess fluid, otherwise hydrocephalus may result in cognitive, communicative, and learning disabilities; severe cases may lead to death. I was unusual in that I did not have hydrocephalus—also fortunate, as shunts did not come into use until several years after I was born.

My version of spina bifida is properly called lipomyelomeningocele (LMM), meaning that a lipoma—a fatty tumor—was adhered to the cord at the lesion site. People with any degree of myelomeningocele may develop "tethered cord," which happens when the spinal cord becomes ensnared by scar tissue at the site of the lesion. Tension on the cord pulls the spine downward, like the string on a bow. This may cause or increase any scoliosis, but the most serious danger is that tethered cord can be fatal should it pull the brain stem out of position.

Before Josef Warkany established the field of teratology, anomalies were explained via a swampy mess of mythology and superstition, as people searched for the comfort of an explanation. Myths gathered details, characters, causes and effects. Mythical monsters can be viewed as explanations for fetal conditions, and vice versa; the names given to many impairments speak to this entanglement of science and superstition. When a child is born with legs fused together, it's called Mermaid Syndrome (or sirenomelia). A baby that lacks a nose and possesses but one eye in the middle of his face is a Cyclops (the medical condition is known as cyclopia or holoprosencephaly). Infants covered with fur-like hair have Werewolf Syndrome (hypertrichosis). Babies born with vestigial tails or "horns" or with albinism have been seen as animals and ghosts.

"Monstrous" children were blamed on mothers via an ancient concept known as maternal imprinting. Maternal imprinting dates back to the first century C.E., the time of Pliny the Elder, and persisted well into the nineteenth century. A fetus could be "imprinted" by something its mother saw. Women were warned against looking at disturbing sights if they were pregnant or trying to conceive. Visual trauma, it was believed, could ripple through the womb, as the boundary between

outside and *inside* was thin and indefensible. "Disturbing" sights included those that lay outside the sanctioned domestic routine of a well-contained woman. A well-contained woman did not attend carnivals, where she might see the antics of a performing monkey and give birth to a baby covered in hair, or a frolicking seal that might cause her child to be born with shortened arms. Maternal imprinting not only condemned a mother for the nature of her infant, it was a tool for denying women their freedom of movement.

We pride ourselves on being more sophisticated (few pregnant women would avert their eyes from a Pekingese in fear for their child's profile), yet fear of and distaste for the disabled is alive and well. I was born just after a surgical breakthrough, yet 1958 hardly constitutes a medical bright line, a turning point when the surgical ability to repair these lesions led to a comprehensive agreement that it should be done. Advances in spina bifida treatment have kept coming, but international debates (such as those in Belgium and the Netherlands) persist over whether to treat infants like me at all. The bioethicist Peter Singer used spina bifida as his central example as to why disabled children should be allowed to die. He opined that we will never have a reasonable "quality of life," and that we consume far too many medical resources for too little societal payback. I can only be grateful that Peter Singer wasn't stalking the halls of Cincinnati Children's Hospital sixty years ago.

Carole's Story: Attack of the Fifty-Foot Woman

I had never left Children's Hospital. Not for a single day. It was spring of 1960, and I was almost two years old, yet I had never seen my parents' home, never even met my new baby brother. Doug lived as an only child, as did I.*

My world was a series of white rooms full of hard machinery. The city outside my window was a mystery I could not begin to grasp. When my mother and father walked out the door, it was if they ceased to exist, until the next morning when Mom's footsteps would ring out in the hall. A repetition of tiny desertions that made me an anxious child.

This, I think, is why I still remember many of Mom's stories of my earliest childhood. Her stories told me that no matter how many times she left, she would always return. I was shaped by these stories into a girl who was both exceptional (in her eyes) and always at risk (in her eyes).

Also, a girl who was endlessly in peril. As far back as I can remember, she told me about the times that I'd come close to dying from fevers or from dangerous operations.

The closure surgery on the day I was born had been only the first of

* Kids were not allowed to visit the hospital, due to their being little petri dishes of measles, mumps, and other microscopic villains.

dozens. Sometimes my surgeons didn't even bother stitching me up between operations but simply tied me together like a Shabbos brisket. I must have been far past infancy, but I remember a surgeon pulling gauze packing from an open wound in my abdomen. Mom sat on the other side of the room, white-faced and white-knuckled, as I screamed that I was being killed.

The dramatic thread that wound through her stories was that she nearly lost me—not only to death, but to life in an institution. For the first two years of my life, the hospital sent social workers to my room, arguing that family homes were insufficient—even dangerous—for children with constant medical needs. It seems as if almost every parent of a disabled child was told the same thing: send them away for their own good, and for the good of the family. I hung on Mom's thrilling tales of resistance. She rescued me through sheer pluck and derring-do.

The moment of truth came that spring, when my health had improved enough that she thought it was safe to bring me home. She knew she'd have to be clever if she was going to bring the hospital around to her way of thinking.

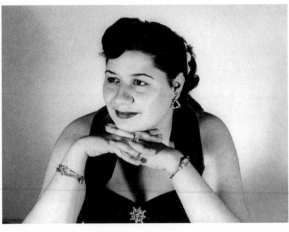

Carole Sue Horwitz Lehrer, just after her marriage

Carole's Story: The Girl with All the Gifts

The men usually showed up at the pinkish crack of dawn, a jostling, white-jacketed herd of specialists who filed in and peered down at me, a small bandaged bundle in the crib. Urologist, gastroenterologist, orthopedist, neurologist, neurosurgeon. They observed, they prodded, they discussed, and moved on.

But on this chilly morning, the men of Grand Rounds were about to get a surprise.

My mother had chosen our costumes with care. She wore the navy suit from when she'd been a researcher at Children's, in the hopes that my doctors would remember the Carole Horwitz who'd moved in Dr. Warkany's orbit. Her ensemble was finished off with a bit of crimson lipstick and a marcasite mezuzah on a chain, appropriate for her double role: that of a fellow specialist and a sweet young mother.

My own frilly dress was the farthest thing from a hospital gown. It was laden with lace and embroidery that cascaded over my bandages and distracted from the incised scribbles of red and pink all over my body—even under my hair, where doctors had nicked my scalp with a scalpel and sewed IV needles inside the veins. My doctors knew the scars, of course—they'd put them there themselves—but Mom wanted them to see me anew. This was the crucial illusion: I had to appear as a Normal Girl. A girl who could survive going outside.

I wasn't in my usual position, supine and ready for inspection. Instead, my mother raised me high on her shoulder and danced us into the center of the ring of balding, bespectacled, middle-aged heads. Easter Island, as carved in Eastern Europe.

Dr. Perlman reached for me, intending to lay me on the examination table. Mom stopped him with a guileless smile. "Just a moment, Doctor, if you please. Riva's been giving me an earful all morning. She has something to say to you, gentlemen."

It was time to hit my lines. "Please give me Thorazine instead of Compazine. Compazine makes me throw up." (Spoken with a lisp: *pweeze, Thoratheen, fwow.*)

This was especially startling because I was small for my age and appeared far younger than two years old. My pediatricians cooed and chuckled. "My goodness, Carole, isn't she something? We should get her a job in the pharmacy!"

Mom whispered, "Keep going," so I complained about all the drugs that made me barf or break out in hives, then tried my own trick of making her earring disappear by sticking it in my mouth. Mom pried my fingers off her earlobe and fished out the pearl clip before I could swallow it like a pill and grinned behind my diapered bottom.

Dr. Suder's eyebrows did a Groucho waggle above his wire rims. "Very impressive, Carole. How'd you pull this one off?"

Mom batted her lashes. "Why, sir, I can't imagine what you could possibly mean."

She sure wasn't going to tell him that for weeks, we'd been practicing a ventriloquist act, in which Mom would settle me on her lap and sound out each syllable of every drug sloshing through my bloodstream. "Say *Er-rith-ro-MY-sin.*" "Say *PRED-ni-zone,*" like a cross between Dr. Seuss and the Physician's Desk Reference: pure aural nonsense rhymes.

Truth was, not all of our performance was a trick. My mother loved dictionaries and crossword puzzles, a love that flowed from her to me, making me part chatterbox, part echo chamber. I had words to take the place of everything I had never experienced. I'd never known wind,

rain, sunrise, clouds, birds. Traffic lights and checkout lanes. Moonlight on a front lawn. Dogs on leashes, snowmen, traveling fairs. The Ohio River, the Cincinnati hills. My family's own front steps. Instead, I swam in a river of grown-up language.

Mom and I had practiced until our audience might believe I understood everything that was coming out of my mouth. In order for her plan to work, Mom needed to convince them that I was more than a surgical triumph; I was to be revealed as a *prodigy*.

She jounced me on her shoulder.

"*Heee*-mo-*glo*-bin," I said. "*Mor*-phine." I curled against her neck, both pawn and prize in our game.

"What do you think of our little genius, Doctor?"

Dr. Perlman winked. "You're going to have your hands full with that one. I'm betting she'll be in college by next year." Maybe they were onto us—but even so, something shifted that day in Grand Rounds. The social workers evaporated and my doctors began to discuss how to care for me at home.

We were a team. Pirate mother and parrot daughter, puppeteer and marionette. My stage mother didn't give me lessons in piano, or dancing, or horseback riding. She taught me to be seen. Visibility was our Basic Scales, First Position, Stay in the Saddle. It was survival.

Leprechaun

There's not just love in this story, but luck.

There is both bright luck and dark luck. Bright luck was two parents who loved me. Bright luck was Dr. Martin as my surgeon, and a mother who'd had a hospital career.

Dark luck is not bad luck. Luck can be shrouded and half-shadowed, if its outcome takes years—even half a lifetime—to be revealed. If its origin is pain. My darkest luck was a gift from my three dead siblings. Carole had three miscarriages in the three years between her wedding day and the day that I was born. After such loss, how could she give up a living child?

By the time that *Frankenstein* was published, Mary Wollstonecraft Godwin Shelley had already had one miscarriage and given birth to two children. The second—a daughter—died before she was two. Of Shelley's five pregnancies, only the last survived to adulthood. Is it any surprise that she fantasized the power to revive the dead? Could *Frankenstein* have been written by anyone but a mother who had lost child after child? A woman for whom the line between life and death had smudged and faded?

· · ·

My mother wrote this poem sometime in my first two years:

Riva was so ill, my Lord,
And we turned to you to pray,
Though doctors said she would still be gone
Your miracles allowed her to stay.

. .

So, I end by giving thanks again,
For Riva's life and miraculous mind.
From our Lord, the Great Creator,
Who is loving, and infinitely kind.

Mom first told me about her miscarriages when I was seven or eight years old. She only explained one of them: it had happened after she'd walked belly-first into a parking meter. I never understood. Did someone bump into her? Did she slip on wet pavement? I began to see parking meters as secret, vicious robots waiting to take down the unwary.

More dark luck: I was born into a generation of Jewish children who were each regarded as an individual revenge on Hitler's designs. In Germany, I would have been the first in line for euthanasia. Perhaps that was another reason why I was kept out of an institution. I never asked Dad how he felt when I was born, but knowing his pessimism and his kindness, it probably fit with his tendency to expect the worst.

My mother never said whether her lost children had been given names, and I never asked. I suspect they had, if only in the secret mourning book of her heart. I imagine that she said Kaddish for them on Yom Kippur, whispering names only she knew.*

* When Carole worked for Josef Warkany, no one knew that the majority of cases of spina bifida were caused by a lack of folic acid in the mother's system. By the 1970s, the Centers for Disease Control recommended that pregnant women be given folic acid supplements, to aid in the formation of neural tissue and dramatically reduce the incidence of spina bifida.

I recently learned, from my uncle Lester Horwitz, that Carole was part of Warkany's research on the effect of vitamins and supplements on birth anomalies. Uncle Lester thought it likely that folic acid was part of their research. I can only imagine how Mom felt when the CDC came out with its findings.

We Have Always Lived in the Castle

After my mother's magic act, the campaign to institutionalize me abated. Children's Hospital tilted and yawed and tipped me out its Gothic doors. I was two. I was going home.

My little brother Douglas (nicknamed "General MacArthur" for his bulbous forehead) was four or five months old when I was released. I arrived home nearly as helpless as my baby brother; a toddler who'd not yet toddled.

I was small, but the same could not be said of my caravan of medical supplies. My toys and bits of clothing were lost among the medications, the boxes of sterile bandages, adhesives, syringes, the antiseptic and antibiotic unguents. Our apartment couldn't accommodate the four of us plus my personal infirmary, so after two years of crowding we moved several miles uphill to a house on Laconia Avenue, in a middle-class Jewish neighborhood called Bond Hill. The affluent Jews lived downtown; Bond Hill was a province of shop owners, bookkeepers, and employees of nearby Procter & Gamble.

I was four years old. This is where my own memories begin.

· · ·

Our red-brick Tudor bungalow stood in the dead-end circle of Laconia Avenue. The house loved sunshine. The stained-glass panel in the front door cast a luminous puzzle across the living room wall. Light was a living thing, shimmering on the bistre varnish of the woodwork, slinking through pebbled glass in the laundry room, and swirling inside cut-glass doorknobs like giant diamonds.

Just as when I'd been in the hospital, I mainly saw my father once the sun went down. He spent most of his time at his office, in a tiny building behind my Uncle Lester's advertising agency. After dinner, he'd pile his tax returns on the dining room table and sort-of watch TV with our family—at least as much as could be seen from fifteen feet away.

At Children's, my mother had been a medical expert, but at home, Carole Lehrer was an artist.

My mother loved objects that made the most of that light. Murano vases, engraved brass bells, hand-blown glass animals, gilded Shabbos candlesticks, patinated menorahs. The cabinet in the living room held wedding china rimmed with gold and painted with platinum wheat. I'd wait until no one was looking and pick up her curios, peer through the red swirls of the glass rooster, and let it distort the colors of the rest of the room. I'd polish her treasures with my sleeve and put them down just the way she positioned them, except for the terrible day when I broke a tiny elephant. Its trunk lay snapped in my palm like a lost limb. I prayed that it was possible to heal glass.

She didn't just collect; she created. Clothing, jewelry, puppets, costumes, elaborate handmade cards. Food that I still remember on my tongue half a century later. Her creativity found outlet in small things, in the permissible, restricted expressions of women with children. Carole's aesthetic was born out of a love for the fleeting and breakable world.

On Laconia, Doug and I shared a bedroom. I appeared smaller than my actual age and Doug was a big child, so not only did strangers think we were twins, our own family treated us that way. We were given baths

Home

together in the tub, facing away from each other, backs resting skin to skin, an imposed modesty that dissolved as we lunged for toy boats and one or both of us peed in the water. I was content to share my room because in exchange I got a person who was mine alone. If I woke up to the slap of my brother's footie pajamas on the hardwood floor, rather than a nurse shoving a thermometer someplace unspeakable, well then, all was right with the world.

We slept in identical twin beds with sharp-edged walnut headboards. Every Friday night, our mother took the warm wax from the Shabbos candles and held it in her hands until it was soft as butter. She pinched and pulled at the translucent lumps until they emerged as a pair of rough white angels, then put one on each headboard before we recited our evening prayer: *Sh'ma Yisrael Adonai Eloheinu Adonai Echad.* "Hear, O Israel, the Lord is God, the Lord is One."

Problem was, Mom watched me like I was one of her glass animals.

She never stopped scrutinizing me for signs of relapse. I was a sickly little pot that must not be allowed to boil.

I would have complained except that I *wanted* her to watch me closely, so close she could see through my skin. I wanted to be a translucent plastic model, like a snap-together kit of the see-through Visible Woman, so that she could explain me to my doctors when all I could say was "It hurts."

I discovered that being watched by Mom was not the same thing as being stared at by strangers. We'd barely step out of the house when people would stop us and demand "What's wrong with her?" as if competing for prizes on a medical quiz show. To my dismay, Mom would provide all they'd need to win the vacation package *and* the new Cadillac. She laid out the details of spina bifida, its causes and effects, as if deputizing a city-wide cadre in case I had to be rushed to an emergency room. For me, this kind of visibility was like being scraped along the sidewalk.

And what did they see, those starers, those strangers?

A little girl of four or five or six, short for her age, with dark brown hair and brown tortoiseshell cat-eye glasses. She wears a smocked shift that her mother has made because regular girls' clothes don't fit so well, one of the lovely hand-sewn dresses designed to cloak the girl's bulging rib cage and the gibbous swerves of her spine.

Her dresses can't hide the way the girl walks: an up-and-down-and-sideways oscillation that can be seen from blocks away. The girl's left ankle folds like a bird's neck when she turns. Her right leg is two inches too long, badly evened out by the two-inch lift on the left shoe, Boris Karloff shoes in child's size 3. From strangers' reactions, you'd have thought that the girl sported fangs, antlers, turquoise plumage, and fourteen tap-dancing legs.

April 25, 1963

I settled into life on Laconia like a cat on its owner's lap, always expecting to be dislodged from my perch. I returned to Children's Hospital

over and over, yanked back by infections, tests, checkups, more infections, and "procedures" that left their marks on my skin.

Yet on that particular Thursday, I wasn't the one in the hospital; Mom was. She'd gone into Jewish Hospital several times over the winter, but I wasn't worried. This was the morning of my fifth birthday party. There was no chance that she'd miss my big giant important day.

Doug and I were staying at Grandma's house, but I was sure that Mom was about to walk through the door and gather me into her arms. And after the party, we'd all go home to Laconia Avenue, where Mommy would sleep in the room next to mine once again.

I put on my party dress and patrolled the front door, stomping to the rhythm of *When is she coming, when is she coming,* patent leather party shoes, clack, clack, clack. I turned away from anyone who tried to talk down my one-girl protest march.

My frazzled grandmother sent in Grandpa and Uncle Barry, who sat me down on the gold brocade couch between their four hundred and fifty pounds of baritone Horwitz. Grandpa said, "Riva, we are very, very disappointed in you. Your mother can't help that she's not here. She is *sick*. You understand sick, don't you?"

Barry added, "It's time to be a big girl. You're making us ashamed of you."

I didn't feel very big. I couldn't think of a single thing to say.

An hour later, I was awash in cake and presents and relatives in droves. I was five years old, and easily distracted into happiness. Grandma's present was a girl-sized metal stove and sink and refrigerator, complete with pots and dishes that fit exactly inside. My cousins crowded around to play with my new, miniature world.

I picked up the shiniest package: *From Mommy and Daddy with Love.* Inside was a big blond doll. The name on her box was Chatty Cathy. There was an extra bundle containing a blue velvet coat the color of Cathy's eyes.

I looked up. My father was turned away, laughing with the uncles. I remembered all over again that my mother wasn't there.

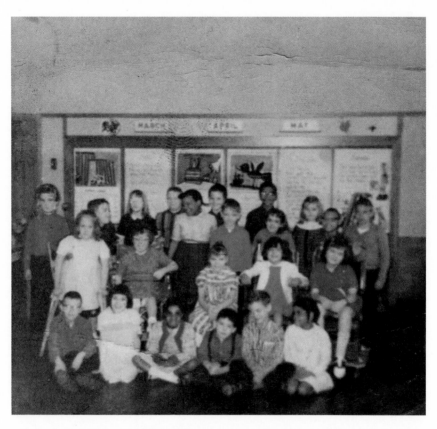

Second-grade class at the Randall J. Condon School, Cincinnati. I am second from left, front row. Julie is back row, under "March."

The Island of Dr. Moreau

September 1963

Mom had been in and out of the hospital over the summer, but this day the three of us—Mom, Grandma, and I—were wedged into the front seat of Grandma's green Pontiac Catalina. It had finally arrived: my First Day of School. And I was totally confused. The neighborhood kids all went to Swifton Elementary, just three blocks away from our house, so why did it look like we were on our way to Children's Hospital? If Mom and Grandma were lying to me about our destination, something truly awful must be waiting for me at Children's.

Mom's voice got more cheerful by the mile. "You're going to love school. Daddy and I already met your teacher and she's really nice. You'll hardly miss me at all." Grandma chimed in, "Be good, and do what you're told. But you're a smart little girl, you have nothing to worry about." By the time they finished reassuring me, I was a wreck.

We turned onto Rockdale Avenue and got to the intersection with Burnet Avenue, where all the hospitals were lined up like Monopoly hotels, but instead of turning left, Grandma stayed straight on Rockdale and pulled over in front of an unfamiliar building. *Definitely* not the hospital.

I craned my neck at the silver letters above the entrance:

THE RANDALL J. CONDON SCHOOL

. . .

We checked in with the principal—Mr. Halfter, a Herman Munster look-alike so tall his head seemed to occupy the next floor up. Mom signed his stack of paperwork, then it was off to our next stop: the nurse's office.

The nurse wore a white uniform, exactly like in the hospital. She took my bag of medical supplies and unpacked it inside a medicine chest that had shelves that went all the way to the *ceiling*. There were beds in the next room, and out in the hallway I saw kids in wheelchairs or on crutches. This place sure looked like a hospital to me.

The nurse told us that kindergarten was downstairs. The elevator was an ancient screechy box with a brass scissor-gate that threatened to cut off your fingers. We clanked our way to the basement, where it sounded like a parade was in full swing at the end of the hall. The noise led us straight to the roomful of children with whom I would spend the next nine years of my life.

The Kindergarten Annex was long and wide, lined with glass-fronted cupboards full of books and art supplies. There was a teeter-totter, a laddery climbing frame, and shelves of toys. Tables were laid out with construction paper and poster paints. In the center of the room was an enchanting fireplace, an Art Nouveau spectacular tiled with medallions of dragons and unicorns in carved white porcelain.*

But all of this sank in a whole lot later. In the moment, I stared openmouthed at a scene of magnificent chaos.

The room was swirling with kids in wheelchairs and crutches, but unlike the ones in the hospital, these kids weren't sick. They were as energetic as any other bunch of junior demons. Boys and girls zipped all over the room in a wheelchair demolition derby, while others crutched at remarkable speed considering the wingspan of five-year-old arms. It was a giant pinball game, as played by rhesus monkeys.

* Rookwood Pottery, founded in Cincinnati in 1880, created much of the art for Condon School. A successful and influential producer of American Arts and Crafts ceramics, including innovative glazes and decorative tiles and murals, the pottery company still exists in Cincinnati today.

Mom led me over to the lady waving her arms in the middle of the floor. "Riva, say hello to your teacher." Miss Woodbridge was Peter Pan's sister, delicate and fey, with the most singularly upturned nose I'd ever seen. I privately dubbed her Miss Nosebridge.

I let the grown-ups talk while I spun around, trying to look everywhere at once. Two pairs of blue eyes were regarding me with equal curiosity. The first pair belonged to a round-faced boy, whose thatch of coppery hair sprouted above a galaxy of freckles. His crutches splayed sideways like the legs of a day-old fawn.

But it was the second pair of eyes that really demanded my attention. Those big blue eyes were *very* big, magnified behind lenses thick as family Bibles. The girl had hair the color of dry autumn leaves, with poofy bangs that spoke of first-day tussles with the curling iron. Tall and skinny and pressed up against the fireplace, she jerked her head in my direction: *Get over here, you dingbat, before they mow you down.*

I glanced back. Mom and Grandma were waving goodbye. I shrugged, and launched myself into anarchy.

That school, formerly the Cincinnati School for Crippled Children, had been renamed sometime in the 1930s for Randall J. Condon, the Cincinnati superintendent of schools. He had (for the times) a radical philosophy: that disabled children should receive a standard academic education. At the time, most schools for disabled children were residential warehouses that provided minimal vocational training and basic literacy, if that, so their students/inmates could qualify for service or industrial jobs.

When I enrolled in 1963, offering standard education to disabled children still qualified as progressive pedagogy.

Kids were sent to Condon on the recommendation of their doctors. Condon had been designed for children with orthopedic impairments, but it eventually included students with cognitive, sensory, and intellectual disabilities. Enrollment in 1963 was less than three hundred students, far fewer than the number of disabled children one would expect in a city the size of Cincinnati. I assume that many of the miss-

ing were warehoused or tucked away in the family home and never schooled at all.

The architectural style of Condon School might be called "Spanish Colonial Convalescent": three stories of cream-yellow stucco that combined modernist simplicity with an unhinged level of ornamentation. Above the scrolled-brass entry gates hung enormous ceramic medallions of women (nurses? teachers? saints?) cradling small children, part of a cornice line featuring a mélange of griffins, globes, books, flags, frowny neoclassical heads, and dimpled cherubs brandishing scissors. (*Flying* with scissors was apparently perfectly fine.)

Inside, fairy tales roamed the halls. A WPA painting of Red Riding Hood stood guard over the library door, while outside the principal's office, a Rookwood drinking fountain depicted a gaunt, redheaded Pied Piper playing his shawm for a blank-faced boy. Condon School was decorated with pictures of children in danger.

Yet the sheer square footage of medicalized space demonstrated that ours was indeed a "special school." The elevators fitted four wheelchairs each. A long banister ran the length of every hallway, allowing us to pull ourselves along like children climbing a horizontal rope. The second floor boasted an extensive medical suite, with a nurse's office, doctor's office, dentist's office, pharmacy, and exam rooms. When we were sick, we lay down in one of five curtained bays, divided by thin slabs of marble.

Delegations of doctors came through to treat, observe, and assess us, though it wasn't always clear whether we were being seen for our needs or theirs. Medical services blurred the line between school and hospital, a distinction that disappeared several times a day when the nurse came into class with little paper cups full of medication.

And just as in the hospital, we had physical therapy every day. We'd be hoisted onto high wooden treatment tables that loomed above a floor full of mats, littered with exercise equipment that looked like toys. (Trust me, they were not.) Even the outside of the building was medi-

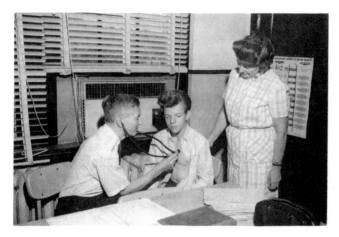

MEDICAL SERVICES

A student seeing the doctor and nurse, circa the early 1960s

cal: the top floor sprouted a row of "sun balconies" constructed for some of Condon's original students—children with tuberculosis—who'd been wheeled out to breathe the fresh air circulating above the parking lot.

Classrooms were predictable provinces of education, with their expanses of blackboard, shelves of books and globes, pull-down maps and charts, and construction-paper alphabets, turkeys, snowmen, leaves, flowers, and pumpkins. Except that the wooden lockers were built at wheelchair height, and the desks were interspersed with refectory tables that accommodated wheelchairs. Every classroom contained a bathroom, with a communicating door between it and the room next door. We had to be careful to lock both doors or the rest of the day would be one of embarrassment.

Classes covered the usual K-through-8 curriculum: English, math, science, social studies, etc. In addition, we were required to have physical therapy, psychotherapy, speech therapy, audiological assessments, and occupational therapy. If it included the word "therapy," we had it.

Nonetheless, our curriculum was considered so innovative, so radi-

cal, that educators came from all over the world to observe us.* Several times a year, cadres of strangers would sidle in and stand in the back of the room, quiet men and women who carried notebooks and clipboards and *watched*. Whispered. Often the whispers weren't in English; sometimes the strangers came from as far away as Japan.

But back to the fireplace:

The lanky girl watched my progress as I forded the river. Once on the other side, I discovered that she towered over me, a sapling to my shrub.

"Hi," she piped, "what's your name?"

"I—er, Riva."

She gestured airily toward the pandemonium. "Aren't they such babies? It's as if they've never left home before. I'd be embarrassed to act so silly, wouldn't you?"

I was impressed. This girl was *sophisticated*. She said her name was Julie, "But really, my name is Juliana. When I'm a famous singer, I'll make sure everybody says Juliana. Don't you think that's prettier?" She told me she lived in Deer Park. I thought it sounded like an elegant zoo.

Miss Woodbridge called out, "Children! Take your seats!" She introduced us to flash cards. (The letter *B* has two *Bumps*! The letter *D* has only one, that's how you know it's *Done*!) I already knew how to read, so was instantly bored and only snapped to attention when she opened the art cabinets. I managed to impress Julie with my painting of a basket of kittens. It was good to know I had something to offer this friendship.

* When researching this book, I found articles dating back to the 1920s and '30s that discuss Condon's pedagogy. Until then, few educators believed in the value of teaching crippled children to be part of the world. There's very little written about Condon School. It was mainstreamed with another school, Roselawn, becoming Roselawn Condon School in the 1980s.

Heidi

We held our breath as Klara rose to her feet. She teetered, unstable, skirt swinging like a ruffled bell. Her little friend stood sentinel by the wooden wheelchair, urging her on, but braced to catch her if she fell. Klara made her way across the inlaid floor, party shoes scraping the stone. At last, she collapsed into her father's arms. "Merry Christmas, Papa!"

It's a miracle! Klara can walk!

Mom and I leaned farther and farther forward. My feet dangled far above the floor while hers stayed planted firmly on the carpet. We nearly fell off the bed as we reveled in our moment of release. It was the WCPO-TV afternoon matinee. We were watching *Heidi*. Again.

I was only six (and a half, almost), but I had already seen it a bunch of times. Normally, I wanted our whole family to watch movies together. Not only did Mom know everything about every movie in the world, but Dad would even put down his ledgers and papers—a rare event—to watch *On the Town* or *Operation Petticoat*. He'd tell funny stories of shore leave during World War II (leaving out the actual war parts).

Today, though, I was happy that it was just Mom and me. (Dougie had started out watching with us, but quickly lost interest. He only liked *Heidi* for the goats.) Mom had been in Jewish Hospital again, this time for two whole weeks. I couldn't take my eyes off her. Two weeks is

a long time if you're not sure when—or if—your mother is coming home. And *Heidi* was our special movie.

This 1937 version of Johanna Spyri's novel cast Shirley Temple as Heidi, the poor Swiss orphan. Heidi's evil aunt Dete steals Heidi away from the grandfather's mountain cabin and sells her off as a rich girl's companion. Klara Sesemann (said rich girl) possesses an array of astonishing frocks, lustrous coils of brunette hair, and a wheelchair so elegant it should have been harnessed to a team of caparisoned horses. But poor Klara. Being rich made her spoiled, being motherless made her timid, and being crippled made her sulky. Luckily, Shirley Temple never met a human disaster she couldn't fix.

Back on the screen, Herr Sesemann was thanking Heidi for his daughter's cure. *You dear child. You've worked a miracle.* He gathered Heidi in one arm as Klara sprawled on his lap like an enormous toddler.

My parents' black-and-white Zenith TV sat on a long mirrored dresser. If I scooted just right, I could watch Mom and the movie at the same time. I saw the reflection of my mother's wide, slow curves, from the planes of her forehead to the swoop of her rounded chin. I needed to know—did we still have the same mouths? The same dark hair and eyes, a pinch darker than the cola in our cups?

Her fingers spun fine wet wisps onto rollers. She saw me staring, blinked, then reached out a speculative, blue-gelled finger to catch a lock of my hair. Twisted it around to make a ringlet—a very, very Shirley ringlet.

"Did I ever tell you that Gertrude Temple had rules for Shirley's hair stylists? She insisted that they put her hair into fourteen identical sausage curls. Can you imagine? She knew her daughter's head that well." I huffed and batted at her hand, but inside I was so glad Mom was back that she could have styled my hair with Elmer's glue.

After a minute or two of fuss, she settled back down. Her heavy body pressed the mattress into a valley; I slid down the tufted slope against her hip. She winced.

I'd hurt her. "Rivie, I better take these pills. I'd love another Coke, can you get us some?" Mom didn't often ask me for stuff, but at eight months pregnant, her belly pinned her down like a giant paperweight.

Second grade

I grabbed her tumbler and poured from the green glass bottle in the fridge, careful not to leave a sticky circle on the countertop. When I came back, the baby was kicking the pale blue nylon of my mother's gown. Fabric rippled like a wind on a pond.

How I hated this baby. This baby was going to kill my mommy.

At least that's what Grandma Fannie said.

Months earlier, I'd come home from school and walked into one of their screaming arguments. Grandma's words were sharp as cider vinegar. "For a smart woman, you sure are acting stupid. I heard your doctors tell you not to have this baby. Such narishkeit! You know better than anyone that the mess in your back is serious, Carole. You want to end up paralyzed? What good will it do your other children if this one kills you? *Deal* with this before it's too late."

"I would never, ever do that to a baby! How can you even ask me that?"

Ask her what? What did Grandma want? I hid in my bedroom but their voices leaked through the doors and underneath my pillows and

covers. I waited to come out until I heard Grandma's car pull away. Mom was sitting in the den, a million Kleenexes balled up under the table. She smiled like her lips hurt. "You were so quiet I thought you fell asleep. Tell you what . . . why don't we pick out names for the baby?"

I stared at the floor awhile and mumbled, "Donald." I'd had a crush on freckle-faced Donald ever since the day I met him in kindergarten. More important, a baby named Donald would be a boy. I did not want a perfect little sister who'd have no need of hospitals. Mom said, "That's a nice name, pussycat. Oh, please don't cry, I promise, there's nothing to be afraid of."

But then she disappeared into Jewish Hospital.

And I imagined a baby with a knife inside the red room of my mother's stomach.

Heidi had diagnosed Klara just by running her hands over her body. *Your back feels just like mine! Your legs do, too! I should think you could walk if you wanted to. Why don't you try?* And hey presto! Klara could walk. I wasn't stupid, I knew that Shirley Temple was Heidi *and* the Little Princess *and* Curly Top *and* Bright Eyes *and* the Little Colonel. And that Shirley's movies had been made a long time ago. Still . . . Shirley Temple really did seem to have magical powers. What if I persuaded her to make a house call?

Mom was in trouble, but so was I. Like Klara, the way I walked was wrong. Both of us were broken dolls in everyone's eyes. Unlike Klara, I was still waiting to be fixed.

People kept giving me books about little crippled girls. One had illustrations of a polio girl who was put in a full-body cast: from neck to toe, she was one long white slab of plaster. When they cut the cast open, her two sides no longer matched up—but her doctor prescribed ballet lessons, and in no time she was leaping in midair, a fluffy pink tutu like a flower around her waist.

In another book, a little crippled girl learned to ride a pony. She fell off lots of times and got really hurt, but she kept smiling and riding and being tough. And brave. And in no time, she started winning races!

And got to throw away her crutches! None of *my* doctors ever prescribed dance lessons or horseback riding. Maybe I should bring those books to my next checkup—or maybe not, if I didn't want to spend the next year in a full-length plaster cast.

All the books agreed on one point: all you really needed to get better was willpower. Heidi gave Klara so much willpower that she literally grew a new spine.

By the next commercial break (*Dream Whip Dessert Topping! With Country-Fresh Flavor!*), I had a plan. I'd get out my Crayolas and make the most incredible drawing anyone had ever seen. I'd draw Heidi's mountain cabin, with goats dancing all over the roof, sweet white goats with garlands of flowers on their horns, all colored with my favorite crayons: cornflower blue, goldenrod, bittersweet, periwinkle, aquamarine, lavender. I'd even sacrifice my precious gold and silver crayons.

Drawing a picture unsnarled me, made me calm, the way I felt when I reached my hand into the rooms of my metal dollhouse. I figured I'd mail my drawing to Shirley's/Heidi's house, then she'd come and lay her small plump hands on my back, and then my mother's back, and no more hospitals for either of us, ever again, amen.

I was so happy that I hopped off the bed and twirled across the floor, arms raised in arcs like the ballerina in my jewelry case. I didn't care that one of my legs was shorter than the other, so that I bobbed up and down like a carousel horse. In the middle of making myself pleasurably dizzy, Mom said, "You know, we were told you would never walk, either. I told them you would, but they didn't believe me. Those doctors. Just look at you now! It *was* a miracle, you know. Grandma Dora said she'd save your life, and she did."

I nearly whacked into the tray tables. "What? Who's Grandma Dora? Do you mean Grandma Fannie? Or Grandma Rose?"

"No, Grandma Dora was Daddy's mother. She was Grandpa Willie's first wife. Willie remarried a long time ago, so Grandma Rose is Daddy's *step*mother."

Well, whoever this "Dora" person was, I couldn't see what she had

to do with me. *Mom* was the reason that I was alive. She'd fought for me from the minute I was born. Truth was, I wasn't sure if my father had even been involved.

"Why don't I remember her?"

"Well, you were a tiny baby." She trapped her bangs in a bobby-pin X. "I'm pretty sure I told you some of this. You were a year and a half, and seriously ill . . . ?"

"Right, right! I know this story. It's 'When I Almost Died'?" This was a good one. *Very* dramatic. I was the star; Mom and Dr. Martin were my co-stars.

"Okay, then . . . Daddy and I had been in your room all night. Dr. Martin came in later than usual. He was really kind, but he told us you weren't going to live much longer. There was nothing left to do. He told Daddy to make arrangements."

"What are 'arrangements'?"

"He meant we should call Weil's Funeral Home. But we couldn't, because we had to go see your Grandma Dora."

"You *left?* After Dr. Martin said I was *dying?*" She was being so matter-of-fact! I raked my fingernails across the seams of the quilt and made the threads go snap, snap, snap.

"*Stop* that." Mom plucked at my wrist. "You done wrecking my bedspread? Look, we didn't have any choice. Grandma Dora was right across the street, in Jewish Hospital. She was dying of cancer. Every night, Dad would meet me at Children's and visit with you, then we'd go and see Dora."

I turned my face to stare at the television. In Switzerland, all had gone cold and dark. Heidi and the grandfather were searching for each other in snowy, monochrome silence.

"Dora asked how you were. When your father explained what Dr. Martin had said, Dora grabbed his wrist so hard I worried she'd pull out her IV. She told us, 'Listen to me! I am going to die tonight, and as soon as I get to Heaven, I will tell God to take me instead of Riva.'"

Whatever I was expecting, it wasn't this. Miracles had angels and the voice of God coming out of the sky. Not a sick old lady in a hospital bed.

"There was no good decision—no matter what we did, we were leaving one of you, and maybe forever. But she insisted we go, so we went, and we did as she said and went back to your room. We fell asleep on those horrible visitor chairs, and only woke up when Dr. Martin came in the door. I jumped up and ran over to the crib.

"And that very minute this nurse stuck her head in the doorway and said there was a call at the front desk. Jewish had been ringing our house for hours until somebody finally thought to try Children's. Grandma Dora had passed away right after we left." Mom flickered a smile. "After that night, you just got better and better, and soon you were allowed to come home. So you see, Grandma Dora kept her promise."

I looked down. My glass of Coke had sweated a puddle on the TV tray. Pools of water made the enameled roses darker, sharper, like a magnifying glass. I felt peculiar, like I'd never seen the trays before, or even my own elbows.

Mom beamed, happy that we were both there, both fine, both together after weeks apart. We had just spent two hours talking about death and cancer and hospitals. I was six years old.

The credits for *Heidi* began to roll, printed in the spiky Gothic letters of a fairy tale. I caught my reflection in the mirror. Was I worth it to Dora? Was I worth saving, if I was never going to be normal?

Mom opened her arms for a hug. I broke free, and for once, my mother dropped her hands and let me go.

That night, as I lay in bed, I knew that a baby really could kill someone.*

* While writing this book, I watched *Heidi* nearly as many times as we had back then. I was startled to realize that right in the middle of our favorite scene is the sudden loss of a golem girl. Klara's resurrection takes place (of course) in the middle of the Sesemanns' Christmas party. Klara's doll is very large and very blond, a doppelgänger of Heidi herself. The housekeeper (the subtly named Fräulein Rottenmeier) is given the doll to hold. Klara steps from her wheelchair and into her father's arms. Just as the newly cured Klara crosses the floor, Rottenmeier drops the doll. It shatters on the ground.

When I was little, this scene left me aggrieved over the loss of a spectacular toy. Viewing *Heidi* now, I see how the doll lies forgotten and irrelevant as Klara strides toward health (and, not incidentally, toward puberty). The golem girl is a sacrifice that takes the place of Klara's previous, "broken" body.

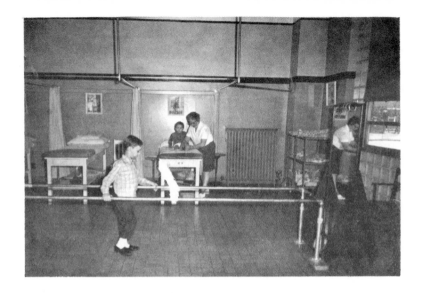

PHYSICAL THERAPY

The dreaded parallel bars, circa the mid-1960s. You can see the boy
walking toward the mirror.

Aerobicide

Come on, you can do it, one more. Good girl. And now one more. You aren't leaving this table until you do ten. Keep that knee straight. Eight, nine . . . okay, now turn on your side."

I rolled away from Mrs. Robinson and started my reps of ten leg lifts. We had physical therapy every day, from kindergarten to graduation; this time, my session overlapped with Melanie's, right after third-grade geography. I was up on the table; Mel was red-faced and sweaty from being put through her paces on the floor. She splayed on the blue medicine ball while her physical therapist droned, "Balance, balance, balance."

Mrs. Robinson helped me off the table and over to the parallel bars. Mel flashed a rueful grimace; she knew how much I dreaded this part of our routine. Parallel bars were two twelve-foot lengths of steel pipe, on supports about thirty inches off the ground. These formed a narrow pathway with a full-length mirror at the far end. I held on to the pipes and walked toward my own reflection, doing my best to avoid the handrails and to learn to walk smoothly. Mrs. Robinson barked, "Lift! Lift that foot! Stop dragging!" The mirror blared that my limp wasn't going anywhere.

Condon School lacked anything like a gym, or any physical games whatsoever, so we kids invented our own sports. My favorite game was hallway racing. The upper hallways were long, straight shots with a steep

staircase at either end. A race team consisted of one wheelchair pilot and one walkie. The walkie's job was to get a good running start and then hop onto the back. I loved to feel the wind on my face as the pilot's hands blurred on the wheels. At the last minute, I'd drag my shoes so we'd reach the staircase without launching into a downhill slalom.

But my mother viewed the world through hazard-orange glasses. Most Condon kids were taught to ride a bike in the PT room, using extra-large training wheels. Nope, said Mom: I could fall off and hurt my back. There was a swimming pool in the basement, prettily tiled in celadon green. The pool had a crane that lifted you in and out of the water, and a ratio of one instructor per swimmer. I begged for lessons. Nope, said Mom, what if the instructor left me to sink like a forgotten tea bag? When it came to any conceivable physical risk, my mother's vocabulary shrank to *nope, nope, nope.*

I needed someone who could show me how to be a kid. Luckily, I had Julie.

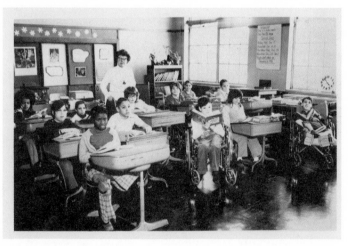

A classroom at Condon (not mine) circa the mid-1960s

I followed Julie's willowy beacon into every new grade. Everything about her was glamorous, even her disability. Julie had juvenile rheumatoid arthritis for which she received "gold shots" directly into her joints. This only added to her luster—who else had a condition that

was treated with actual precious metals? Arthritis gave her a distinctive, gliding lope, as if going for a Girl Scout badge in stilt-walking.

Whatever she loved, I loved too. She was passionate about the Monkees, so our lunchtimes were spent filling our notebooks with hand-copied lyrics and trying to decipher their meanings: *For Pete's sake, does he want her to go to Clarksville or not?* In 1968, Julie decked herself in peace-sign necklaces and bell-bottoms so encrusted with patches and embroidery that they qualified as light armor. We competed to grow our hair long, like Peggy Lipton's on *The Mod Squad;* in 1970, we agreed that Julie was a perfect Laurie Partridge. Julie encouraged me to noodge my parents for guitar lessons, even though, unlike her, there was no sign I had talent. I was defeated by the tuning fork.

The art room was the only place where I could be the leader, not a follower. I liked to open the glass doors where the paints and modeling materials were kept and breathe in the white-bread-and-salt tang of the kindergarteners' Play-Doh, mingled with the basement pong of wet gray clay. I loved the slickness of paint on a brush, the shivery scrape of pencil on sheets of crappy newsprint. Every kid loves to make art, but I noticed that I got more attention and special praise. People would look at my work, and then look at me with a changed expression.

Cincinnati of the 1960s was a fractured palette of Black* and white neighborhoods, as sharply defined as houndstooth check. Thirty to forty percent of Condon's students were African American, an unusual degree of school integration for the time.

A chain-link fence divided our parking lot from that of Rockdale Elementary, where all the students were Black. At recess, both schools emptied outside to play in the parking lots that were our playgrounds. I knew that some of my classmates, like Larry Freeman, lived nearby. I wondered if those scuffles were harder for Larry, if he had siblings or neighbors amid the bottle throwers. If he longed to jump the fence.

* https://www.nytimes.com/2014/11/19/opinion/the-case-for-black-with-a-capital-b .html

God knows, I was no paragon of understanding. I was as awkward and incompetent as any outsider, particularly around my classmates with verbal impairments. I'd freeze when trying to talk to Darlene, whose speech was affected by cerebral palsy. I'd mumble a cursory "Hi uh huh" and run away. I rarely thought about what it was like to be Darlene, seated at the back of the class, fighting to be heard through an entire answer while even the teacher bunny-hopped over her deliberate words. But Julie had patience for Darlene's raucous laugh, for Shirley, whose fingertips danced on the Braille book open on her lap. I stayed terrified that I'd say the wrong thing, or simply not enough of the right thing.

In seventh grade, Tommy joined our class. Somehow, he ended up at Condon rather than at St. Rita's School for the Deaf. Tommy was gorgeous, so I made a half-hearted attempt to learn the ASL alphabet, a challenge that Julie approached with the fervor of Sir Edmund Hillary on Everest. In no time it was Julie and Tommy, wooing each other with flying fingers. The entire school had a crush on their crush.

Seven-forty in the morning. I leaned against a tree and watched a procession of yellow buses perform complicated six-point turns in the circle by our house, like a pod of ungainly marigold whales. Sleep-muted faces jounced in the windows. I waved at the ones I knew.

Next came the Condon bus, with its retractable steel ramp. The driver would roll a kid upward and use a bolt and clamp to lock the wheelchair to the wall behind the driver's seat. Each bus held seven wheelchairs and a dozen bench seats.*

We made the northeast rounds, from Kerrie and Robbie, to the two Donalds, Darlene, Jack, Amy, Simon, and Mark, and lastly to Julie's house. Laconia was early in the route, which let me save her a seat.

I'd begun to detect certain puzzling exchanges between Simon and Kerrie. I'd watched them for years. They were both older than me (and what creature was more captivating than an upperclassman?) not to

* The Petermann Bus Company was the first to design ramped buses for wheelchairs.

mention that Kerrie and Robbie Whitaker ranked as Condon's very own rock stars, a pair of flaxen, curly-haired Muscular Dystrophy Association Poster Children who looked like twins, though Robbie was a year older. Robbie and Kerrie were nice, as a rule, but Simon had a tongue like a pocketknife.*

My bench gave me a seat near the action. Simon kicked things off with a little style critique. "Kerrie, what's wrong with your head? Are you raising mice inside your hair?"

"It's called *teasing*, Simon. It makes my hair look fuller. Not that *you'd* understand fashion."

"What, now you like being teased? Yesterday you were all mad, just 'cause I said I can't tell you and your brother apart if you aren't wearing a dress. Is that why your hair is bigger than a beach ball? So I can tell you're the girl?"

"You might try being nice once in a while. Or, I dunno, *ever*."

"Nice is for weenies."

Robbie defended his sister's honor. "You know, Simon, it'd be so easy to run you over. No one would blame me for not seeing you down there." We rarely made fun of one another's disabilities, but Simon's status as a Little Person was fair game according to the time-honored rules of He Started It. Simon tried to snatch one of Kerrie's hair ribbons. The bus driver snapped, "Sit down, young man."

I startled when Julie dropped into the open seat. Her eyes were circles of blue fury. "Rats, rats, rats! She did it again."

"What this time? The guitar or the records?"

"Oh, I hid the records inside the box with my winter sweaters. I mean, why does *she* get to say how I spend my allowance?" Julie shoved her glasses up her nose with force. "Mom says I should save up for my own guitar, but that's like two hundred dollars."

As one who borrowed liberally from her stash of singles, I staunchly supported Julie's right to blow her pocket change. "Gee, that's awful. So, like, what did happen?"

* I'm leaving off most of the last names of my fellow students, but the Whitakers were quite famous.

"She came in right when I was finishing some lyrics, and says, 'What about your social studies test?' And I say, 'But, Mom, I have Girl Scouts tomorrow, I have to finish this or I won't get my music badge.' Anyway, who cares how many pioneers settled in the Ohio Valley?"

"Yeah, right, like you ever failed a test."

That got a grin. "Well, like, didn't you think the chapter about Indian Mound was cool, though? Like, romantic? Maybe I can write a song for extra credit." She searched her pockets for a pen. "Hey, I forgot to tell you but yesterday, this lady at Kroger's said I look like an Indian. With my hair and all."

"I didn't know there was a tribe of blond Indians."

Julie gave me her "get with it" look and bent over her notebook. The hem of her Girl Scout uniform poked out above her swollen knees. I was wearing mine, too: the belted green dress, dark green beret, and bright yellow tie. Our troop's badges were tilted toward things you could do sitting down. Indoors. Not for us the Skater, Gypsy, Foot Traveler, or World Games; we were masters of Home Nurse, Personal Health, and (of course) Home Health and Safety.

Boy Scouts and Girl Scouts were among Condon's few bridges to the mainstream—not that we ever met up with other troops. Still, it

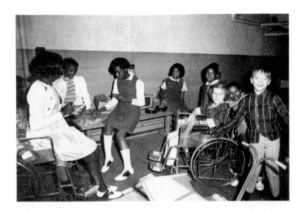

RECREATION TIME

Girl Scout meeting in the "gym" downstairs, circa the
mid-1960s. My friend Lonnie (who also appears in
the parallel bar photo) is far right.

was thrilling to see other brown or green uniforms on the street during cookie season and know that no regular troop could outsell a bunch of girls rolling down the street with lapfuls of Thin Mints.

One summer, it was decided that we could safely leave the confines of Condon for an open-air adventure. A dozen Scouts and just as many mothers (though mine was not among them) got on a Petermann bus early one Saturday morning and were driven to Camp Stepping Stones, one whole hour away from school.

Sue Rumbaugh, our troop leader, pointed out plants and birds and insects, calling *Tufted titmouse, Mourning dove, Red admiral, Dogwood, Paper birch.* Mary Ann braced her spastic arm against her waist and bent to pick up an orange-and-black caterpillar. Sue called it a "woolly bear," so of course we all started making up ridiculous names. When Janice picked up a pill bug, Mel asked, "But what *kind* of pill? Looks like an antibiotic to me."

When the sun went down, we built a campfire and toasted marshmallows on peeled green sticks. Sue helped us earn our Outdoor Cooking badges by making a recipe that our handbook called Friendship Soup. We'd been instructed to bring one can of Campbell's soup each; Sue took our offerings of Chicken Noodle, Tomato, Beef Barley, Cream of Mushroom, and Vegetarian Vegetable and dumped their contents into one huge pot. The handbook advised us to stir well in order to "blend the flavors." The resultant Friendship Soup looked—and tasted—like a cauldron of boiled Girl Scouts. All one can say is, thank God for s'mores.

At bedtime, we spread our blankets and pillows on top of the cots. Our troop sang handbook songs and giggled, until overcome by night wind and cricket song and the incomprehensible distance from home.

Every child at Condon was a Golem; little medical monsters,* constructed by doctors who wrote down our diagnoses on prescription

* And when I call anyone else a monster, I'm not ever saying that that's how they saw themselves, or that they were evil, freakish, or anything negative whatsoever. I am saying that that's how we were often treated in the world; as disturbances, threats, as frightening or pitiable creatures, not as young humans on their way to human lives.

pads and forced those names into our mouths. We breathed around gags made of paper, scrawled with our alphabet: Achondroplasia, Cerebral Palsy, Clubfoot, Cystic Fibrosis, Down Syndrome, Epilepsy, Microcephaly, Muscular Dystrophy, Osteogenesis Imperfecta, Phocomelia, Poliomyelitis, Progeria, Rheumatoid Arthritis, Spina Bifida. Really, though, I can only guess, because we seldom talked about them with one another. Adults spent so much time discussing our bodies, defining us by our diagnoses, that we learned our classmates' medical names by osmosis.

We were kids being kids, making friends, fighting enemies, forming cliques. Having crushes and breaking up. We liked each other, or didn't. Friendships weren't based on shared disabilities. There was no Team Spina Bifida waiting for my membership dues.

My friends and I knew that Condon was a place you were sent to, not one you'd choose to attend. No one on the outside could understand its pleasures or why anyone would become attached to "the Retard School." They didn't understand that at Condon, we *were* the school. We didn't have to ask permission to be included—accepted— by the "normal" kids, the way we might have in the mainstream. The Glee Club was *our* Glee Club, the Christmas play was *our* school play, *our* Scout troops, and *our* student newspaper, albeit produced on a mimeo machine that turned our fingers the color of Welch's grape jelly.

We were messed up the way kids were, but not the way outcasts were, until the end of the school day, when we got back on the bus and turned back into freaks.

House of Wax

I jumped off the school bus and furrowed a trail across our snowy yard, clomped inside, and let the muck of outerwear thud to the carpet. I was careful not to splorch anything with accidental slush. It was the Most Wonderful Time of the Year: our living room sofa had once again been transformed into the Chanukah Couch.

A gust of 20-degree air hit the back of my neck. Doug must have run all the way home from Swifton Elementary. He pulled off his cap, revealing hat hair that made him look as if he'd worn a salad bowl to school. I snickered; he shoved an icy mitten down the back of my sweater. From the other room, Mom yelled, "Kids, knock it off."

Doug and I stood before the couch, drooling like cannibals at a mosh pit. Before us lay a seven-foot length of navy upholstery entirely covered with presents. It was the first night of Chanukah, that perfect moment in which not a single package had been unwrapped. Eight separate piles of gifts that gave us a smug superiority over all those gentile children, who had but one night, poor things. Eight nights that helped us endure solid six weeks of "Jingle Bells" and "Silent Night" and red-and-green everything.

Doug grabbed a box covered in dreidel paper. "It's for you. It's a *sweater.*"

"Nuh-*uh*. It's a party dress."

"I bet it's green. Like a pickle. Pickle nose, pickle nose," he sang,

never tiring of pointing out that mine was, indisputably, a very large nose. Like we didn't have the same schnozzola.

"Well, if it is, don't worry, it's all yours. Green is *your* favorite color, isn't it? You'll look sooooo purty—just like a kosher dill."

"Eeww! Gross!" Realistic barfing noises ensued. The boy did have his talents.

Totems and Familiars: Nomy Lamm
2008

Our little brother, four-year-old Markie, wandered in from the kitchen and began to climb the couch like a dazzled monkey. (Obviously, his birth hadn't killed our mother. In fact, of the three of us, he looked the most like her—a beautiful, wide-eyed child with the sturdy frame of a Horwitz.) Mom called out, "Don't let him tear open the packages." As *if*.

At dinner, Dad wore a fresh white shirt and an unspotted tie (talk about your Chanukah miracles), while Mom had on the fancy new dress she'd made the week before. I had been in my bedroom re-re-reading *Little Women* (I was Jo! No, I was Beth, dying—in poetry!) when I heard the snip, snip, whirr, coming from the den. I wandered out to see Mom bent over the table, pinning filmy pieces of a Butterick pattern to a bolt of orange brocade.

"Hey, what's that? Is it for me?"

"Go look."

I picked up the pattern envelope, on which an emaciated model vamped in an evening gown, though the label said size 16.

Mom said, "Just the thing for your Christmas pageant. What do you think, maybe a Wise Man's robe? Or are they making you be an angel again?"

"I'm just a villager this time. They never know what to do with me." I was one of only two Jewish kids in my entire school. So far, I'd avoided being cast as either of the Marys.

Mom held up a section in front of her chest and pinched the dart points. "Just as well. I have a feeling you'd need someone to carry your train."

I fingered a scrap of ornate fabric. "Think there's enough here to make me a skirt?"

"Don't lose that, it's a facing."

"I thought you went shopping yesterday. No luck?"

"Well, if your idea of high style is a beige muumuu, Lane Bryant is certainly the place to go." She bent forward and pushed brocade under the needle, her voice too tight for the joke.

My mother had wanted to be a fashion designer. She'd won a scholarship to Pratt Institute, but her parents demanded that she attend pharmacy school since they'd allowed her older brother, Lester, to attend the School of the Art Institute of Chicago and *someone* had to take over the family business. And that was that. She escaped after a year by virtue of a lab accident involving a Bunsen burner and a quantity of magnesium. She flash-blinded herself, a blindness that lasted for several months. I don't know if Carole was a chemistry genius or a future liability for the pharmaceutical industry.

Carole loved clothing with an unrequited passion, even considering that the fashion industry pretended that she didn't exist. When Doug and I were eight or nine, she'd take us downtown on the bus all the way to the Cincinnati Art Museum. Our final pilgrimage was always Gainsborough's *Ann Ford (later Mrs. Philip Thicknesse)* so that we might marvel at the satin gown, a cascade of frothing silver. Ann Ford herself was an afterthought, a vehicle for the glory of the dress. And Carole was always a dress-loving woman: not for her the plebian pantsuit, the wash 'n' wear slacks.

These days, she consoled herself by drawing wasp-waisted debutantes in Dior "New Look" frocks. She'd never find such things in her size, because Carole Sue Horwitz took after her father. Sam Horwitz was height times width times girth times appetite, six foot two at a time when Jewish men were built like Woody Allen. Big men could get clothes, since big men got respect, but Lane Bryant was the only store that served big women, offering a range of shame-based garments that ran the gamut from Drab to Saggy to Punitively Asexual.

The dresses that my mother made were beautifully cut and daringly, anti-Bryantly colorful, graced with embroidery on the collar, tiny jewels at the neck, lace and velvet trim at the sleeves and hem. She caused a small sensation when she swanned down the road in one of her own creations. More than once, I saw a lady grab her sleeve and demand, "*Where* did you get that? Can I buy it from you? You MADE it? Please, please, make *me* one!" I feared that someday an admirer would peel my mother like a banana, and run away clutching the purloined gown like a golden fleece.

Totems and Familiars: Neil Marcus
2007

I thought my mother was very beautiful, but it was hard for her to feel that way. Grandma Fannie had sown land mines along that road years ago. When it came to Mom's weight, Grandma's fuse was permanently lit. "My God, Carole, I'm surprised your husband hasn't left you already. You look like a chazzer! How can you even leave the house?" After one of Fannie's pep talks, Mom wouldn't come out of the bedroom for days. Yet I suspect that if Carole had been pretty in the same way that Fannie was, Fannie would never have forgiven her for that, either.

. . .

Mom set the menorah on the table and draped her hair with a cloth. She lit the first-night candle with the Shammes candle, and we prayed, *V'tsivanu l'hadlik ner shel Chanukah, O-main.* Rivulets of pastel wax crept down the arms of the menorah.

We passed around the browned kugel, the amber bowls of matzo ball soup, the brisket, the tzimmes—an edible museum of Jewish culture. The finale was Carole Sue Lehrer's Famous Homemade Strudel. When dessert was reduced to microscopic flakes, our parents took pity and said, "Okay, kids," whereupon we bolted to the living room and clawed at the gift wrap like uncaged vilde chayas.

The small packages were for the first night. Hefty eighth-night gifts waited at the far end of the couch.

I already knew what was inside my big package. For years, I'd been given the same two-feet-by-one-foot box. I was five when I got my first Chatty Cathy doll. She'd seemed so big that she could have been my unbending sister, blond and blue as apple pie.

Cathy could talk if I pulled a cord out the back of her neck:
Will you play with me?
Let's change my dress.
Please brush my hair.
Where are we going?
I'm hungry.
Carry me.
I hurt myself!
I'm sleepy.
I love you.
Tell me a story.
Cathy sounded like a child gargling hot glue.

Like me, Cathy went away for repair; not to Children's but to the Doll Hospital downtown. Cathy's voice box was actually a tiny record player mounted inside her chest, easily broken during even mildly vigorous

play. The girl had cardiac issues—hence the succession of new Chattys. I'd demanded to be taken to see the Doll Hospital. I was so disappointed that it was just a tiny storefront on Elm Street with hundreds of dolls wedged inside its dusty cases.

When I was little, Mom had sewn us matching outfits: Mommy dress, Riva dress, and Cathy dress, cut from the same bolt of cloth. Now that I was ten, Mom and Grandma had begun buying me A-line shifts that hid my spine. I didn't feel safe, I just felt sad.

My dolls had stopped being my companions and become excuses to make elaborate dollhouses instead. Castles made of appliance cartons, with Morton Salt turrets and corduroy carpeting cut from scraps of my trousers. I was better at loving those houses than loving my perfect pink dolls.

Have Fun Storming the Castle

Whenever I came home from school, the first thing I did was to head to Mom's bedroom to check on her. More than once, she'd been taken back into Jewish Hospital between the time I'd left for school and when I'd hopped back off the yellow bus.

Her bedside table was colonized by tipsy ranks of amber bottles, by tumblers of flat Coke and small bowls smeared with crumbs. My father's side was marked by whiffy ashtrays and crinkled packs of Kents.

Mom shrouded the bedroom windows with blackout shades. My parents' king-sized bed turned invisible as an aircraft carrier in fog. Those shades gave her night when she needed it.

When I was ill, Mom installed me on Dad's side of the mattress. We'd watch TV and fill out crossword puzzles until she fell asleep. Then I'd be hemmed in beside her all night, listening to her snore, while Dad was banished to the couch, the reek of his cigarettes reminding me that I was an interloper. When I turned twelve, I begged to be allowed to stay in my own room when I was sick. What a ludicrous victory.

The house on Laconia would have crumbled like a sandcastle were it not for Grandma Fannie and Dora Holiday.

Mom had hired Dorie Holiday back when Doug was born, while Mom was still bouncing between Children's Hospital and my parents'

first apartment. Dorie was called our "housekeeper," but that didn't come close to describing her role in our lives.

Dorie was around Dad's age, roughly forty years old. A bespectacled chain-smoker, she was skinny as high-tension wire, with swooping cheekbones and a high forehead. Subtle freckles ornamented the deep brown of her skin.

Dorie had a husband, Joe, and a daughter, Georgia. Georgia was ten years older than me, and looked at me with a smirk I couldn't comprehend. On occasion, Dorie would stay too late to take the bus back to Over-the-Rhine, so Dad would drive her home. I liked to go on these nighttime drives; Joe would be waiting on the sidewalk outside their apartment building, but I always wanted to go upstairs to see the rest of her home. I never did. Dorie guarded her privacy. I once asked why her nickname was Scat; she muttered something about chasing a cat when she was little, but later she explained that it was because of the way she sang. I hadn't even known she could sing.

Once a year, Dorie left us for two weeks of vacation, during which the Holidays would go back down to Georgia, the place for which their daughter was named. I tried not to think about the fact that every minute that Dorie gave our family was stolen from her own. I was terrified that someday she'd stop.

Whenever Dorie left, Doug and Mark and I would go to live with Grandma Fannie and Grandpa Sam. Their living room was a symphony in muted gold. The china cabinet was full of pink crystal dishes rimmed in chased gold bands; the drapes were raw silk, in an aureate color that matched Uncle Lester's hand-painted chinoiserie mural. Not that my grandparents were born with such rarefied tastes. My very upright grandfather was a scrapper as a teenager (reputedly, Sam ran money for the Jewish Mob, sailing to Cuba with cash packed inside a so-called "money suit"); and Esther Fannie Newmark came over from Chernigov, Russia, when she was five months old. Right away, she was determined to be *modern*. Her wedding photo shows a poised beauty in a flapper's gown. Next to her, Samuel is tall and imposing and mustachioed as Errol Flynn.

They'd had multiple locations for their pharmacy before landing the

sweetest spot of all: directly across from Findlay Market, where people came from all over the city for the kind of fresh produce, meats, and cheeses you couldn't get at Kroger's. Grandpa Sam was known as Doc, so, of course, Fannie was Mrs. Doc. She was such an astute business-woman that Sam said they should change the sign to "Fannie Horwitz Drugs."

Grandma's motto could have been "Better Living through Obsessive-Compulsive Disorder." Her household cabinets were divided and sub-divided and sub-sub-subdivided: one entire shelf contained plastic bags inside plastic bags, labeled PLASTIC BAGS: SMALL, MEDIUM, LARGE. The walk-in closet was Horwitz Drugs in miniature, stocked with every-thing one might need following the collapse of civilization.

In our times of need, Fannie always came for us. She'd do whatever was necessary—as long as everyone in our family understood that this gave her the right to control our lives. Resistance struck her as willful perversity.

She berated Mom for—well, everything—and chastised Dad by proxy, via lecturing Carole on what Jerry was doing wrong. The one and only thing I ever did right was when I told Fannie that she was so pretty she must be a teenage grandmother. She became so fond of repeating "teenage grandma" that I knew I'd racked up emergency brownie points. Mind you, by the time I was ten, that brownie was down to crumbs.

The person who came in for the full, unmitigated Fannie Treatment was Dorie. When Grandma walked in the door—I kid thee not—she'd take a handkerchief out of her purse and swipe at the furniture. If it came away gray, Dorie was in for it. "What do you do all day? All you do is watch soap operas. I can't imagine why Carole lets you get away with this kind of laziness."

Grandma, strangling a dust rag: "Why are you frying a chicken? I left a brisket in the freezer. That would leave a lot less grease all over the counter."

Dorie, arms folded: "They ask for it. They love my fried chicken. I'll make the brisket on Monday."

Grandma: "I planned it for this week. I have more groceries in the car, and now they won't fit in the freezer."

Fannie went out to empty the trunk. Dorie took out the brisket and held it in her arms. "Figure I should hide this under the couch?" She stood and smoked and didn't say much at all until after Grandma left, when she leaned against the kitchen counter and said, "Your grandma. I bet she sleeps in those danged white gloves. What does she think your family gonna do if'n I up and quit?"

I made a panic noise. Dorie softened her voice. "Aw, honey, I ain't gonna do that. But that woman sure does know how to rile a person up."

I loved her with all my heart. She was funny and sarcastic, a truth-teller and a wizard at whipping up urgently needed comfort food. Dorie was more reliable than almost anyone else in my world, and without the need to deliver the kind of salutary corrections that I got from Fannie. She also tried to break me of my terror of strangers. The minute I tried to hide behind her legs, she'd give my arm a tiny shake and say, "That boy (lady/dog/squirrel/lamppost) ain't studying you!"

All my childhood, Dorie and Carole said they were best friends. These days, I don't know what to make of that. It felt to me like real love, but the inescapable truth is that Dorie was paid to be our support, and I cannot speak to what was real for her. I have no reason to think that her affection and generosity were false, yet the relationship between Dorie and our family was a product of imbalance, economically, racially—almost every way one can count. On our part, Carole would have been in danger without her. I would not have been able to stay at home, and would likely have been institutionalized.

Would Carole and Dorie have been close under any other circumstances? Almost certainly not, not in the segregated Cincinnati of the time. I know that Mom was terrified that Dorie would leave. Physical dangers aside, she would have been so much lonelier.

What I saw pass between them looked like love, at least from the pinhole-camera view of a white middle-class child. But there is much I'll never know. And there is no one left to ask.

Gooble Gobble

RETARD RETARD RETARD! REEETAAARDSS!!!" Sometimes six or seven kids stood at the corner where we'd stop at the red light; other days, there would be teenagers or even a single vicious adult. There was no lack of people eager to scream "Retard!" at the top of their lungs.

Our bus was painted with CONDON SCHOOL in big block letters, so we were always 100 percent visible as we made the rounds. Certain blocks were best traveled with our heads ducked below the window line. The projectiles might be rocks, or water balloons, or eggs. The splattering of yellow yolks on a yellow bus leaves it buboed and swollen, a plague bus carrying an infectious cargo. If I was stupid enough to tell anyone where I went to school, they'd look puzzled and say, "But you don't seem . . . uh . . ." The R-word wasn't forbidden; strangers just didn't seem to know how to rate my "intelligence."

Several times a year, our bus would merge with an influx of field-trippers from schools all around town. Masses of children were shepherded toward edification at the Museum of Natural History, the Cincinnati Zoo, or the red-brick cathedral of the Symphony Orchestra. But as soon as we stepped off the bus, *we* were the spectacle. No one was used to seeing disabled kids in such numbers. One kid in a wheelchair looks like an individual; two kids in wheelchairs look like a telethon; three, and you're a full-blown clinic. The sight of several dozen disabled children was regarded as pure entertainment.

For me, the worst was our yearly trip to the Shrine Circus. The Shriners were a lodge of Freemasons that funded the Shriners Hospitals, places devoted to the treatment of sick or disabled children. Condon kids were always seated at ringside level so we would get all the Special Attention that Special Needs Kids deserved. I'd press myself backwards as the clowns came around and zanied themselves right in our faces. As the spotlight swept over our heads, I felt as if it was picking out the visiting sideshow for the entire audience to enjoy.

Usually, once I got to school I could relax. Fifth grade was uncommonly homey under the auspices of Mrs. Bocklage, a sheltering hen of a teacher. But one day, Mrs. Bocklage was nowhere to be seen. An unfamiliar woman stood at the blackboard. She was thin and dry as a rawhide chew, draped in a flowered dress that hung loosely from her bones. Her neck stuck out of her Peter Pan collar like a dandelion in a Dixie cup.

She spoke loudly and slowly. "Mrs. Bocklage is out sick. Take your seats. Hurry up, y'all. My name is Miss Boyd." Obediently, we settled in, our desktops rising and falling with a bang as we fished out our textbooks. Miss Boyd interrupted with, "Nah, nah, no books right now. We got something else to do this morning. All you children get ready to hear what I got to say. I'm gonna tell you a *real* important story." She strode to the classroom door and turned the latch with a thunk. Up until then, I had no idea the room could be locked.

I hazarded a glance at Julie. She was just as nonplussed. "Boy, this must be some story she's got up her sleeve."

Miss Boyd planted herself in front of her desk, arms bent and ending in balled fists. "Pay attention now! I'm gonna explain to you 'bout why you are the way you are. Why you're all crippled up." What? Was there such a thing as a group diagnosis? I looked—none of the teaching assistants were in the room. The substitute must have sent them away before class began. This did not strike me as a good omen.

"Now. I know you all been to the doctor and he said you got diseases and conditions and whatnot. But I'm gonna tell you the *truth*. I

bet none of you ever been told *why* you're the way you are. Why ain't none of you can walk worth a lick, or talk right, or take care of yourselves better than a dang baby. It's because each and every single one of you is the wages of sin. Your mama and your daddy were drinkers and smokers and thieves, I know this for the Lord Jesus's truth." Her voice singsonged and rose and rose as enthusiasm ran roughshod over her grammar. "It's obvious! He done punished your parents by making you all crippled up an' droolin' and making doody in your pants!"

From Nancy and Darlene and Larry and Debbie and Donald and Henry and Patty and Mary Ann and Shirley and from all of us poured a river of snot and rage. Somebody in the back of the room moaned, *"Noooo, noooo."* We were fifth graders, but this woman had reduced us to traumatized infants. I was baffled—how could she know anything of our parents? My mother and father weren't drinkers, or thieves, and not even Rabbi Indich—who was always *so, so* sorry for me—had ever said that I was handicapped because my parents were bad people!

Miss Boyd pitched her voice above the rising din. "You parents are FORNICATORS! With people they ain't married to! Fornicatin' with the Devil himself! And *you* are the WAGES OF SIN. Jesus wants to make sure that EVERYBODY can tell you be the children of SIN-NERS!" Her cheeks were shiny with muscular righteousness. I couldn't believe no one was pounding down the door.

Julie clutched my wrist under the desk. She cut her eyes at me and then toward the hall. I understood. *We* could run for help; anyone in a chair or on crutches would be caught halfway to the door. I wiped my face and mouthed, "Let's go."

Soon as Miss Boyd's head was turned, we dashed for the door. Julie snaked a long arm and twisted the iron lock. Miss Boyd yelled, *"Where do you two think you're going?"* but by then we were halfway down the stairs, on our way to the principal's office. We burst past his shocked secretary straight into the inner office and babbled over each other until he held up a stop-sign hand. "Girls, calm down." Mr. Halfter rose to his stack-of-giraffes height and said, "Show me."

At the door of our classroom, he said, "Shhh. Be very quiet. I want to hear." We eavesdropped for maybe one whole minute before Mr.

Halfter stepped inside, wrapped his fingers round her white cotton collar, and lifted her clear out of her seat. "That'll be quite enough." He marionetted her down the hall, and that was the last we saw of our substitute teacher.

Back in class, no one met each other's eyes. Eventually, the secretary told us that the buses were coming to take us home early, but no one came to talk to us. Not the school nurse, not the psychologist. No one ever did.

Soon as I got home and saw Mom, I fell to pieces. Condon would never be safe again. Something I had no words for had been lost. Mom sat me down at the kitchen table with hot cocoa and cookies and listened as I hiccupped through an entire box of Kleenex. I blew my nose and waited for her reaction. My warrior, my street-fighter pillar-of-justice mother, would burn down the school with her fury.

She shoved back her chair with a peppery snort and said but a single word:

"Goyim."

Coloring Book
2011

CHAPTER 13

Body Parts

In early autumn of 1970, I stood up at the lunch bell and barfed all over my shoes. The nurse called Mom, and Mom called Grandma. By the time we got home, I was green and damp as a steamed cucumber. By dinnertime I was worse.

A brief phone consultation with Dr. Dunsky was enough for Mom to start packing my suitcases (three matched pieces in mod-patterned turquoise vinyl; they meant "hospital" so completely that when I used them on a vacation, it was as preposterous as bringing a gurney to the beach). Dad loaded the car while Mom laid me out on the back seat. I gripped the slick upholstery and watched the stars spin in the rearview window. When I was little and scared and sick, she'd flash her engagement ring in a beam of light and make it throw slivers of rainbow: "Look, Riva. Tinker Bell is here. She's going to make sure you get well." I wished I wasn't too old for such sparkles now.

"Emergency" only stays emergent so many times until it becomes routine. We pulled up at the ER entrance and hardly needed to exchange a word. Dad got Mom and me and the suitcases to Admitting and headed home for a few hours' sleep. Mom knew all the Admitting ladies by name. It was eleven at night, but they socialized as if it was Saturday afternoon at the Lucky Lady Salon.

"Dorothy, hello! I love your haircut. That color is *so* becoming. Yes, we're back again. Can you page Dr. Martin and tell him that we're here?"

Dorothy put down her ballpoint pen and leaned toward me. "Sorry you're feeling poorly, sweetheart. Promise we'll take good care of you. But, Carole, it's always nice to see you. Is that a new coat?"

"Yes, I picked it up at that clearance sale at Mabley's last week."

"Oh, I meant to catch that. Too late, I guess. Ah . . . sign over here . . . next page, bottom paragraph . . ." Around me, adult voices spoke in the flat tones of paperwork. I hunched tighter into my coat. Nothing was required of me yet.

The orderly came to take us upstairs. I climbed into the wheelchair, already a compliant prisoner of medicine's best intentions.

Children's hospitals are built to the same specifications as the adult variety, but with a thin veneer of whimsy pasted on top. Our little procession wheeled through the lobby. A battleground of hardy toys lay strewn under the bright vinyl couches as if a playdate might break out any moment. The walls were hung with posters of Elroy and Astro, Fred and Wilma, Yogi Bear and lawman Quick Draw McGraw, each "signed" by the characters themselves.

Ahead were the signs telling you what you were in for. TO RADIOL-OGY. TO PULMONOLOGY. OUTPATIENT LABORATORY. ONCOLOGY. ORTHO-PEDICS. TO ELEVATORS, FOLLOW THE ARROWS. Once you got upstairs, grimmer realities began to appear. The hospital was a war between textures: a thin layer of soft, bright, and touchable as camouflage over the sharp, hard, and brutal. Effective as a lace doily laid over a tank.

The orderly set my suitcase and bulging chart on the bed. People in white coats filled the room, Mom's cue to commence her recital of my history for the intern, the resident, the head nurse, the shift nurses, the nurses' aides, the attending physician, the dietician, the chaplain, and God knew, the orderly who came to take me down for films. At all times she was clinically precise. This not only served to protect me, but proved her bona fides: that Mrs. Lehrer knew her stuff and should be respected.

As Exhibit A, my role was to be stripped down, swabbed, needled, thermometered, squashed by the blood-pressure cuff, weighed, mea-

sured, given the dubious coverage of a tie-back gown, and finally bagged and tagged with a plastic bracelet. With each step, I lost track of how my body actually felt, and listened to the doctors for clues as to how I should feel.

Two hours later, the tide of lab coats receded. Time to meet the roommate—who had, of course, been watching the whole thing.

Your roommate could make a stay more bearable or stir great heaps of misery into the mix. Bad luck was a terrified, weepy girl, or a girl prone to screaming fits, or worse, one whose parent was prone to screaming fits. All you could do was pray that she'd be sent downstairs for extensive tests—or, hopefully, general anesthesia. Good luck was a roomie who liked the same TV shows, since rooms had just one television and I was never good at winning the channel wars.

Floors at Children's were arranged according to treatment. General Surgery rooms reeked of vomit and steaming bedpans. In Orthopedics, we were pinned down by plaster casts, fixators, and traction, all writhing like foxes in leghold traps.

This time, Bed A held a round girl whose skin was blanched the color of vanilla pudding. Her straight black hair fell in ropes the way it does when you take all your baths in bed. Her mother had sat quietly during my intake, but once the white coats had departed our mothers fell into the technicalities-and-trauma lingo of veteran hospital parents. Dawn was pinking the windows by the time they wandered off to the cafeteria for restorative cocoa and pie.

A shy, breathy voice asked, "Um, hello? Can you come say hi?"

The curtain was closed between our beds, but I wasn't hooked up to anything—not yet—so I pulled it open again. We'd heard each other's mothers' recaps of our histories, so I knew that she had a heart valve that never quite opened or closed (Suzie fainted a lot), and she knew my own grisly details. We wouldn't ask those kinds of questions, anyway. Medical sagas were the stuff of grown-up conversation, like property taxes, car repair, and the divorces of distant cousins.

Suzie was in fifth grade, one year behind me. It was clear she'd been here awhile. Her side of the room was full of the usual: potted chrysanthemums, wilting balloons, piles of get-well cards, mixed amid the de-

tritus of care: syringe wrappers, empty metal-capped vials, rolls of tape, crumpled gauze packets.

A nurse came to adjust the wires hooked up to Suzie's chest. Her heart beat like a toy truck—*meep, meep, meep*—stuttering every once in a while, as if she'd hit a speed bump. Those wires pinned her down for her own good, the way that IVs did for me. Hospital rooms kept you where they wanted you.

Children make friends at warp speed in the hospital. New pals come and go with no explanation. Friendships are as brief and intense as an episode of *Star Trek;* any minute, somebody might beam down and never be seen again. We'd cling to each other as best we could and ignore the vast blackness outside the door.

The hospital was the only time when I still played with my dolls. My suitcase was packed full of troll dolls and Liddle Kiddles, as well as Mumps the stuffed kitty, who had accompanied my every stay since I was five years old. Mumps had been laundered bald and her nylon whiskers had snapped off, but she still had those empathetic green glass eyes.

I got out my toys and showed them to Suzie. She popped open her tray table and revealed a menagerie of dinosaurs and zoo animals lurking in the cavern of her under-tray drawer. In a few days—after I was better—we'd push the table back and forth and build a castle out of Styrofoam cups and Kleenex boxes, and trolls would kidnap Kiddles and imprison them in the dungeons of our nightstands.

Toys reminded us that we were children, connected to other children, even if we were marooned on the Island of Misfit Toys. They kept us company in bed and surfaced in the sheets like tiny storm-tossed lifeboats when the aides changed the morning linens. They were things we were allowed to touch.

But we were brutal when it came to the toys in the playroom at the end of the hall. Kids ripped the pages out of books and covered the remainder with a thick impasto of crayon. Games were missing cards, tokens, instructions, or all of the above. We were most pitiless with the

dolls. I could dig through the toy chests all day and not find one that wasn't headless, armless, legless, or reduced to a mere torso. We treated the dolls like stunt doubles for our own surgeries—with universally bad outcomes.

"Now you settle down, toots. Try to keep your eyes closed. You'll fall asleep before you know it." The nurse's arm rose and fell as she switched off the overhead lights, again. Suzie emitted a demure, whuffling snore, as if to prove that she, at least, was an accomplished sleeper. *She* would never press the call button for no good reason.

I usually put myself to sleep by reading from the stack of Nancy Drew mysteries by my bed, but the reading light would wake up my placid roomie. I tried to soothe myself with the rhythms of the hall: the squeak of rubber soles, the rattle of carts, the chatter of on-call residents.

No luck. It was me against the night.

Intravenous poles circled my bed like steel trees, branches heavy with saline and antibiotics. Reedy tendrils of plastic tubing looped down like airborne roots and planted themselves in my arms. I had to stay careful, since the wrong move could dislodge a needle and trigger an hour's search for a usable vein.

Blue light flickered in the patient rooms across Burnet Avenue. Jewish Hospital was mostly for grown-ups. *Their* nurses couldn't make them go to sleep. I bet every TV was tuned to *The Tonight Show*. Mom and Dad let me stay up and watch when I was sick—and since there was no chance I was going to school tomorrow, why not let me see if Johnny Carson had Stiller and Meara? Or Joan Rivers?

Children's Hospital was only a few blocks from the Cincinnati Zoo. When the wind was right, I could hear the elephants and lions singing to the ambulances in a call-and-response to the sirens' delirious howls. I knew how it felt to be caged. I could still remember my earliest hospital beds: metal cribs raised several feet off the floor, with bars that locked in place so I wouldn't fall out, or go anywhere at all, given that a hospital floor is as dangerous as the surface of Mars. The staff at-

tempted to contain our intrepid toddler spirit, but inevitably some tiny explorer would climb up and over the bars, trailing IVs like parachute cords.

I had long ago graduated to beds with low, locking rails, beds that offered a small modicum of freedom, but these came with a bargain: as you grew up, you were expected to control yourself. No playing with IV lines to scoot the bubbles up and down the tube. No pulling off the oxygen mask no matter how sweaty your face got, no scratching or peeking under the bandages, no examination of stitches. No pushing the NURSE CALL button just because you were lonely. Above all, Keep Your Hands Off the Equipment, even if it stuck a hundred appendages into your arms, up your nose, or down your throat. I'd have wiggled out of bed and roamed the halls if I hadn't been afraid to bring a steel tree down on my head and smash the antibiotics all over the floor.

Dawn brought the phlebotomist, a sponge bath, six pills in white paper cups, and a ravenous wait for the breakfast cart (a single-serving box of Rice Krispies, a red-and-white carton of milk, and a sour green-ish banana). I remained marooned in the ring of poles all day till some-one came to bleed me or feed me or roll me downstairs.

Five-thirty A.M. Grand Rounds. Mom walked in the door within mo-ments of Dr. Martin and crew. A resident pushed against the right side of my belly, making me yelp and gag. Mom and Dr. Martin stepped into the hall. When they came back, Dr. Martin explained, "You're hav-ing this pain because your gallbladder is full of gallstones. I'm afraid we're going to have to remove your gallbladder in the morning." He took a pad of paper out of his lab coat pocket and began to sketch a stomach, liver, kidneys, and a blobby gallbladder with little dots inside.

It was never good news when they started with the diagrams.

I squinted at my abdomen under the thin hospital blanket. I couldn't have heard right. "How did I get stones inside my body? Were they hid-den in my food?"

The resident said, "In a sense. Actually, you're quite young to be needing this procedure. It's mostly an adult disease." He looked to Mar-

tin, who nodded his blessing. "But you're right, gallstones *can* be caused by food. Mrs. Lehrer, do you use a lot of fat in your family's diet?"

"Ah—I'm not sure. What kind do you mean?"

"Cheese?" Yes.

"Butter?" Yes.

"Mayonnaise?" Yes, but homemade, is that better?

By the time they got to "schmaltz," the resident looked ready to report her for child abuse. Poor Mom. I've since found out that my gallbladder dysfunction was probably an aspect of spina bifida organ syndrome, and likely had nothing to do with my diet. I wish I could tell her now that I don't regret a single crunchy mouthful of gribenes.

The doctors told me not to worry, gallstones weren't life-threatening.* I stayed relatively calm until the next morning, when the anesthesiologist came by for pre-op questions. His cotton cap and apron gave off That Smell. He said, "Hey, hey there," but I cowered against the railings, more afraid of the black rubber mask than of the actual surgery.

The nurse gave me a shot to "relax" me and said they'd be coming for me soon. She may as well have shot me up with Dexedrine. My eyes stayed so wide that my peripheral vision extended to the back of my head.

And then my gurney was passing under the hallway lights. My gurney was turning onto the elevator. My gurney was being wheeled into the waiting area, where the nurse started an IV; my gurney was being wheeled into the operating room. The doors whanged shut like the swinging doors of a restaurant kitchen. Operating rooms, bright and clean and full of things for cutting meat. The whitest white that humans can produce. Cold as an industrial fridge.

T h e m a a s s k k . . .

Wake up wake up wake up wake up vomit vomit vomit vomit vomit vomit *vomit.*

* Not necessarily true in my case. Removing my gallbladder could have endangered my earlier abdominal surgeries, and destabilized the constructed systems that kept me alive.

. . .

A day gone. The nurse changed my dressing. My newest incision traced the inner curve of my rib cage in thirty pairs of spiky black stitches. Furious ants crawling out of my skin. My fingers hovered and ran away.

Gallbladder surgery had nothing to do with the way I looked or the way I moved. I'd just had a broken part. Fix it or die. All better now. All over.

Still, I curled myself around Mumps and drooled on her fur while I fell back to sleep.

The Cabin in the Woods

That spring, I came home from school and saw an ambulance in the driveway. I assumed it was for Mom—again—until I saw Dad on the stretcher. My forty-five-year-old father had had a massive heart attack. His cardiologist blamed Dad's four-pack-a-day habit and warned him that he had to go cold turkey or he wouldn't live another six months. Nicotine withdrawal turned our gentle father into a bastard of jealousy. Each time Mom visited him in the hospital, he accused her of so many trysts that had they been real, she couldn't have grabbed a sandwich between assignations.

Nothing in our home was stable. Mom was too overwhelmed to notice that I began closing my bedroom door. I was learning that I liked to be alone.

When I was little, I had shared my room with Doug, until one day in second grade when I came home and ran to our room to change into my play clothes. I reached the door of our bedroom and stopped cold. Grandma and Dorie were folding Doug's clothing into laundry baskets. His bed was missing—no, *both* of our beds were missing. In their place was a high bed with a white headboard. A few bits of furniture were scattered about, like flotsam after a storm.

Grandma's head came up. "Oh, good, you're home. Where do you want your desk? By the closet, or under the window?"

"What . . . where . . ."

"What are you so upset about? We told you that the boys were moving upstairs. Here, let me show you how to work the trundle bed."

I didn't want a trundle bed, whatever that was. I wanted my brother. I'd scrupulously blocked my ears when our parents had discussed plans to renovate the attic as the boys' new bedroom. Two years before, when I was six, my little brother Mark had been born. He was walking now, and way too big for the crib in the den. It seemed as if Mark and Doug were now a set; so much for my twin-brother illusion.

How I came to envy their bedroom. The attic gave it a high, peaked ceiling, like a treehouse or a castle; the drapes and quilts were printed with cowboys and astronauts that beckoned the boys toward freedom and adventure. I snuck upstairs to admire their Tonka trucks and brightly enameled Matchbox cars (I really wanted that shiny black Batmobile). We all had Tinkertoys, but those were for girls or boys. Erector Sets were Boys Only. (Because, you know, erections.)

And their privacy! The attic was at the top of a narrow staircase, while my room lay a whole five feet from my parents' door. My brothers could have raised Shetland ponies or gotten certificates in bowling-ball repair without catching our mother's attention, while the faintest snick of my doorknob summoned Mom to my threshold. I was not allowed to close my door. After all, what if I got sick? Came down with polio, cholera, hydrocephalus, fell down, got trapped in my closet and died of septic fever, just because she didn't know I was in trouble? Was I willing to take that chance? How could I force *her* to take that chance? I wasn't even allowed to take a bath by myself until I turned twelve.

Once Doug and I were split apart, Mom and Grandma gave my room a full-on gender makeover. It was astonishing just how much Princess they managed to cram into a twelve-by-twelve-foot space: pink-and-gold French Provincial furniture with flowered enamel drawer pulls, shell-pink walls, rose-patterned sheets, pink chenille comforter, pink window treatments (pale sheers, fringed flowered sateen curtains), and a blushing Princess telephone. Flesh pink, skin pink, lip pink, palm

pink, vagina pink, eyelid pink. A round salmon-and-black braided rug sat like Estrogen Target Zero in the middle of the floor.

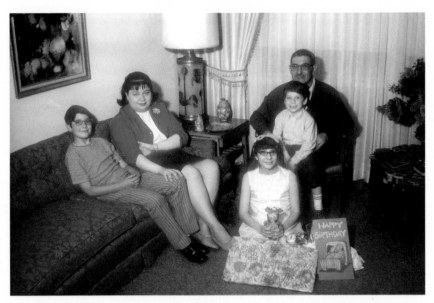

My twelfth birthday, at Grandma's house. Yarn hair was big that year.

And at first, the pink wasn't so bad. I was desperate for proof that I was a girl. My female cousins were being asked about boys and crushes, and whether they wanted to be mommies one day. No one asked me. Sometimes, my bedroom felt like a joke being played behind my back.

Still, I grieved the loss of my bedroom every time the hospital claimed my body. All the art supplies I left behind, the sketchbooks full of paper-doll costumes, the cardboard girls I cut out with Mom's nail scissors, the closet full of clothes that didn't tie up the back or come stained with other children's blood and vomit.

But when I turned twelve something inside me snapped. I marched to the hardware store and came back with a quart of screaming chrome-yellow enamel. I painted the bedroom furniture and replaced the flow-ered drawer pulls with stark black iron, then tacked up a poster of a hirsute James Taylor, the most annoying rock star I could imagine (sigh).

Nonetheless it was my shout of the great *I AM.*

. . .

When I absolutely had to flee the house, there was another refuge right in our backyard. We kids called it the Bushes Cave. The Cave was formed by a wide thicket of forsythia bushes that ran between our house and our neighbors' (the gloriously named Spinnenwebbers). Vegetation grew together to create a hollow, a green room drenched in flickering light, the upper branches of a pine tree its filigreed ceiling. We'd enter by pulling back a segment of the bushes. The thicket was so dense that it hid anyone inside. My brothers and all our friends played in there—but I was the one whose books were found moldering under the leaves when autumn came.

That backyard became the reason that my family left Laconia Avenue.

I had just turned twelve and was scheduled for another summer surgery, so Dad decided to take us on our very first family (yes, first) vacation. This consisted of three rainy days at a Howard Johnson hotel in Dayton, Ohio, a whole forty-five minutes away. The HoJo had a pool with a wave machine, but a downpour started the minute we checked in. The boys and I ran out to the pool anyway, which was when the aquamarine ring I'd gotten for my birthday fell off and was lost amid the sloshing waves.

We pulled into our driveway at dinnertime Sunday night, cross and disappointed. Mr. Vaughn came hurrying out to the car. Our neighbor always sounded like a hospital chaplain; this time, he was preternaturally calm. "Now, folks, there's been a mishap, but don't you worry, the house is fine. Jerry, why don't I show you what happened."

Like we'd wait in the car. Right. We all went running, and there was the disaster: the backyard had burned down. Our shrubs and trees and flowers were nothing but charcoal scrawls. The oak tree had scorch marks halfway up the trunk. The swing set that Dad and our uncles built had blistered and melted. The Bushes Cave was just gone. The yard stank of something harsh and chemical. Mr. Vaughn thought that someone had poured kerosene over our entire yard—*only* our yard, as it turned out—and lit a match. We never found out who, or why.

The grown-ups had been talking for a year about how "the neighborhood was changing." They meant that Bond Hill used to be mostly Jewish, and now was mostly Black. Our grandparents were upset by the "race riots" that had been happening on and off all around downtown Cincinnati, but they rarely mentioned the reason: the police had been beating and arresting Black people without cause. Horwitz Drugs had not been touched but nearby businesses were damaged.

Grandma clipped newspaper articles about the riots and left them on our dining room table. When we went over for dinner, our uncles and aunts freaked one another out with the latest headlines. Some of our relatives had already moved to a "better" neighborhood. The whole thing drove my aunt Ruth Stregevsky utterly bonkers. Her family lived on Laconia, one block away from us, and she proclaimed that she was never going to move (in fact, she never did). My brothers and I couldn't understand why Bond Hill was suddenly scary. Another one of those adult mysteries.

But then the Kabakoffs sold their large house right across the street and eight or ten African American adults moved in. A rumor started: the Kabakoff house was Black Panther headquarters. Aunt Ruth responded with a barrage of sarcastic Yiddish.

The backyard fire cracked us open to fear. The adults whispered and huddled, and all of a sudden we were moving from our pretty red-brick house to an ugly duplex in Roselawn, a Jewish neighborhood three miles away, where black-garbed Hasidim waited to tell us that we weren't very good Jews at all.

It was only a few weeks after the fire when we pulled away from Laconia Avenue for the very last time. I wished I'd taken one of the diamond doorknobs and mounted it on a ring. I wished I had pried the stained-glass panel from our front door window. Anything to bring the colorful light of Bond Hill to our exile in Roselawn.

And yet, I rarely thought about the fact that my beloved Laconia Avenue house had played a part in the devastation of our family. My mother's care of our house had caused what had happened, when what happened, happened.

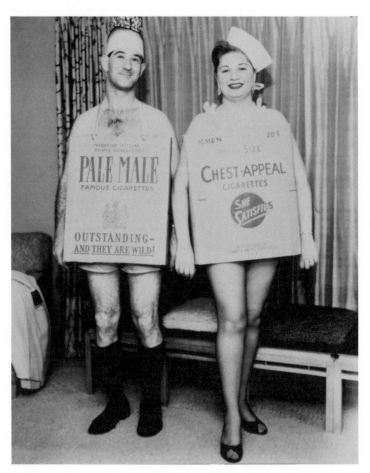

Halloween, early 1960s. Carole made the costumes out of cigarette cartons from Horwitz Drugs.

Carole's Story: The Winter Walk

What happened happened in the winter of 1962, when we were still new to Laconia Avenue.

I was four years old. And what happened was snow.

Snow was falling on the walkway to our house. At first it made lacy patterns, and then it made a problem.

Jerry was at the office. Carole stood on the porch and watched the snow. Each icy pellet hit the ground with a tiny tick. She waited for her husband to come home for lunch and clear the walk before it got too deep. She thought about asking the next-door neighbor to shovel the walk again, but that month alone Mr. Vaughn had plunged out the bathroom sink, fixed the hallway light switch, and killed a mouse that was eating through Jerry's tax records in the basement.

It was only a couple hours before dinner and the snow was coming down with purpose. Dorie was watching the kids, so never mind the fact that this was supposed to be Husband Territory. Carole got out her wool coat, her galoshes, and her lined black leather gloves. She smiled at those gloves; her large, square palms dictated that she wear a men's size small.

Carole went down to the basement for the shovel and carried it back upstairs, through the living room, and out the front door like the torch-

bearer in a domestic Olympics. She'd cleared all the way to the edge of the yard when a dense load of snow tilted in the shovel. She twisted and fell and something shifted deep inside her spine. An icicle of pain pinned her to the ground.

It was the fallow time, after the postman and the milkman but before the return of school buses and husbands. There was no one outside at all as the day darkened and shadows took on a violet hue. Carole thought that surely, any minute now, Dorie or one of the kids would look out the front window to see where she had gone. In time, Dorie did look outside, and saw Carole's stockinged legs splayed beneath a winter overcoat of snow.

An ambulance came and Carole was peeled off the frozen concrete, strapped to a stretcher, and whisked off to the ER at Jewish Hospital. It was 1962, a time when X-ray films didn't reveal much information regarding spinal damage, so doctors dealt with back injuries via full surgical assault. In the ER, Carole was told how lucky she was that Dr. James Litvak was willing to take her on. Litvak was medical royalty. Carole was twenty-eight years old.

In the OR, the surgical residents prepared her for Litvak. They pushed the ether mask over her face, then nurses turned her on her stomach and draped her back in sterile green cotton. A square was left open in the middle. Curtains parted for the theater of blood.

Dr. Litvak picked up a scalpel and sliced through the pristine skin of her back. He peeled back the fascia around the erector muscles, divided the bat-wing latissimus dorsi, and moved delicately around the cream-colored strings of the nerves. Four layers down, he bared the lumbar vertebrae where the L4 disc was leaking synovial fluid like a split tomato.

Orthopedic surgery is a brutally physical business. It took an electric saw to cut through the bony prongs guarding the disc, and pliers to pry the disc out of its place in line. Her back was an exploding flower, each petal held down by the teeth of a retractor.

If this had been a good operation, Carole would have woken up a

few hours later, nauseous and miserable but beginning to be well. She would have had a few weeks of using a walker to maneuver around the living room, of being unable to pick up her children for hugs, and of making Jerry pick up the groceries. In another year, there would have been nothing but a thick scar and a bit of stiffness in winter to remind her of the day she fell.

But at the end of this operation, Dr. Litvak reversed out of her body like a man driving down a dark road backwards. A man who cared not for mirrors. He didn't see what he'd left behind.

Litvak became increasingly nasty during Grand Rounds. "Mrs. Lehrer. Mrs. Lehrer, wake up," he snapped. "Are you awake? Good. The nurses tell me that you've been refusing to get up and do your exercises. Your pain isn't going to get any better until you start moving around."

"Hurts. Can't. Stand up."

"Well, we cannot give you any more medication. You're already getting the maximum dose. Mrs. *Lehrer.*" Litvak was practically yelling in her face. "You do want to go home, don't you?" he said, as if he was holding her house hostage behind his back.

Her brother Barry was midway through his medical school residency at an adjacent hospital and tried to stop by every day. Barry flirted with the nurses so they'd let him see Carole's chart. (At six foot four, with thick sandy hair and big blue eyes, he didn't have to flirt all that hard.) He read, "Patient not improving due to continuous immobility." "Patient noncooperative."

The next morning, Barry turned up in time for Litvak's rounds. He was hesitant to loom over an attending physician, but what the hell, he'd chosen the placid waters of dermatology, far from the reach of the scalpel gods. He planted himself in front of Carole's surgeon and spoke in the slow, you're-rather-stupid voice he used when pissed. "I know my sister. She isn't lying and she isn't an idiot. If she says she's in too much pain to get up, then you had better figure it out."

Litvak, though, was comfortable sending her home. He seemed to consider Mrs. Lehrer one of those problem patients who made his practice an occasional misery. The kind who needed to heal on their own time. But before the discharge papers could be signed, Mrs. Malingerer

had developed a dangerously high fever. Litvak was forced to take her back to the operating room.

They opened her up and found a thousand bloody shreds of gauze. Litvak had closed the incision without removing all the surgical sponges. (These are not like dish sponges; surgical sponges are pieces of cotton gauze used to mop up blood during a procedure.) Counting sponges is a basic step of any operation. Foreign objects trigger infections that can cause permanent damage. That damage was now taking place in Carole's spine. Litvak spent hours picking cotton fibers out of deteriorated tissue, but the ravage could not be stopped.

Many weeks later, our mother came home. Dad and Grandma got out of the front seat and guided her out of the back of the car in a broken-glass, stop-motion ballet.

Before the hospital, my mother used to spend every morning arranging her long dark hair into a ponytail. I'd stand by the edge of the sink and watch her swirl the tail under her brush before corralling it with a twist of ribbon. But after she came home, she looked down at me and got out the barber shears; she amputated that limb of hair and tied it off with a rubber band. "Here," she said, "you keep this now."

These days, her braid sits hidden in a round glass case in my living room. The last remnant of my mother's body. A secret reliquary that no one knows is there.

The Abominable Dr. Phibes

I

Roselawn was a Hasidic enclave where newly arrived black-hat Lubavitchers had built the first Chabad House of Cincinnati. Rebbetzins came to our door with little kits containing Shabbos candles and a card printed with prayers; they wouldn't go away until I'd proved I could bentch licht (they never tried this on my mother).

It was fall of 1970. We hadn't been on Glenorchard Drive for very long. Our family was renting a brick duplex with all the pizzazz of a dumpster full of rocks. We lived in the front half; the back was rented to thirteen Chabad House yeshiva buchers, aged from mid-teens to early twenties. The sonorous drone of their Shacharit morning minyan vibrated through my bedroom walls.

October, 1970

I yanked my bookbag onto one shoulder and made sure I hadn't dropped my sweater on the floor of the school bus. For once I forgot to snarl at Box House for not being my beloved Laconia Avenue home. I was in a good mood. We'd learned to build terra-cotta sculptures in art class; I'd made a yowling cat and coated it with a honey-colored glaze

flecked with tiny morsels of copper. Mine had been among the few that survived its trip into the kiln.

Mom was sitting at the dining room table, pasting Green Stamps into one of our bazillion coupon books. (Our toaster, blender, and electric knife were all converted from Green Stamps. That tells you something about our grocery bills.) She looked happy, too. "Hey, great news! I just got off the phone. We have an appointment with that new orthopedic surgeon."

Well, that drained the helium right out of my high. I dropped into a chair and started pasting stamps too, glad for the soothing repetition of filling page after page.

"Mom, you mean a surgeon for you? Do I get to go to one of *your* appointments?" This was a first; the thought was both scary and like an important rite of passage. "But I don't remember anything about this."

"No, no, he's a pediatric specialist. I must have told you—Dr. Street? Still no? Well, you'll meet him next Wednesday. I hear great things about his ability to help children who limp as badly as you do."

This was nuts. It had been barely a year since they'd yanked out my gallbladder, and here she was, lining up another trip to the OR. I argued, "But really, I don't mind my limp. Everybody else makes it such a big deal." I often forgot I limped until I saw my shadow bouncing on the sidewalk. Or until some ever-helpful passerby pointed out that there was something wrong with me.

"You might not mind your limp, but it's not good for your back. And you complain more than you think."

The next Wednesday, Grandma and Mom picked me up after school. I stared out the window and practiced my *no*s in my head. *No, no, no, no, no . . .*

Grandma said to call the drugstore when we were done. In the exam room I shed my school clothes for the usual overwashed tie-back gown, even though meeting a doctor without my clothes on made me feel defenseless as a boiled egg. Mom always said, "Get over it, doctors are too busy to wait."

The door opened. "Riva, Mrs. Lehrer, it's a pleasure to meet you

both." Dr. Street shook our hands. He had passionate eyebrows, sharply cut hair, and the coiled posture of a distance runner.

He said, "Your mother says you don't like wearing those heavy shoes, Miss Riva. I don't blame you. A pretty girl like you should have pretty shoes. I could help you wear any shoes you want! High heels! Flip-flops! Tennis shoes!"

Despite myself, I felt a flutter of excitement. Ever since I was little, I'd gotten my orthopedic shoes at Ludwig's Shoe Shop, where they put a thick prescription lift on the left sole. Only certain shoes were brawny enough to take the weight, so year after year, I got identical black-and-white saddle shoes. I'd moon over the patent leather Mary Janes, the Red Ball Jets, the sandals with teensy straps, even as Mom marched me straight to the clodhoppers at the rear of the store.

I narrowed my eyes and said, "Go-go boots?" All innocent, knowing it was a ridiculous test.

Dr. Street laughed with delight. "GO-GO BOOTS!" he roared. He said that young bones could be pruned and shaped like bonsai trees, but that they fused into permanent shapes as soon as you stopped growing. Then he frowned. I only had a few months left before I'd be twisted for life: left hip too high, right leg too long.

"But if you have this surgery, you'll grow up straighter and taller. All we have to do is cut a little piece of bone out of your right knee."

And here came the diagrams. Cripes.

His reflex hammer drew an arc above my patella. My skin goose-bumped under the cotton exam gown. "The epiphyseal plate is like a clock that tells your leg when to stop growing. We'll tell it to stop growing *now,* and your left leg will catch up, and hey presto, no more terrible shoes! Not only that, your spine won't curve anymore. You'll look just like other girls!"

I saw myself running down the hill behind our house wearing high-top sneakers and jeans just like Doug's. Only my jeans would have fringe . . . and rhinestone studs, and really big bells . . . and what about those silver shoes at Ludwig's, with the perforated toes? How cool would they look with my pink sparkle dress—

I blinked. Mom was glowing like a convert to a new religion.

On the way home, Grandma and Mom talked plans. I was heading for another summer in the hospital. I hardly listened. By eighth grade, I'd be so normal I wouldn't need Condon. A thought that brought every possible emotion in its wake.

That night, I lay down and wiggled my hips till my legs were the same length. I gazed at them kindly, my new old new appendages.

As soon as school let out for the summer, I went in for the operation. I woke encased in a plaster cast from the V of my pelvis to the top of my right foot. Dr. Street had removed a cross-section of my femur. I hadn't quite grasped that my leg was going to be completely cut in two.

The cast was a tree trunk lashed to my body. I struggled not to wreck the cast when I used the bedpan. All I needed were streaks of pee and poo running down its glaring white length. Showering was impossible. I was heading for a summer of sponge baths, sweat, and filth.

Dr. Street entered the room later that afternoon. "I'm happy to say that everything went well. Now, I don't want you putting any pressure on your leg, so you'll have to stay here for at least three weeks," he said. I nodded obediently; I'd take all the help I could get. "You'll be in the cast for a total of nine weeks." He winked. "But it'll be worth it—I promise."

My mother smiled. "Thank you, thank you, Doctor."

I stared down the thick column of my leg. My poor red foot poked up, stranded a mile away.

Mom went home for the night. I was alone with my silent roommate. Janie was my age—thirteen—but had the air of a girl who was comfortable with high school seniors. She was all vertical lines; maybe five-six, long, straight blond hair, oddly hairy forearms, and no body fat whatsoever: this Janie weighed less than eighty pounds. I'd discover hanks of her flaxen hair all over the bathroom floor.

Her silence ended as soon as the orderly brought our dinner trays. The minute we were alone, she knelt on my mattress and bellowed, *"How can you eat that?"* directly into my face.

I recoiled. "Why not? They brought mashed potatoes. I don't want them to get cold. Cold gravy is unspeakable." I reached for my fork but she grabbed my wrist. Thin as she was, the sinews of her arm could've held up the Brooklyn Bridge.

"You are *so* stupid! Don't you know what happens if you get fat? Well, you're already fat, so maybe you don't care." Already fat? My stomach went into free fall. No one had ever said that to me before, but I was certainly a whole lot plumper than my roomie. *Fat.* I could hear Grandma's voice as she screamed at Mom. *Pig. You should be ashamed to leave the house.*

Janie leaned so close her lips brushed my hair. "Getting fat makes you *pregnant.* Do you want a baby, you disgusting moron?" And then she swooped my tray off my bed and scraped all the food out the window. Meatloaf, peas, clumps of mashed potato, and Jell-O fell like glutinous raindrops, rapidly followed by Janie's meal as well. Then she went off to retch behind the closed bathroom door.

Janie was supposed to be eating her food on an honor system, so at first our meals were unsupervised, but as the days passed, the staff noticed the blobs of food on the sidewalk and caught on that Janie's "clean plates" didn't involve eating. Nurses sat with her during meals, trying to shove a spoon between her clenched teeth, then stayed for an hour afterwards to ensure that whatever food she had eaten stayed down. "Don't make us do forced feedings. We can put a tube down your nose, but believe me, you'd hate that even more." After the nurse left, Janie tried to vomit but ended up weeping.

Everything Janie wore was enormous, because Janie believed *she* was enormous. She wandered the halls clad in her father's XXL wool sweaters, Daddy's massive gold watch hanging off her wrist. Its accordion band was far too loose to stay on her arm, so she held her left elbow bent upward all the time, as if trying to hail a taxi out of hell.

She resorted to using her teeth, nails, and extensive vocabulary of profanity to hold the staff at bay. They threatened to put her in restraints. Her father visited a few days later. He never sat down but tilted backwards against the windowsill, as if his daughter was a high wind about to blow him into space. By contrast, Janie became another girl

entirely, someone droopy and compliant as a willow tree. She wrapped herself around his cable-knit arm and whispered, "Daddy, I *promise* I'll eat. Please, I want to go home." A day came when Janie got moved to some other ward. Better? Worse? All I knew was that she was another hospital roommate I never saw again.

My next roommate was trundled into my room locked in a circular cage. Gloria had had something called a Harrington operation. The surgeons opened her back from her neck to her pelvis, broke her vertebrae apart, and screwed them to a metal rod. She was then encased in a full-body cast and strapped to an open bed frame that was rotated every few hours. Half the time, her face pointed toward the floor, her long red hair brushing the linoleum.

Despite her ordeal, it seemed that Gloria's doctor did not believe in pain medication. Gloria shrieked the entire two weeks we shared our room. Without stopping. At. All. Girl as ambulance, sirens blaring, night and day and night and day. I hid my head under my pillows whenever she faced downward. I didn't want her to see me cowering.

There are no secrets in a hospital room. I heard her doctors and her parents arguing behind the drawn curtains.

SOPRANO VOICE: You're sure that thing is necessary? It looks dreadful. Why can't she sleep in a bed?

TENOR VOICE: We explained, ma'am. She has incisions on both the front and back of her body. It's best to keep her turning as often as possible. A Circle Bed keeps the pressure off her spine while she's immobilized.

BARITONE VOICE: But it looks so . . . medieval.

TENOR VOICE: We had to correct her scoliosis while she's still young enough to heal. A Harrington rod implantation is tough stuff, but believe me, any curvature that bad was going to be more problematic in the long run.

This was the most gruesome thing I'd ever heard. Gloria's doctors had broken her apart so she could be reset in an acceptable S-curve line,

instead of whatever curve she'd come in with. My worst nightmare lay on the other side of this thin cotton wall. Gloria had severe scoliosis. *I* had severe scoliosis. Did a Harrington rod wait in my future? I felt as if Gloria's wails were coming from my own throat.

When Dr. Street showed up, I expected him to say it was my turn now. To my great relief, he only wrote an order for crutches.

Three weeks were up. I was released, though I faced six more weeks in plaster. Summer heat made the cast into a gulag for one. I focused on my future of spectacular shoes, of dance parties and Saturday night popularity. It was all that kept me sane as I felt uglier and uglier. Showerless days of slimy hair and body odor made me long to throw myself, plaster and all, into the Jewish Community Center swimming pool.

I was determined to have some kind of vacation experience, so each morning I set myself up in the front yard with two folding chairs: one for my butt, one for my leg. I wore cutoff shorts, a halter top, and a look of abject misery. Passersby asked if I'd been in a skiing accident. In July, har-har-har.

I'd hear the Yiddish chatter of the buchers on their way to Chabad House as they filed past me on the short walkway to the street. I'd never exchanged a single word with any of them, but I was bored and feeling sorry for myself, so I called out a timid hello. None of the thirteen so much as acknowledged my existence. I didn't know that Orthodox men were forbidden to look at unmarried women, especially one showing a lot of (even unwashed) flesh. I thought, What assholes. Did they think I couldn't hear them at night? Lifting weights and taking showers for hour after hour? Did none of them ever picture me on the other side of the wall?

The cast made it impossible to move without crutches, so my parents rented a folding wheelchair with caster wheels. Had they rented the kind with large spoked wheels, I would have been able to move independently, but such was not the Lehrer Way. One hot afternoon, the

family decided to go to the Art Deco–style Krohn Conservatory in Eden Park. Dad dropped me off in front of the huge glass greenhouse while everyone else went with him to park the car.

That summer, Cincinnati was in the middle of a seventeen-year cicada invasion. I was sitting in my transport chair when I heard a faint *thip*. Something hideous landed on my plaster leg. I tried to dislodge the little monster, but there came another *thip* and *thip* and *thipthip-thipthipthipthipthipthipthipthip*. I was trapped in the wheelchair as dozens of thrumming bugs landed on my cast, my arms, my head, and crawled down my T-shirt. Their compatriots sang *scree scree scree* from the treetops. I could not escape, since I could not reach my wheels. By the time my family returned, I was covered in creatures and screaming like Linda Blair. It was the final scene in my summer of self-loathing.

After nine weeks, Dr. Street was ready to cut off the cast. My leg emerged with a thick black pelt of hair as if part of me had reverted to an earlier order of primates. What mattered was that Dr. Street gave me his blessing to buy all the footwear in the world. *You're cured,* he said. *Go forth.*

I begged begged *begged* to go straight to Ludwig's and celebrate my transformation. I maneuvered my crutches around the display tables and never even glanced at the back of the store. Mom said, "So what'll it be? Nothing too drastic till you get your sea legs back, okay?"

Oh, I knew. Had known for weeks. We left with a pair of strappy sandals *and* a pair of Red Ball Jets. I slept with them next to me on the pillow, dreaming the best dreams I'd had in years.

II

The hospital demands surrender. You accept the piercing, the cutting, the swallowing of noxious chemicals. You roll over and stand up even when it's as impossible as flying around the ceiling. Whoever has authority can remove your clothes and display your stitched-up monster body to crowds of young white-coated men. You're an assemblage of parts that lack gender and those elusive things called *feelings*. I remem-

ber being photographed in the hospital; somewhere there exists a medical textbook that holds a picture of my small, scarred, and naked body, writhing under the black bar pasted across my eyes.

Passivity unto death is the price of staying alive. I try not to scream very often. Only one thing transforms me into a shrieking, flailing wild animal:

The Black Rubber Mask.

I am wheeled into the OR still fully and frantically conscious. The anesthesiologist uses an ether-type gas to put children to sleep; halothane is the choice for pediatric patients. Wikipedia says it has "a pleasant odor." This is a grotesque lie. Its rotted-flower smell means "people are about to cut you apart."

The surgical team positions my gurney under the lights. Three nurses and an orderly hold me down. Doesn't matter that I've gone through this time and time again, I fight fight fight. The mask pinches the bridge of my nose, squashes my cheeks, and cuts into the base of my chin. They press me to the gurney as the detestable sweetness seeps down my throat, and I'm yanked under, a swimmer in a shark-filled sea, my body eaten into nothingness. Ether collapses time like a clapped hand.

In the elastic second before darkness, the gas whispers, *Waking up is never guaranteed.*

I have a recurring nightmare:

I'm dodging around the corners of an empty city street. Everything is muffled in thick white fog. I'm shivering inside a loose Jerry the Mouse costume, being pursued by a baggy Tom the Cat. If he catches me, I will die. The fog is heavy with a syrupy metallic smell that I can't identify for years, until the day I go into a Black Angus butcher shop with my mother and pass out in front of the ground chuck. The smell is fresh blood. I understand; that dream is about what happens to me in the OR as soon as the cutting begins.

Ether haunts my lungs for weeks. Each exhalation a ghost in my

mouth. I hallucinate, I clutch the sheets and howl, I fall upward off the bed into a staircase that bursts through an opening in the ceiling. There is a dissected, violated body called mine that others have seen, and that I never will.

III

My life in scars:

Lumbar spine, seven inches, opened three times, painful to the touch

Linea alba, center line of my abdomen, ten inches, thick as rope

Twenty, thirty—forty?—puckered punctures scattered from clavicle to pubis

Two scars, four inches each, medial and lateral sides of my right knee

Horizontal scar above my pubic symphysis, a white track through the curls, five inches, opened three times

Short, wrinkled, curving scar, left hip, iliac crest, pinkish potholes where the pins came out

One long line like peach embroidery floss that hugs the inside arc of my ribs

Five round scars, like vampire bites, on my neck and breasts

Nine faint one-inch scars on my wrists, arms, ankles, and under my hair

One diagonal keloided slash on my right thigh

One line on my chin from falling on my face when I got hit by a bike—

I change, and change again, with no end in sight. I've never had a final form. I've been protean since the day I was born.

CHAPTER 17

Attack of the Killer Tomatoes

Any thoughts of leaving Condon after the epiphysiodesis were wiped away when Mom reminded me that it would take a few years for my left leg to grow enough to catch up with my right, and until that happened, I would still limp. "And, *ahem,* but what regular school would accommodate your absences, your many doctors' appointments, your frequent bathroom breaks—"

Okay, okay.

And so it was decreed that I was to finish out my scheduled nine years at Condon. I felt equal parts impatience and shame-faced relief. It's not like I'd had clear-cut notions about the next stage of my life. We kids talked among ourselves about what we wanted to be when we grew up, but you'd think we'd chosen to be astronauts and rodeo clowns for all the career guidance we got from our teachers. To a (wo)man, they were resolutely mute on the question of life after Condon.

In the 1970s, high schools were under no legal obligation to let us in. For many of us, eighth grade would be as far we would go.* No one was encouraged to dream of possibilities or given a single role model. No Helen Keller or Stevie Wonder or even FDR—no one even mentioned that we'd had a president who'd used a wheelchair! As far as we

* When I graduated eighth grade in 1972, Condon extended senior-year classes for a handful of students.

In the Yellow Woods
ND

knew, no disabled person had ever gotten a job, gotten married, or had children.

This made the purpose of school a little murky. What *were* we supposed to know by the time we graduated? And where would we live? With our parents? In a group home? Or even (unlikely) alone?

I suppose that the faculty expressed their tacit hopes for us through the simple fact of our education, but still I wonder, did they see themselves as radical activists creating a new world? Charity workers who believed in a cause for the cause's sake alone? Or did they labor beneath a flaming sign saying MAYBE in letters twenty feet high? They gave us basic tools, and then I guess they crossed their fingers.

Condon School's experimental optimism contained a pedagogical

confusion at its core. This ambivalence was revealed in courses like Home Economics, where the question lay in what we were taught, and for whom.

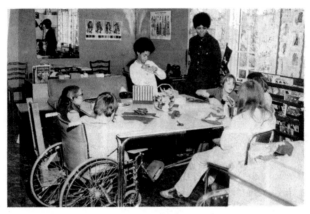

HOME ECONOMICS CLASS

Girls' Home Economics class, with Mrs. Copeland.
Circa the mid 1960s.

The Home Economics room had a full double kitchen at one end and a bank of battered Singers at the other. Mrs. Copeland taught us how to do dishes from wheelchair height; how to use a broom while juggling a pair of crutches; how to open and heat cans of Campbell's soup, our recipes building in complexity toward the one-dish meal topped with inevitable Durkee's onion rings, the Midwest's answer to puff pastry. Julie, whose mother was a terrible cook, was thrilled.

Our teacher, Mrs. Copeland, had the patience of a bomb defuser as she helped us work our way up from sewing on buttons to valiant attempts at following the battered McCall's patterns she kept crammed in her file cabinets. We were never taught how to adjust the patterns to our particular bodies; it was just pick a size, sew it up, and pray that it'd fit you in the end. I'd inherited none of my mother's talent. Poor Mom. She'd labor to unclench her jaw as she said, "You put the armhole facing in backwards. Again. Sweet. Heart." How it must have pained her to

"help me" finish my eighth-grade project, a drawstring polyester-jersey sundress in an eye-searing Op Art print.

Girls began Home Ec in fifth grade; there were separate Home Ec classes for boys in seventh and eighth. My friend Philip Moore told me that if you didn't sign up for Home Ec, you were sent to the boys' shop class at Walnut Hills High School, where the man's man of a shop teacher hated any boy who was insufficiently macho. Of course, Condon boys were automatic sissies. Philip was content to spend his days wrecking trouser seams instead.

I knew that girls at other schools were taught "domestic science" in order to become wives and mothers (and that "normal" boys never took Home Ec at all). At Condon, we learned to feed ourselves, and only ourselves alone.

One day in seventh grade, we came to class and found Mrs. Copeland uncharacteristically excited. She clapped her hands and gestured toward the kitchens. "Girls! Go to the freezers! I have a surprise for you. We're going to make Baked Alaska!"

Well, that sounded . . . ick.

No, no, Mrs. Copeland explained, Baked Alaska was a *very* elegant dessert served in the best restaurants in the world. Invented at Delmonico's in New York, where *famous people* ate. We'd be ready to host our own elegant soirées once we'd mastered this feat. She didn't mention that Baked Alaska had last been fashionable a decade before we were born.

I was stupefied. Did she imagine us having parties? For fancy people? With a dinner menu comprised of Campbell's tomato soup and tuna-noodle surprise?

She had already browned a row of piecrusts and laid them on the counter. We unloaded gallons of vanilla, chocolate, and strawberry ice cream and packed the prebaked shells with a chilly strata of brown, white, and pink. The pies went back into the freezer until the next day's class, when Mrs. Copeland told us to turn up our ovens all the way to

500 degrees. "I know, I told you to never, *ever* do that, but we're making an exception. *Promise* me that you'll be very, *very* careful."

Gosh. This was high-wire stuff indeed.

It took us forever (and five cartons of eggs) to whip the egg whites into meringue, but the pies did look quite Alaskan under their stiff glacial peaks. Once the ovens had furnaced up, Mrs. Copeland said, "Remember, set our timers to *only two minutes.* All we want is for those peaks to brown! Any more, and you'll have a mess on your hands."

We slid the pies onto the rack—and promptly freaked out. No one believed that ice cream could be impervious to heat. There were two ovens and ten girls (eight in wheelchairs), so there wasn't enough room for everybody to watch through the oven windows. We stampeded one another out of the way, anxious to rescue our pies before they turned into sweet milk soup, which led to much frenzied snatching at pie tins, until a couple of Alaskas hit the floor, leaving tricolor skids across the linoleum.

Mrs. Copeland had never asked us to handle anything trickier than stirring cream of mushroom soup into a pot of instant rice. Our recipes were in line with our probable destinies as people with limited expectations. But her Baked Alaska belonged in a different story altogether, one in which we wore cocktail dresses and went to Paris for the holidays. Our teacher harbored a secret vision, one in which we did not end up in nursing homes or in the back bedrooms of our parents' houses. Mrs. Copeland gave us a story of glitter and flight.

Mirror Shards: Sheri/Dragon
2011

Vampire's Kiss

As a teenage girl, I became adept at looking wounded and puzzled while saying, "What do you mean? I was downstairs reading, didn't you look?" when I'd been anywhere but. Mendacity was my best chance at liberty—such as it was. I wish I could say that I was ever found draped drunken and miniskirted over the hood of a hot rod on the Bad Side of Town (as if I could've identified the Bad Side on a map), but no. Freedom, for me, was slinking off to hang out with a friend a whole three blocks away, just outside of actual shouting distance of my mother.

Despite this, Mom knew how to ferret out my secrets.

I kept a box under my bed (and why *do* children think that's ever a good hiding place, if they're not the ones making the bed?) where I hid yearbook photos of my crushes. I had inch-sized shots of Don S., the sole other Jewish kid at Condon; Donnie A., my lifelong crush; and Desha F., my dentist's son. Not that any of them paid a molecule of attention to me.

My brothers and I were watching TV in the den when Mom came out of the back hallway bearing my box aloft like an archaeologist who'd stumbled onto Cleopatra's hieroglyphic diary. She grinned and hoisted her find. "Well, my goodness. Looks like Riva's in love—with three boys at once!" Mom flipped open the lid. The boys tore their attention away from *The Six Million Dollar Man* to produce some truly eloquent

brotherly mocking. I barricaded myself in my room for the intended rest of my life.

At least this was a change from Mom's usual lectures, in which she warned me (*honey, I just don't want you to get your hopes up*) that I'd always be alone: "I know it's not what you want to hear, but you have to face facts. Boys just aren't interested in girls like you. They're going to be scared or confused. But if you're very lucky, someday you'll meet a nice handicapped boy and the two of you can take care of each other." That sounded swell, if your idea of romance was matching engraved bedpans. Mom said she was only trying to keep me from being hurt. Like this didn't?

Back when I was ten, she had brought me into the den and said, "Sit here, next to me. I think that you're old enough to understand human reproduction, don't you?" On the table was the kind of notepad she used for everything from grocery lists to her sketches of furbelowed gowns. She picked up the pen, and before my eyes emerged anatomically accurate naked figures of a man and a woman, their genitalia precise in every detail.

Boy, could Mom draw. And boy, was this *gross*. "Mom! What are you doing? This is dis*gust*ing."

"I thought you enjoyed it when I explained medical stuff."

"This is *medical*? It's so dirty!"

She gave me a mock-stern frown. "Riva Beth Joan Lehrer, would your mother show you dirty pictures? Just bear with me. Here, these are the ovaries . . . and these are the testes. . . ." Arrows and dotted lines charted the movement of gametes on the way to zygote union. Adam and Eve faced front, stiff as boards. It was hard to imagine them making any of that sticky biology happen.

Mom kept drawing, turning the paper so I could see. She was having a fabulous time, totally in her element. "So, the man puts his penis inside the woman's vaginal canal. Then his sperm travels up . . . here, where an egg is waiting inside the uterus. That's what a woman's period is, it's the lining of the uterus getting the egg ready to meet the sperm. I mean, she sheds the lining if there's no fertilization."

My skin was on fire. Clearly, there was no escape, so hey, might as

well ask a question. "Uh, Mom. How old do you think I'll be when I start my period?"

Her face went still. She laid down the pen. "Can't really say."

"Why? How old were you?"

"My circumstances were different, sweetheart. I didn't have spina bifida. And you're so . . . fragile, I'm not sure you can have sex."

"Why can't I have sex?"

I waited. And waited. *"What?"*

"Listen, you know I usually try to tell you everything, but in this case, let's wait till you're a little older. Things might change. Right now, your doctors think it would be a very bad idea . . . uh . . . if you got pregnant."

Pregnant? I was only asking about periods. This conversation was getting out of hand.

She folded her hands across her cartoon Genesis. "Pregnancy puts a lot of weight on your spine. If you got pregnant, it might undo everything your doctors did to make sure you can walk."

"But can't they fix me?"

Silence.

"Can I have children?"

Silence.

Monster girl.

At least she taught me the basics. Condon's faculty would rather have offered ROTC training than sex education. An absurd squeamishness, considering that disabled children are matter-of-fact about bodies. Frank and precociously knowledgeable. Yet the same adults who openly discussed illness and surgery quailed at our burgeoning carnality. One minute we were nascent medical experts, the next we were Kens and Barbies whose crotches were flat, smooth expanses of nothing.

Last year, when I'd turned thirteen, and Grandma had taken me on a shopping trip for my first real brassiere, training bras having prepared my breasts for their debut. I had C cups right away, but no menses, in a lopsided onset of pubescence. I wore tight sweaters to class and ro-

tated my chest toward Mr. Liebman as if my breasts were heliotropic marigolds following the sun.

Our class had begun to hold parties at recess. Henry's locker was so crammed with Motown singles that he barely had space for school supplies. We set up the classroom's Close 'N Play record player, shut the door, and *danced*. Henry dropped the needle and "Going to a Go-Go" spun around. Linda was our dance instructor. No one else could make their wheelchair shake like a one-seat roller coaster. "Leslie, move your knees! Julie, swing your hair, stone-cold groovy, baby. Henry, show 'em your hand jive!" Linda's arms wove invisible patterns in the air; she so outstripped the rest of us in sexual maturity that we could only look on, dazzled and slaphappy with hormones.

Henry played "ABC" and "My Girl" and "Chain of Fools," twisting his body so hard that it threatened to unscrew. Larry swayed in a corner, his delicate face peaceful as prayer, rocking from one crutch to the other, while Donnie pounded his own crutches on the floor, mouth parted, bangs flopping into his eyes. Todd and Jack stage-whispered in the back of the room, retelling their stockpile of dirty jokes and making sure we heard the filthy punch lines, which I never quite got.

Despite all my crushes, at thirteen I was not ready for contact. When a boy tried to hold my hand, I broke out in an icy sweat. But dancing was safe. Dancing was almost touching, was showing off, flirting, without being expected to pair off for a makeout session in the coat closet.

Problem was, our homeroom wasn't cut out for parties. The wooden desks were too heavy to move, so we danced on the margins of the room—until one day in seventh grade when the new art teacher heard us complain. He offered the use of the art room as long as he could hang out with us.

I'll call him George Cooper—or Mr. George, as he encouraged us to say. A far different creature from the smock-wearing, artsy-craftsy woman who'd taught art classes for years, she of the polka-dot trapeze shifts and bobbly handmade earrings. Mr. George smelled of pipe

smoke and oil paint and said things like *That's heavy* and *right on* and *far out* and *Don't bogart that paintbrush,* despite being a decade too old and too late to pull it off. He'd pull down the shade on the hallway door and regale us with stories of his many successful gallery shows and with naughty tales of famous artists, though I could have done without the (mis)information that Picasso painted his canvases by dipping his penis in the paint. Julie picked up the word *raunchy* from him and thought it meant "groovy." Other teachers were alarmed when she used "raunchy" in every other sentence.

Yet Mr. George was one of the few that didn't treat us like permanent children. Like children who should never be allowed to make more children like us.

And Mr. George watched us with a half-smile that had something of the zookeeper in it.

It was late in the school year. April sun limned the easels, the cans of brushes and bottles of tempera paint. Our teacher slouched back in his chair, boots up on the table, and drawled, "You're a pretty girl. You gotta have a boyfriend by now, am I right?"

Linda paused in the act of tugging down her sweater. An inch of cleavage rose above the buttons as she tried to keep her clothes from riding up in the back. Linda had arrived at pubescence miles ahead of the rest of us, with a precocious sexuality that thrilled me with a queasy mix of joy and dread. She was the first to revel in the power of a low-cut drawstring blouse as worn by a girl in a wheelchair (in that position, one's décolletage goes all the way down to one's undies). She was also the only girl in our class who could talk about making out in a non-theoretical manner.

Linda looked at our teacher with an expression that was half suspicious, half pleased, but she answered his question. "I have a boyfriend. But not here. I mean, not at school."

"Where, then?"

"Home. Um, on my street."

"What's his name?"

She blushed, a little weirded out to be discussing this with a teacher. "Johnny. He's my brother's friend. But he says I'm his chick. We hang out in his car almost every night."

Lopsided grin. "Yeah? So, how far you gone?"

Linda's eyes took up half her face. "Well, uh . . . He likes the way I look."

George dropped his feet, and leaned all the way forward. "You ever give him a hand job?"

"Wha-wha . . . uh . . ."

This was *way* past asking if they'd ever kissed. George was grinning like mad. *Fun.* "You know. When a girl puts her hand on a guy's dick to make him feel good. You chicks ever seen a penis?"

Henry, fizzing with joy, stood up and enlightened us by unzipping his fly, pulling out his own dick, and moving his hand up and down on the shaft. George, realizing that we were one turned doorknob away from disaster (and, I suppose, less fond of penises than cleavage), growled, "That's enough! Henry, zip it up *now!*"

Word must have gotten out, because it wasn't long before George Cooper disappeared. But before he left, I suspect that good ol' Mr. George may have had a hand in the worst thing to happen to me at Condon.

Jack was a stocky brown-haired kid who told me that he had a crush on me every day. I never took it seriously: Jack pledged his daily troth to Melanie, Julie, Leslie, Patty, and Linda as well. Still, no boy had ever liked me before, so I wasn't sure how to feel when Dad shouted, "Riva, phone's for you."

"Heya, it's Jack. What did you think of the English test? Bet you did good."

He knew exactly how I did. We'd been in the same grade for years. A geyser of adrenaline rushed up my throat. "Gee, uh. I got an A, but dinner's ready, I gotta go—"

"What'd *you* have for dinner? Man, you'll be jealous. We picked up a whole sack of White Castle. *And* extra fries."

"Sounds good, but my mom is—"

He plowed on. "Hey, I really liked that dress you wore today. You looked real cute."

He started calling me every night. I wanted to like him since he liked me, but it was hard. Jack made me feel as if he was grabbing me even from across the room.

And I guess he told Mr. George about his crush. And just maybe they arranged a trap.

I had memorized the times of the day when the art room was empty and I could work in peace. The art room had always been *my* room. I could remember everything I'd ever made there, from the string-and-glitter-and-glue pictures of kindergarten, to the jointed paper puppets of fourth grade, to last year's animal paintings, so stiffly loaded with poster paint that they crackled and flaked like Passover matzos. Art was magical, and not just in the making: people would look at my work, then look at me with a changed expression. One far from the usual *oh poor you.*

That day, I was alone in the art room, glazing a terra-cotta devil, when Jack came in and closed the door. He squinted, asked, "Whatcha workin' on?" and pinned me against the table. He pressed his face against mine, smooshing my lips against my teeth as if I'd been punched. My first kiss. This molestation kiss.

The edge of the table cut into my hips as Jack used his weight to bend me backwards. I yelled, *"Mr. George!"*

Jack smirked, "Oh, he knows we want to be alone. Told me you'd be in here during study hall. I should come find you since we'd be . . . private."

I wiggled out but he chased me in circles around the tables like Bugs Bunny in a cartoon of mechanical rabbits at a racetrack. And so I socked Jack in the gut as hard as I could.

I broke for the hall and ran to the nurse's office. Next thing I knew, she'd hauled me to the principal's office for my one and only punitive visit at Condon.

Mr. Halfter talked quietly with the nurse while I sat, bewildered, in

the outer office. When they called me in, the nurse's arms were crossed hard as if she was struggling not to spank me herself. Mr. Halfter looked sad. "Riva! We are surprised at you. Jack was just here. He said you hit him? That isn't any kind of ladylike behavior."

Wait. They were mad at *me?*

The nurse cut in. "I'm afraid it's more serious than you know. Didn't you realize that Jack has muscular dystrophy?" Actually, I didn't know what Jack had. It had never occurred to me to ask during any of our excruciating phone calls. "A boy like that is *very* easy to injure. You could've hurt him rather badly, by punching him in the stomach! Why, you could have put him in the hospital!"

I squeaked in protest, "But he tried to kiss me." How could I explain how dangerous he'd seemed? How unwelcome his attack? That it *was* an attack?

Mr. Halfter sighed. "Well, boys *will* try that kind of thing, but it's no excuse for violence."

They called my mother, who listened, aghast, as they described my delinquent behavior. I rode the bus home, terrified that I'd put him in the hospital. That I was going to jail.

Mom delivered a confused, confusing, half-hearted lecture once I got home.

And ever afterwards, Jack made sure to shove himself within six inches of where I danced.

And I remembered Mr. George the first time a guy ever flashed me from under the Chicago "L" train tracks.

Condon kids experienced a different social timetable than our able-bodied peers. We weren't invited to the same parties, given the same advice about romance, or encouraged to imagine ourselves partnered. We started dating much later (if ever; I've met people from my generation who've never dated at all). Few were given instruction on how to protect ourselves from sexual assault or abuse.

I have wondered whether Linda's precocious sexuality was the result of molestation. I've only recently learned that a Condon friend (a girl

not in this story) was regularly molested by her father. We never knew; her mother trained her to be relentlessly sunny and outgoing. The incidence of sexual abuse among the disabled is grim, with statistics being extremely high for both sexes. According to an NPR report by Joseph Shapiro,* for every 1,000 people *without* disabilities, 0.6 will be sexually assaulted, but the number jumps to 2.1 for people *with* disabilities, and all the way to 4.4 if the disability is intellectual and/or developmental. For women with intellectual disabilities, the rate is 7.3 out of 1,000; for men, it is 1.4. These numbers are over four times the national average. Statistics for disabled children are estimated, conservatively, at double the national average. Yet even these statistics are, in all probability, higher than was known in Shapiro's 2018 report.

Secrecy is markedly problematic for disabled victims of assault, who may be dependent on their abusers, and forced to cede control of their bodies to these so-called "caregivers." This vulnerability raises the pressure to not report sexual crimes. The abuse may happen in institutions, or within the home, but the risk is that reporting might result in the loss of any help at all.

* https://www.npr.org/2018/01/08/570224090/the-sexual-assault-epidemic-no-one -talks-about

Liz Carr
2011

The Changeling

At Condon, students who could walk often used it as a way to flout the rules. Julie and I were, admittedly, epic flouters.

We liked to sneak into such forbidden zones as the boiler room and backstage at the auditorium. Taboo gilded them with far more fascination than they merited. When everyone else took the elevators to lunch, Julie and I opted for the marble stairs. By sixth grade, we were seasoned outlaws.

One winter afternoon that year, we'd been heading down the steps when Julie abruptly stopped and seized my arm.

"Wait!" she breathed. "Stay right there. There's something I've been meaning to show you."

I frowned. There was nothing in that stairwell I hadn't seen a hundred times before. Walls painted in two sickly shades of green, hung with thick handrails like warped and lacquered Tootsie Rolls. "I don't see anything unusual. Is there something I'm missing?"

"Yeah. Just walk down one more step. One more . . . and . . . okay, *stop*. Feel anything weird?"

"Hmm, well. It's freaky cold. That what you mean?"

She jerked her chin. "Let's go back up to the landing." Julie demonstrated that the cold was confined to a three-step section. Top of the landing: warm. Two steps down: meat locker.

I shrugged. "So what? Maybe the radiators are broken—"

"No!" She flailed her arms in exasperated semaphore. "Don't you get it? This is a COLD SPOT! A Cold Spot is what happens when someone dies. WE JUST WALKED STRAIGHT THROUGH A GHOST!"

Julie caught me in mid-flight. She insisted that we sit in the middle of the Spot while she recited every story she'd ever heard about kids who'd died at Condon. Turned out, there was quite a list.

"So, Linda says a long time ago this kid lost control of his wheelchair and rolled down the stairs. Amy heard about this other girl, she had a seizure and fell off the third-floor balcony. You know those porches at the back of school? And Todd, he says this first-grader drowned in the swimming pool—"

"When?"

"When what?"

"Did they . . . uh . . ."

"I dunno. Like a hundred years ago."

What Julie didn't say was, we all knew kids who had died.

Our first friend to go was Janie, thin and agile and lemur-eyed: second grade, heart disease. There were kids we knew, and others we'd just seen around, kids like Jimmy, and Don, and Diana, who'd gone into the hospital on a one-way ticket. Neither Julie nor I said their names as we paced the Cold Spot. It was easier to imagine an icy child from a distant long-ago.

None of the adults ever talked to us about our disappeared friends. No grief counselors reassured us that we were not next. Death was our shared but private child's knowledge.

And so we began holding lunchtime séances in seventh and eighth grade. We met in homeroom, pulled down the shades, and turned the lock on the classroom door. The Ouija board was unearthed from its hiding place in the coat closet.

It wasn't easy to overcome our nerves and giggles and to hold hands in the dark without feeling like a dork. We asked no serious questions; no one brought up anything medical or mortal whatsoever. Instead, we

pestered the Ouija board about crushes and secrets as if the great beyond was one big pajama party. We denied that the planchette was ever pushed by our living fingers, and when the board spoke, we never asked to speak to any of our lost friends.

But maybe they hung around homeroom anyway.

We always began a séance by chanting "Oh, spirits, show us a sign," and more than once, they seemed to oblige, such as the time that a mason jar containing a pickled frog shot off the science table, flew all the way across the room, and smashed against the wooden lockers. And then there was the giant ball of colored light that appeared over the table, hovering and pulsing like a lava lamp before slowly fading away. Someone hissed, "Do you see that?" From the dark came a whispered *"Yes."*

We returned to eating in the cafeteria with all the officially alive people.

Around the end of seventh grade, a morning came when Grandma dropped me at school so early that the sky was still pink. There were no buses in the parking lot, only a smattering of cars, so I settled in the basement hallway and aimed to grab Julie as soon as she got off the bus. We'd both been fighting with our mothers and needed our usual pre-class commiseration.

To my left, French doors closed off the Cold Spot stairway. The cafeteria lay down the hall to my right. I hunched on the floor in front of the pair of elevators. Their scissor-gates and glass doors made it easy to tell that they were empty. The elevators had manual controls, so you had to call them or be inside to make them go. But all was quiet. Nobody around.

I was immersed in a paperback copy of *Lisa, Bright and Dark* when both elevators lurched upstairs and came right back down. I glanced up, but no one got out. Both were still empty, which made no sense.

As I watched, they went back up to the third floor and returned to the basement, still empty, still without my doing a thing. I was pretty

sure that elevators were not supposed to have minds of their own. I stood up to find a maintenance man.

Just then, something flickered at the corner of my eye.

A milky fog was filling the hallway. The French doors disappeared behind a cloud of—smoke? There was no smell, but smoke did explain the— Wait, oh shit, the school was on fire!

As I got up to run, the cloud contracted and shrank to nothing. In its place was the faint shape of a little boy.

He was dim, like a slide projected through a sheet. Dark hair, a light blue shirt, and darker pants. His face and hands only pale blurry blobs. I could see the French doors right through his body. And he was floating six inches above the floor.

The boy began to drift in my direction. I was terrified that he was going to talk to me.

He didn't. At least, nothing I could hear.

His shape just drifted closer and closer. And vanished.

No boy, no mist, no fire.

But in that moment, I heard the sound of small, hard-soled shoes running straight at me as I stood flattened against the wall. The banister gouged my spine. *Ker-slap, ker-slap.* Just as he was close enough to touch me, his shoes clattered past and headed for the cafeteria.

I bolted for the parking lot—where, thank God, the first buses were coming in. When Julie stepped off, I dragged her to the bushes. She made me tell it over and over, startled that this had happened to me, not her. After all, *she* had been our séance medium, the only one who could intone "Ohhhh, spiritsss . . . speak . . ." without convulsing into giggles.

The ghost—or something—made a final appearance the day of our eighth-grade graduation.

I'd started in 1963, with over twenty kids in my class. The Class of 1972 was down to less than a dozen. Some had mainstreamed out, others had moved away; a few had disappeared, as ever, with little explanation.

The auditorium was a two-story space, with a wide stage hung with heavy red velvet curtains front and back. For graduation, we were arrayed in a line facing the audience. I sat between Amy and Donald, singing our farewell song, when somebody smacked me hard on the shoulder. I glared at Donny and whispered, "Why the heck did you hit me?"

He glared back. "You're crazy! You hit *me!*" Mr. Glanzer pressed a finger to his lips, so we shut up.

When the ceremony ended, our families swarmed the stage, so it wasn't until the cookies-and-lemonade reception that I found out that every kid onstage had felt someone slap or punch them. We'd been thumped in full view of the audience—yet all the audience saw was the red velvet curtain rippling as if in a high wind.

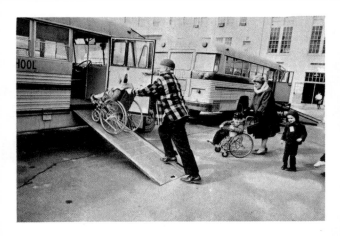

END OF THE DAY

I was not sad for the Condon ghost. I wasn't ready to leave, either. Condon was the one place where I felt safe, where my friends and I had invented our own ways to use our bodies and minds. We'd made a world for ourselves, for one another, to replace the one in which we were irrelevant. Where we had no value.

Some of us did hate Condon. Could not carry the burden of stigma,

of exile. Those of us who longed to be accepted into the mainstream, even if it meant denying every true thing about ourselves.

I had that longing—but more, I needed those eight hours a day, when I was a Golem among Golems. A monster in a school for the strange, where normal was whatever was real for us.*

* I'm not sure what to call these events, the Cold Spot, the séances, graduation, other encounters I've left out. I can't insist that they were supernatural, and have even wondered if I imagined the ghost. However, while writing this book, I sent a draft to my cousin Diane, who reminded me that I'd told her the elevator ghost story back when I'd been in sixth grade, right when it happened. I had been both terrified and very, very specific. Make of that what you will.

A Sweetness in the Blood

Mom's condition was becoming more erratic. Some days I'd come home to find her full of news about the neighbors, or eager to catch me up on our soap operas (Dorie and Mom liked to compete to reenact that day's turgid doings on *Another World*). That version of Carole would help Mark draw a fire truck, or help Doug with his biology homework. That Carole would put on her yellow dress with the velvet sash, fix Dad's tie, and set out the canapés and the cocktail shaker full of sloe gin fizz for an evening with Pearl and Buddy Schindler.

Time was stealing that woman away, piece by piece, in repeated surgeries that sewed and severed her body until blood leaked out between the seams.

At first, Mom's care took place at Jewish Hospital, but her newly random assortment of doctors sent her to Christ Hospital, Drake Hospital, Otto C. Epp Memorial, Good Samaritan Hospital, and Bethesda Hospital. None of these places allowed children on the adult patient floors. We waited for Mom in dayrooms full of sick, smelly, bathrobed strangers, and their stoic, or weeping, families. This version of Carole was bombarded with drugs, procedures, and haphazard psychiatry. Months might go by before we saw her again. My brothers and I came to believe in her existence the way that gentile children think of Santa Claus.

For a long time, Mom still believed in the medical establishment. Many afternoons, she'd sit at the kitchen table in alert and upright Business Pose, armed with a sharpened pencil and a notepad, telephone receiver wedged against her neck. I'd be sprawled on the couch with a book but would stop reading to listen.

"Hello, I'd like to make an appointment with Dr. Schwartz. . . . Yes, for an orthopedic problem. No, I already have a set of X-rays, I'll bring them along. . . . Wednesday at two is fine. It's Carole Lehrer. L-E-H-R-E-R. Thanks so much, I'll see you then."

But next morning, the phone would ring.

"Yes, this is Mrs. Lehrer. . . . I don't understand. What do you mean, the doctor's not accepting new patients? Can't he— . . . Oh, all right. Never mind."

Dial, dial, dial . . .

"Hello, is this Dr. Mandelbaum's office? It's Carole Lehrer. . . . Yes, Riva's mother. No, I'm not calling for Riva, it's for me. . . . Tuesday at four?"

A day or two later.

"What? He's out of town for that entire month? Well, how about the beginning of— . . . That makes no sense. How can he be booked up till February?"

Click.

All this, because my parents had finally filed a malpractice suit against Dr. Litvak. It seemed obvious that Litvak was trying to ensure that no other doctor would take her on. The Cincinnati fraternity of surgeons was small; her physicians would be asked to testify in court, and Litvak was an influential colleague. Soon the only doctors willing to treat her were third-rate practitioners, quite as skilled as one might expect of doctors whom no one ever recommended. My mother regarded them as prescription vending machines.

Carole had been injured in the early 1960s, just as new, powerful painkillers hit the market. Drug companies did not warn physicians about their addictive nature, nor was there much understanding of the complexities of pain control. I have heard anecdotes that the pharmaceutical industry used women as unregulated and uninformed crash

The Horowitz side of the family, 1969

test dummies.* Women complained about pain far more frequently than did men, and in addition, were inculcated not to question authority. Carole's doctors handed out narcotics with abandon. Her bedside drawers were full of capsules and tablets, and vials of liquid that she injected into her thighs, turning the skin a mottled blue. When Doug turned fourteen she asked him to shoot her up. Said it was good training for med school. Such are the crumbling boundaries around caring for a sick parent.

Years later, Doug and I would share our parallel experiences of being

* This article cites the lax practices around prescribing for women, as described in Jacqueline Susann's *Valley of the Dolls*: http://www3.uah.es/farmamol/The%20Pharmaceutical%20Century/Ch5.html.

It appears that rigorous human trials were just beginning to be reinforced during the period of my mother's addiction. A discussion of the history of drug regulation: https://www.fda.gov/media/110437/download.

An interesting look at the struggle between doctors and patients for the right to narcotic medications: https://www.ncbi.nlm.nih.gov/pmc/articles/PMC5679069/.

Mom's caregiver; he was the only person in my family who would ever be honest about her behavior back then.

In the 1970s, Cincinnati's medical establishment was an agglomeration of disconnected providers. As the daughter of a pharmacist, and the erstwhile employee of a hospital, Carole was familiar with dozens of physicians. This let her doctor-hop like a junkie kangaroo. Nonetheless, there was a limit to how many times a physician would pull out the prescription pad. After she'd worked her way through the yellow pages, she fell back on the fact that she was, indeed, the daughter of a pharmacist.

Horwitz Drugs smelled of the gelatin capsules and sweet syrups and bitter powders that Grandpa used to compound medications. All of us grandkids grew up working there, doing our homework in the back room, where a miniature kitchen vied for space with towering cartons of merchandise, restocking the yellow tins of Anacin, the cobalt blue bottles of Milk of Magnesia, and the sickly pink of Pepto-Bismol, all to earn the right to unpack the comic books—with Grandma three feet away, watching that we didn't crease the newest *Superman*.

I'd always thought Mom hardly ever visited the store, but not long ago, my uncle Lester told me the truth. When my brothers and I were at school, she'd call Grandpa Sam and offer to help out. He'd try to hold her off, but if she was desperate enough she'd take the bus downtown anyway. Carole would wait until her parents were distracted, and then she'd go hunting in a languid drift from shelf to shelf, helping herself to a few bits of opioid this and alkaloid that. Her pockets were as full as any other thief's as she slipped out the door.

Grandpa Sam understood about need and hiding. His appetite was a matter of some awe; he'd follow the last bite of Shabbos dinner with the quasi-serious suggestion that we all go out for a cheeseburger. It was Sam's misfortune that Fannie was obsessed with obesity; her idea of fun was driving around in her gold Catalina and commenting on passersby in pleasurably disgusted Yiddish. So Sam turned Horwitz Drugs into a repository for his own addiction. The entire store was honeycombed

with hiding places: opaque glass jars, tiny forgotten drawers, old drug canisters, even two metal bank boxes hidden under the floorboards stuffed with cookies and doughnuts and tacky-stale Mounds bars. I suspect that Sam's own furtiveness helped him "forget" that Carole was raiding his stocks.*

Twice, I had opened the door to our house and found Mom lying naked on the living room floor. She was three times my size, yet I felt it my duty to get her back in bed before the boys came home. I yanked at her arm and shouted into her ear until she levered herself off the floor. And then I tried to forget what I'd seen.

Other times, she'd be awake but still in her nightgown. Her face puffy and blurred. Her hair pillow-smashed and clearly untouched all day. There was the time when Dorie was still there, holding Mom's wrist with her thin brown fingers. "Cissy, your husband gonna be home any minute now, you go get cleaned up. You don't need to do anything. I got a tuna casserole in the oven." Mom saw me and said, "I'm a terrible mother." The slurring of her voice turned me inside out like a fraying sock.

Pain was wreaking havoc on my parents' marriage. Dad spent too many nights sleeping on the couch because Mom couldn't bear his weight on the mattress. When we came out for breakfast, there'd be Dad, asleep in a crumple of green ledger paper.

* A few weeks after my grandparents retired and sold the store, Fannie got a call from the buyer. He whispered on the phone, "What's in there?"

She replied, "What's in where?"

"You know, in the *safe*. Diamonds? Gotta be diamonds."

Fannie thought, what kind of a meshuggener is this guy? "There shouldn't have been anything in the safe. Sam cleaned it out. Did he forget something?"

"Well," the buyer said, "it looks exactly like a jar of chocolate chip cookies. But I ask myself, there's gotta be something baked into them, and what else would be worth hiding in a safe?"

Grandma could hardly breathe for laughing. "Those cookies?" she gasped. "They're cookies."

So there we were, in Roselawn, in a duplex, because the lawyer assured us that we'd win a big settlement, enough to pay off all our medical bills and buy a real home. The lawsuit would turn all our lives around. Unfortunately, the quality of Mom's doctors was going downhill faster than the speed of hope.

Dad at the yellow kitchen phone, pulling at its curling ten-foot cord as he ducked in and out toward the bedroom, trying to keep an ear on noises coming from his wife. It was Saturday; Dorie had stayed over, and both had been up all night. The kitchen table was crowded with stale coffee cups and an ashtray filled with Dorie's crushed Kents.

The answering service finally put him through to Mom's latest physician. Dad tilted the receiver so Dorie could hear. No one paid attention to the fact that I could hear, too.

"Dr. Weinberg, it's Jerry Lehrer. Carole's in really bad shape. She can't stop crying and she's been throwing up all morning."

"Mr. Lehrer? Has she been taking the medication I prescribed for her?"

"Yes, I think so, Doctor, but it's not helping. She's sweating and shaking. Her pain is really severe. Maybe we should come to the emergency room."

"Um, well. There's actually no need . . . uh . . . she's in withdrawal."

"I don't understand. In withdrawal from what? She's been taking the Percodans on schedule."

"It's not Percodan."

"No, wait, here's your name on the label, that's how I found your office number."

"Mr. Lehrer. It's a placebo."

"What?"

"I've been concerned about your wife's intake. When she was here last week, I called her pharmacy and had them give her sugar pills. Carole needs to understand that she doesn't need this level of medication."

"Jesus Christ. Did you tell her that?" He jerked upright. Coffee sloshed down his undershirt. "Does she know she's not *getting* actual medication?"

The doctor's voice bleated from the receiver. "No, of course not.

That would defeat the purpose, wouldn't it? We have to wean her off the dosage first."

"This is not weaning!" My father never yelled, but he sure was yelling now.

We heard, "Call me in a week, and until then good luck to you." And click.

Dorie lit a fresh cigarette. Dad looked at it like a drowning man looks at a buoy. For a long minute, they just stared at each other, trying to figure out how to tell Mom she'd been in untreated, unspoken, unmonitored opiate withdrawal for a week. That she could have had a seizure, a stroke, or a heart attack because of what this putz had done.

Even with all that, I understood about the drugs.

By the time I was five, doctors had already fed me all the same chemicals that colonized Mom's bedside table. I only had to read the labels and I knew just what she was feeling: the suspended ecstasy of morphine, the nauseous headache of codeine, the nice-try of Tylenol, the pointlessness of aspirin. I knew the patience you needed for pills and the brutal efficiency of a syringe.

Mom's pills sent her zigzagging through the house, leaving a cornice line of handprints along the walls. Dad insisted that she see a psychologist at Jewish Family Services. She came home in a state between triumph and frustration. "They can't help me. I'm smarter than any of them. It's so *boring*. All they hand me are platitudes."

"Cissy, please keep trying. Something's gotta help."

Chin high, she scoffed, "Oh, I will. But I must say, you don't need to be very bright to be a psychologist. But I guess anybody brilliant isn't going to work for JFS."

Six or eight times I came home to see an ambulance sitting in our driveway. Dad and Grandma always claimed it was a problem with Mom's back, but once, when they thought I couldn't hear, they whispered "overdose." The word "divorce" began to percolate through our

parents' arguments. Grandma warned Mom that Dad was going to leave.

He didn't. She did.

The first time it happened was right after we moved to Roselawn. I came home from school and discovered that Mom was gone. Her suitcase was missing from the bedroom shelf, the absent cosmetic case our clue that she wasn't in the hospital. Dad was a red-rimmed shambles who could only groan "I don't know" when asked where she was. Late that night the phone rang. We all ran for the receiver. When it was my turn to talk to her, she sounded like someone who'd been in a terrible accident.

"I can't be there. Don't ask me why. I'm sorry, so so sorry, I miss you but I can't come home. . . . No, don't ask me where I am."

Since then, she'd disappeared three or four more times; a weekend here, ten days there. Dorie told me that Mom was staying at a cheesy motel about a mile away, one of those places that is mostly parking lot. Dad slipped off to try to talk to her but was never able to fetch her home. We just waited for the yellow taxi to show up again.

I laid every bit of this at James Litvak's feet.

Litvak had operated on my mother's spine at the level of her fourth and fifth lumbar vertebrae—L4 and L5. These are the bones at the waistline—the most frequent location for back injuries. L4 and L5 are also the exact location of my spina bifida myelomeningocele lesion. The same X marks the spot where Dr. Martin closed up the gap in my vertebrae and where Dr. Litvak blew a hole in hers.

I felt as if the S-curves of our spines were twisted around each other like a DNA helix. My strand was embryonic, hers situational, but everything she felt moved through my body, too.

So, of course, I understood about the pain.

. . .

My childhood experience of pain came from surgeries or from the pain that had led me into surgery. I hated asking for pain medicine in the hospital, not out of any moral rectitude but because I was intensely phobic about needles. Nurses used to carry the pain shots into the room on a little metal tray; the sight of a capped syringe caused me almost as much heart-pounding misery as pain itself.

For me, narcotics were part of inpatient life; I rarely took them at home. Mom lived with the kind of pain that obliterates thought or breath. Pain that blots out the world outside one's body. Muscle pain makes it hard to function, but nerve pain makes it hard to exist.

So I forgave her almost everything.

Almost.

When I was fourteen, I walked into Mom's bedroom and found her propped up by her usual rockfall of pillows: left leg at 45 degrees, right leg acute, spine shored up perpendicular to the headboard. I'd come in to see if she needed anything. I saw the silent television, the magazines tossed to the floor: signs that this was a bad, bad day. She was gasping so hard I had to piece together her words. Which were, "I can't take this anymore."

I gingerly perched on the edge of the bed. "Mom, do you need to go to the hospital?"

"I, I, it never stops. Noooo, uh, no, not for one minute. The . . . doctor says there's only one option. But, Riva, I'm so scared."

"What do you mean? Do they want you to have another operation?" Stupid question. The answer for both of us was always another operation.

"Yes. A . . . really bad one. The worst." She gulped more air. I waited until she could talk. "It's called a cordotomy. He says it's the most serious surgery you can have."

"Why is it so bad? Would it make you better?"

"Well. I. Wouldn't have. Pain anymore. But—the—doctors would

cut my spinal cord. It's, well, it's voluntary paralysis. I wouldn't feel pain. Or anything else from the neck down. I wouldn't be able to hold my children anymore. Or feel when you hugged me. I'd feel . . . just . . . nothing."

I could see her in my mind, a quasi-robot, my mother's head mounted on top of a metal cylinder. I wanted to throw up.

She gave me a look of such despair.

And then she said the words that bound me to her pain.

"Riva, if it wasn't for the fact that you need me, I would kill myself. But I could never leave you like that. I have to keep going. You're the reason I can't kill myself. So I just . . . have to keep living like . . . this."

I was the reason? Me, *I,* was the reason my mother was choosing not to die? Had she said this to my brothers? Our father? Were we all holding her hostage to pain?

I understood that I was going to have to show her that I needed her for the rest of my life. I would have to stay her helpless, fragile child. The faintest independence would push her over the cliff. I went back to my room and cried myself to sleep.

I never knew the precise amount we were suing for in our malpractice suit, except that it was enough to cover all current and future medical bills, including a significant amount for pain and suffering. Mom had gone to the Mayo Clinic and Cleveland Clinic to see if anything could be done, which led to several spinal fusions performed by other surgeons. Her bills climbed like swallowtails funneling into the clouds, joined by flocks of Dad's bills and the boiling mob of my own.

There was no doubt that Carole's condition was caused by the forgotten surgical sponges. There *was* doubt as to whom our lawyer could call as witnesses on her behalf. The Cincinnati medical community had formed a white-coated wall around Litvak. Carole had had a terrible time finding an orthopedic specialist who was impressive enough to wow a jury.

After many tries, she hired a wonderful advocate. Dr. Gray was shocked and sympathetic and promised he'd explain everything a jury

needed to know. We gathered boxes of medical records from all Mom's hospitals and all her specialists. The whole family, Grandma and Grandpa and Mom and Dad and Doug and I, spent hours at the dining room table, armed with a three-hole punch and a stack of binders. We gave Dr. Gray the entire collection, including half a ton of X-rays.

Dr. Litvak kept calling for continuances. He knew that if he drained our ability to pay for a lawyer, we'd have to give up. At last, in 1973, eight years after filing, the judge stopped granting his motions and gave us a carved-in-stone date for our day in court. Our lawyer said we'd definitely win; there was only debate over the size of the award.

Two weeks before the suit went to court, I was down the street at the Stregevskys' when Aunt Ruth stuck her head in the room and said I had to go home right away. My parents and grandparents were sitting in the dining room. Mom's arms were wrapped tight around her body. Grandma's eyebrows were two iron bridges. Grandpa's fists ground against the arms of his chair. Dad appeared on the verge of a second coronary.

The lawyer had called to inform them that Dr. Gray had absconded with all of Mom's medical records. Every single box and file and X-ray was gone. Every last scrap of evidence. Dr. Gray had also absconded from his marriage and fled to Florida with his nurse, apparently taking Carole Horwitz Lehrer's records along for the ride. The lawyer couldn't come right out and say the word "bribery"—but never let it be said that James Litvak was bad at making friends.

This was long before digital records, so in most cases these were the only copies and could not be reconstructed. Even if they could, it would be the work of months and months, not to mention thousands more dollars to the lawyer. And where would we find another expert witness?

Our parents went through with their day in court. Doug and Mark and Dorie and I sat at home waiting for news. They returned at dusk. Mom stalked directly to the bedroom. Dad paused long enough to say, "We won. That's what they called it. Winning. The judge didn't even award enough to cover court costs."

The weight on our family would never be lifted away.

. . .

James Litvak died in 2012, at the ripe age of eighty-seven. I looked him up but he'd left little trace: no citations in journals, no endowed chairs, no techniques named for his sixty years holding a scalpel. Not even one picture in Google Image Search.

My brother is now Douglas Lehrer, MD, a forensic psychiatrist who has been on faculty at some of the same hospitals where Litvak practiced. Doug called me when he spotted the obituary. "I looked him up on the Ohio State Medical Board's site, and wow, Ving, the guy was sued some incredible number of times. Even for an orthopedic surgeon, and those guys get sued all the time, they do so many high-risk cases. The board yanked his license when Litvak was in his seventies. *No* one loses their license at that age! They either retire or the department moves them somewhere safer than the operating suite. This was one incompetent schmuck. Bastard kept going until the board had no choice. They should have pulled his license a hell of a long time ago."

I never met Litvak, destroyer of lives. I've imagined him as a chicken-boned ectomorph, and as a deluded Colossus bestriding the halls of Jewish Hospital, but I'd never imagined that our mother was just one in a long line of casualties. As Doug and I hung up, I could see Litvak at last. He was peering at me from behind the black balaclava of a serial killer.

Cissy Inventing the Pantheon

Bedsheets rubbed away the downy hairs at the back of her arms and legs, abraded the hair on her skull and left patches of scalp bare as a November field. Her elbows were a strange pewter blue; stranger still, she could take a nickel or a dime and write words on her own arm, due to a condition called dermatographic urticaria. The word she wrote most often was *Carole.*

Cissy Inventing the Pantheon
1976

Nerve damage and drugs caused her to fall and break her sacrum and coccyx, a painful and limiting injury that cannot be immobilized in a cast or with pins. The only cure is bed rest, so yes, more weakness, more isolation. And then her thyroid gland gave up. And then she became a full-fledged type 2 diabetic. Injections of insulin joined the other, narcotic-filled syringes on her bedside table.

Let's not forget the tapeworm. Yes, the tapeworm. Weeks of intestinal agony before she received the humiliating diagnosis.

Society had no use for a sick, sad, fat woman who was in pain all the time. I'd stopped looking to her for lessons on how to be female, but neither could I look to her for tutorials on how to be disabled. Neither of us had role models for how to perform our own bodies.

My mother was a snowman, a snowwoman, a stack of gingerly balanced spheres like eggs piled on a rocking chair. Illusory solidity, utter fragility.

And yet she was still my mother. A winter landscape viewed from an airplane. Too vast to take in all at once.

CHAPTER 22

I Was a Teenage Werewolf

September 1972

The day I started high school, I wore a secret necklace under my ugly green uniform: a gold disk, engraved CONDON SCHOOL 63–72. Nothing could have persuaded me to wear it out in the open, even though I'd asked for it as my eighth-grade graduation gift. I wore its small cold weight as a comfort.

In seventh grade, I had scraped up the courage to join the Habonim Labor Zionist Youth Group, an organization that encouraged Jewish children to "make Aliyah," that is, move to Israel for part or all of their futures. Habonim was the center of my hard-won social life—ergo my life, full stop. My Habonim friends knew nothing about Condon, but they did know I was weird. For months I was too afraid to sit at the table during meetings—so I sat under the table and admired their muscular feet ṣhod in kibbutz-made, Sabra sandals.

When not under the table, I stole rabbitty glances from behind my curtain of hair. Mainly, I watched as the chaverim made out in corners, an activity that required much groping and shoving of hands in each other's pockets. One night, at someone's parents' house, Yitzhak and Becky disappeared into the basement while we all stood upstairs by the door and eavesdropped on their moans and cries. Sex scared me from

the bones outward. I shuddered as Becky climbed the steps clad only in a towel and Yitzhak did up the copper buttons of his Levi's.

The first kids to accept me were Shari and Arlene, both one year older than me, both willing to give me the shelter of their wings. I never talked to them about my disability, but it didn't matter. Mom blew my privacy any time either of them came to my house to pick me up. She'd take my friends aside, thank them for *being* my friends, and deliver medically explicit instructions on my care, thereby turning them from my friends into my caretakers, as if I became mute and incompetent as soon as I left home. By the time we got to the car, I was humiliated and convinced that my so-called friends were just doing their good deed for the day. (I was depressed to discover, in college, that Shari and Arlene both became nurses.)

Everyone in Habonim went to Walnut Hills High School. I'd worked so hard on passing their battery of academic tests required for admission, unaware that Mom somehow diverted my scores to get me accepted at Hillsdale College Prep. I would be a scholarship student among the rich. Worse, Hillsdale was *all-girl*. What was wrong with boys? And *why* couldn't I go to school with my friends?

And yet, here I was. Our station wagon pulled into Hillsdale's parking lot on Orientation Day. THE HILLSDALE SCHOOL was painted in Ye Olde Scripte on a sign in front of the administration building; the entire campus was gray clapboard with white trim, as if a chunk of New England had migrated to a hill in suburban Cincinnati. Mom's big selling point had been that every building was only one floor tall (except, as it turned out, the art building. That's irony for you). I'd bleated, "But, Mom, that's stupid. Julie and I hiked up three floors several times a day at Condon."

"Missy, let's not forget all the times you've been on crutches or in a wheelchair." She'd tapped a finger against her cheek. "And Condon had—oh—*elevators*. Walnut Hills is, I regret to say, bereft of such conveyances."

Hello, Another Weirdo Island.

· · ·

The main hall was lined with Orientation Day tables of cookies, balloons, and brochures. A fog of fresh paint and shampooed carpets scoured the inside of my nose. I trudged along, arms stiff as rebar, eyes on my shoes.

We stopped by the supply store and bought my uniforms: two box-pleated tunics—pale gray-green cotton for spring, forest-green wool for winter, in a style that made anyone look instantly pregnant (a strange choice for teenage girls). Uniforms were supposed to elide the fact that most Hillsdale students were the daughters of Cincinnati TV station owners, executives at P&G, senior bankers, and CEOs of insurance agencies. This egalitarianism bit the dust on free-dress Fridays, when girls broke out the heirloom Fair Isle sweaters, much prized for their white reindeer pattern like woolly Christmas cards. Who knew that sweaters were handed down for generations?

There was one Black student in the entire school, and, as it turned out, a handful of Jews, but I was the only disabled student as far as the eye could see. A scholarship student to boot. My uniform should have come with a tiara with PARIAH picked out in rhinestones.

Accordingly, I was the subject of much giggling behind cupped hands, much side-speak and many abrupt silences when I set foot in the student lounge. One girl liked to comment on my body like a sadistic news anchor. At Condon School, I'd been one of the Cool Girls, but now, if anyone asked where I'd gone to elementary school, I lied and said Roselawn Elementary. I knew what would have happened if they saw my golden disk. *REEEEETARD!* By tenth grade, I'd taken to hiding in the bushes outside my classrooms and listening to lectures through the open window.*

There were a few sweet girls who sat with me in the cafeteria, odd-

* For the purposes of this story, I'm calling the school Hillsdale, but in truth I'd only been there a year when Hillsdale changed its name to Seven Hills and went coed. I was a sophomore when boys poured into the seventh- and eighth-grade classrooms. Administration immediately established a football team, so that the boys could fully express their testosterone. I was part of the last all-girl class in Hillsdale history.

I think Mom chose Hillsdale for some of the same reasons that transgender students might opt for an all-girl college. I'd be more accepted, safe from boys, and the competitiveness of girls vying for boys. You bet.

balls of the mildest kind, but at Hillsdale, it didn't take much of a shove to fall off the social calendar.

At least I was starting high school as an Official Girl. The summer before, I'd been babysitting a couple of children as they paddled around the JCC kiddie pool when I glanced down at my swimsuit bottom and saw a crimson stream snaking down my leg. I thought I was having a medical emergency, so of course I screamed, which of course meant that the entire pool now noticed the deranged and bleeding girl. A nice woman lent me her beach towel and asked if it was my first time, then put a quarter in the Kotex machine on the bathroom wall and went to call my mother. I spent the weekend curled up in Crampville under rotating heating pads.

If pain was the price to pay for Girlhood, fine. I was fertile. My body had a future. It had a purpose.

And then menstruation began to mow me down like a bright-red Sherman tank.

The pain stopped letting up between cycles. My aunts said that some women just had really bad periods and to get used to it. I should have been taken to a gynecologist; instead, my pediatrician sent me to a psychiatrist who asked if I had those cramps when I fought with my mother. "*No*," I snapped, "I have them during *my period*." (*You idiot.*)

CHAPTER 23

Curse of the Spider Woman

November of my sophomore year, I was doodling lions in the margin of my American history textbook when a grenade went off in my belly. I lurched out to the hallway and fell over on the carpet, cheek pressed against a thousand muddy sneaker prints. Two teachers hoisted me to the nurse's office, called an ambulance, then called my mother.

Sirens. Curious faces. A bitter wind sliding around the stretcher. Mom and Grandma met me in the Children's Hospital ER, where I was given a whomp-load of painkillers. I dimly registered the X-rays, the excruciating pelvic exam, the doctors mumbling in the hall . . .

Mom roused me at five A.M. (had she ever left?) and said I had a hemorrhaging uterine cyst the size of a grapefruit. (Universal law decrees that tumors and cysts are either golf balls or grapefruit.) Orderlies were on their way to take me to the OR, where Dr. Martin would perform an emergency hysterectomy. Not the usual surgery for a fifteen-year-old kid. Even the nurses were a little nonplussed.

I woke up with a wide flat smile of an incision just above my pubic bone, and the sensation that I'd been set upon by sadistic plumbers.

Eventually the anesthesia receded and the questions began to ar-

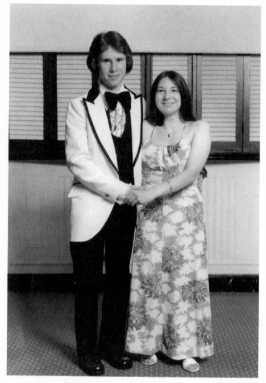

1976. Senior prom at Hillsdale. Poor guy.
I think his mother made him take me.

rive. I knew what a hysterectomy was and what it meant for normal women. I had no idea what it meant for me.

I would discover what my hysterectomy meant for Mom.

A couple days after surgery, we were sitting around my room waiting for the lunch trays when she asked, "Are you glad you won't have periods anymore?"

I hadn't thought that far. There were bandages on my abdomen and giant pads between my legs. I was still the Vesuvius of menstruation. "Yeah, I guess. But Dr. Martin said that I kept my ovaries. Won't I feel something?"

"You might get a little moody. But you're a teenager, so moody is

pretty much your job description. A lot of women would give big money not to have cramps every month."

"An operation isn't a whole lot easier, Mom."

"Maybe not." She sighed and covered my hand. The sign that she was about to be Deeply Serious. Hoo boy.

"I know this was scary, honey, but it was all for the best. If you hadn't had your uterus out now, you'd be stuck doing it down the line. Your spine isn't able to withstand a full-term pregnancy. If you ever did get pregnant, you'd have to make a terrible decision. Now it's out of your hands. This was a blessing in disguise."

What. The. Hell. Fury shrapnelled my brain. I had *had* that fucking emergency operation because nobody—including *her*—believed that my period was more painful than it should have been! And she'd always said that men wouldn't be interested in me. Was she saying I would have gotten—jeez!—*offers*?

And—I knew perfectly what pregnancy had done to *her* spine. Mom had toughed it out, hadn't she? Was I that much worse off?

No one ever had asked me if I wanted to have children. Our relatives asked my girl cousins whether they had crushes on boys. Did Diane and Leah and Ellen and Betsy want to go shopping for dresses? Who was taking them to prom? Oh, a boyfriend! How nice!

But no one asked me. Never me.

Mom went on, seemingly unaware of my rage. "I've been so worried that you'd meet a boy one day and he'd put you in terrible danger. Even though most men aren't attracted to handicapped girls I was afraid you'd be forced to make some terrible decisions. Now, though, I think we're in the clear."

And she *smiled*. My mother smiled.

My last morning in the hospital, I caught Dr. Martin's sleeve as he turned to go.

"Could you wait a minute? There's stuff I don't understand." There was no one else I could ask, and it wasn't like this kind of thing would bother him. He was a *doctor*.

Shaky breath. "Um, Dr. Martin. Does having a hysterectomy mean . . . that . . . I can never have sex? Does it mean I'll never feel anything if I do?" I had a creeping notion that the hysterectomy had paralyzed my orgasm nerves. Whatever they were called.

He froze. My idol, my hero, my own Rabbi Loew, said, "Riva, I thought you were a *nice* little girl. I cannot believe what you just asked me. Promise I'll never hear anything like that from you ever again." And then he walked out.

Back then, I had no idea that there was a history of involuntary sterilization of disabled women. The most famous example is that of Carrie Buck, plaintiff in the Supreme Court case *Buck v. Bell*. Carrie Elizabeth Buck was a poor girl from Charlottesville, Virginia, who was raped and impregnated by a member of her foster family when she was seventeen. That family avoided prosecution by committing Carrie Buck to the Virginia State Colony for Epileptics and the Feebleminded, at which she was declared incompetent to raise her baby.

While in the Virginia State Colony, Buck was sterilized against her will, under the Racial Integrity Law of 1924, a eugenics program carried out by the State of Virginia. Buck's mother, Emma, had already been committed to the Colony for "feeblemindedness," often a code word for "promiscuous," denoting a sexually "uncontrollable" female. Later, Carrie's sister Doris was also sterilized using similar justifications. Carrie's daughter, Vivian, was *also* labeled feebleminded and died at age eight.

There is evidence that none of the Bucks qualified for these spurious "diagnoses"; researchers have cited sources indicating that the Bucks were all of normal intelligence. This is *not* to say that if they'd had intellectual disabilities any of this would have been morally or ethically justified. Nevertheless, Justice Oliver Wendell Holmes Jr., in ruling against Carrie in *Buck v. Bell*, pronounced the famous verdict: "Three generations of imbeciles is enough."

The Buck case may be the most infamous, but there are thousands of stories of disabled women being sterilized against their will—and

often without their knowledge—throughout the twentieth century and into the twenty-first. Most were—or are—poor; many were women of color; but any woman was at risk of being committed by her family and subjected to this atrocity. This included women who went to public health clinics, or who were considered "inappropriate" mothers for any reason whatsoever.

These days, people born with intellectual disabilities are still involuntarily sterilized, on the assumption that they would be incompetent parents.* Deaf, blind, and paraplegic people are also frequently treated as having no right to reproduction.

Few Americans realize that the eugenics movement began in the United States and not in Germany. The Nazis embraced it to a horrific degree, but eugenics was a lethal export from the Home of the Free. If you prevent disabled people from having children "for their own good," and abort us as fetuses, "for the good of society," soon we've never existed at all.

I don't equate my situation with that of Carrie Buck's—but it's not fully unconnected, either. If my fertility had been valued, perhaps I would have been taken seriously when I complained of pelvic pain. Instead, I had to begin hemorrhaging before anyone examined me. I don't know whether anything could have been done to preserve my fertility, or whether pregnancy was as dangerous as my mother claimed, but I do know that her reaction, and that of Dr. Martin, speaks to a long-held societal dread of disabled people making more disabled people. I know that no one, back then, expressed a single word of sorrow at the loss of my ability to procreate.

* https://www.washingtonpost.com/news/volokh-conspiracy/wp/2014/04/18/sterilization-of-the-intellectually-disabled/

Face/Off

S terilized I might be, but Jewish I still was.

The great milestone of Jewish womanhood was the Nose Job. All around me were girls under the exact same spell of body dysmorphia. What a nice change it made, not to be alone in colossal self-loathing. Every one of us was convinced that rhinoplasty was *the* route to beauty.

For me, my nose had become my body in miniature. Too sizeable, too wide, too lumpen. Too visible by far. I was certain that if my nose was "corrected," the rest of me would magically follow.

Nowhere was this desire more acute than during summers at the JCC pool. It had been easier when I was twelve, when my friends and I had splashed and dunked each other wearing one-piece suits patterned with fishies and whales. We couldn't wait to be teenagers. Now, at sixteen, we ran a lot less and posed a lot more.

In the 1970s, "ethnic diversity" had yet to arrive in Cincinnati. Our ambition was to be as undiverse as possible. My friend Nancy had been asking her parents for a nose job since she was eleven, until, in desperation, she made herself swim directly into the concrete wall of the JCC pool. She was sure that they *had* to come through, since Nancy could hardly go through life with the schnoz of a Ukrainian prizefighter.

Nancy was but the most intrepid of the rhinoplasty devotees of

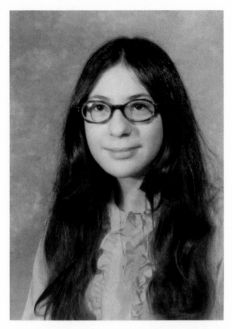

The Nose, circa 1974. It was so much
worse in my imagination.

Roselawn. Walk down the sidewalk and a Dr. Peerless Nose came at you
from one direction while another, identical Dr. Peerless Nose passed
you going south. Sidney Peerless was the plastic surgeon who remod-
eled all the shayneh maidelehs of middle-class Cincinnati. Like Nathan
Hale, he had but one nose to give to his country. The doctor was fa-
mous for whittling cartilage into teensy little shiksa buttons.

This was the first time I'd ever *asked* for a surgery. A very perverse act
of adulthood. And lucky me! Sidney Peerless was my father's client.
Dad even looked so much like Peerless that they played the same joke
every time: Sid put a lab coat on Jerry and sent him down the hall,
where my father poked his head in every exam room and promised, "I'll
be right with you!" Sid and Jerry thought this was hilarious.

But my parents said no. Too expensive. I looked fine.

I whined and wheedled until they relented. Peerless peered inside
my nostrils and discovered his ten thousandth deviated septum, yet one
more of the epidemic of deviant septa sweeping the Jewish community.

This was a kindness to my father. Peerless's diagnosis meant that Blue Cross/Blue Shield would cover my nose, as it were.

I lay on Peerless's exam table and explained that I *did not* want him to tilt my nose upward. I only wanted it narrowed, and please preserve that hook. The doctor's jaw dropped. This was a new one on him. "But you'd be such a pretty girl! Here, let me show you." He picked up a mirror. Gloved fingers pushed my nostrils skyward. "See?"

What I saw was a man with a serious fetish.

I balked: "But if you tilt my nose, I won't look like Cher anymore." It was embarrassing to admit, but I loved when people said, "You're just like a miniature Cher!" This was largely down to my hair, which hung past my waist in a thick, red-black flag. Middle-aged moms and skeezy older guys alike asked if they could touch it. I couldn't do anything about my height, but Cher's profile was within my grasp. I liked looking Jewish. I just wanted to look *elegantly* Jewish. Like Cher.

He sighed, and acquiesced.

I woke up in the recovery room and touched my face; his betrayal was obvious, even under the swaddle of bandages. When the packing and gauze came out, my new nose indeed pointed to the sky like every other Peerless nose. Worse, the damned thing was asymmetrical. Not only did the tip have a rubbery bump the size of a lentil, the whole thing careened to the right. Accident? Intention?

Or—perhaps my body just refused to be normal. To blend in, to be anything other than its own peculiar self. My life would have been different had I listened to that lesson; after all, it was as plain as the nose on my face.

CHAPTER 25

The Red Shoes

The next fall, I went to see my childhood orthopedist, Dr. Perlman, for the first time in years. He wondered aloud why I wasn't wearing my prescription shoes. I explained, happily, that I didn't *need* to. *I was cured!* He scowled and directed me to walk in front of a mirror. Swell. There I was, back at the parallel bars. I was horrified to see myself bobbing up and down and side to side, precisely the way I used to do. Perlman sent me for a fresh series of tests.

At our next appointment, he said, "Mrs. Lehrer, either your daughter's surgeon never performed the required growth plate studies one does before an epiphysiodesis, or he entirely ignored their findings. Growth plate studies are de rigueur. If he'd looked carefully, Riva's would have shown that she had already stopped growing. It was at least six months to a year too late for an epiphysiodesis to have any effect."

I ground my teeth and said, "Wait, no, you're wrong. I walk fine now. The surgery worked, I can tell it worked." Mom looked nauseous. She also wouldn't look at me.

Dr. Perlman spoke with regret. "No. I must insist. It did not." He bent to his desk and got out his pedorthics prescription pad.

All the way home, Mom ranted that she was going to sue Dr. Street if it was the last thing she did. What an incompetent momzer! A schmuck, a schmendrick!—tossing out Yiddish curses like guttural grenades.

That night, she walked into my bedroom and said, "I'm incredibly sorry, honey, I wish this wasn't the case, but you're going to have to give up those shoes. Dr. Perlman says you're hurting your spine. We'll go back to Ludwig's this weekend."

Chorus
1994

I rolled over and faced the wall. I hated her. She'd talked me into this, and now look! I didn't consider how willing a victim I'd been.

Grandma took all my beautiful shoes to the Hadassah Resale shop. I only kept the white sandals with the daisies on the straps. Two years later, I wore them under my prom dress and limped all over the dance floor.

Because of Dr. Street, my scoliosis became much worse. I had stopped wearing lifts at a calamitous moment, when the pressure of my uneven gait was too much for my still-developing spine. I ended up far more curved than I would have otherwise. But even this didn't cure me of my objective: to eliminate the Golem from the Girl.

There Will Be Blood

Mom and I always dressed up for a doctor's visit, it being our version of church. We sat on one side of a desk, opposite Dr. Martin, while Dr. Perlman leaned against the wall. I crumpled the pleats of my sailor dress as Dr. Martin explained that my situation was urgent. Someone had to correct my bones before I reached adulthood. Despite all the surgeries and the lifetime of physical therapy, I still limped.

Problem was, no one in Cincinnati had any answers. Dr. Perlman said that my best hope was a Dr. John Hall at Boston Children's Hospital. He'd invented a new procedure that was effective in cases like mine.

I yelled, "*NO*. Not again. Not after Dr. Street."

Dr. Martin made a bemused sound. Mom was decidedly unbemused. Eyebrows up, mouth down, she wasn't used to my refusing surgery, and anyway, those decisions were her purview. "Riva, be realistic. Dr. Martin is treating you with respect, so listen to what he's saying. This is your last resort. Do you want to be stuck permanently like—this? And consider—Boston could be the answer that lets you wear anything you want."

Dr. Perlman spoke as if I were a much younger patient. Which, admittedly, was the way I was acting. "I'm afraid that your mother is right. If we don't do this now, you really are looking at immense problems in the future."

What I heard was that old siren song. *You could be normal.* And it *still* worked on me. I trusted Dr. Martin and Dr. Perlman; I wanted to run away; I wanted to give in.

I moaned, "Oh God, okay, tell me again . . . what would they do?"

Dr. Perlman said, "Well, the procedure *is* experimental." Mom winced at my doctors. "But here's the problem. If you choose not to do this, you're going to need a Harrington rod operation, the way things are heading now."

I stood up so fast I tipped my chair. Terror lit up my body like a lightning-struck tree. I heard a scream and flushed to realize it was mine.

Dr. Perlman leaned down to right the furniture. Mom knew she'd won. "Do you think your doctors would recommend Boston if they didn't have faith in Dr. Hall?"

"No, I mean, no, I can't end up like Gloria!" Oh God, Gloria, my shrieking hospital roommate. She'd been waiting in the shadows all along.

I screamed in my head: *I AM NOT ALLOWED TO BE ANGRY!* Everyone just wanted me to be *better.* So how could I be angry?

I didn't even know who to be angry at. I sometimes thought that my doctors were only marionettes guided by my mother's intentions. They cut, but she drew the plans.

Mom and I chose pain as a complicated act of love. She chose to refuse the cordotomy that would sever her spinal cord, because it would limit her ability to show love. I let myself be reconstructed so that her worry for me would lessen. Our mutual ouroboros bargain.

After any surgery, Mom would take my hand and say, "Sweetheart, I would do anything in the world to take your pain away. If I could take it into my own body right now, I would. I wish I could ask God to give me your pain instead." Why did she think I'd want that? Why did my mother think I could wish more suffering on her? That I didn't love her as much as she loved me?

But what we expected out of surgery couldn't be the same. Carole Lehrer had had a Before Body. She lay down on the operating table in search of that original body. I had never had a before; I had always been

this. A Golem. There was no other me. Carole remembered what she once had been, but I had no clear picture of what I was supposed to be. There was no previous, preferable me. Only an ever-elusive fantasy.

When I was a child, I thought surgery was a purely medical event. I would learn that surgery is a conversation between your body and the world. Humans use surgery to force one another into a desired ideal. If it's medically possible to push a body toward that social ideal, then we make it a moral imperative to do so.

I hadn't known there was a difference between the cosmetic aspect of the way I walked and whether my limp was doing me any harm. It's still hard to sort out. My scoliosis was never seen as benign. My curvature was upsetting for others to look at, therefore harmful to society, ergo injurious to me.

I gambled my body on other people's visions. I believed that there could be an end to surgeries. That someday, I would be normal enough.

Mom and I flew to Boston over winter break. John E. Hall, MD, was yet another doctor straight out of central casting. White-haired, kindly and incisive, an innovator in the field of pediatric surgery, yet lacking the hucksterish air of Dr. Street. After two days of diagnostic exams, Dr. Hall agreed that I was a candidate for this procedure.

Yep. I was catnip for these guys.

He lightly dug a finger into my left side. "We'll cut a piece of bone off the top of your hip—it's called the iliac crest, let me show you—"

He pressed harder on the spot where my hip would be sawn apart.

"—and we'll cut above the acetabulum, here—"

The finger moved down three inches.

"—we'll turn the bone sideways vertically, and insert it into the cut place. This will position your leg several inches lower than it is now so your legs will even out. This will give you a much more stable gait."

Hall tapped the pelvic X-ray clipped to a light box. "It's called a transiliac limb-lengthening osteotomy. We'll insert a pair of long metal

pins until your bones heal and then remove them a few months down the road." I examined my ghostly portrait, flesh stripped away, inconsequential, revealing my glowing Scheherazade bones.

Whose fantasies were I succumbing to? Mine? Mom's, Dr. Martin's, Dr. Hall's?

Right before we'd flown to Boston, I'd gone for pizza with my friend Michelle. She'd looked up from her plate and asked, "Reev, do you ever imagine what you would have looked like if you'd been born normal?" My slice landed cheese-down on my lap. How could Michelle, one of my closest, oldest friends, not understand that this was the one thing I could never afford to imagine?

There Will Be (More) Blood

A transiliac limb-lengthening osteotomy* had a long recovery time and included extensive physical therapy. Mom and I would be in Boston for months.

To my surprise, my parents started planning the trip as a family vacation. It had been five years since our one-and-only putative vacation in Dayton. Now all five of us were going to Boston to stay in a big-city hotel and tour the sights, courtesy of my fucked-up spine. After Dad and the boys flew back, Mom would stay at a hotel down the block from the hospital.

One month before the trip, the most Cinderella thing happened: Carole's fairy godfather appeared in the guise of a portly, middle-aged retail executive.

Mom liked to wear one of her own creations on the perishingly rare occasions when my parents socialized. One of Dad's clients was a buyer for Lane Bryant women's clothing. He'd met Mom before and always complimented her dresses. They ended up at a dinner with him at which he asked a bunch of questions about her designs. Said he had an idea—give him a week or two, he'd be in touch.

The Fairy Corporate Godfather was good as his word. He called and

* A paper on this procedure by Hall and colleagues. I suspect I'm in there somewhere. https://www.ncbi.nlm.nih.gov/pubmed/389929; https://pdfs.semanticscholar.org/ab26 /e6190382b35194891a608316fea2e4a19b7d.pdf.

offered her the chance to design for the Lane Bryant clothing line. What a miracle! Twenty-two years after she'd been forced to relinquish fashion design, Carole Horwitz Lehrer would work to change how big women dressed. She left a trail of notepads all over the house, full of gowns that swirled with joy and dignity (and, of course, rhinestones).

We left for the East Coast in a state of high excitement—for Mom, for me, for the promise of a real family adventure. As we flew over Boston Harbor, I asked, "Which ocean is that?" Dad teased me for the rest of the trip, no matter how much I groused that I wouldn't need geography in art school.

The Lehrer Five went to the Boston Aquarium with its Giant Ocean Tank, a marvel with foot-thick glass walls twenty-four feet high by forty feet wide. Scuba divers floated through the vertical sea, feeding and petting the sharks, the Jurassic turtles, the schools of luminous fish. Doug was fifteen, and Mark was eleven, both of them taller than me by now. They flung their long legs up and down the spiral ramp, Mom yelling "Stay out of the tank!" and "Don't mow down the tourists!"

She was in heaven once she discovered that Boston had a Chinatown. We followed her broad back as she led us on a moo goo gai pan tasting tour. I was fascinated by the crowds: the interracial couples, the herds of kids not much older than me toting their Harvard Coop book bags, the elderly women in bright sundresses, not polyester pantsuits like back home.

Then it was goodbye, Dad; goodbye, Doug; goodbye, Mark. We will miss you.

Two days after they left, I was on the table again.

Pinch, pinch. *Pinch*. "Riva, waaaaake uuuuppp . . ." Swimmy voices, getting louder. I'm down in the bottomless bluuuee . . . *pinch*. My toes, ow, stoppit, okay, *okay*. Is it over?

I half-opened my eyes. Dr. Hall had a firm grip on my foot and

wouldn't let go until I spoke and wiggled, but speaking led to vomiting and the taste of Those Chemicals resurgent in my throat. "This is the third time you've asked, but yes, you're fine, it all went well," the recovery room nurse said, patiently repeating what she'd already explained.

Then I was in my room, awake. An arcane contraption built of pulleys and ropes held my leg at a 45-degree angle. I hadn't realized that "traction" meant being trussed up like Wile E. Coyote after another self-induced misadventure. I supposed this was self-induced as well. Beyond my leg sat my mother, looking drained.

She stayed by my side day after day. Day after day after day after day after day. *Sheesh, woman, leave me alone.* Except where would she go?

And she was still Mommy, though I called her *Mo*-om in my exasperated teenage rasp. Mommy who brought me sherbet and pudding and kept M&M's in her purse because she knew they were my favorite. Mommy who was there to watch *Mary Tyler Moore* when *"You're gonna make it after all"* started playing at eight o'clock, and who critiqued *M*A*S*H* with me as a fellow hospital professional. Who kept me in magazines and crossword puzzles and Chinese food snuck in after hours. Who, even when I was utterly sullen and resentful, still sent a jolt of *she's here* through my heart each time she walked in the door.

And yet she was also *Mo*-ther. I was seventeen, craving privacy in the least private place in the world, and resenting her for being there without a break for either of us. I was once again reduced to the status of a small child who couldn't even use the bedpan by herself, but I did not want *Mo*-ther wiping my butt. She was once again enacting her routine of befriending every other hospital mother from Autoimmune Diseases to Urology. My room might as well have been a coffee shop, for all the schmoozing and chatting going on around my bed.

And what did they chat about? Their kids. Their sick kids. Me.

"So that night, Riva started running a fever of a hundred and six, and her doctor told us it was going to destroy her brain if they didn't bring it down. I said, 'My daughter isn't going to end up as a vegetable, I'll stay all night and help change the ice packs.' Vegetable, ha! Riva, tell Mrs. Greene what your GPA was last year. Go on."

Mom, stop it now, please.

"Anyway, I guess I'd say I'd be careful, Grace. Riva had an infection just like that when she was six months old that nearly destroyed her b—"

"Mom, please . . ."

"Then, two years ago she began having hemorrhaging cysts, so her doctor did an emerg—"

"MOM! STOP IT!!! This stuff is private!"

She shook her head, confused and affronted. "But . . . this is the hospital. They're concerned. What, you think they're going to call the papers?"

I wouldn't let myself see that my mother was lonely and that these women were *her* ability to cope. Dad and Grandma and Dorie were far away, and she was ready to fall over. There was only my frustration that she couldn't see me as a grown-up.

Many parents of disabled children form a new identity, that of an autodidact expert on their child's condition. This unlooked-for education bestows self-respect and efficacy that buoys them through the grief, the uncertainty and expense. Carole had started out ahead, having had a medical background, but she'd already lost the possibility of art school or a medical career by the time I was born. Being my mother gave range for her ferocious intelligence.

As long as a child is able to self-advocate, there comes a time when a parent should hand over mastery. The child must learn to argue on its own behalf, to comprehend its circumstances and decide what is best for its own body. As the child takes control, the parent should begin to take the role of advisor, rather than director. For some parents, this is an excruciating loss—of status, of control, of centrality. If you think handing over the keys to the family car is hard, try giving up stewardship of your child's vulnerable body.

Mom and I were engaged in just this battle. She received positive benefits from her role as my parent, while my own feelings about my disability were entirely negative. It would be decades before I would find

a political and cultural identity built around disability.* All this to say that adulthood doesn't come easily in the midst of a children's hospital.

And so, during my weeks of recovery, we argued more than talked.

"How many mothers would leave the rest of their family to spend an entire summer a thousand miles away? I do have other things I could be doing, you know. Like getting ready for Lane Bryant." She slumped in my visitor's chair, flipping the pages of *TV Guide.*

"Fine. Why don't you go home."

"And how, pray tell, would you manage without me?" She raised a sarcastic brow. "Do you think the nurses will come running every time you want more juice, or a different novel from the library cart?"

She could tell from my sulky lip that that's exactly what I did think. She snorted. "You're not the sickest girl in the hospital, kiddo. They're not interested in waiting on you hand and foot."

Part of what was going on—for both of us—was chemical. I was swimming through the aftereffects of anesthesia and the current effects of painkillers (and let's not forget teenage hormones). Mom's problem was the exact opposite. She must have had to severely curtail her narcotic intake, since there was no way that she could have staggered through the hallways and still held everyone's respect, not to mention be able to take care of me, however ungraciously I received that care. She must have been in withdrawal and in dreadful pain, unable to scream what I should have known: *Every minute of this is agony for me, you clueless child.*

My response was to develop a case of hospital delirium.

The social worker was in my room, again, listening as I went off the rails. "Please, please, don't make me go home. I want to live here at the hospital. I'll pay rent on this room, like a dorm, you know? I can work in the kitchen. Or for a doctor. I do the filing for my father's office, he's a CPA, I even work his Xerox machine and it's super complicated. Just

* For a thorough and breathtaking discussion of identity and disability, read Andrew Solomon's extensive study, *Far from the Tree,* 2012, Scribner.

please please make my mother go home." I'd move into Boston Chil-dren's Hospital just like Eloise at the Plaza. Who cared if the social worker said it was impossible.*

What happened next saved my sanity, but I still struggle with those events after all these years.

One of my nonphysician caretakers—let me call him Roger, but you'll understand why I can't give his name, or details about his job—began to visit me for professional reasons. Soon, he came by whenever he had a few free minutes. At first, it didn't occur to me that his visits were anything but professional, especially since I was thoroughly repul-sive. I was suffering through three post-op weeks before they'd let me shower, so I was greasy as a cheeseburger, my acne a red, infuriated Milky Way. I'd progressed enough to hobble around on crutches, but I still spent several hours each day hooked up to the torturous traction contraption.

Roger stopped by my room every day as part of his duties. He was gorgeous and funny, and I prided myself on giving him adult conversa-tion (yeah, right) after he spent hours with the littler kids.

One day, as I lay back in traction, he reached out a tentative hand. "Can I touch your hair? It's so pretty. Like a black waterfall."

I nodded a scant inch. He ran a slow palm down the length of it spread across the pillow. "It feels just like silk." After that, I kept my hairbrush within immediate reach.

My physical therapists encouraged me to walk around the grounds and practice my crutches. I'd usually head to the courtyard garden at the heart of Boston Children's. Roger began doing the rounds of the flowers with me when he had free time. I wished I'd brought a better bathrobe.

My skin tingled from the merest glimpse of him in the hall. I watched my doorway hoping he'd pass by. If I saw him with another girl (boys didn't count, nor did girls under twelve), I'd flush from neck to hairline. *Please, come back when I'm alone, or there's no use—I don't want to watch you make nice with Mom.*

* Hospital delirium can happen under many types of circumstances: https://www.ncbi .nlm.nih.gov/pmc/articles/PMC3255198/.

She saw me staring over her shoulder and kept turning around. "What are you waiting for?"

"Nothing." Everything. Roger listened to me complain about Mom until I was hoarse.

One afternoon, he and I were miraculously alone in the garden. And he kissed me. I thought I'd die if there wasn't a next time, but there was: another garden afternoon when he slipped his hand inside my robe, hiked up my stupid embarrassing hospital gown, and reached the edge of my underpants. I had pins in my hip, crutches under my arms, and wasn't able to open my legs. A lot could be done nonetheless, and we did a thrilling amount of it.

A man saw me as a woman. I would have a life as a woman.

Or.

This wasn't long after my bout of hospital psychosis. I was on drugs and sloshing with anesthesia. Which gauzy image is real and which a product of the desperate longing of a teenage girl? I counted myself as (basically) no longer a virgin, but since I was missing a hymen (post-hysterectomy) my body held no "proof." We left Boston soon after, so Roger didn't have to deal with my obsession for long.

If it was real, then I know now that what Roger saw was a vulnerable child who could be molested right under her mother's nose. True, I was seventeen, above the age of consent, but hardly a competent adult. I was as susceptible as they come. In any case, he was involved in my care, which makes this a massive professional violation.

And yet, and I want to make this clear, I did not feel preyed upon. His actions were reprehensible—and yet he saved me. I needed a secret so badly. A secret that let me have walls in my head, boundaries that let me keep my mother out.

But I will never know if he laid his hands on other little girls, girls who did not need to be set apart from their mothers.*

* It broke my heart to hear that the Prouty Garden has been demolished: https://www .bizjournals.com/boston/news/2018/05/17/childrens-hospital-prouty-defenders-agree -new.html.

Weeds
1976

Friday the 13th

July 26, 1975

M om and I had bruised each other too many times for easy heal-
ing, but I was sure that once we regained our normal lives, we'd
be okay. After three months of waiting for the graft to take, Dr. Hall
said it was safe for us to go home.

We flew out on a Friday. Mom was phobic about flying under the
best of circumstances. Even tiny bumps caused her to grab her armrests
with a force that could crush rocks. So of course our plane slammed
into a frightening pocket of turbulence. She kept swiveling to face me
and gasping, "You know I love you, don't you, sweetheart? I love you *so
much,*" to which I responded with a cranky "Mom, knock it off, we're
not going to die!" even though my knuckles were as white as hers.

We reached calmer skies. I badly needed to use the bathroom. I
crutched down the aisle and was halfway to the john when I had the
sensation that my hip was cracking apart. I toppled over in the aisle,
wailing, "It's broken! It's broken! The pins are coming out!" Passengers
shot up out of their seats, but Mom shoved past all the Good Samari-
tans and looked down at me in exasperation. "They are *not* coming out,
that's impossible. Let's get you out of the aisle." The stewardess grabbed
me by the armpits and levered me upright, plainly wondering why this
woman was picking on her poor crippled daughter.

It was late afternoon by the time we landed in Cincinnati, bedraggled and exhausted. I was happy to see Dad and the boys standing at the gate but couldn't muster much of a response to their greetings. Mom looked really rough, like she'd just spent three months in the hospital—which, technically, she had.

The Cincinnati airport is actually in Kentucky (don't ask), so it took hours to reach our house. After a listless dinner, she laid down her fork and said, "The flight really did my back in. I'm going to take some medication and lie down. Don't wake me up. I really need to sleep." She stumbled away from the table, then turned and asked her husband if he minded sleeping on the couch. Disappointment clouded his face—he'd had three months of sleeping alone—but he nodded and said, "Sure, Cissy, whatever you need." Mom shuffled to the bedroom and closed the door.

I thumped my way downstairs, still in pain and afraid that my hip was coming apart. I did not sleep well. It was strangely quiet above my head. My bedroom was right under my parents'. I'd usually hear Mom or Dad get up in the middle of the night to use the bathroom or go to the kitchen. Sometimes Mom made a midnight dinner or watched TV in the living room till the sun came up. That night, there were no sounds at all.

I came upstairs the next morning just as Dad was leaving for work. It was Saturday, but he was never a man to take time off. I asked how Mom was. He replied, "She's still sleeping, I guess. I didn't want to disturb her, so I stayed out here all night." He'd taken his clothes out of the bedroom the night before, so hadn't checked on her since dinner. Dad asked if I needed anything. I said the boys could help if I got stuck, I'd see him later.

It was a brilliant blue day. Hot and clear. Doug left to hang out with his best friend, Gary, a few blocks away. Mark went out to play in the yard.

And then it was two P.M., and I hadn't heard a single sound from the bedroom all day. I stood in the living room, balancing on my crutches, and listened to the silent house.

My parents' bedroom door was firmly shut. I knocked. "Mom? Mom? Can I come in?" No answer.

I turned the knob. The room was colder than it should have been if it had contained a large, sleeping woman. I did not turn on the light. There was a shape in the dark. I faltered toward the bed and put my hand out—

there it is, she is, it, her cold arm. Cold. Her cold stiff arm. My hand will never forget that cold against my palm.

And I think:

I think.

I think, I have to think.

I think, what do people on TV do when they find a dead body?

And the answer comes: they scream. So I scream, I am screaming, and it's so loud that Mark hears me from outside in the yard and I hear him slam open the door and come up the stairs and *no, Mark, no*—

And I am in my mother's room, and she is here, and she is gone, and I am alone.

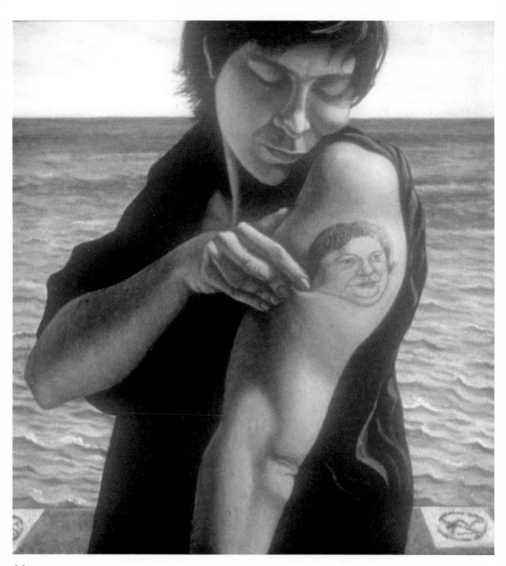

Mom
1999

CHAPTER 29

Armageddon

I

Quick, close the door. Mark can't come in. Must not come in.

Never ever turn on the light.

Stop shaking. There's no time. Back out slowly, take care of your brother.

"I'm sorry, Mark. It's my hip. I gotta go over to Dr. Gniwesch, tell him I need help."

Please go back outside and play, oh please oh please.

Bang, bang, across the sidewalk. I fall against the painted metal door. Someone says come in

my crutch catches on the carpeted steps.

Close the door, Leah, quick, my brother can hear.

She's dead. My mother is dead.

Dr. Rabbi Gniwesch scoffs, "That's ridiculous. I'm sure she's just asleep." The smirk on his face. The black bag in his hand. He holds a palm on his yarmulke as he runs.

. . .

One hundred million seconds. Why didn't I turn on the light?

II

The door swings open. The Rabbi Doctor Gniwesch says, "Son of a bitch, you're right."
 Grief, for one molten second, is lifted away
 and transmuted into hate.

Mrs. Gniwesch picks up the white pages and calls Gary's mother.
 Doug is here. Why didn't anyone tell him to bring Mrs. Freudenthal? He collapses on the stairs, just as I collapsed on the stairs. The Gniwesches' house is a mirror copy of our own.

We are the first bereft.

Someone is outside playing with Mark, distracting him, I don't know who. His turn to know trembles on the clock's minute hand.

I can't move my head. Doug says, "Her name is Dr. Rosen. Elaine, I think." He's remembered the name of Dad's cardiologist. Jack Gniwesch says, "Let's get her out here first, then we'll call your father."
 I am confused—who makes house calls anymore?

III

Here's Dad, baffled, panic rising. Doug takes a deck of cards from his pocket

from his poker game with Gary. He says, Dad, wait, I learned a trick. Pick a card, any card.

And the card my father draws is the Ace of Spades.

Death, what a card.

Dr. Rosen gets out of her car carrying her own black bag. The crashing of waves in my ears. "Jerry, we have something to tell you, but sit down, please, I'd like to give you a little bit of medication first. Just . . . it's for the best." The snap of the buckle on her leather doctor's bag.

I never want to hear the sound my father just made, ever again.

IV

Four of us. We orphans. We widowers.

Grandma is here. Grandpa is here. Doug and Mark and I will go home with them. Forever?

Every human contains the end of the world.

V

That night.

Someone says, "Heart attack." Soon everyone is saying "heart attack."

VI

Weil's Funeral Home. Price Hill Cemetery. Jews bury our dead so fast. It's only twenty-four hours since, can this be right? There is an autopsy, but I'm not supposed to know.

We stand around the square muddy hollow, looking hollow, feeling hollow.

The grave is a movie set.

Dorie at the funeral. "Oh, that's the maid." I know she hears. I rain burning coals on the heads of the crowd.

Carole Sue Doris. Chaya Sarah Horwitz Lehrer. Her name was Cissy, but that's
 not what will go
 on the granite slab.

VII

At the house
 The rabbi gives me a book that has two sections. The first half cites the marriage rituals.
 The second lists the rules for sitting shiva. We cover the mirrors, we tear our clothes.

People bring food. Soon food covers every flat surface. Egg salad on the chairs, egg salad on top of the dryer, bagels left in corners to be found weeks later. We can't wash our hair or bathe
 for a week. Grief smells like festering armpits.

The marriage rituals say that if you have sex, the room must only be lit with a candle hidden behind a tall screen. Another blackened bedroom. The book says cut a hole in the sheet. Maybe someone will want to fuck me if they never see or feel me at all.
 The book says it's a mitzvah to be fucked on Shabbos.

. . .

Mom. We were arguing. We will always have been arguing. Mom I'm sorry I'm sorry I'm sorry I'm sorry I'm sorry I'm sorry Mommy I'm sorry I'm sorry I'm sorry I'm sorry I'm sorry I'm sorry I'm so

Dorie. The crimson rings around her eyes are magnified by her spectacles. She helps
with everything, but people ask her for more help, can you just this, just that. Dorie is a mourner. Not our shiva caterer. You assholes.

My father. He wanders the house. Our house. Who is "our"?

VIII

One week.
Dad. I don't know you, do you know anything about me? You're in charge of my life now?
You?

IX

Grandpa pulls a massive handkerchief out of his pocket when he tries to speak. Carole looked just like him, had his kindness, his taste in jokes, his love of a perfect meal. Grandma
washes and irons his handkerchiefs and puts them back in the bureau.
Grandma is half her normal size.

X

Two weeks later Doug and I come home to live. All of Mom's things are gone. Grandma has bundled our mother's clothing into her car and taken it—somewhere. Do those revenant garments hang on the racks of the Hadassah resale shop? Fannie holds the bulk of Carole's hand-made dresses, garments sized for her daughter's body. An ungainly hug of the remains. A memory, perhaps, of the last time she held her daughter that close.

Fannie is washed gray by grief but she only breaks when Aunt Ollie lays her hand
 on her shoulders. Otherwise, she operates with a brusque practicality. She'd just as soon smash whatever she's holding as clean it or pack it away.

Grandma is furious with Carole for dying. But then, I think, she's en-raged with herself. The morning after Great-Grandma Riva's death, all of Fannie's hair fell out in the bathroom sink. Grief comes costumed when it comes.

I want to reach out, but I'm trapped in my own bitter replay of Boston.
 I'll never be able to fix the damage done by any single word. Grandma and I can't forgive ourselves, so I can't forgive her,
 and I'm sure that Mom told her I did things that needed forgiving.

Grandma says she's packed away my mother's jewelry until I'm a little older. What I wanted were Carole's drawings, but it's too late; Fannie's efficiency has swept through our house
 and left a parade of blanks everywhere we look. As if we can't fill in what had been there
 before it was taken away.

. . .

Doug and I come back to Roselawn, but Mark is living with our grand-parents in Golf Manor. Grandma tells Mark to call her "Mom." Maybe it's wise, maybe it's what an eleven-year-old needs—he has had less of our mother than any of us—but I want to scream *NO*. And possibly punch my grandmother in the nose.

XI

Dorie comes back to Glenorchard. How tiny she is. For years, Dorie and Cissy said they were best friends. What this love meant for Dorie, I will never know. But Cissy endured longer because of Dorie Holiday.

It was Dorie who helped Cissy back to bed during narcosis. Who called Dad during emergencies. Who dealt with the unpleasant physicalities of my disability. Who talked Cissy down after a visit from Fannie. Who reined in my impulses to be ruder to Grandma than I already was. Who reassured my mother that my father still loved her.

Who, besides us three kids, can recognize the depth of her grief?

XII

If it was a heart attack, why are all her dresses gone?

XIII

My family. We spin into separate orbits. We hear our father crying when he thinks we're asleep. Doug is gone with his friends, or he throws things at the walls of his bedroom
 when you piss him off. Which is always.

XIV

The fresh scar on my hip. You left me alone with this. *I'm* the one who's in charge of my life now? Me?

My Creator. My truest Maharal. I am only half-here.

XV

Dad is permanently installed on the living-room couch. The cushions are crushed into the shape of widowhood.

XVI

What I cannot think
It took the end of the world for me to be offered freedom.
To open the only door I was ever going to get. But
when you are a monster, all luck is
Dark luck.
I step through anyway.

PART TWO

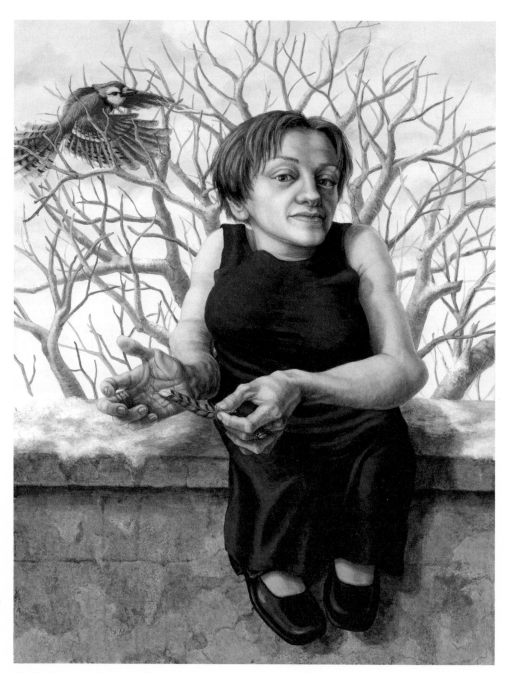

Circle Stories: Rebecca Maskos
2001

The Birds

September 1976

The Sander Hall dormitory of the University of Cincinnati was a twenty-seven-story glass slab that possessed all the charm of a Kleenex box dropped on one end. I gazed up at the twenty-fifth floor, my home for this, my freshman year. Doug staggered along behind me, weighted down with boxes. "Come on, Ving, this stuff is heavy!" I dutifully shouldered my duffel bag and tottered to the elevators.

Each dormitory suite consisted of four bedrooms off a central hall, a multi-stall bathroom, and a minuscule kitchen. I'd share the space with seven other girls. Bedrooms were graced by huge windows that framed a dramatic view of the city. One might be fooled into thinking Cincinnati was cosmopolitan, at least until you found out that every one of those mirrored privacy windows had been put in backwards by the contractor and that boys waited till dusk to spy on the fully lit girls.

I was the only fine art student on a dorm floor teeming with fashion majors. Design students were easily distinguished from painting students by their color-coordinated wardrobes, general cheerfulness, and meticulously groomed, unspattered appearance. This grooming required such a staggering amount of paraphernalia that my own brush and shampoo vanished amid the welter of hot curlers, curling irons,

styling shears, teasing combs, industrial hair dryers, and makeup cases the size of army footlockers. I was a crow among the flamingos.

Mom had been dead a year. I woke up from dreams of falling. My days were full of vertigo and fog.

Senior year at Hillsdale had been surreal. Mom's death became one more thing I could never speak about at school, maybe the reason why the news never spread—or maybe people did know, but no one knew what to say to me. Members of my family came to my graduation, but far as I was concerned I was surrounded by the Not-Moms.

There was no one left to tell me how to take care of myself. I clattered alone inside my body, not even sure what was left of me after all my operations. Mom had been my librarian, my architect, my surgeon general, my curator. She had left me half-formed; for all my teenage rebellion, I was unprepared to take over the task of inventing myself.

Dad did take on Mom's paranoia about my safety and well-being. He wanted me to live at home all four years of college. The Department of Vocational Rehabilitation had offered a full scholarship, materials included, but only if I stayed in town. Dad heard the words "free college" and closed his earholes to all other entreaties—which he had the right to do, considering that he'd worked himself sick paying my medical bills—but this did nothing to forestall my fury. I'd gotten into five good schools—and the University of Cincinnati, which was not. I wanted bright lights and big city and entire state lines between me and Price Hill Cemetery, but the scholarship forced me to let go of Boston University, Cooper Union, the School of the Art Institute of Chicago, the Kansas City Art Institute, and the Cleveland Institute of Art. All the escape hatches I'd planned to fund with Pell Grant money.

Dark luck strikes again.

Home was nothing I recognized. At the center of every room was a silence; as Julie would have said, a Cold Spot. In the quiet, the boys and I could hear our father crying. When we tried to comfort him, he'd turn away, saying, "This is all my fault. I should have been a better husband." His guilt was a mystery to me but immovable for all that. Mark lived

most of the time at Grandma's; Doug locked himself in his room as soon as he came home from—wherever. Who knew? I didn't.

One afternoon that summer, I'd gotten home unexpectedly and spotted Dad in a corner of his bedroom. In one hand he held a sheaf of paper. The other grasped a book of matches. Instinct bade me to stay still. I watched as my father set the papers on fire and dropped them into a metal wastebasket. He jumped when he saw me in the hall.

"Dad, what are you doing?"

"Never ask me that again." Then he got up and closed the door.

Doug and I finished schlepping my worldly goods up to the twenty-fifth floor. He lingered and flirted with my suitemates till I chased him out. I curled up on my bed, grateful for the flamingos as they bounded from room to room, clutching their zip-up portfolios full of Pantone marker sketches. Their soprano chatter banished the quiet in which I might have heard the nothing sounds of a house across town.

CHAPTER 31

Art School Confidential

1976

I was about to start classes in the Department of Design, Art, and Architecture (DAA). I expected (and fervently hoped) that art school would be a hotbed of eccentrics and mavericks, eager to welcome a fellow weirdo. Imagine my surprise: For all its difficulties, Hillsdale School turned out to have been a way more radical bastion of modernity. Hillsdale, at least, had given me four years of study with female faculty and female students. By contrast, the *entire* painting faculty of my department at DAA was male, most nearing retirement, and manifestly unfond of "coeds." Their ideas about art were just as retrogressive. They roundly ignored current conceptual movements, most notably feminist art, no surprise, considering that our department chair was famous for photo-realistic airbrushed paintings of nude women in a welter of purple satin sheets. Had it not been for the lone female art history professor (the marvelously named Jo Face), we'd have assumed that women had been banned from art-making ever since Eve carved that apple with her teeth.

I was, if anything, even more disappointed by my fellow students. The first kids I met had zero ambitions of being the next Andy Warhol; an illustration job at Procter & Gamble or at Gibson Greetings was quite exciting enough.

Plus, I seemed, once again, to be the only disabled kid on campus. Perhaps the only one in the history of DAA.

So what was I doing there? Why had I even wanted to be an artist?

The answer crept in only after the sun went down, after I'd done my homework drawings, after I'd finished the charcoal sketches of apples and coffee cups, the ink studies of wads of fabric, after I'd assembled the spectrum wheel and matched the Josef Albers Color-aid squares. I'd hunch over my desk and make upsetting drawings. Works that I never showed anyone, much less brought to class.

I layered pencil over pastel over pencil in successive chalk strata of ivory, peach, and pink, laid over a jewel-tone substrate of ultramarine and emerald, terra-cotta and crimson. I drew the snarl of veins and arteries, pea green for the liver and pewter for the ribs. I pressed so hard I broke the leads. And in the end, I had a dozen drawings of whales stranded between sea and shore. Whales that lay with a golden beach beneath their heads and a cobalt ocean at their tails, flaccid and insensate, unable to go either forward or back. Sand and sea shone through their bodies. Organs pressed against the pink of their skins.

Were they me, a halfway person without my mother by my side? Or were they Carole, bloated, dissolving, pale as pearls, not alive but impossibly dead?

The answer, as always, was both of us.

The Man Who Fell to Earth

October 1976

He said, "The day I met you, you were wearing overalls."
I protested, "But, Will, I've never owned a pair of overalls."
"I don't care," he said. "They were overalls."
What I do know is, the day we met, we met in the dark.

The lights went down in Zimmer Auditorium. The screen began to
glow with prismatic color. Art History 101 had begun in September,
with the horses of Lascaux running across stone as if on air. Jackal-
headed canopic urns guarded the hearts of the dead; winged lapis bulls
thrust their beards atop the Assyrian gates. Now, six weeks later, we'd
reached the pellucid stillness of the Northern Renaissance, where
painted faces gave off light as if their pigments were ground with fire-
flies. These were my favorite works of all; almost enough to distract me
from the student in the next seat.

My much-underlined *History of Art* by H. W. Janson helped me to
identify him as a Titian, this Italianate beauty, with his elegant half-
moon nose and eyes of a river otter; a princeling whose cheekbones cast
triangles of shadow above his beard, and who, each week, wore a differ-

ent iridescent sharkskin suit. No wonder half the auditorium observed his entrances and exits.

Van Eyck's *Virgin and Child with Canon van der Paele* came up on-screen. A tenor voice breathed in my ear, "Look at those bottle-glass windows. I want to use those in my next house. Think of the patterns they'd make on the floor."

Oh. My. God. The Titian was talking to me. In English!

Which I instantly forgot.

Tongue, O faithless tongue, forsake me not. "Aaaaahhh . . . I'm, er, guessing you're an architecture major?"

"Yeah, second year. What about you?"

"Painting. Though we're mostly doing first-year projects. Which is boring. Thought about majoring in art history, though."

He whispered, "Me too. I love this class. Well, except for the essay questions. I love looking, but I hate reading."

Oh dear. Saying you hated reading was as bad as saying you hated puppies. Still . . . so pretty to look at. Someone behind us hissed, *Shut up.* We stayed quiet until the house lights came on.

My seatmate closed his notebook. *Oh, don't leave.* "Wait—so—why did you take this class, then? Is it required?" Sheesh. I had better repartee in preschool.

"No, I'm actually the only one in my program taking the survey course. I mean, I could take Venetian Architecture for the credits, but this is so great, y'know?" He hoisted a knapsack over his shoulder (his was made of supple black leather—not for him the usual army-surplus pack).

I said, "I always think those slides are like, oh, swimming pools full of color. I just want to float around on Vermeer till I die." I blushed. Mute to pretentious in three minutes flat.

He laughed, a dry downward scale of notes. "My name's Will. What's yours?"

"Riva . . . Lehrer."

"Lehrer, like 'teacher' in German? Cool. I'm in third-year German. I'm applying to co-op in Berlin next year. Anyway, my name is Will

Fugo. Junior, so my parents call me Billy, but don't call me that, okay? I hate it. Hey, wanna grab a Coke?"

Why, yes, I did—and so did Libby, René, and Polly, my friends who had been sitting on either side of us and watching with interest. We trooped off to the Student Union, where all four of us collided in an impromptu round of musical chairs as we vied for a seat next to Mr. Otter Eyes. Will explained that he had dyslexia (ergo that "I hate read-ing"; all was forgiven) and had a dreadful time prepping for exams.

This suffering, we pledged, shall not go unchecked! Our study group was forged over Big Macs, french fries, and each girl's unspoken resolu-tion that she become Study Buddy Number One.

Where Sander Hall was a vertical paean to glass, the Design, Art, and Architecture building was a horizontal hymn to concrete. Our study group took to hanging out in its brutalist stairwell with the blaze-orange handrails, a nowhere spot from which it was easy to scatter in different directions.

I knew I couldn't compete with the other members of our group, much less the hundreds of nubile girls at DAA. I'd barely gotten off crutches in time for college and still could not walk with ease; I wore outfits that covered me so all-over that I could have hidden a marching band inside my sweatshirt. No wonder, years later, Will remembered overalls.

At final exam time we got our bluebooks back and found we'd hauled each other above the B+ waterline. We were comparing papers in the stairwell ("Oh, God, that was Masaccio? I put Mantegna!") when Will said, "I think we should celebrate. Go to the movies Saturday night? They're showing *2001* in the Student Union."

I carefully did not look up. I knew he was talking to my friend Polly, a sly and bewitching pixie who had once taken me downtown to Foun-tain Square and taught me how to scoop up pigeons in my bare hands

and toss them at men in business suits. Who wouldn't be enchanted? Question was, why didn't Polly answer?

I raised my chin. Polly was down on the next landing, talking to René. The person Will was talking to was me.

I stammered, "Wait, what?"

He waved a palm. "Movies? This weekend? You know . . . Hal and the monkeys?"

"Oh. Right. Yeah . . . ?"

He smiled. "Yeah."

And just like that, I had a date. I thought of the boys I'd had crushes on over the years. What did Otter Eyes see in me that none of the others had?

Or perhaps he didn't. Over dinner at Sander, Libby, René, and Polly explained that this was obviously platonic. Not to get my hopes up. If Will was into girls, I wouldn't have been the one he asked out. *Really, Riva, look at what he wears, for God's sake.*

I'd discovered that there were satisfyingly weird people at DAA. People like Polly, who played the ocarina at dawn, and René (proud of her missing French "e"), whose wardrobe consisted of tie-dyed dungarees, tie-dyed scarves, tie-dyed T-shirts, and tie-dyed socks (we avoided asking about her underwear); Libby, pale and fair and shy, until she got wired on vending-machine coffee; and Jan, who'd toured the West Coast as Iggy Pop's girlfriend, riding in stretch limousines with David Bowie. I'd ask her to repeat her stories over and over, like a two-year-old asking for *Goodnight Moon*. The nearly-too-weird was represented by Hubert, a sheet-white child-man with water-parted hair who called himself a necrophiliac and owned an impressive collection of Victorian hair jewelry. I thought he had a crush on Will; Will thought Hubert's crush was on me. In retrospect, he probably coveted both of us for our hair.

Most of the time my own peculiarity went unmentioned. I hoped it passed for just another form of art-school-odd. But then someone

would ask if my tackle box of art supplies was too heavy or if the res-
taurant was too far to walk. I'd retort with a tight-lipped "I'm fine." I
got away with bluffing because my health problems were fairly quies-
cent, even though I still limped and still wore repulsive shoes. Dr. Hall's
transiliac limb-lengthening osteotomy had done fuck-all.

My most pressing problem was that Art School didn't want me to make
art. I didn't know what to do with the peculiar bodies that kept surfac-
ing in my work. My sketchbooks exploded with headless, armless,
heavily scarred men and women whose torsos were rent by gaping hol-
lows. With page after page of hospital rooms infested with loops of IV
tubing that grew from the ceiling like jungle lianas. My professors gave
me no insight whatsoever. I suspected that these drawings were realer
than anything I'd ever done.

Final crits were all-day group affairs. By four o'clock we were punchy
with art overload. At least I wasn't making the creepiest work. The male
students were wont to draw cartoon beasts bristling with scales and
horns and phallic appendages, or pages and pages of melon-titted blow-
up "girls," as if they were all vying for simultaneous jobs with *Playboy*
and DC Comics.

I pushpinned my work to the wall. Bryan, our TA, leaned back in
his chair and gestured with his coffee cup. "Can you explain what you're
trying to accomplish here?"

"I guess, well, you assigned us to work without reference, so these
are stream of consciousness—"

He cut me off. Per usual. "Gee, glad to hear you're exercising your
imagination. But what a waste of time. The drawings are . . . uh, dis-
turbing, I'll give you that, but in the end they take us nowhere." Bryan
sure hadn't said that to James, who'd brought a whole folio of pen-and-
ink sinners roasting in a priapic hell.

I clamped my fingers around the edge of my chair. "Bryan, is there
something else you think I should be doing?"

He smirked. "Your assignment is to find Universal Subject Matter
for your work." I could hear the capital letters. "A viewer is never going

to recognize himself in these pieces of self-indulgence. Yet it's hardly feminine work, is it?"

"What" (in Holy Penis Hell) "is Universal Subject Matter?"

"The themes that civilization has always chosen as basis for great art! Conflict! Think of Rubens's *Consequences of War*." He folded his arms and regarded the ceiling. "And beauty! Ingres's *Grande Odalisque*. I expect something ambitious from you next time around."

Got it. The Universal equated to men at war and women in bed. The fragile human body pertained only to me. Bryan Jones, TA Extraordinaire, had just stripped me of my nascent purpose in becoming an artist.

I unpinned my work with hands that shook so badly that each drawing dropped to the ground. Kids dove under chairs to retrieve the sheets before they were ruined. I surprised myself, though. Instead of sobbing, or quitting, I felt the beginnings of *fuck you* stirring in my soul.

Finals over. Bluebooks handed in. Date Night had inched its way up the calendar. Will said he'd meet me in my suite's common room. I draped myself in blue crepe and rhinestones and brushed my hair like a cat-show Persian. At seven P.M., there was a knock on the door. I flung it open—and was immediately doused from head to toe in shaving cream.

I wiped the goop from my eyes. A trio of frat boys were standing openmouthed in the hallway. "But—but—you're not Laura!"

To their credit, my roommates came running. One girl screeched at the miscreants while another led me to the bathroom, where I wept through a speed shower. I could hear Laura lying to Will: *Riva got home late from her cafeteria job, she's reeeeally sorry.* I emerged in a damp T-shirt and jeans. Will, of course, was dressed for a weekend in Milan. As we crossed campus, he shot sidelong looks at my red and puffy face.

Two hours and twenty minutes later, the Kubrick apes had finished groping the monolith, and I had managed to calm down. Will and I walked back to Sander. It was too late to ask him up to my room (our

RAs being escapees from the local convent), so when we got to the lobby, I raised my face and hoped. Would he—might he—

Nope.

I got a side hug and a "Well, that was fun, we should check the movie schedule next month." I rode up twenty-five unkissed floors to my suite. I really wasn't the right kind of girl—or boy—for him.

I settled into a resigned friendship, happy just to hang out at Will's apartment and help cut foamcore for his architectural models. He taught me to read axonometrics, façades, and floor plans until I could picture the building in my head. His designs were stern and witty: my favorite was one in which he populated the top floor of an Italianate four-story home with rows of stark columns, like partygoers caught in the flash of a paparazzo's camera.

I'd never seen anyone work the way he did. Will couldn't concentrate unless he had the TV nattering away on his drafting table, Kraftwerk blasting from the stereo, all while chewing gum, singing along, and dancing in place. All he needed was a pair of cymbals strapped to his knees and he could have hit the road as a one-man band.

I plied my X-Acto knife while he talked about his last breakup. His girlfriend had cheated on him. This was incomprehensible—but at least the word "girlfriend" hinted that my friends were wrong. Whether Will saw me as a girl was a different question.

One afternoon he asked, "Ever been to that little vintage store off Race Street?" A *no* got me whisked off to a tiny, musty shop crammed with the kind of dresses that had filled my mother's notebooks. Carole's ghost led me straight to a dupioni coat in brilliant manganese blue.

William Fugo Jr. was Pygmalion unleashed. He pulled satin frocks and cashmere jackets off the racks, tossed fedoras onto my head, dropped earrings the size of baseballs into my hands, and pointed an implacable finger toward the dressing room. The mirror reflected my mother's daughter clad in the costumes of her youth.

I bought the entire pile and topped it off with four—count 'em, four—pairs of vinyl go-go boots in neon colors. Will insisted that a shoemaker could add my lift to the boots. I'd learn that when it came to clothing, Pygmalion was never wrong.

He dressed me in tune with my parents' time, but he introduced me to our own time through music. We took breaks from cutting and gluing to listen to *Aladdin Sane* and *Another Green World;* next morning I donated my John Denver albums to the Salvation Army. Everything was more vivid though his eyes. Especially me.

But my feelings for Will were patently hopeless. I went out on a few tepid dates with other boys, and forgot their names even as they kissed me good night.

What Music They Make

July 1977

W hen Will and I first met, he'd just come back from autumn in Indianapolis. The DAA architecture degree was a six-year program that required students to spend half of each year at a co-op job. His next job took him to Washington, DC, though he'd spend little time in the city. The Park Service had him schlepping up and down the Potomac, documenting the locks and dams all along the river. It was hard to picture him anywhere so . . . forested.

Will had been gone a couple weeks when he phoned. "Would you like to visit me here? Half the things we saw in class are here at the National Gallery, it's incredible."

I squeaked, "That sounds nice." Also strange. Did he really want me to come all the way east just to show me some paintings?

It so happened that my Condon friend Julie wanted to visit a pal who'd moved to the Beltway. Julie had stayed up late packing and skipped her shower—and makeup—and contact lenses—and tucked her lank hair under a housewife scarf. When I picked her up before dawn, she had acne cream all over her cheeks and had replaced her contacts with bug-eyed spectacles. Julie amused herself by pressing her face against the passenger window and freaking out drivers all the way

to Washington. Thirteen hysterical hours later, we arrived at her friend's apartment.

The next evening, I puzzled out the Metro instructions that Will had given me over the phone. He was waiting in front of the restaurant. Hope sparkled in my blood.

We dined on crab cakes at a café near the water and went to opening night for *Annie Hall*. The DC audience was a swarm of thousand-dollar suits and hundred-dollar haircuts. At the Metro station, people shouted Woody Allen lines until they echoed off the coffered concrete ceiling. "I lurrrve you!" "I think what we got on our hands is a dead shark!"

Will spoke right into my ear. "Why don't I take the train back with you. It's easy to get lost in the system." At the apartment, I fished out my borrowed key. "We gotta be quiet, but want to come up?"

Anticipating *no*. Hearing *yes*.

Inside, Julie and friend were asleep, but still awake was the other inhabitant, namely the friend's six-week-old unhousebroken kitten. The floor was covered wall-to-wall with soiled, stinking newspaper.

Will and I picked our way across a treachery of cat shit and landed on the couch. Kitten cried *mew mew mew mew* and climbed up my stockinged legs, continuing her ascent all the way to my shoulder, where she latched onto my earlobe and began to nurse. Needles of milk teeth sank into the lobe as far as they could go. Her little wet noises were loud as toilet plungers. I almost missed what Will said next: "There's something I've been meaning to tell you."

Oh no. Here it came. His coming-out story. The bastard had had me drive five hundred miles to explain why we'd never be more than friends. Fireworks winked out in my heart.

I sighed, "It's okay, you can tell me anything."

"I have feelings for you."

He—what? Feelings? For—

Me?

My first reaction was—weirdly—indignation. I wanted to yell, *You idiot! What the hell was your problem all year?* All the times I'd told my-

self I wasn't pretty enough, sexy enough for him. If I'd had any idea, the whole last year would have been different.

Then I actually heard what he'd said. Blood shot from my head to my groin like delirious crosstown traffic. I quivered, "Me too. I have feelings too. For you, I mean. But . . . I thought you only wanted to be friends."

Will shook his head and pulled me in and we kissed for the first time.

His mustache was a bestial shock. Bristles scraped my lip, a sensation so frank, so man-not-boy, so prosaically redolent of crab cake and Marlboros. His body was big and emphatically solid. We kissed and kissed, and then he yiked. Kitten had traveled across our shoulders and was suckling from one of Will's larger, furrier ears.

He whispered he didn't want to leave, so here came the quandary I thought I'd never face: Should I tell him I was a virgin? I heard my mother saying, *We're not even sure you can have sex.* For all I knew, permanent virginity was a side effect of spina bifida. After all, I hadn't quite left my chastity behind in Boston.

I temporized. "Are you kidding? Stay, on this terrible floor? It's so grotty. Your suit'll get ruined."

"Oh, I'm sure the dry cleaner can handle it. But if this will make you uncomfortable, I can go. You have three more days here, we'll see each other again."

"No! I mean, uh . . . if you're sure, it's just I'm not ready to do very much."

"Don't—I just wanted you to know how I feel." He smiled against my cheek. "Really, you like me, too? Weren't you dating that guy, whatshisname, John?"

"Like, once."

"Look, is it okay if we stretch out?" He cleared his throat. "But, um, if you want, I can keep my pants on."

I dug my plaid flannel pajamas out of my suitcase. I really had to get better sleepwear. By the time I came back, he'd cleared away the nearest poopages, switched off the lamps, and lay down on the floor. Kitten rampaged over our bodies, looking for hidden teats.

I'd never had a man on top of me. Will was heavier than I expected. I twisted and turned and moved his hands away from my scars and bony projections. Any minute, he'd recoil and it would be over, but no, and no, and soon heat took over and we slammed together hard enough to erode the nightwear between my thighs.

I woke up next morning with the beard burn and bruising one might expect when sandwiched between a 140-pound man and a thinly carpeted floor. I was still—technically—a virgin, but certain of the imminent demise of my virtue.

That afternoon, I moved to Will's co-op housing, a National Park Service employee bungalow miles from the city but just yards from the Potomac. I acquired erotic strategy by the hour. So much so that when we went to Roosevelt Island for a picnic, I proposed a little practice. We came across a wonderfully secluded glen, and no sooner was my head in his lap than a troop of Cub Scouts burst through the shrubbery. Welcome to your Nature badges, kids.

On our third night, lust trumped fear.

What a fantastical creature Will's body was. The magic trick of the penis alone—supernatural. Morning brought a long hunt for where we'd flung my undies, thrilling proof that I was debauched, for yes, I could have sex, though it was not easy.

My drive back to Cincinnati was an eleven-hour marathon. I parked my orange Civic in front of Michelle's house, where I was staying for the summer. As I stepped out of the car, she dropped the garden hose and cackled, "Oh my God, girl, you got laid!"

It took months for me to trust that my relationship with Will wasn't a mirage. With trust came an overdue appointment at campus health services. They weren't used to couples like us—or, more likely, women like me. The male gynecologist seemed both taken aback and bemused.

No matter. I'd learned that I loved, I mean *loved*, sex. I had no room for thoughts that were not-sex. I got pointy-headed at the sight of Will's

hairy forearms, much less his actual dick. Alas, every time Will and I fucked, it felt as if we were digging a well . . . and not in the good way. There's being penetrated, and then there's being excavated. Practice was not making perfect.

No one's ego survives being seen in stirrups, so Will was banished to the hallway during the exam. The doctor confirmed just what I'd suspected: my childhood surgeons had left a web of cicatrices inside my pelvis. Adhesions that dated all the way back to the day I was born. As the doctor talked, I vaguely remembered a few overnight hospital stays when I was little, times I'd woken up with baffling pain Down There. I supposed these were attempts to clear away some of the debris, but since no one expected I'd lose my virginity, it had been a half-hearted job at best. Or perhaps Mom had advised, *Don't bother.*

I was humiliated at having to go through their removal at this late date. Surely Will would pack up and move on.

Instead, he named me Chen, from *Liebchen.* The beloved one.

Shrek

1977

In my sophomore year, I fled the dorms in favor of a Chavurat (Hebrew for "Friendship House") off-campus, along with seven other Jews who wanted to observe Shabbos and the laws of kashrut. We rehabbed a decrepit house on Emming Street and thereby, inadvertently, established a center for Jewish students from all over the university. Our holiday celebrations were massive events of communal cooking; I once spent three solid days making blintzes, only to see them all eaten in the space of forty-five minutes.

My bedroom was the solarium. Three walls of windows that stayed freezing cold in winter but bathed me in light all year round. Will and I lay entwined on my narrow bed and listened to Dylan albums, working backwards from *Desire* to *Blonde on Blonde*. A perfect picture of college love.

A picture that didn't register with the rest of humanity. Will and I went out on a date at a fancy (for college students) restaurant—linen tablecloths, linen napkins, the whole shebang—when a babe in a slinky gown shimmied up to our table and dropped a slip of paper by Will's highball glass. On it was inscribed a phone number, a name, and *Call me sometime.* Another night, we were holding hands in a movie line

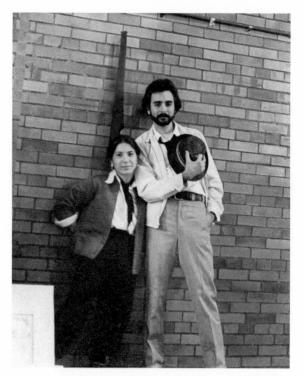

Riva and Will, 1980, at the University of Cincinnati

when the girl behind me said, "No, she must be his sister. Look at her. Look at *him*."

We were starring in our own version of "Beauty and the Beast,"* a fairy tale that tells us that it takes a selfless love to desire an ugly body. *Male* ugliness is not an obstacle: talking frogs and werewolf noblemen suggest that no matter how repugnantly a man may behave, inside every brute is a prince, yet there are markedly few stories in which a beastly woman is revealed as a great beauty (even *Shrek* shows us Princess Fiona as more-or-less Cameron Diaz long before we see the trollette). The female member of the couple *must* be beautiful, at least as attractive as the male, or something has gone wrong in the social order. *La Belle et la Bête* lay under the movie Will and I saw on our first real

* In the original French, "La Belle et la Bête," by Gabrielle-Suzanne Barbot de Villeneuve.

date, *Annie Hall,* another story in which an ugly guy deserved a pretty girl. In fairy tales, the reverse never holds true.

Fairy-tale ugliness is symbolic of evil (or of moral ambiguity at least, e.g., the Beast's behavior pre-and-post Belle). Female beauty symbolizes the purity and morality demanded by patriarchal social structure. (There is too much to say about beauty here, but its relationship to power begs this question: Why would a man, a beautiful man, want to plant his seed in a monster?)

Will and I confuted the myth, so we were invisible as a couple. Even to people who knew us well.

That Thanksgiving, Will's sister Denise got married at a ritzy hotel in Cleveland. Will's uncle Mike sidled up with his own little slip of paper. "Hey, Billy, here's a list of gals you should call while you're home. Get yourself some action, kid." Uncle Mike somehow failed to notice Billy's girlfriend standing three inches away.

During the wedding dinner, Cleveland was hit by a blizzard. The entire party was snowed into the hotel, leaving Will and me all the time in the world to explore the arcana of cuff links and cummerbunds and strapless bras. As we drifted off to sleep, he murmured into my ear, "Chen, I dropped that list in the trash."

Most of my own family treated Will with friendly bafflement, but Grandpa pulled me aside while I was downstairs shooting pool with my cousins. "I know you like this boy, Riva, but if you really care for him, you should let him see other girls." Apparently there had been a family conference: all these people who loved me believed that Will could not.

I couldn't believe that my mother would never witness this unforeseeable love. She would have made it real.

Mais ne nous délivrez pas du mal

1976

Phil Foster, professor of drawing, was a cranky mystic who cultivated his own bamboo forest. Every Monday Phil would hand out three-foot stalks of bamboo. We'd whittle a sharp nib on one end and then draw standing up several feet from our easels, learning to control the stalk with our wrist and shoulder muscles and keep our fingers still.

One morning Phil set up a still-life composition. Not for him the classical marble bust, the vase of flowers, or the skull brooding atop a Bible. Instead, he dumped a cardboard box full of broken objects onto the model stand and grunted, "Draw." I wrangled with his pile of chipped crockery, discarded shoes, and toasters with fraying cords, but I'd never been so glad when break time rolled around. Break time was designated as our "Free Drawing Period," though in reality, it was Phil Foster's Free Smoking Period. He yelled, "Work from your imaginations," and ran out the door.

My imagination had gone on strike after the morning's assignment, but it didn't matter. I knew exactly what I wanted to draw.

I wanted to draw *her*.

She was a sudden addition to class several weeks into term. Agile and lithe as cats' whiskers, Adèle had swept in wearing a black greatcoat with Salvation Army patches on both shoulders. Her work was far more

original than anyone else's in class; Phil would bark "Vogel!" and point at her easel until everyone turned to look at her drawing.

Me, I turned to look at her. Those eyes, that grace, that hair, oh that hair, ten thousand shards of bronze, thick and complicated as an unabridged dictionary.

That day, I taped together four sheets of drawing paper to make a scroll twelve feet long. I dipped my bamboo in my jar of ink and pulled long, tense lines across the paper. Her profile anchored the leftmost border—the softly blunt nose, tapered chin, the heavy plum of a lower lip—as the ends of her hair skidded off the opposite edge. I told myself I was just drawing an interesting-looking person, and that's all there was to it. For her part, Adèle pretended I didn't exist. Her own "free drawing" was a series of languorous, calligraphic arabesques that could have been music, or an alien language, or a portrait of her own hair.

The University neighborhood wasn't very big. I saw her at Hillel services on Shabbos. I saw her at nouvelle vague movie nights at the Student Union. In the art supply store. At the bus stop. In the co-op, filling her bag with raw vegetables. We never spoke.

I went to a Chanukah party at someone's parents' house near school. A curly-haired boy pulled me onto his lap and kept shoving chunks of falafel—and his tongue—into my mouth. I got him to buck me off by dropping a glob of hummus on his ironed Jordache jeans.

Whoops. I couldn't leave without my ride. There were a pair of brocade drapes across the room; as I hoped, they concealed a balcony. The glass doors were locked but the drapes offered a refuge straight out of a drawing-room farce. I slid behind them and prepared to wait the party out.

Then somebody slipped in behind me. Oh, God, that heinous boy had come to harass me with dolmades. I spun around—and came nose-to-nose with Adèle. I hadn't even seen her come in.

Without preamble, she said, "I have to tell you that I'm a little afraid of you."

I replied, "Yes, me too," and had no idea whether I meant her or myself. "I understand if you want me to leave you alone."

Adèle paused. "But you're the most interesting person here."

And that was enough. We hid and shivered as our words steamed up the snow-cold glass, and the partygoers frowned at the giggling lumps behind the curtains.

Adèle and I fell into the kind of absorbing friendship that is the province of small children, until fall of 1977, when Adèle left to spend a year at the Sorbonne and Will left for co-op in Hamburg, Germany. I fixated on the daily arrival of the squat, square mail truck, my new erotic totem, that brought me blue aerograms from Will, filled with poems in his spiky architect's printing—but nothing from her. I didn't understand why my half-empty mailbox made me so much more than sad.

After eight months of silence, a sepia postcard came in the mail, dense with her sibilant handwriting. Dèl had sent me a dream. We were in a boat on a lake, fishing jewels out of the water with only our bare fingers for hooks. I read and reread those few paragraphs for an hour.

And then I was struck by a terrible thought: I was in love.

Oh, but. Oh no. I was *already* in love. Could you even love more than one person? It felt . . . illegal. Not to mention I already had quite enough problems. *Cripple. Weirdo.* And now *Lesbian?* Not now, not when I was savoring my first honeyed taste of normalcy.

It was no use. That word, "love," banged around my brain like a slow concussion.

The Haunting of Hill House

In 1979, Will and I moved into a top-floor apartment on Wheeler Street. We painted the walls, the furniture, the lamps—even inadvertently painted the cat, Gia, his deaf Angora. Gia escaped her carrier and ran across the wet ivory floor, jumped onto the wet orange windowsill and back, leaving a trail of polydactyl pawprints everywhere she went. Our landlord came up just as we were trying to catch the little hellbeast; to our shock, he loved the effect so much that he proposed we dip Gia in latex and let her go berserk.

Will, the radical architect, tacked up strings all along the ceiling in conceptual axes that dictated where we were to place our belongings. I was happy to comply. I loved our apartment, especially the full-sized window in the shower stall. The elm tree right outside the window gave me just enough cover that I could stand nude against the sky for the first time in my life.

We put our studio in what would have been the bedroom, being the kind of people who'd use the best room for art. A trip to a salvage yard yielded a gargantuan industrial light fixture that we bolted to the ceiling. One afternoon, Will yelled at me to stop shaking his table. I swiveled around in my chair and looked up to see that fifty-pound fixture swaying like a pendulum. We grabbed the cat and ran outside, where the street was full of students marveling at the novelty of a midwestern earthquake.

. . .

Every weekend our friends (gay and straight, though at the time no one, I mean *no one*, was out) went to the gay discos, where DJs played music unavailable to the mere record-buying public. The best was Badlands, down by the river, half-hidden among the massive supports for I-75 and I-71. Ohio's sodomy laws had been repealed in 1972, but Cincinnati clubs were still subject to police violence, and it remained an arrestable offense to "express" same-sex interest. Bars and discos were rumored to pay hefty bribes to the cops to avoid being shut down. More than once, we felt a ripple through the crowd as the police pushed through the front door and a queer exodus fled out the back.*

I hadn't really danced since Condon (if you don't count the occasional klutzed Israeli folk dance, and the two hours of wobbled waltzes at my senior prom). But club dancing was another creature altogether. Club dancing had no rules. It was literally impossible to dance wrong. At Badlands, dancing was simultaneous group sex with Blondie and Donna Summer and all six Village People. I surrendered to a thousand heaving strangers; I exaggerated my limp and stumbled and swayed and it was all *fine* because I did it to the beat. Will was thrilled by my abandon.

Sunday mornings, he and I would get up late and hike down Vine Street to Findlay Market, which sat directly across from my grandparents' old drugstore, and come home laden with cheeses and herbs and semolina flour. Will was trying to teach me to cook. He never let me live down the time I filled a pan with two inches of olive oil and inadvertently deep-fried our pizza.

It was an idyllic life, until Will decamped for a co-op in Chicago and Gia and I were left to our own devices.

Our devices, as it happened, were four doors down from Adèle's apartment.

* One of Will's co-op advisors said that the planning commission was going to raze the "gay neighborhood." When Will asked, "What gay neighborhood?" the guy replied, "Oh, you know, all those bars. The city wants them gone."

. . .

For the last year, ever since she'd returned from France, the two of us had become closer (though at times I was overcome with secret sexual turbulence). I had christened her place "the Vogel Museum," a sprawling exhibition based on the principle of horror vacui. Every surface was piled high with shells, feathers, and bones; with rusted springs and broken watches; with scraps of velvet and bright glass beads—fragments that Dèl would wire into jittery icons she hung from the ceiling.

Adèle was a contradiction. A woman whose desire for luxurious experience collided with native asceticism. An appreciator of strong flavors and exotic dishes who'd limit herself to meals of raw okra. She loved opulent fabrics but shopped at the shabbiest of resale joints. Her literary tastes were more consistent. We read together on the damp grass of Burnet Woods: Susan Sontag and Roland Barthes, Angela Carter and Colette. I watched her lips as she read to me in French.

My work was turning turbulent and messy. I covered bristol boards with wet gesso and drew into them with broken pencils. Embedded hunks of plastic into the wet paint and penciled on top of the hardened surface once it was dry. The woman in *The White Drawings* was a stick-thin wraith who played with televisions as if they were marionettes, who set fires, screamed aloud, and raced around in strange machines. Who hid behind transparent curtains and gave birth to shards of glass. The Badlands dancer, flayed to no body at all.

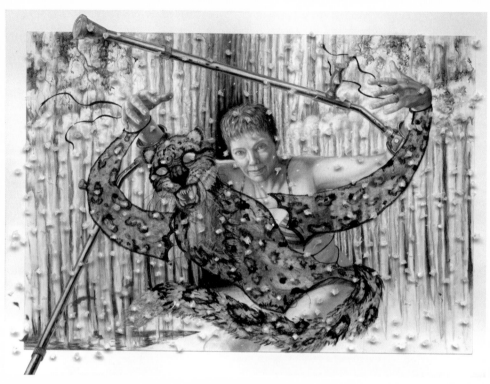

Mirror Shards: Nicola/Snow Leopard (Nicola Griffith)
2013

CHAPTER 37

Suspiria

April 1979

I was about to turn twenty-one. Will was gone again, this time to a spring co-op in Chicago. Adèle and I had birthdays only three days apart, so she invited me for a celebratory dinner. When she opened her door, I saw stars. The Vogel Museum was lit up by candles. Drops of flame in all directions.

She set our birthday meal on the table.

"Dèl . . . what is this?"

"I made sardine soup."

My bowl was afloat with tiny, fragile spines. I gritted my teeth and spooned them up. Dessert was a (happily un-horrific) carob brownie, pierced by one last candle.

I said, "I brought homework. Want to work on our screenplay?" We were collaborating on a script for Hector Curry's film class, on the subject of mother-daughter relationships (Dèl had her own Mama Drama, one of the things that had brought us together). She stopped in the act of clearing the table and stepped toward the far doorway. "No, actually, there's something I want to show you in the next room."

Turned out that that *something* was her white iron bed.

. . .

Dèl pulls me over onto the sheets. I let myself fall. Her hair is a tent around our faces, a bower made with her body alone. Dèl is slow, deliberative, her hand asks wordless questions as she glides up my thigh. She is female in a way I can never be. A different species, watery, insubstantial, as if I could put my fingers right through her skin. Skin that smells of salted grapefruit. Her irises are every color of the forest—umber and verdigris and beech-tree gold. I am made of thicker clay.

I woke up in her bed the next morning. I lay very still and waited for the guilt. I waited while we ate our gritty whole-grain toast and while her roommate muttered a blearily unfazed "Good morning." I waited for guilt about Will, even though I'd discovered that he'd been unfaithful to me while on co-op in Hamburg. I waited for shame to fall like a meteor and leave a smoking crater in the shape of a strangely made girl.

It didn't. It never did. The sky remained a placid April blue.

For the first time in my life, I had deliberately broken the bounds of normalcy. I had let something happen that was difficult and frightening and true about me.

My love for Will had come with the gift of acceptance. I knew that if I came out, I'd lose the only societal approval I'd ever had. Perhaps I felt no guilt because I didn't matter as a woman—not to society, not to my family's expectations of future generations. They knew I was not the one who would produce more Lehrers.

I supposed I was "bisexual," like Bowie and Colette, but that word didn't quite . . . fit. What was closer to the truth was that I had little sense of bodily affiliation. There was a blank where *woman* should fit. Spina bifida forced me to perform being female despite being female. *Woman* was a hard-won costume, real and unreal all at once.

Was I a girl? A woman? Come to that, a human being? Yes and no. Yes by birth and by biology; no by public consensus. No one ever explicitly said I wasn't female, but they didn't have to. I was exempt from everything that "female" meant.

Even now, when I reach for "she," it drips off the table like hot syrup and puddles on the floor.*

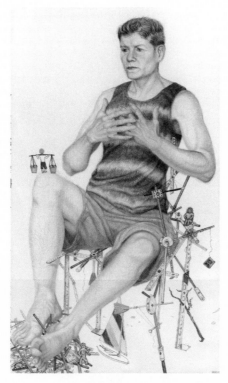

The Risk Pictures: Finn Enke
By Riva Lehrer and Finn Enke
2015

I slipped away to a few meetings of the campus GLB club (we only recognized a stunted three-letter alphabet in those days). Meetings were clandestine affairs located in out-of-the-way rooms in the student center, only identified by a scrawled "HERE" on notebook paper tacked to the door. Dèl pleaded that I keep us a secret, so I stayed quiet. And anyway, what if someone knew Will and outed me by accident?

I knew I was an asshole for cheating, but I told myself it was okay

* I don't use neutral pronouns. My claiming of cisgender, of "she" and "her," is still hard-fought. A costume that is both the truth and a lie. The intersex activist Pidgeon Pagonis recently offered terms for my experience: *Gender Void*, or *agender, genderblank, null gender*.

because Will had confessed to straying while on co-op. He claimed that the others meant nothing. I chose to believe him, since (a) I didn't want to break up, and (b) his infidelity gave me carte blanche to lie my head off. I claimed that Dèl and I were doing homework together when I didn't come back till dawn. I walked a tightrope from roof to roof.

Staying balanced took effort. Adèle and I would make plans, then she'd cancel at the last minute or just not show up at all. I'd touch her and she'd shy away, then I'd find flowers on the windshield of my car and a little ink drawing of a rabbit. Two weeks later, she'd pull me back into bed, then it was hands-off for three months. I'd give up, say *fuck it,* then like an angler, she'd know the precise moment to throw her fishhook handwriting back in my mailbox and her fishhook love back in my mouth.

Twenty-one years old, semi-butch, semi-femme, all defiance

Spring 1980

I should have graduated by the end of my fourth year, but I'd been in the hospital with various illnesses and had had to drop classes. Dad wanted me to stay and finish up, but Will was graduating and itching to start his career. I knew if he left without me, I'd lose him. I was going

to lose either Will or Dèl, but my life with him was more established—and public—which was no small thing.

Being public did have its downside. Will often showed up at my critiques (as I did for him), which led one professor to admonish me, "You're clearly just going to get married. Why bother to even attend school?" Marriage wasn't the issue. I was deeply unenthusiastic about another year of academic abuse. Every fourth-year painting student was required to go through Portfolio Review, during which the graduate faculty would decide whether we'd be invited to apply for the MFA program. I expected to be told that my work was worthless; I was stunned to be awarded the top score. The undergrad professors exclaimed, "We just pushed you so hard because you're so talented!"

I was lucky they hadn't actually flogged me in service of my suddenly conspicuous "talent."

Dad was understandably upset that I wanted to leave so close to graduation. Like the parents of artists the world over, he knew that art school was a rutted road to fiscal success. He argued that getting a degree would help—and I could go for my master's on a full ride! But Will had asked me to go wherever he was bound. The contest was won by youthful delusion, as it always is.

Yet, for all that, had Dèl asked me to stay, I would have stayed. One evening after class, we walked to the park and sat on our favorite stone wall. I asked what she wanted. What she wanted was the man she'd just started dating. A guy whose existence was news to me. That future collapsed like the mirage it was.

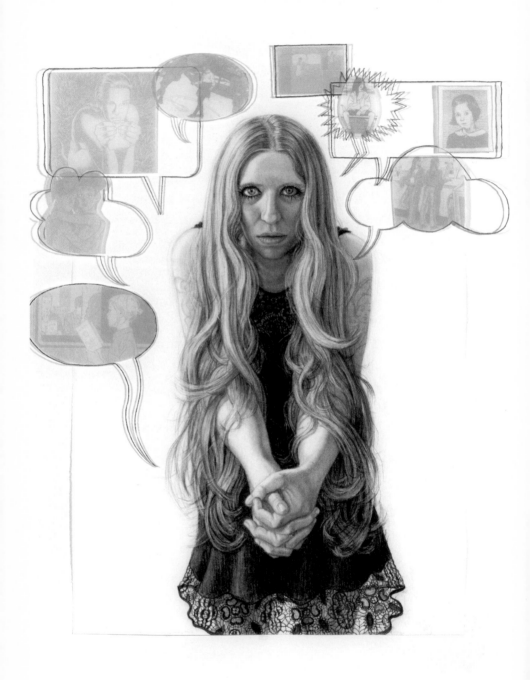

The Risk Pictures: Hillary Chute
By Riva Lehrer and Hillary Chute
2015

Gone Girl

Will and I moved to Cleveland to design the restaurant his sister was about to open in the Flats, a run-down area of downtown. "Sammy's" overlooked Lake Erie and helped to launch the Cleveland revival. Our new home was a loft in the Flats, right above a dance club. After dinner, we'd go downstairs, exhaust ourselves, and stumble over the sidewalk drunks on our way upstairs to sleep.

Toward the end of the summer, Will drove to Chicago to interview at the architectural firm of Skidmore, Owings, and Merrill, where he'd twice worked on co-op. He called me from a noisy pay phone in the Loop. "Chen! I got the job, but I have to start on Monday. I'll stay here and get us an apartment. Start packing."

Will settled into life as an up-and-coming young professional, while I became a lowly retail robot. Our incomes bore no resemblance to each other; soon, neither did our wardrobes. We'd collected (and shared) over five hundred ties, including pleated, hand-painted silk, and rare block prints; now he waffled in front of his tie rack and worried whether his plain red tie was a tiny bit too . . . red. I responded by dyeing my hair in hot-pink stripes (in 1981, pink hair stopped traffic) and by shopping at grungy thrift stores in Boystown. One Friday, I showed up at Skidmore, Owings, and Merrill to meet Will for a round of gallery openings. He ran right past me and straight out the door, panicked that his colleagues would see us together. This was not the man I knew.

Left to right: Will, me, Michelle, and Doug, following
the opening of *Some Girls,* the first show I was ever in in
Chicago. 1981. Also the night I met Hollis Sigler.

By our second year, Will and I had developed separate lives and
separate friends at our separate jobs. I started classes at the School of the
Art Institute of Chicago. SAIC was a different universe from the Uni-
versity of Cincinnati. The faculty engaged with the full range of con-
temporary movements, and had little interest in replications of
white-man glory. The students were politically engaged, and daring.
This was Art School as I'd imagined it.

Will and I still shared a studio, but he became so critical of my work
that I cringed when he leaned toward my easel. I'd recently discovered
Frida Kahlo, and after that there was no going back. Melodrama was
what I needed.

I'd first seen Kahlo's work a few years earlier, in 1978, when I'd vis-
ited Will on one of his co-ops. The Chicago Museum of Contemporary
Art had hosted her first posthumous solo exhibition in the United
States. I'd been swept away by her lexicon, her defiant, wounded pos-
ture, her use of self-portraiture as theater. The show had also left me

distraught. It seemed that whatever I had to say, Frida had already said it, in works such as *Self Portrait with the Portrait of Doctor Farill,* a painting that achieved the precise amalgam of worship, vulnerability, and desire to be seen that I'd felt for Dr. Martin. If I wasn't careful, I'd end up making Frida's work instead of my own.

And as time went on, Will only told me he loved me when he was drunk. Nights, we'd sprawl on the sheets while he sipped through high-balls of Johnnie Walker Gold (*the* approved drink of the Skidmore crowd), and he'd roll toward me, eyes unfocused, and murmur, "Chen, let's get married." I promised myself that if he ever asked when he was sober, I'd say yes, but the next morning, he'd show no sign that he re-membered.

We were losing the war of attrition. I tried to hold on to the belief that he loved me, but oh, that chorus, the voices of my family, his fam-ily, our friends, all those strangers trying to pick him up. All who told me I must set him free to marry, have kids, be normal. It hardly mat-tered that Will never said any such thing.

We reverted to the self-involved firstborns we both were: the only boy and the only girl.

Me, pissy from the sight of shopping bags as he came through the door: "You stopped at Marshall Field's again?"

"I got a new shirt."

"Another? You have so many!"

"It's for that client meeting next Monday."

I parted the tissue paper. A button-down oxford with a subtle grid pattern, just like every other shirt in his goddamn closet. "Do you know I couldn't even afford a newspaper this morning?"

"Yeah, well, I am paying most of the rent. Least you could do is keep this place from becoming a sty. Maybe start by doing the dishes."

"Do I look like a housewife? I pay what I can. It's not like I'm free-loading."

"If I go buy you a paper, will you do something about the mess?"

"Sure, if you throw in a new shirt!"

We couldn't have resolved a conflict if we'd had Dear Abby herself taped to the refrigerator door.

By the summer of 1983, Will and I had been in Chicago for two years. Unfortunately, I hadn't bothered to get a new dentist, so I went home to have my wisdom teeth out. A bad infection ensued and I had to stay a month longer, on antibiotics. Adèle and I fell into our old patterns, albeit with less *go away* and more *come here*.

One velvet night we trekked to the top of Eden Park. Ohio and Kentucky shimmered, divided, on either side of the river. Another park, another river, another attempt to figure us out.

I was out of excuses. It was time to go back to Will.

"I should've called him today."

"Look, R, you don't have to go."

"What are you talking about? Of course I do." I dug my fingers into the ground and pulled up handfuls of grass. The ripping sound was a comfort.

"No, well, see, Peter and Vicky built this loft downtown. Right near Arnold's, on Eighth?" Her words came in a rush. "I'm going to move in next month. I'm pretty sure—I mean, I think there's room for you. If you want it, that is."

"How can I stay here? I don't have a job, and what am I supposed to do about him?"

"Are you happy?"

"Good God, D."

"Then move in with me."

The wind lifted the hair from my neck. I raised my head. Dèl looked like a woman who'd just jumped out of a plane.

She sucked air. "We can be a couple. If you still—"

"*Yes.*"

And as happens with love, my future turned on a single word.

. . .

My train back to Chicago was a nine-hour anxiety attack. I got home and told Will I was leaving in two weeks. He was stunned; I was ashamed that I'd been such a good liar, but then I'd had years of practice with my mother.

I'd wake up and watch him make the morning coffee, feed the cat, and pull that day's suit from the closet, all our normal life until he'd snarl, "When are you going? Hurry up. It can't be too soon." I began to walk to the lake at six A.M. to sit on the rocks. Runners flashed by in their tropical spandex. I didn't come home till Will was on the "L."

We had been together for almost seven years. From the beginning, people had warned me that he couldn't really love me because I was an ugly cripple who didn't deserve him, or Will was gay and I was nothing but his beard. Either I was letting myself be duped or I'd entrapped him through my invalid's selfishness.

The joke was that he wasn't leaving, I was. Seemed I was the gay one after all. I did love Dèl, no question, but what would I have done if I hadn't felt guilty for loving Will?

Adèle showed up with a rental van—and a brand-new boyfriend, John, who was moving in with us, surprise! The three of us tottered downstairs with my past packed in cardboard boxes. Will planted himself on the porch, arms folded tight and back turned to the parking lot. But as I climbed into the van, he nearly jackknifed over the rail to shout, "Chen, I love you! Don't leave me."

I lost it. If at any moment in those last weeks he'd said he loved me, I wouldn't have been sitting in a van with my potted plants on my knees. But—could I even have heard Will's love above the chorus of *he can't really*? I leaned out the passenger window and tried to read his face, wanting to call out, *I needed you to choose me, no matter if the whole world called us Beauty and the Beast. Did you?*

Then the van turned onto the street, and William Fugo Jr., my lovely Titian, was gone.

Graveyard Shift

I had signed the lease long before I'd known we were to be a three-some. Adèle, John, and I moved into a massive red-brick edifice that took up an entire block of East Eighth Street. It had once been a print-ing factory; now the ground floor hosted the Polly Flinders Factory Outlet, a store that specialized in the ginghamiest, puffiest, most berib-boned garments imaginable.

Old friends from DAA—Peter, Vicky, and Liz—had built a warren of rooms on the eighth floor, using drywall partitions that didn't quite meet the ceiling. The smell of ancient ink rose from the floorboards whenever we swept. I slept on a single mattress on one side of a parti-tion; Adèle and John pushed their double bed against the other side of the wall. I heard everything they said and did. And let me tell you, fucking is a lot louder than a whisper.

Dèl and I never touched each other anymore, but I couldn't help but know what her skin felt like under John's palms. John, he of the golden choirboy curls and the boundless self-assurance, of the jars of badly kept corroding paintbrushes, and the acoustic guitar propped against a boombox the size of my car. I ate breakfast and lunch and din-ner with the happy couple. I'd pass around the bowl of lentils and think, *This* is who she chose?

At the first muffled cry on the other side of the wall, I'd head for the freight elevator and ride down into the moonlit city, where cops drove

in repetitive circuits and hookers hung around the jazz bar on Gano Alley waiting for convention center trade. I careened without purpose until exhausted enough to sleep. The night people left me alone. Once, I wandered for so long that I woke up in the arms of a paramedic, wrapped in a sheet and soaked in my own urine. They'd found me passed out by the river just as the sun came up.

I knew I couldn't stay in the loft, but leaving wasn't so easy. Dèl had never explained why she'd asked me to come home nor why she didn't want me to go. Which didn't change the truth that I was the one sleeping on the cold side of the wall.

My body, as ever, made the decision for me. I lost control of my right leg. I told myself I was just tired, but soon it took half an hour to walk a block.

I went to visit Dr. Martin for the first time in years. My sense of homecoming was so intense that I longed to curl up on his exam table and never leave. When he recommended Robert McLaurin, a neuro-surgeon at Jewish Hospital, I felt oddly rejected. Even though I was twenty-five, I'd taken it for granted that I'd be welcomed back into Children's Hospital.

Dr. McLaurin had a face like a saintly basset hound, and looked appropriately mournful as he pricked me all over with a medical basting pin in an effort to rule out multiple sclerosis. Which he thought unlikely, yet still sent me home with brochures titled "Living Well with MS."

He ordered a myelogram, and what a novel experience that turned out to be. The radiologist pushed a syringe through the skin and muscles of my back and injected contrast dye into my spinal canal. This was quite entertaining enough, but when the needle scraped my spinal cord my brain shorted out in a blinding flash of white light.

My films came back positive for tethered cord syndrome. This condition attacks the majority of lipomyelomeningocele patients. In my case, scar tissue from my birth lesion had wrapped itself around my spinal cord and was strangling the nerves to my leg. I needed a "debulk-

ing laminectomy," which sounded like a weight-loss procedure but actually involved stripping the adhesions off my cord, a procedure not unlike peeling dried glue off of wet linguini. McLaurin warned that the surgery could result in paralysis—or death—but could save my ability to walk. On the other hand, I was free to wait until my tethered cord pulled my brain stem through the base of my skull.

I had to make this decision on my own. My mother was gone, Dad was melted down with worry, and Grandma still had unquestioning faith in doctors. I had never been so frightened. Fast paralysis and death versus possible cure versus much slower paralysis and death—I think? Which option was more hazardous? What was a little drag in my gait compared to the risks?

Whatever my feelings for Dèl, staying in the loft was no longer an option. Dad insisted I come back home, to the modest house on Greenland Place we'd moved to after Mom's death. Doug had taken an apartment near the medical school, and Mark had left for college in Atlanta. It was just going to be Dad and me. And silence makes three.

Mom's death was an ice wall between us. Glacial words, unsaid, unasked. What did he feel about widowhood? About the single ladies *d'un certain âge* who were circling him like planes trying to land? What *had* Carole been like when they met? Who was the Carole I'd never known? Who was the Jerry I still hadn't met?

The laminectomy went well, for the most part. I regained the use of my leg but lost some function and sensation. After six months of outpatient rehabilitation, I was stir-crazy, unemployed, and living as a dependent twenty-five-year-old in my father's house. Voilà! My childhood nightmare had come to pass.

As soon as possible, I went looking for a job. Dad insisted that I meet a client of his, a counselor at Jewish Vocational Services. Dad even gave me money for a business suit and urged me to shop at Gidding-Jenny, *the* fancy downtown boutique, an act so unlike him that I nearly called his doctor. I was browsing the racks when a woman planted her-

self at my elbow, checked me up and down, and announced, "If I looked like you, I'd kill myself!"

I dropped my armload of tweed and ran out onto Fourth Street, where I boarded a bus and collapsed into a seat. When I raised my blotchy face, I found myself surrounded by women brandishing Kleenex, clearly wondering if I'd lost my husband, my job, or my marbles.

Nonetheless, the next day I dutifully reported to the Jewish Vocational Services offices. I'd spent all night typing up my one-page résumé, which allowed me to put "typing" on my list of skills. The JVS office stank of Wite-Out, burnt coffee, and Cremora. Dad's pal had the look of a man who hadn't gone outside since the Eisenhower administration. I handed him my résumé and said I'd take anything—retail, waitressing, illustration, daycare, whatever.

He frowned at the pages. Frowned at me. Slapped his palm on his desk. "I can't help you if you lie to me."

"I'm not lying about anything, sir."

"Oh, come on. You can't tell me that any of this is real." He chin-thrusted my résumé. "I'd believe it if you told me you worked stockroom or inventory, but *nobody* is going to hire you to work the front of a store. Your résumé lists not one, but *two* boutiques. In Chicago, no less. You do understand I'm going to check your references?"

For a split second, I actually wondered if I'd hallucinated my employment history. Then I bolted for the door.

I found my own damned job a week later, at the Cincinnati Art Museum, where I peddled the chinoiserie trinkets that accompanied their "Silk Road" exhibition. Every paycheck went into a savings account meant to help me flee town.

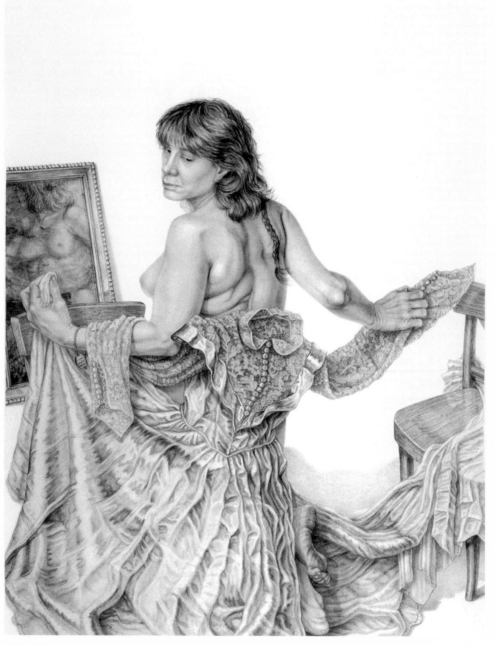

If Body: Dress
2004

The Bride of Frankenstein

By the summer of 1985, I'd saved enough to cover six months' rent, so I Amtraked to Chicago to look at apartments. An old friend, Laurie Lee, invited me over for wine and cookies—and a late-night kiss I didn't see coming. Laurie was adorable, the kid on the Dutch Boy paint can, all big blue eyes and turned-up nose, with a spiky buzz cut in place of Dutchie's yellow bob.

The kiss went where kisses tend to go, and next morning we exchanged fervent promises that this wasn't a one-night stand. Laurie left for her job as business manager at Steppenwolf Theatre, as glamorous as an accounting job ever gets. I grinned all the way back to Cincinnati. Unlike Dèl, Laurie was an unequivocal, storm-the-barricades dyke. She rid me of the skittishness of my own desires, and in the process taught me that you've never been kissed till you've made out with a saxophone player. Embouchure deserves its own chapter in *The Joy of Sex*.

In July, I got us tickets for a one-night lesbian riverboat cruise down the Ohio (yes, it's a thing). She got off the Amtrak carrying a garment bag. I went to take it from her but she pulled away with a flash of dimples. "I don't want you to see what I'm wearing. It's a surprise!"

Well, I had a surprise, too.

I got dressed downstairs while she changed in my room. We met in

the living room, at exactly the moment that Dad stepped in from the porch. He'd picked that day of all days to come home early for dinner. There was I, clad in a tuxedo with satin lapels, pleated shirt, and velvet bow tie. There was Laurie, resplendent in a concertmaster tuxedo complete with tails. Laurie looked at Dad who looked at me who looked at Laurie who looked at—well, anyway, this went on and on until Dad furrowed his brow and ventured, "Gee, girls, are you on the way to a costume party?"

"Yes! Exactly! A friend's birthday party. Er—a costume party, right, Laurie?"

"You betcha, Mr. Lehrer."

"So, you're *both* going as Fred Astaire? Neither one of you chose Ginger Rogers?"

"Gosh, Dad, guess that would've been smarter, huh? But hey, the party's in Kentucky, so we really gotta leave." I tugged Laurie's tails toward the door.

"You gals gonna pick up a couple of live wires on your way out?"

It was Laurie's turn to look befuddled. I whispered, "*Live wires* are *guys*. He means our *dates*." She flushed bright pink and squeaked, "You bet, Mr. Lehrer, it was nice to meet you—"

Our laughter was the escaping steam from a boiling teakettle.

I had never come out to Dad. My brothers and I had a pact: under no circumstances were we ever to do anything that might give Jerry another heart attack. This wasn't mere paranoia on our part. Angina had put him in the hospital on multiple occasions.

When I'd embarked on the process of coming out, I'd lost a few friends along the way, as most queers do. This made me even more afraid of telling Dad or Grandma. But *someone* in the family had to know, so I prepared to out myself to the boys.

After Mom died, Doug barricaded himself behind the posse of gangly nudniks he'd known since high school, a bunch of wannabe Marx Brothers equipped with bongs and a comprehensive collection of porn.

Doug had since entered the University of Cincinnati, where the medical school was far superior to the art school. Doug had since entered the University of Cincinnati, where he first got a degree in pharmacy, then entered med school on an Air Force program. The UC medical school was far superior to the art school. My brother seemed to glide through college, six feet two of poise and talent.

Doug was almost done with residency when I called him to meet for lunch. He'd never dated a lot, so I was surprised and pleased to hear that he had a genuine girlfriend, a Susan Leugers person who had him acting like a summer-stock Romeo. This gave me an opening for my own halting lines: "Doug. I'm . . . Thing is, Doug, I'm . . . You remember Dèl from college? We . . . I mean, that is, not her, but there's this . . . person. . . ." He endured a few interminable minutes before rolling his eyes. "Oh, stop. You think this is news?" Of course he knew. Quasi-twinship was a two-way street.

The prospect of telling my *other* brother gave me the galloping shpilkes. Mark had had a profound religious experience in Israel, one that was leading him away from our loosey-goosey Conservative Judaism into the deeper waters of Modern Orthodoxy. (Soon, he would use his Hebrew name full-time and become Meir.) Doug was kind enough to handle that one; at first, Mark was unfazed and even supported my relationship with Laurie. That would hit a few bumps over the years as he became more observant (though Meir and I have since attained a state of warm rapprochement).

Fannie's health was beginning to fail. Leukemia was stealing her old wild energy. Laurie and I went to visit her one Sunday when she was up for company. Grandma lay under her golden brocade coverlet (so small, how could she be so small?) and took both of our hands in hers. She murmured, "Laurie, dear, I am so grateful you're here to take care of Riva. Meeting you has put my mind at rest. I just pray that the two of you will always be there for each other." We'd just gotten her blessing—but as what? Lovers? Or cripple and caretaker?

. . .

That August, Laurie and I decided to go to the Michigan Womyn's Music Festival. The festival was a world-famous gathering in northwest Michigan where, every August, thousands of women (womyn, wimmin, womben, woman . . .) congregated on a large piece of private property known as "the Land," to camp, listen to music, make crafts, sell crafts, hold workshops, and shop for a new lover, occasionally with the current one in tow. Men were strictly verboten. Straight women did attend, but the Fest was *the* epicenter of lesbian culture, and had launched such luminaries as Holly Near, Margie Adam, Ferron, and Sweet Honey in the Rock. Laurie and I drove the endless hours north, passing an increasing number of compact cars and pickup trucks driven by women with Marine-length hair. That year, 1985, was the festival's tenth anniversary, so they predicted record crowds.*

The Michigan Womyn's Music Festival was populated by every imaginable variation on the theme of Dyke. I hadn't quite believed it when people told me that women went topless (and often bottomless) for the entire week, but indeed, the campground was a seething mass of skin; no doubt I'd be an expert on nipple colors by morning. Laurie left her shirt partly open. The August sun burned a raspberry stripe down the middle of her chest.

We were proud to have erected our small tent in only (!) two hours, and struck out for the chow line radiating the glow of butch accomplishment. After dinner we signed up for one of the (many, many) workshops on body image.

* The Michigan Womyn's Music Festival ended in 2015. In its later years, it struggled in part due to a hurtful policy of excluding transgender women, and allowing only cis "womyn-born-womyn" to attend. Laurie and I had attended in 1985, years before the onset of the exclusionary policy. This decision split the queer community into painful factions. The LGBTQ advocacy group Equality Michigan boycotted the fest in 2014, starting a major conflict between EM and the Human Rights Campaign, GLAAD, and other national organizations. That and certain reported aspects of financial poor planning brought Michfest to a close.

https://en.wikipedia.org/wiki/Michigan_Womyn%27s_Music_Festival

A circle of women sat on the ground. Darkness softened the edges of Amazonian mastectomy scars and the less identifiable cicatrices that bisected bellies and limbs. A dozen women passed a feather around the circle. Whoever held it spoke of their body trauma: Fat shaming. Incest. Rape. Cutting. Anorexia. Breast cancer.

Twilight bathed us blue and primeval. Everyone urged me to take off my shirt. I fingered my buttons, but out of the thousands of bodies on display I'd still not seen one like mine. No one so surgically defined. So orthopedically conspicuous.

The woman next to me placed the feather in my hand. It shivered with my ragged breath. I would have given anything to pull my T-shirt over my head and join their sea of skin, but even in this vast and accepting crowd, I was still a Golem, made from mud, sitting on mud, yet separate from the Land. Separate from humanity.

The moon hung at apex. Laurie and I lay on our blanket among ten thousand other souls. The Perseid meteor shower spilled its magnesium-white alphabet and wrote mysteries across the dark. Ferron sang "Testimony" in a soaring alto. The hair prickled on the back of my neck and all down my arms.

I whispered, "Are you upset that I didn't do it?"

Her eyebrows rose. "Do what?"

"Take my shirt off. In the workshop."

"Why would I be upset?"

"I feel like a coward."

She bit her lip. "All I want is for you to be happy and relaxed. I can't think of another place where there's less judgment about who we are. Isn't it incredible? Just be you, okay?"

"But you must be interested in . . . all those naked women."

"What, are there other women here? I hadn't noticed."

I laughed and pelted her with blowsy dandelions. I'd never know why Laurie accepted my bones and scars, but I believed our luck would stay bright forever.

Laurie and Riva, circa 1986
Photo credit: Chris Gutjahr

Winter 1987

There's an old joke that lesbians bring a U-Haul to the second date. Laurie and I were proud of lasting six whole months before succumbing. We rented the first floor of a house owned by two dyke filmmakers who'd been working on an animated herstory of women for twenty years. Alas, herstory never stopped long enough for them to catch up and finish the film.

Laurie and I had been together for two years. I was working a totally square job as a technical writer. Such a grown-up thing to do. Everyone we knew was coupling up with firm intent. I was twenty-nine. I was ready.

On my lunch break, I called a florist and sent an order to Steppen-wolf: a spray of birds-of-paradise with a note: *Will you marry me?* I chewed my fingers until the very end of the working day, when a secretary dropped a pink message slip on my desk.

Yes.

Wedding plans on a pauper's budget. Wedding plans when one fiancée hasn't come out to her father. When the other fiancée's parents wish she never had. Our wedding was going to be both frill- and parent-free.

But not unattended. Our friends decorated a room at the LGBTQ community center, and distributed orange I WAS A FATHER OF THE BRIDE stickers so that all fifty of our guests could give us away. Laurie's "gown" was a saffron-dyed surgeon's smock (hey, *she* picked it out), and mine was a black flannel shirt imprinted with planets and galaxies. (It was a lesbian wedding. You know there had to be flannel somewhere.) Doug, Mark, and Laurie's brother Rob filled in for our missing parents. They draped us in our tallit and stood by us at the makeshift altar. Our officiant was my former Chavurat roommate Charisse Kranes, now a Reform rabbi. Laurie and I carefully repeated the Hebrew vows and exchanged the very thinnest of gold wedding bands.

The reception was held next door at Leona's Italian Restaurant. Queer weddings were such a novelty in 1987 that the waiters observed us as if we were a floor show, and Mark tried to pick up a pretty server by telling her he'd been our ring bearer. Laurie's musician friends sang and played and everyone danced, but the truth was that though Laurie and I loved each other, the State did not. Despite our best efforts, we were not actually, legally, married.

Left to right: Dora Holiday, me, Doug Lehrer, Susan Leugers Lehrer, and Meir Lehrer, at Doug and Susan's wedding, October 18, 1986

The Tell-Tale Heart

My wedding fell between those of my brothers. Grandma had promised them Mom's wedding china and Mom's wedding ring. I pretended that those things had never existed.

Doug and Susan's wedding was lovely and joyous and hard. I was delighted for them; still, my throat tightened as Susan came down the aisle wearing Carole's wedding gown. I would never have asked to wear it to my own wedding, if only because I couldn't do that to the gown. Half that weighty satin would have lain chopped on the tailor's floor.

A few years later, Meir married Shoshana Nahum, an Orthodox Jew born in Baghdad. I sat on the women's side of the shul and knew that I'd damage my brother's reputation if I let it be known I was queer. A year or so later, they moved to Israel, and eventually had six children.

Just after my wedding, my cousin Diane Stregevsky was set to marry Howard Yasgur, a distant relative of Woodstock Max. Laurie and I drove in for the event.

The synagogue was noisy with familial updates: marriages in need of a little glue, children in need of a little confinement, businesses held together by staples and spit. My father was there with Evelyn, the most horrible of the women who comprised Dad's dating life. (Many years later, Doug told me that Dad said he'd never remarried because he

didn't think he had it in him to cope with another sick wife. That he didn't want to fail another woman. This certainly explained the penitential quality of Dad's choices.)

Laurie went off to use the ladies' room and never reappeared, snagged by some yenta the rest of us would have known to avoid. I saw Doug being his bonhomie self. I sidled up and moaned, "I need a break, boychik. Let's hide."

We repaired to a quiet bench near the drinking fountain and traded the latest alter kocker news: which uncles had had heart attacks, which aunts had which cancers. I said, "Sheesh. Better skip the chopped liver. Between Mom and Dad, we're in the cardiac danger zone."

Doug narrowed his eyes. "What do you mean, Dad *and* Mom?"

"What do you mean, what do I mean? Dad had a quadruple bypass. Mom died of a heart attack."

He straightened up. "You really believe that?"

"Yeah . . . ?"

"Why do you think that Mom died of a heart attack?"

"'Cause Dad and Grandma said . . . oh."

He dropped his voice. "You sure I never told you this? Well, when I was in med school, I went to the medical examiner's office and had them pull Mom's death certificate."

"What? You can do that? Don't you have to be a cop or something?"

"Or, y'know, a *doctor*." He sighed. "Riva, look, it wasn't a heart attack. The medical examiner ruled it a suicide."

I gaped. I was hearing this here? *Now?* "Why—how did they know?"

"The level of drugs in her system was so high that the M.E. ruled it could not have been accidental. There was just too much."

"But . . . we never found a note."

"No, you never turned on the light, right? Maybe Gniwesch did. And Dad won't talk about it. So who knows." We glanced up. Dad wasn't in earshot. "There were more than six different drugs in her system."

My vision went gray as the room turned silver as a daguerreotype and the thunder of Jewish lungs faded to a muffled rumble. There was only Doug, the creases in his jacket, the pattern in his tie. Hieroglyphs

without meaning. I looked around. Who else knew the truth? This aunt, that cousin, those long-ago neighbors?

"Doug, does Meir know?"

He shook his head. "Not from me. He says he doesn't remember much of our childhood. I don't want to push this on him. I sort of assumed you knew."

"No, I—" And then it hit. Of course I'd known. This day, Diane's wedding day, was July 31, 1988, marking thirteen years and five days of rigorous, intentional unknowing.

Our bench was right next to the ladies' room. I ran into a mauve-pink stall and wrecked my makeup. A cousin asked if I was sick. I made myself shrug. "Weddings. You know."

Diane, no doubt, came down the aisle, impish and exquisite as a kitten, satin skirts flaring like a little girl's dream. Howard, no doubt, brought his gleaming shoe down on the goblet under the garlanded chuppah.

I remember none of it.

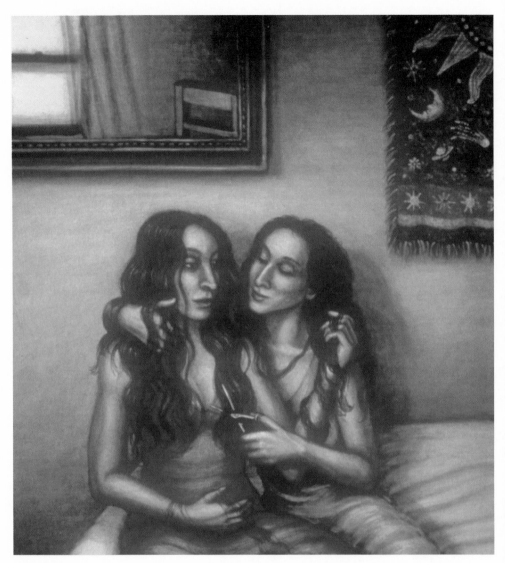

Woven
1993

Picnic at Hanging Rock

At least Doug had broken the news when my life was going well. I had Laurie, I had great friends and a decent job. What I didn't have was an art career. Gallerists still turned me down and curators sent me on my way. Was it really because of my subject matter? Or did my paintings possibly . . . suck?

That did seem the likeliest answer. My painting teacher at the University of Cincinnati hadn't known what to do with me, so rather than talk technique, he'd blathered on about his passion for bagels and where to find them. I, his sole Jewish student, was his designated conduit to all things delicatessen. All these years later, my paintings remained awkward and cartoonish. My drawings were okay, but few artists' careers were built on drawings; the sad truth is that galleries can't charge enough to make the wall space worthwhile.

Maybe more school could uncrappy my work.

I re-enrolled at the School of the Art Institute. On a visit to the museum, I happened on a display case filled with portrait miniatures. I practically left nose prints on the glass. Each small face seemed the condensed spark of a human being. The guard ordered, *step back;* I tried to convey my need to examine every stroke of watercolor on ivory. He was unimpressed, but I'd found my way forward.

By way of a substitute for ivory, I cut dozens of two-by-three-inch rectangles of tin and prepped them with gesso. Instead of gray-wigged

royals, I depicted wild animals and mythological creatures, magicians, ghosts, and sorceress queens. I framed the vignettes in shadow boxes shaped like forests, cathedrals, cloudscapes, and castles. A steel pin back made them wearable.

Red Birth
2.5″ x 3″ x 0.3″

These miniatures let me teach myself the basics of painting in the least intimidating fashion. I was floored when they won me my first professional representation. I took them over to the Ann Nathan Gallery where they were scooped up on the spot. I found myself making a real living for the first time in my life.

Most important, after three years and five hundred eye-cramping paintings, I had acquired a tangible level of skill. It was time to tackle the subject matter I'd put aside for so long.

I began with beds.

Beds are crossroads, where impairment and sexuality intersect, the mattress a palimpsest of ecstasy and hurt. I rarely made sexually explicit

images, but preferred to paint women on the verge of touching, when lightning crackles and desire burns the edge of *maybe* and *oh please.**

I thought they were plenty erotic enough, though, so I was astounded by the contortions that viewers put themselves through in order to avoid seeing lesbians. Even art critics said that I was depicting "affectionate sisters." (On the other hand, I didn't have sisters, so what the hell did I know?)

My models were friends of mine—most were dancers, a deliberate choice. I hoped that viewers would accept paintings of normatively beautiful women, no matter what they were up to in bed. I was still working small; not miniature, maybe eight by ten inches. I said I was trying to create intimacy and mystery, but really, I could only bear to be honest at dollhouse scale.

Honest. Yeah, right. Like I even knew how to be honest. I'd devoted thirty-two years to lying and hiding, mainly from myself.

I began each day with an illusion. My last act before leaving the house was to take off my glasses, put them in my purse, and let Chicago disappear in a smear and a blur. I dodged traffic and baby strollers, dogs and deliverymen, all to ensure I wouldn't see myself reflected in the city's shop windows and plate-glass mirrors. The sight of me literally made me sick.

I kept telling myself I passed for normal. This worked just fine, as long as I avoided reality—specifically, if I avoided other disabled people. Lucky for me, I didn't have any actual disabled friends.

Which had become a sudden problem. I had to find a few disabled friends, like *now*. Not because I sought self-acceptance, nothing as healthy as that—no, this revelation was purely selfish. I had acquired a brand-new and terrifying set of health problems and was desperate for guidance. So I did the unthinkable: I joined the Illinois Spina Bifida Association. Whose picnic, they said, was being held that very Sunday. After ninety minutes of highway driving, I turned to Laurie and asked

* Well, there were those porno illustrations I did for a local lesbo zine.

if we were still in Illinois. Rockford, it transpired, wasn't a suburb; it was a whole other *city*.

At the time, most disability organizations were centered around children and parents, but this ISBA event had been touted as the "adult group." This was not easily discernible. Every last adult was there with their parents.

I walked into a field populated by my own body. All of us short and barrel-chested, all of us limping, leaning on our braces, crutches, and canes, or wheeling our chairs over the grass. In the back of my mind, I'd hoped to find what I'd lost since Condon, but there had been too many years in the trenches of normalcy. I couldn't even remember what I'd had.

Instead, I was rattled, and grabbed on to any proof that I was different—a city dweller and a queer, ergo hip, clad in my leopard-print tunic and black leggings à la Cyndi Lauper. Nothing like the picnickers' beige rainbow of wash 'n' wear. I tsk-tsked to Laurie under my breath. "Bad self-image," I whispered, "or the hell of suburban shopping?"

Our paper plates sagged and threatened to spill the potato salad as we crisscrossed the lawn. Picnickers muttered and stared at their laps, as untrusting as I. A few brief conversations confirmed my worst suspicions. No one had a job, no one was married or even had a sweetheart, and *everyone* lived at home. Laurie and I resorted to talking with the parents, whereupon I turned in a remarkably obnoxious performance, blathering on about my art career and offering to arrange an outing to the Art Institute.

A woman approached from across the lawn. She was my height, my shape, my identical shoes. Said her name was Carole. A good omen, until she glowered at my feet and spat, "Well, gosh, don't *you* walk awfully well in those shoes!"

I laughed, uncertain. "I've had lots of practice." Oh, bad move.

"Don't let my father hear you say that! He keeps telling me I could walk normally if I'd only try harder. *Try harder,* Carole!" She mimicked a sarcastic male voice and stomped away.

Well, I thought, I certainly deserved that.

. . .

I'd believed I could visit the world of disability while holding myself above it. I had no idea how ignorant I was. I had kept myself separate for so long that I knew nothing about the dearth of accessible housing, or how expensive independence was for anyone living on Social Security or Social Security Disability Income. My family had been able to help me out, so I'd never been homeless, even though my own income was below the poverty level. I'd never had to find—or afford—a personal assistant to help me with the tasks of daily living. Nor did I know anything about intersectional identity, or how race, queerness, class, and national origin affected the arc of disabled lives. All the reasons that the picnickers lived with their parents.

Such was my cost of isolation from community. Now I was paying that cost. I was so alone in my body, so unenlightened, that I was afraid I might die of normal, and soon.

Suspension: RR
2014

Nerve Endings

As if in revenge for my behavior, my new health problems mani-
fested themselves on the drive back from Rockford. I developed
such a high fever that we drove straight to the emergency room. One
ultrasound later, I was told I had ovarian cysts—or, quite possibly,
cancer.

The surgery took place a week later, at a Catholic hospital. Laurie
and her mother stood by my bed and waited for me to regain con-
sciousness. A tiny nun-cum-nurse joined their vigil and exclaimed,
"Oh, the dear thing! She doesn't look well at all. The doctors don't think
she's going to make it." Laurie had a conniption; her mother, Laura,
hunted down the head nurse and suggested that the nun be rotated to
duties elsewhere—say, for instance, in the morgue.

My doctor turned up and explained it was a cyst after all. I ran my
fingers along this new slash across my pelvis. A bowl emptied of all but
a few shreds of my gender. The rest had been carted away with the bio-
hazard waste.

Laurie and I didn't get much of a break between crises. Only months
later, my left leg (the first laminectomy had been for my right) began to
drag like a dry-dock anchor. I went in for tests, and as suspected, the
scar tissue on my spinal cord had grown back. Laminectomy number

two was so tricky that it was performed by a pair of renowned neuro-surgeons (that's what Medicare versus Medicaid will do for the disabled body). They saved my ability to walk but took away more feeling and function. I didn't know how to grieve those losses without making my-self unattractive in Laurie's eyes.

We used to visit her mom and stepdad in Boca Raton once a year. They always made me feel welcome, which was why it hurt when I overheard Laura say, "You're spending much too much of your time and energy taking care of this girl. What's left over for you?"

Yet my mother-in-law wasn't wrong. A darkness was edging into our marriage. We were in a new, uncharted country where queer marriage met interabled partnership. I was adept at finding excuses not to do housework, pay bills, or take care of any of the tedious adult stuff that I expected others to do for me. Laurie began coming home later and later. I had paranoid visions of the cute girls in her band and how much cuter she must find them after midnight.

Five years after our wedding, seven and a half years after our first night together, I came home from work and Laurie demanded I move out. We'd never even discussed breaking up. I got in my car and aimed it toward a tree. At the last minute, I swerved and drove to my therapist's office, where I spent the next six hours in a fetal position on her waiting room couch.

It was July 26, 1992, the seventeenth anniversary of my mother's death.

That following November, I made a grief painting—

I stand wet and naked in the heaving blue water of Lake Michigan, pulling a wave up against my chest like a bedsheet made of glass. On the wave is a melting portrait of Laurie's face. My beloved is dissolving back into the undifferentiated ocean of humanity. I can only watch her go.

I called the piece *Aftermath*.

Aftermath
1992

The Picture of Dorian Gray

Chicago, Spring 1994

A year went by. I began to date again. My new girlfriend was on the mailing list for the Anderson Ranch Arts Center. I was flipping through her catalogue when a picture caught my eye. It was a painting titled *Mea Corpa* by Bailey Doogan; I'd seen her work during historian Joanna Frueh's lecture at the College Art Association conference not a month earlier, and had been taken by Doogan's toughness and honesty. The catalogue listed a two-week workshop at Anderson Ranch that summer: "Painting the Psychological Self-Portrait" with Bailey Doogan. My own work had been stalled out for months. This felt like a sign.

Snowmass, Colorado, Summer 1994

Anderson Ranch is a sprawling collection of studios, administration buildings, and cabins clinging to the side of a mountain just above Aspen, itself a virtual Scandinavia populated with statuesque, six-foot-tall blondes and their seven-foot-tall mates, all brandishing skis like Viking spears. (Weird. It *was* summer.) I stood at a grocery checkout and felt like a Hobbit.

The ranch's parking lot was paved with plum-sized gravel, *the* worst possible surface for my orthopedic shoes. I couldn't even get out of my car. A passing carpentry instructor saw that I was stranded, ran to his woodshop, and came back with a rough cane that let me gingerly hobble to the cabins.

I was in line in the cafeteria when a slight and rangy woman appeared at my elbow. Bailey Doogan was all hollow cheeks, tea-brown eyes, and feline jaw; her graying, waist-length braid twitched like a puma's tail. She drawled, "You're Riva, aren't you? I saw you during orientation. Call me Peggy." Over dinner, "Call Me Peggy" told tales from her days as an advertising illustrator on the Morton Salt account, where she modernized the "When It Rains It Pours" logo; later, she showed me drawings of Joanna Frueh as a lewd Umbrella Girl.

Seven A.M. in the mountains. Mist scumbled the hill behind my cabin. I sipped coffee and watched a vixen carry her kits through the beaded grass, then grabbed my box of Cheerios and headed for the dining hall. Cheapo cereal was going to have to sustain me for the next two weeks. I got directions to the converted garage that served as the painting studio. Peggy was taping brown paper over the windows. I thought, That's odd, don't studios need lots of light?

Ten students had signed up for this seminar: eight white women (seven blond, one brunette), one Black male nurse (also from Chicago), and me. Peggy explained the reason for the covered windows. We were all going to take off our clothes and paint ourselves in the nude.

The blood drained from my head as if I'd been guillotined. How had I missed this? Did *everyone* but me know this? The eight white women looked delighted; all that NordicTrack hadn't been for naught. Chicago Guy seemed stoic. Nurses, I supposed, were professionally copacetic with nudity. I'd spent a hell of a lot of effort, time, and money getting here, but no way was I stripping off. The "Psychological Self-Portrait," indeed! Hieronymus Bosch himself couldn't have designed a tidier hell.

I waffled and panicked and waffled some more, even as I claimed

my own easel, taboret, and standing mirror. Peggy went around the room helping people set up.

When she reached me, I pulled her down and whispered in her ear, that for me, "naked" was the seven seconds a day between stepping out of the shower and into my panties.

Peggy nodded a brisk "Right, let's find an answer to this," and helped me devise a cabana out of sheets, towels, rope, and clothespins, just enough space to remove my clothing, as long as I remembered not to lean against the terrycloth walls. I was all too aware that my naked feet with their contracted, *pes cavus* arches were exposed beneath the edges of the towels.

I had nowhere to run. The mirror was inches from my skin. But by day three, I'd simply become a series of abstract problems to be solved, as questions of measurement, color, and texture took over. I became an object, an animal, a subject in need of observation and nothing more. I let my brushwork track the convolutions of scars and the asymmetry of bones.

Peggy circled the studio, instructing and correcting. When she got to me, I muttered, "Wait a minute—sorry, sorry," and threw on my T-shirt and shorts. She couldn't see my body, so could only guess as to whether what I painted was real. Acrylic paint is removed with dabs of isopropyl alcohol; this made my impromptu exam room smell like a hospital.

I stand in a bare room. A torn window shade casts a circle of light. My hands claw the wall. A compass rose flares on my belly. The title is *Corner (Terra Incognita)*.

Terra incognita is Latin for "unknown lands." During the fifteenth- and sixteenth-century Golden Age of Exploration, Dutch mapmakers illustrated the uncharted areas on maps with monsters. Blank lands abounded with centaurs, with dog-headed Cynamolgi, with headless Blemmyes who wore their faces on their bellies, and with Monopods who stomped about on a single, elephantine leg. The seas were full of mermen and mermaids and coiled sea serpents. Monsters were the sci-

ons of xenophobia, warnings that people who weren't *like us* weren't people at all.

It takes me months to finish a painting. In September, I brought the panel, still in progress, to my advanced painting class at the School of the Art Institute. SAIC was several steps up from DAA, but you wouldn't have known it that day. My professor complained, "Your tight brush marks are a form of dishonesty. Let me see your hand *move*. Loosen up, use a gestural stroke! Then you'll really reveal yourself." Showing myself scarred and scared wasn't candid enough for him.

He was wrong. I had no more secrets. I was able to go forward, because I'd done my worst.

Corner (Terra Incognita)
1994

One of Us

I

Chicago, Winter 1996

"I'm sorry, what?" I'd been examining the joystick on Susan's power chair, idly imagining an arcade game featuring pixelated wheelchairs. "You want me to join a club?"

"We meet Sunday afternoon. You gotta come."

"It's nice of you to ask." I sipped my oolong. "But no, I'd rather not."

I'd met Susan Nussbaum years ago, in 1987, when our friend Achy Obejas took me to see *She Always Said, Pablo* at the Goodman Theatre. The director, Frank Galati, had defied convention by casting Susan as Gertrude Stein. We'd only recently struck up a true friendship. I was smugly pleased with myself for finally making a real disabled friend, but that, I felt, was sufficient. Joining something called the "Chicago Disabled Artists Collective" was a very long bridge too far.

Susan brandished a piece of sashimi like a tiny club. "Not giving you a choice, Ree—you *need* this."

Stall. "Tell me again, who's in the group?"

She raised a sardonic eyebrow. "Who cares? You're coming."

. . .

Sunday afternoon, two P.M., a conference room in the back of Victory Gardens Theater. Susan waved me to a seat by her side. Of the eight or ten people arranged around the table, I recognized only one, Bill Shannon, a fellow student at the School of the Art Institute.

The tabletop bloomed with torn bags of Doritos, packs of Chips Ahoy, and shiny cans of seltzer. I smiled, plucked up a cookie, but my legs remained tense as a jack-in-the-box, ready to pop me the weasel outta there. Figured I'd give it a few minutes, excuse myself to the ladies' room and neglect to come back.

But then I noticed a tiny thing. A superficial thing. A crucial thing. A *me* thing.

What I saw was that everyone was *well dressed.*

For years, I'd only seen people like me in the hospital or in waiting rooms—demesnes of the tracksuit, the polyester muumuu and tie-back johnnie, so like the clothing I'd had to wear as a kid, camouflage garments that could have done duty as duck blinds.

These people had zero interest in hiding. The woman sitting across from me was absolutely resplendent in a purple suede jacket and orange feather boa; even her wheelchair was stylish, a low, open design like an Eames chair on speed. A woman at the far end of the table was wearing an actual Red Riding Hood cape. Next to her sat Bill Shannon, outfitted in hip-hop regalia. There was more dress-up in this room than in an entire season on the BBC.

None of it was haute couture. It was *style,* and a refusal to flinch from being looked at. The message was loud and clear and it was "LOOK. WE EXIST." I'd expected to meet a few of my people, but holy cats, these were *my people.*

I was hooked by the attitude, but what made me stay was even more unexpected: I found myself actually laughing. I should have known, as a Jew, that humor grew best in bitter ground, but when it came to disability I'd been a stone-cold curmudgeon. I heard a guy at the far end of the table talking about a recent morning when a commuter had dropped money in his open cup, certain that anyone in a wheelchair

must be begging for alms. Sometimes strangers had chased him for blocks, pleading that he allow them to perform an impromptu faith healing. Soon, everyone was outdoing each other with tales of awful behavior.

A word bobbed in and out of the crosstalk like a cork in a bathtub: "crip." Susan explained that it was a reclaimed word, like "queer." I loved its hard, palatalized edge, both weapon and protection. *Crip. Crip.* I scooped it into my mouth, that night's great prize.

Susan was right. I did need this. She'd invited me into our very own Algonquin Round Table.

II

The Collective wasn't all jokes and Cokes. A lot of what was discussed was political, though a politics that was, at first, nearly incomprehensible. Members spoke a shared language developed through activism, through protest marches and Disability Rights organizations, a universe of advocacy I knew nothing about. I didn't even know that there was a political term for being stared at: This, I learned, was called "aggressive ableism." I'd never heard that term: *ableism.* A diagnosis not for my body, but for my life.

When I was a kid, people said "handicapped" or "crippled." No one said "disabled" unless it was "He was disabled in a terrible car accident." I whispered, "What?" to the guy to my left; he explained that Disabled people were engaged in a wrestling match over what the hell to call ourselves. Some opted for "person-first" language, as in "I am a person *with* epilepsy" versus "I am an epileptic." I wasn't sure if I was a person with a disability (a PWD) or a disabled person. Did I have spina bifida, or did spina bifida have me? We agreed that terms like "handi-capable" were odious, mealymouthed smoke screens. I thought, You can call me "differently abled" the day I wake up with bat wings and gills.*

When I got home, I looked up "cripple" in my mother's cracking,

* If I'd been British, I'd have called myself by the charming appellation of "biffie."

leather-bound dictionary. The root of "cripple" is *crypel,* an Old English word meaning "to creep." "Cripple" is both noun and verb, as if impairment is contagious. For me, "cripple" didn't have the self-possessed snap of "crip." "Gimp" was another word in the reclamation rankings; the dictionary posited that it was a corruption of "gammy," from Old North French *gambe,* or "leg."*

Even the word "disabled" was up for grabs. According to the Collective, "Disability" did not refer to medical status. Rather, "Disability" or "Disabled"† (with a capital D) was the political term for our identity, while "impairment" described the physical, cognitive, or psychiatric conditions of our bodies. My impairment was spina bifida, and/or its neurological and orthopedic effects. Our true obstacle was not how our bodies or minds functioned; it was having to wrangle with physical and social environments that ignored our existence. I'd always accepted that *I* wasn't strong enough, tall enough, fast enough, *enough* enough for the demands of the world. I'd never considered that society derived benefits from ignoring the needs of the Disabled. Self-blame absolved the normate world for its failures of justice.

I had spent years fighting against misogyny, homophobia, and anti-Semitism, yet I'd so easily believed that I *should* be ashamed of my body that I'd never understood that shame was both the product of and tool of injustice. I hadn't just needed Disabled friends. I'd needed friends who could give my experiences context and analysis.

Yet in the thrill of these discoveries, I didn't reckon with the fact that this new consciousness wouldn't stop oppression from being painful. All these years later, I'm still wounded every day. But the injuries heal faster, and fewer things get through the pervious armor I have built over the decades.

* Note to the reader: Just as you'd refrain from using "queer" without asking a person's preference, ALWAYS ask a disabled person how they'd like to be referred to. The choices are much more complicated than "crip" versus "PWD" versus "disabled" . . .

† From here on out, I will often use capital-D Disabled when it refers to the political identity. The same goes for capital-D Deaf, used by those in the hearing-impaired community as a political marker. The use may be somewhat inconsistent, since whether or not the appellation is appropriate can be a hard call, particularly when referring to someone else.

At the heart of disability is imagination. We rethink every act of daily living, not to mention the obligations of a career. Imagination rules our lives. Even after we've reinvented how to shop, how to get to our job, how to *find* a job, our body decides that what you could do on Monday is no longer doable on Wednesday.

Rethinking defined the work of the Collective. I admired the members so much that I could hardly believe that they—like me—had been told that their art was unpleasant and unsalable. The exception being the ever-popular Overcoming Story, in which a cripple (of whatever variety) transcends the effects of their impairments. Make a movie in which a quadriplegic (played by an able-bodied hunk) free-climbs Kilimanjaro with his teeth, and clear room on the mantel for your Oscar. But *realistic* stories—starring actual crip actors—were considered to be box office poison. Little wonder that Collective members wrote and produced their own material. And it was no accident that almost all Collective members were performers: constant public scrutiny does tend to turn you into a de facto performer.

The mid-nineties were a transitional time in terms of mass-media representation of Disability. There had never been a lack of shows with crip characters, from movies like *Wait Until Dark, A Patch of Blue,* and, of course, *The Miracle Worker; Rain Man, Born on the Fourth of July, My Left Foot,* and *Forrest Gump* had all been huge successes. Television had had *Ironsides* and *Longstreet;* more recently, there had been *The Facts of Life, Diff'rent Strokes, Life Goes On,* and *L.A. Law.* However, almost all these roles were played by able-bodied people. Almost all these characters were innocuous, unthreatening, and easily acceptable. The few actors with actual disabilities included Geri Jewell on *The Facts of Life* and Chris Burke on *Life Goes On.* One one hand, it was an enormous breakthrough for disabled people to play Disabled people—and not as much of a change as one might expect. These roles were written to demonstrate that crips could be accepted into the mainstream. They weren't aimed at the Disability community, in order to foster identity, encourage cultural development, or reflect the complexity of our experiences. I can only think of one actor who embodied rage, sexuality, and self-

definition, and that was Marlee Matlin in *Children of a Lesser God*. So when I joined the Disabled Artists Collective, this was all I knew (with the exception of Susan Nussbaum's work). There *was* a rich, nuanced world of depiction in every conceivable medium, but not in the mainstream arts.*

Lack of access cut us off from success in the wider world. Access to venues was crucial. Most Chicago theaters had neither accessible stages nor accommodation seating. The audience didn't fare any better. No wheelchair seating, no ASL or audio description. Accommodation was considered too expensive for small venues and unnecessary for large ones. Performance venues complained that disabled audiences never showed up. Weird, huh?

Art school was built on the conviction that all art was made by able bodies: for example, I was expected to stand up for the duration of our six-hour painting classes (I had to raise holy hell to get a table and a chair). Lockers were inevitably several floors away from our studios. The total lack of disability parking prevented my ability to even get my gear to school.

In addition, most Chicago galleries were located in old warehouse buildings reached via steep flights of stairs. Even if *I* could climb up, I couldn't invite friends, fellow artists, viewers, critics, or collectors with mobility issues. Professionals *still* lectured me against "ghettoizing" myself (their word) and damaging my career. My art was "therapy," rather than an engagement with the history of portraiture.†

The purpose of the Collective was to workshop our performances or to critique visual work, but there was a fundamental divide as to who we wanted our audience to be. Some believed we should develop Disability Culture as a crucible in which we could define ourselves for

* This chapter was based on a conversation with Disability media scholar and performer Lawrence Carter-Long.

† The School of the Art Institute of Chicago has improved since 1996. There are now protocols and methods for accommodation. I've taught at SAIC for almost seventeen years, and have received increasing levels of support and assistance. However, most art schools in the United States still fail to recruit either students or teachers with disabilities, or to offer courses in Disability Culture.

ourselves. Others were focused on overturning the prejudices of the mainstream. I didn't know yet where I fell.*†

III

It was my third meeting with the group. I was snacking during a long argument over Jude Law's character in *Gattaca* and falling into a chocolate coma. Just before blinking out altogether, I glanced at Alana Wallace, the dancer sitting to my left, and my chocolate-addled mind flashed to the night we first met. I remembered the silver-shot hair, the feather boa and purple suede jacket. Then, as if laid on top of that vision, I saw the fur-collared, slashed-sleeved, ringleted Albrecht Dürer in his *Self-Portrait at the Age of Twenty-Eight*.

The next few minutes were hallucinatory. I saw Hans Holbein in Mike Ervin's solid jaw; Rogier van der Weyden in Anna Stonum's heart-shaped face; Leonardo whirlpool-swirling in Susan's mop of curls. Memling, Petrus Christus, Velázquez—each member evoked a different Renaissance portrait. I fiercely wanted to see a gallery filled with portraits of luminous crips.

I suspected I was going to have to make them myself.

* The *Medical Model* frames "disability" as a medical problem, limited to the body of the affected individual. Under the Medical Model, impairment has no political meaning or social context. If you require accommodations, that's your personal problem.

Under the *Social Model,* "Disability" occupies a sociopolitical position, and is the result of imposed barriers that limit one's personal or professional life. The Social Model asserts that mainstream culture is built on (and benefits from) ableism, and from its insistence that impairments are abnormal and undesirable. Ableism is the belief that in an ideal world, all bodies should be flawless, or that they should at least try to be cured. Ableism denies the benefits that disability brings to society, such as conceptual flexibility and creativity. It operates through attitudes and laws that dictate the design of places we live and work and our tools of daily living, and through educational systems that create and maintain these barriers. Under the Social Model, ableism, not impairment, is responsible for most of the obstacles of life in a disabled body.

† Members of the Chicago Collective included Susan Nussbaum, Mike Ervin, Alana Wallace, Anna Stonum, Jeff Carpenter, William Shannon, Kathleen Rose Winter, and Rob Rotman, among others. Other members of Chicago Disability Culture included the playwright and actress Tekki Lomnicki.

. . .

I had always loved the portraits of the Northern Renaissance, brimming with furs, jewels, veils, and torrents of ringlets. Such details demand an investment of time, and time tells us that the subject is worth knowing. The intensity of detail bestows a gravid timelessness; centuries fall away, until nothing stands between us and a face from long ago.*

The faces in Renaissance paintings belonged to the wealthy, privileged elite of their time, but the Collective members were *my* elite. Notwithstanding my enthusiasm, I still had to contend with our shared experiences of being looked at. I was quite aware of our histories of Awful Encounters, of comments we'd gotten on the street, in stores, in waiting rooms, as strangers tried to strip away our surfaces and pry out the diagnostic meat they craved.

Why are you so ugly?

Do you think you were born THAT WAY or did God make you THAT WAY?

Are you gonna die?

If I had to use a wheelchair, I would kill myself.

If I looked like you, I'd kill myself.

Were you, like, one of those kids from Vietnam who was forced to test land mines or something?

Are you a midget?

Well, you're a beautiful handicap! A handicap like you, I don't mind sitting next to at all.

I believe in God and I believe that God heals, so I am going to pray for you.

* Legends claim that Hubert and Jan Van Eyck invented the use of oil paint during the Flemish Renaissance (though they may just have perfected its formula). Before then, painters used egg tempera, in which one lays down thousands of tiny brushstrokes that dry on contact. The illusion of reality is created by skillful transitions from one stroke to the next. Oil paint, by contrast, glides on and stays wet for hours, even days. This allows for smoother blends and subtle effects, permitting realistic illusions that outstripped anything that came before. Unfortunately, I am allergic to oil paint and use acrylics, which behave like a cross between oils and egg tempera.

Can you talk? (Or they only talk to whomever you're with.)

Is she a moron?

Can you have sex?

I support the handicapped because I believe in karma and wouldn't want to come back disabled.

It all began with staring. The aggressive gaze of the examiner. My problem was that doing a portrait entails hours and hours of looking. A portrait *was* staring. I had to find a strategy or I'd subject my collaborators to more miserable scrutiny. It was trial-and-error time: I resolved to start with the Collective member who seemed like the toughest cookie of them all.

Night Gallery

1997

I

Jeff Carpenter had pink skin and a round skull like a grown-up Charlie Brown. He'd performed at my very first Collective meeting, a monologue about the day he was injured. One year earlier, Jeff had been riding his bicycle down Ashland Avenue, when out of nowhere, a car pulled up at a red light and the driver shoved a gun out of the window and shot Jeff in the head. No reason was ever determined. As Jeff lay in the gutter, a *different* someone stole his bike.

The ambulance took him to Cook County Hospital, where the surgeons couldn't save his left eye or do more than a cack-handed job of rebuilding the socket. Now, Jeff was attempting to reenter the dating pool, but romantic evenings came to an abrupt end each time his prosthetic eye fell into the soup.

I was impressed by the quality of ledge-walking about Jeff. Perhaps he wouldn't be easy to hurt. I approached him after a meeting.

"Jeff, got a second?" He narrowed his eyes. Oh, jeez, I thought, he thinks I'm asking him out on a date. I hurried on, "I wonder, would you be interested in posing? For a painting, I mean?"

His brow scrunched in confusion. "Is this a joke?"

"I don't mean . . . Not like a life model. A portrait. You'd keep your clothes on."

"What? I don't get to be a centerfold? I'm crushed."

I tried to appear harmless and stern, like a high school librarian. "Jeff, you would stay *dressed*."

He shrugged. "Sure. What do you have in mind?"

Circle Stories: Jeff Carpenter
1997

He came to my house a couple weeks later. I expected lots of shtick, but he put the comedy on hold when I asked about his family's reaction to the shooting. His knee jounced like a one-legged tap dancer's; any minute he was going to bounce himself right off my couch.

"We grew up in this church that tells you that when something bad happens, you must've brought it on yourself. My parents kept asking

what I'd done to cause this. That I must be a really terrible sinner, because there's no way this was an accident. They didn't even come to town to see me in the hospital. Not till it was all over."*

His story left me sad and speechless, and suggested no images whatsoever, no way to enter Jeff's story. I flailed around and trashed a couple dozen sketches—but one should never underestimate the power of insomnia. One night I was lying in bed, examining the dark, when my mind said, *This isn't hard, just listen to what he told you,* and from some biblical recess of my brain rose a vision of Jacob and the Angel. And Jacob morphed into Jeff; and Jeff wrestled with an invisible adversary who might not be there at all.

We walked to St. Ita's Church, two blocks from my house, a neo-Gothic splendor plopped between a pet supply store and a cellphone bodega. I unpacked my camera; Jeff was a beautifully frail mortal set against Ita's soaring columns, but then the priest spotted us, and taking us for troublemakers, cast us out of his vaulted Eden. Jeff and I trooped back to my place, where I substituted the medieval carvings on my newel-post for our lost ecclesiastical glory.

I knew that Jeff taught improv classes; still, the hair rose on my wrists as he summoned his Angel. An immensely strong creature who pushed him against the oak railings and forced him down on the carpet. Jeff was overpowered; the Angel pinned his wrists; Jeff's shirt spiraled around his torso, a coat of many colors.

Over the next weeks, I sketched the underdrawing for his portrait. And there it was, the truth: I was a horrible perceptual realist (art-school-speak for "is crap at painting things so they look real"). This was a big, big problem. Disability is all about variation. I *had* to depict bodies as they actually were, otherwise the viewer would assume that nothing I depicted was real. In Jeff's case, the issue was that his eyes were

* I can't locate Jeff Carpenter to check on the accuracy of these memories. My apologies for any misrememberings and errata.

asymmetrical: the left socket, which held his glass eye, was significantly lower than the right. His face had to be convincing, or the whole point of doing his portrait—of disability portraiture—would be lost.

Realism also precluded much in the way of formal invention, for instance, I couldn't employ loose brushwork, or any kind of distortion, à la Alice Neel. Perceptual technique came with some pretty hefty restrictions.

And then there was the whole flying-church debacle.

I'd painted St. Ita's Church in the window behind Jeff's head, but my friend, the painter Tim Lowly, pointed out that I'd portrayed the church as if it was hovering in midair. This was due to my childhood problem: I could see perspective, I just couldn't replicate it. I told Tim to consider it just another midwestern miracle.

Four months later, I gritted my teeth and phoned Jeff, saying, "Come over, it's done." I loaded the kitchen table with pecan rolls and walnut brownies in preemptive apology for my skills.

Jeff stood in silent confrontation with his own painted face. It's never easy to see yourself through another's eyes. He turned and gave me the gift of a lie. "I *think* I like it." Then, "Do I really look like that?"

I wanted to say, *No, you're better looking than that,* or *No, I'm not good at this yet,* but saying so would only make it harder for both of us. A portrait subject has to have faith in the result, or the image becomes their very own Dorian Gray. I chirped, "Everyone thinks it's extremely impressive!" and handed him a brownie.

I brought *Circle Stories: Jeff Carpenter* to the next meeting and fought not to be flattered by the enthusiasm. I knew it had less to do with the quality of the work, and more to do with what I call mirror hunger: the longing for a reflection one can claim as one's own. Jeff's portrait—awkward as it was—was neither sentimental nor grotesque, not a charity poster, freak-show banner, monster movie still nor medical photograph; not a piece of political agitprop that used disability to make the "other" more frightening. All the funhouse mirrors that aren't fun at all.

His painting became the first of a series: "Circle Stories," named for the wheel of a wheelchair, for the universal symbol of impairment, and for the Collective, my circle of safety. And whether or not I was a bad painter, I *could* give people control over how they were portrayed. These works weren't commissions. Technically I needn't obey anyone's wishes but my own, but this work actively demanded a collaborative ethics of representation.

So I started by listening. A portrait began with days, even months of conversation. We spoke honestly about the relationship between our bodies and our work, after which I'd go home and make thumbnail sketches based on what my subject had said. We adjusted the sketches again and again until we agreed on an image.

II

Bill Shannon was a student at the School of the Art Institute. He called himself "the Crutchmaster" and was notorious for zipping around the Loop on a skateboard, using custom-made oval crutches to push off and steer. Bill's movements were so graceful that people would sniff that his crutches were just an affectation. He performed on the streets around the Art Institute, pretending to fall down until someone bent down to pick him up off the sidewalk, whereupon he'd sweep them into an impromptu waltz.

He invited me to meet him in Wicker Park at the high school playground where he practiced his choreography. Low afternoon light sent Bill's shadow arcing across the walls. I saw a languid *David* spinning on crutches, Icarus on aluminum wings.

Bill came to my studio. I ping-ponged between jittery flirtiness and inappropriate medical questions ("So, this thing with your hip sockets . . ."). I have a vague memory of asking to feel his knee, though God knows what excuse I offered at the time. His physicality left me shaken. Making a portrait can feel like falling briefly, if abstractly, in love.

I worked in black-and-white, a complicated amalgam of charcoal, chalk, gouache, soft pastel, and colored pencils, each a different textural shade along the monochrome spectrum. The paper furred up and nearly tore under all the slashing, erasing, and blotting that the image required.

When someone lets me do their portrait, it's because they imagine who I am and how they'll look through my eyes. At the same time, I imagine that I can explain them to the world. It's a shared illusion. Delusion. A *folie à deux*. We imagine that I'm representing my subject with accuracy, even though no matter how detailed and objective I try to be, no one can capture the reality of a human being. A portrait is only a fragment.

For most of my life, I had glanced at impairment and looked away,

Circle Stories: William Shannon
1997

afraid to see myself. Now I looked slowly and deliberately. I let the sight come to me. And beauty arrived.

This was a beauty I couldn't name. It startled me and didn't, was familiar and unexpected. I remembered how it felt to love disability back at Condon School. I'd rejected that love ever since. "Normal" beauty is unmarked, smooth, shiny, upright; but my gaze began to slip past normal beauty as if it was coated in baby oil. I wanted crip beauty—variant, iconoclastic, unpredictable. Bodies that were lived in with intentionality and self-knowledge. Crip bodies were fresh.

III

Two portraits down. I asked Susan Nussbaum to sit.

We slid open the glass door to her balcony. Traffic roared like a mechanical ocean. Slices of Lake Michigan played hide-and-seek between the buildings.

She shouted over the wind. "You know what I hate more than anything? Idiots who say that things happen for a reason. People like to tell crips we're part of some grand plan, like we should be grateful that God gives us wisdom in exchange for all our glorious suffering."

I squinted into the brightness. "You don't believe in meaning?"

"What, like religion?" Susan laughed, incredulous. "Don't tell me you believe in God."

Did I? When I was a kid, I believed in God the way children do. There had been no precipitating crisis that made me lose my faith—I still vaguely expected to find God at the back of a drawer someday.

I sighed, "Not anymore, I guess. I assume you don't?"

She snorted hard enough to rattle her earrings.

"Then what do you want your painting to be about?"

"Ree, is there any way we can show that reality is arbitrary and unstable? I just don't believe that the Earth is some galactic self-help manual so that humans *learn* and *grow*."

I knew the origin of at least some of her worldview. A random event had changed the course of her life. In the 1970s, Susan had been a rising star at the Goodman Theatre's School of Drama. At the age of twenty-four, she'd been walking to class on Monroe Street when a car hit a patch of icy winter road, spun out of control, and jumped the sidewalk—and then Susan was a quadriplegic. She fully intended to continue her career, but no one in film, TV, or theater cast disabled actors for any roles whatsoever (such characters were and still are routinely played by able-bodied actors, in a manner referred to at times within Disability as "cripping up," that is, mimicking—often wrongly—

Circle Stories: Susan Nussbaum
1998

the physical and behavioral aspects of a given disability, in order to demonstrate the actor's amazing skills).

Disgusted, Susan chose to write her own material.

In 1992, I went to see her solo monologue, *Mishuganismo,* on being a white Jewish woman obsessed with Latino men and Cuban politics:

"I've already envisioned the inevitable desolation and black void existence I will lead after Miguel breaks my heart. That is, if we ever do get together. That's the mishuganeh part. Imagining how miserable you're gonna be before you even get to the part where you're actually happy."

I painted Susan on her balcony, amid a rain of falling objects— a shoe, a compact, a pencil, a burning wheel—each a symbol of who she was before the accident, and who she was now. The building across the street from her balcony implodes in a cloud of greenish dust.

When I brought her the finished panel, she leaned forward and exclaimed, "I love it! You got my gimpy hands just right."

IV

Years earlier, I had had a brief liaison with a woman who'd lost a leg in a mining accident. She was smart, political, a shtetl Lorelei. I was smitten—right up until she said that we belonged together because no one else would take us. We were too disgusting for normal partners. This was too much for even my crappy self-esteem.

Still, such was my view of crip romance until I met Mike Ervin and Anna Stonum.

Mike was a playwright and essayist who attacked ableism with enough sarcasm to power a nuclear reactor. He'd been a 1960s Muscular Dystrophy Poster Child and wrote essays that mercilessly and hilariously skewered Jerry Lewis. I was shocked. I'd been raised to consider Jerry Lewis a virtual Jewish saint, and had never considered the ways that his telethon dehumanized its little targets of charity.

Anna Stonum had designed the famous ADAPT "Evolution" graphic: a parade of silhouettes that trace the stages from apes to modern human. The last person sits in a wheelchair, below the slogan "Adapt or Perish."

Mike and Anna, both artists, both activists, and both married— to each other. I watched them during meetings and longed to ask about how it felt to be together, but when I was near them I lost my tongue. They were an answer to a question I didn't know how to ask.

I emptied my bookshelves onto my living room floor in search of marriage portraits. Van Eyck, Rubens, Lotto, Ghirlandaio . . . but when I closed my eyes, what I saw were the covers of romance novels. Whirlwinds of hair, windswept skirts, manly muscles bulging through ragged pirate blouses. An unexpected template, perhaps, but I'd seen Anna and Mike's own language of communion, the way she would take his unmoving hand and put it on her own arm or leg. The kind of automatic intimacy that exists between any couple. Nothing special, just two people in a marriage. Which was the point. Mike and Anna were not each other's consolation prizes.

Circle Stories: Mike Ervin and Anna Stonum
1998

I approached them to pose for a double portrait. They seemed as wary as if they'd never seen me before. Nonetheless, at the next meeting, they said yes. They'd roll into the tempest just for me.

The storm was real. I caught them just before the lightning struck the ground. A year after our collaboration, Anna Stonum died.

V

I practically worshipped Hollis Sigler for the beauty and bravery of her paintings. She had made her early career on images of lesbian desire (at a time when this was still a risky endeavor), but by the time I met her she was famous for an entirely different—and difficult—subject: decades of life with breast cancer. Hollis was the only contemporary artist I knew of who dealt with both impairment *and* queer erotics. In 1993, I made a pilgrimage to Washington, DC, to see *The Breast Cancer Journal: Walking with the Ghosts of My Grandmothers,* at the National Museum of Women in the Arts. I spent several days at her 1999 retrospective at the Chicago Cultural Center, watching as women inched through the exhibit with their hands stuffed with Kleenex. Women who'd come back an hour later with a companion in tow. *See,* they'd say, *do you understand now?*

After my trip to DC, I wrote a nervous postcard and invited Hollis to meet me for lunch. I managed to drop the silverware and knock over the water carafe, but Hollis must have been a fan of slapstick because she hired me for teaching jobs, recommended me to curators, even sent her San Francisco gallerist to see my work.

Hollis's cancer kept returning, just at the same time that my kidney problems were dominating my life. We took to calling each other from our respective hospital rooms. By 2000, she was on continuous chemotherapy. Her doctors said no more breaks.

My chance to do her portrait was fading, but Hollis was an artist, and artists understand that images outlast our bodies. Her *yes* was one of the most generous gifts I have ever received.

It is thirty-two miles to Prairie View, Illinois, to a house half-hidden in the pines, and behind that house a garden that twinkled with fairy

lights all year long. Hollis had lived there with her longtime partner, jewelry designer Patricia Locke. I'd first visited Prairie View a few years back and had been thunderstruck by Hollis and Patty's life, their houseful of dogs, their beautiful art, beautiful furniture, beautiful clothing, jewelry, flowers; even the glowing indigo of their night sky seemed more luminous than that over my own roof. They were my icons of non-sporty lesbian chic. I was devastated when they broke up.

Now Hollis lives alone. The garden has been converted to raised beds that she tends from her wheelchair. She names the sprigs: basil, carrots, purple columbine. "I'm afraid I planted the broccoli too early. It's so hard to know when winter is over."

I whoop, "Persephone!" startling us both.

"Sorry, I'm lost. What are you talking about?"

"I need to paint you as Persephone. Right at the moment when . . . uh, when the seasons turn." Dusk has turned us into silhouettes, but her soft laugh says she knows perfectly well which turning I mean.

I set up a small version of my studio in her studio. The side of her face glows white in the clamp lights. Her assistant, Joe, gently ushers me out when he sees her flagging.

Circle Stories: Hollis Sigler
2000

. . .

I get on the highway as a full moon rises in the eastern sky. I have to pull off. I've never told anyone that the face in the moon is my mother's face. The moon changed the year she died. There is no more distant comfort than Carole's face hanging in the void.

I paint faster than I ever have. Holly's face waxes in Hades's cave of night. Except I know that she's waning. And that the sky doesn't care how much I pretend.

I unload the panel from the car. Holly gazes at Persephone, caught between the distant spring and the tunnel of winter. Pomegranates lie split and bleeding their seeds—breasts exploding their bounds. She strokes her finger across the stalagmites and stalactites. "It's wonderful! There's so much to look at."

Four months later and I'm driving out to Prairie View, not to paint but to help where I can. We are a team of people taking care of our friend, though I'm on the periphery, lacking the ability to do much more than fetch books and glasses of tea. An afternoon comes when she's in more pain than I've seen before. I blurt, "I love you, Hollis," as if that helps anything at all, and she gives me a glance of sheer exasperation. "Yes, I know." She's had it with me. I am still and always a motherless daughter.

March 29, 2001. The springtime earth takes its due. Hollis leaves me the purple velvet suit she wears in her portrait. I keep it in the cedar trunk that belonged to Grandma Fannie, nestled against her Purim costumes of eighty years ago.

VI

By the time I reached the end of the *Circle Stories* project, I'd painted a total of ten portraits: Jeff Carpenter, William Shannon, Susan Nussbaum, Tekki Lomnicki, Brian Zimmerman, Mike Ervin and Anna Stonum, Hollis Sigler, Rebecca Maskos, Eli Clare, and myself. This work brought me face-to-face with my ethics and capacities as an artist and a human being, with all the difficulties, painful mistakes, and confusions along the way.

I tried to address the needs of my collaborators, but at the same time, I still had to contend with the formal questions of art. To wrestle with the effects of light and shadow, of hue and value, even as I held my subject's ego in my hands like a lump of warm strawberry preserves.

Circle Stories: Tekki Lomnicki
1999

. . .

Viewer reactions to *Circle Stories* reminded me of the misreadings of my lesbian works. I learned that paintings are perceived differently depending on whether one assumes that the subject is disabled or able-bodied. A distorted perception I call a "pain reading."

Viewers seem to imagine that the disabled body is constructed of pain. That for crips, pain is not temporary, it is our essential nature. Pain is often seen as truer than joy, or pleasure, or any other emotional state. A positive picture of a crip is often read as a compensatory response to pain, that is, the subject may appear to be happy, but they are actually overcoming hidden misery.

I first encountered "pain reading" when I exhibited *Circle Story: Tekki Lomnicki,* at my 1999 solo show at Lyons Wier Gallery. I depicted Tekki as she is, a radiant and welcoming human being. I couldn't believe it when viewers said, "Oh, the poor thing! She looks so happy! But isn't she a dwarf?" As if being a Little Person precluded any happiness. I listened in despair as Tekki's joy was twisted into pathos.

The Woods

I met Eli Clare in March 2000, at my first Disability conference, held at the University of Chicago. Eli read from his memoir, *Exile and Pride,* describing a childhood in a Pacific Northwest logging town, where Eli was the target of bullying, threats, and violence. The forest provided refuge for a young queer poet with cerebral palsy. He later wrote, "I had to learn / the muscle of my tongue." Eli challenged ideas about what is "natural." Disability was *natural,* as was queerness, and neither were in need of correction or eradication.

I saw him again when the Society for Disability Studies conference came to Chicago that July; then, in January, 2001, Eli had a gig at the University of Chicago, finally giving us time to sit down and talk. I didn't have many friends who were as rigorous as Eli. He took nothing I said for granted, and revealed to me my own misapprehensions and ignorance of others' realities. When Eli visited my apartment, I crossed my fingers and told him how much I wanted to work together.

In July of 2001, our serious collaboration began. We trooped off to the Caldwell Woods Forest Preserve for a photo shoot. The woods were green on green on green, a retina-blast of ten thousand greens. My eyes were thrilled, but my skin was not. Caldwell was hotter and stickier than it was by my lakeside neighborhood, and worse, the news was full of horror stories about Lyme disease and West Nile virus. I kept slap-

ping at my body like a bongo player, making Eli shake his head at my urban wussy panic. When he gestured to a cluster of fawns across the stream, I erupted with an imaginary bull's-eye rash.

Back at my apartment, it was time to sketch. Eli offered an idea.

Circle Stories: Eli Clare
2003

"You want to . . . embrace a tree?"

"Yeah, maybe a Sitka spruce?" He said that the northwestern woods were composed of many varieties—we could think about Douglas firs, or red cedars, and I said I'd find a good book about trees. I imagined him in the woods, able to hear his own thoughts and finding the poetry waiting to happen.

But then I realized what "tree" might mean for our picture. "Oh, gosh, Eli, think of the proportions. You're either going to end up a teensy little figure next to an enormous tree, or you'll be wrapping your

arms around a huge section of trunk. You might play second fiddle to a hunk of bark."

"Well . . . how about if banners with my poems on them weave in and out of the trees?"

"I'm afraid that would look like cartoon balloons. Or captions." I scribbled a picture of poetry floating through the trees. Eli picked up the sketchbook and sighed. "Huh, maybe not. But what about just the words themselves? As if they're floating on the wind . . ."

Things that work beautifully as poems often make dreadful pictures. My job was to translate from the verbal to the visual.

When Eli stayed with me, I couldn't wait to hear him stir in the next room, for him to rise from my foldout sofa for breakfast so that we might dive into our marathon-session conversations. Personal history, literary philosophy, and debates over queer desire, all the entanglements with crip identity. How to deal with your own wounds while staying receptive to other people's pain—a thing I was far less good at than I had fondly imagined. We spoke about the terror and risk of letting a lover touch our bodies. I said things I'd never told a single other soul. I was a different person by the time I dropped him back at the Amtrak station.

But meanings multiplied so fast that they washed away any single picture. Months elapsed while we failed to come up with an image for his portrait.

One night, we got off the phone and an idea came to me. I pulled *Bulfinch's Mythology* down from the shelf and turned to the Greek myth of Daphne and Apollo. Daphne, a naiad, is pursued by the god Apollo. He is about to rape her when she calls out to her father, Ladon, the river god. He transforms Daphne into a laurel tree so she can escape assault. In *Exile and Pride,* Eli writes of his experience of sexual violence; an experience that informed Eli's lifelong activism.

I roughed out a sapling that was both Eli's body and his lover. Thin branches burst through the neck of his shirt; red leaves trembled to the rhythm of his tremors. A slender trunk snakes beneath his clothes and channels him to the quickening earth.

Eli came to Chicago and sat by my easel. I'll never forget his intensity as he gazed at the verdant lover cradled in his arms.

I learned to render the light on rippling water, the difference between sunlight on a leaf and sunlight through a leaf. Two and a half years after our initial sketches, I applied the last dabs of green paint. My lover, Brian, wrapped an arm around my shoulders and gave me a little shake. "It's done, babe. I'm taking you out for dinner."

Thus concluded the *Circle Stories* project. All ten portraits had their premiere at the Chicago Cultural Center on March 26, 2004.

I Know What You Did Last Summer

In 2002, Eli Clare, Corbett O'Toole, Alison Kafer, and other queer crip academics and activists organized the Queerness and Disability Conference at San Francisco State University. I was invited to present a lecture on the *Circle Stories* project.

I was light-headed with excitement. I was heading toward my island, where every single person would be like me. All queer! All crip! Five days of mutual understanding.

And the conference did start off as a glorious adventure. The weather was Hollywood-perfect; we popped in and out of one another's rooms like characters in a Wodehouse farce. There was a swimming pool in the middle of the campus; the sight of so many alluring crips made me dizzy.

But by the second day, it became obvious that Queer Cripdom was not the seamless community of my naïve daydreams. People of color were raising concerns that the field of Disability Studies was dominated by white academics and activists. The conference organizers were all white, which was seen as the precipitating factor of the dearth of attendees and presenters of color.

I gave my presentation the second day. When I opened the floor to questions, a Latinx woman (who had been a Chicago Collective member), stated her belief that I had deliberately snubbed people of color in the *Circle Stories* project. I tried to explain that I had invited two

women of color to participate, but that major scheduling conflicts had bollixed our plans. This explanation was met with more anger. I didn't understand the reactions as fatigue with white supremacy, and instead interpreted it as a personal attack. Others joined in with questions about the absence of people with invisible disabilities. I dissolved into tears of confusion. A friend stepped up and guided me off the podium.

The Risk Pictures: Lauren Berlant
2018

Once there is the possibility of equitable representation, exclusion opens an even deeper wound.*

At the time, I didn't know how to respond. I was one of the only people doing this work. I could not force anyone to sit for me, only invite, and sometimes it worked and sometimes it did not, for a million complicated reasons. I could not publicly discuss the circumstances that led to a failed collaboration, or disclose who was on my list for future portraits. All I could do was to examine my own failures of attention.

I had arrived in San Francisco on a Wednesday. I was leaving on a Sunday. I'd flown west in the naïve certainty that I'd find a home in the world. I winged east knowing that sanctuary was the wrong destination. Five days on my imaginary island had taught me that my ethics of portraiture—my understanding of the other, *any* other—had a long way to go.†

* As a result of the conference, Eli dedicated himself to activism and education around white privilege, in addition to his work on ableism and homophobia. And since 2002, there has been a burgeoning of Disability scholars, artists, and activists of color. These practitioners have radically changed the field, exposing the deep entrenchment of racism, colonialism, and multivalent oppressions.

† http://www.queerculturalcenter.org/Pages/Qfestival02/DisabilityCf.html

Theater of Blood

April to July, 1998

For the last five years, my kidneys had been reminding me that spina bifida eats internal organs for snacks. These reminders took the form of aggressive pyelonephritis infections. Despite years of nonstop antibiotics, my left kidney could fit on a Triscuit and my "good" kidney felt like a can of Sterno under my ribs.

My life had shrunken as well. I had been teaching at the Evanston Art Center, but now I was either stuck at home, hooked to a portable IV, or languishing on the twelfth floor at Illinois Masonic Hospital, where they knew to save me the corner room with the skyline view.

I always had three suitcases packed and ready to go. Two with the usual hospital-stay paraphernalia, and a third bag containing a collapsible easel, a box of paints, and a roll of brushes. I'd discovered that making art in the hospital means that you hardly ever have to wait long for the nurse. The whole staff—RNs, residents, and attendings included—liked to hang out in my room to watch me paint. They'd tell me how much they regretted no longer having time for a hobby (!) and interrogate me about my work as if it were a diagnostic symptom.

On rare occasions, I'd be granted a few glorious weeks in which I was well enough to leave the house. I'd linger at the grocery store, riveted by the textures and hues and variety on the shelves—and of the

people!—but that was before the infections became antibiotic resistant and my gut began to produce the aptly named bacterium *C. difficile*. And before my doctors suggested I fill out a living will.

I was forty. I'd always expected to die before my mother's forty-one, but I wasn't as ready to go as I'd thought. So I did what I'd always done when in fear for my life: I made a pilgrimage to the offices of Dr. Lester Martin.

My doctor was semi-retired but kept a presence on the hospital grounds. The first thing I saw as I stepped into his waiting room was a large framed lithograph of Horwitz Drugs. My childhood whispered *welcome back* as the receptionist called my name.

Dr. Martin still looked like a movie star, though one more likely to play Obi-Wan Kenobi than Mr. Darcy. He wasn't terribly surprised that I was having problems. There were few people like me who had lived as long as I had, and fewer doctors who knew how to treat aging spina bifida crips.

Then he brightened. "Well, why don't we call my old friend Hardy Hendren? You'll like him. Quite a character. Remind me, you had surgery at Boston Children's some years ago, didn't you? He's their chief of surgery."

Oh, dear, was Dr. Martin losing it? I was far too old for pediatric *anything*. Carefully, I replied, "Yes, that's right, when I was seventeen. Right before Mom died."

His smile dimmed a few watts. "I'll never forget your mother. What a bright woman, she kept up with everything we told her. Got it all right away. Fought like a lioness for you." I melted. The man I'd idolized my whole life remembered my mother with such specificity. His words felt not only like a eulogy, but like a benediction. It seemed I was never going to stop worshipping this man.

Dr. Martin opened his desk drawer and pulled out a battered address book. W. Hardy Hendren, he said, was an innovator in the arena of pediatric urology, who had pioneered a number of techniques to repair damaged urinary tracts. Then he told me something astonishing: Dr. Hendren had already had a hand in my life. It was he who persuaded Lester Martin to enter the field of pediatric surgery when it was

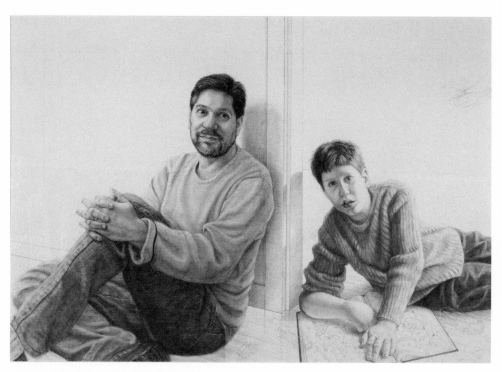

Family: Douglas and Nathan Lehrer
2002

still a brand-new specialty, back in the early 1950s, when they were colleagues at Massachusetts General Hospital. Hendren had saved my life by proxy when I was born; now Martin was sending me back to Boston, in the hopes Hendren would save my life again, exactly forty years later. The hair stood up on the back of my neck.

Dr. Martin flipped through his book and dialed a Boston number, but Hendren was out. "I'll give him a heads-up later on, so why don't you try him tomorrow. He's pretty selective about who he'll take on as a patient. He's an old codger, like yours truly, but I bet I can talk him into looking at your case."

The next day, Hendren's nurse said, oh, what a coincidence—the doctor was actually heading to Chicago to accept an award from the American College of Surgeons. If I could gather up my medical records, he might be able to meet with me before he flew home.

I drove back from Cincinnati with two cardboard cartons from Children's Hospital. I scavenged Chicago for even more records, from six different hospitals and a small battalion of specialists, giving me flashbacks of Mom's boxes that were stolen by Dr. Gray. I strapped the load to a luggage rack and lugged it up to Hendren's suite at the Palmer House Hotel.

Dr. W. Hardy Hendren was a balding, walnut-faced man with eyes like honed steel. I'd researched him a bit, and had heard that his nicknames ran to things like "Hardly Human" and "Hard-Hearted Hendren" owing to his reputation for treating medical students, residents, parents, and adult patients alike with unsparing astringency—though he was sweetly solicitous with anyone under voting age.

His wife, Eleanor, sat on the extra bed, offering polite questions and calling me "dear" while Hardy flipped through my files at speed. After only twenty minutes, Dr. Hendren fired the most astute, focused medical questions I'd ever been asked, by anyone, ever.

He curved his fingers in imperial command. "Come here. Let me examine you." He probed the massive scar down my abdomen, then fished out the hotel stationery and began to draw. (Hoo boy . . . dia-

grams.) "We'd cut this in two and sew this flap in a new formation. Keep the urine flowing in the right direction. But I warn you, this is very, very invasive surgery. I tell my patients it's the second-worst surgery you can have, right after a full organ-block transplant."*

"A what?"

"Surgeries in which multiple organs are transplanted at once. Look, I've never had one go wrong, but there's no guarantee. You do understand that?" He peered at me, trying to discern whether I might be the kind of quixotic patient who expects a miracle.

"I've had forty-three surgeries to date. I expect that gives me a certain realistic outlook."

Hendren chuckled. "How soon can you come? Wait, I'd better call the office, this is going to be quite a procedure. And I'd like you to lose ten pounds first. I'm going to want to open up that old scar, use it for access, but I won't know what I'm dealing with till I get in. The less fat I have to cut away first, the less time you'll spend open on the operating table. Deal?"

Well, that dropped my jaw. I looked down at my stomach. Had I, at long last, completed my transformation into Mom?

Back home, I huddled on my bed and called Dad. My father was Eeyore with a distinctly Yiddish moan—*Oy, vey, oy vey, vey iz mir, do you think you should, what if, gee Reev are you sure?*—punctuated by fatalistic gasps of angst, so when it was decided that I was going to Boston, we both knew he should not accompany me. Instead, my brother Doug would fly me to the possible end of the world.

I lost ten pounds. I dyed my hair aubergine. I prepared to leave a good-looking corpse.

* I often feel that Disabled people are expected—compelled—to disclose every medical detail, the more embarrassing, the better. It gives us credibility and feeds the voyeurism embedded in medical narratives. I understand that we all deal with mortality through others' stories of illness and injury (just as horror films and disaster flicks help us manage our fears), but this sort of expectation creates a compulsory humiliation.
Mine is not primarily a medical story. I'm limiting my specifics to what's necessary. This is a story of how we treat each other as embodied humans.

. . .

We sat in a tourist restaurant in Boston's Chinatown perusing a menu the size of a coffee table, and chose a platter of moo goo gai pan in honor of Mom. Later, Doug and I wandered through the gift shops along Harrison Street in search of places we'd gone as a family twenty-three years ago. I spent the next morning having pre-op tests and signing papers peppered with "emergency contact," "religious preference," "Living Will" and "DNR." I was amazed that they left off "burial options."

Doug had taken two weeks' leave from his position as a clinical psychiatrist at Wright-Patterson AFB Medical Center. It was just as hard for him to be away from his wife and children; this was a debt I'd never be able to repay. I witnessed his metamorphosis from sweet funny brother to Imposing Hospital Administrator when a resident was a bad listener during intake. The luckless kid was tutored in the "eggshell skull" principle of patient care—that is, when you have a patient who's a walking medical liability, you document *everything*.

My childhood memories of Cincinnati Children's and Boston Children's hospitals had a watercolor quality, all misty washes and faded pastels. By contrast, the present Boston Children's was garish as a Crayola mural. Its lobby featured a perpetual motion machine, a transparent eight-foot cube housing a Rube Goldberg sproingy-bingy-boingy tangle of springs, slides, chutes, and ladders that shot steel balls hitherward with admirable zeal. I wasn't much taller than the children who pressed their faces against the glass, so it came as a shock to see my reflection and realize that I now looked like a parent.*

The orderly took us to a floor dedicated to adults whose congenital impairments remained the purview of pediatric specialists. Half the patients were adults with cystic fibrosis. During the weeks of my recovery, I'd pace the halls to the rhythm of respiratory therapists pounding on

* http://georgerhoads.com/portfolio/bippity-boppity-balls/

their patients' backs. Mornings echoed with the racket of emptying lungs.

My own room was a positive onslaught of cheer, a seething, decorative mass of cartoon flowers, fish, whales, trees, stars, stripes, and teddy bear heads. Boston Children's had become the most luxurious hospital I had ever seen. A pullout recliner! A padded bench that doubled as a cot! A VCR next to the television! Sick kids had come up in the world since 1975.

I crossed to the window and looked down. Below my feet was the courtyard garden where I'd lost just enough of my virginity a teenage lifetime ago.

Dr. Hendren breezed in carrying two copies of his biography, *The Work of Human Hands: Hardy Hendren and Surgical Wonder at Children's Hospital,* by G. Wayne Miller (another guy with a penchant for first initials). Doug and I were both handed a copy as if we were being entrusted with an awesome responsibility.

That night, we stayed up watching *Duck Soup*—one of the hospital's few non-Disney videos—but once Doug left for the hotel, I called everyone I loved. The nurse brought me a Valium. My nerves were such that I was still awake when the orderlies came for me at dawn.

Doug paced my gurney down to the pre-op suite. My mouth was cottony from thirst and premedication, my brain too slo-mo for the profound final words I'd hoped to impart. Oh, well. What was there to say besides "I love you"?

And then, again, again, the white, white overhead lights, the meat-locker chill, the IV full of Pentothal. The backwards count from one hundred . . .

Twenty-two hours of surgery elapsed before the team closed me up for good. I'd been transfused with eight units of blood. A ventilator was

doing my breathing. I stayed in the ICU in a medically induced coma for the next five days.

I don't remember pulling out my nasogastric tube or trying to pull the trachea tube out of my throat before they tied my wrists to the bed frame. They couldn't let me wake up in uncontrollable pain. I could have died from shock.

On Day Five, they reduce my sedatives. Shout in my ear. Put cold cloths on my face, my hands and arms. On Day Six

I wake up
 I am nothing
I am not someone empty
an amoeba an earthworm
a nervous system in a bed.
 Unbodied. Primordial.
incoherent sensations only pain cold pain
 hot itch shake
no name. I
 I pull the dark across my mind
 Voices—
WAKE UP

*

I sleep through the entreaties, through the sponge baths, through the pinch pinch pinch. This Golem has been hollowed out.

*

Then—

Slow days of emergence. I/she watch my/her/some self be reconstructed. A self rises through the primitive animal building blocks. Simplified.

The snap of each piece as it clicks into place. The day she/I ask for water.

The night she. That I. That I ask to have the light turned on so I can see who I am talking to.

The day I speak a full paragraph.

The day a resident is doing the daily check of my twelve surgical drains. These segments of tubing begin deep in my swollen torso and end in transparent pouches bulging with pinky-yellow fluid. He empties them one by one, a procedure that reeks of putrid decay.

Doug walks into the room and looks at me, supine on the sheets, drains spread in every direction, and remarks, "You look like a cross between Gulliver and Cthulhu." I laugh so hard that the resident yelps, "Don't move!" Which makes it even funnier. It hits me that I haven't laughed since I went into surgery. Since I've been gone. Suddenly, I am back. I have my sense of humor again. I am complete.

We are made of parts. Lose any of them, and discover you are some other thing than you thought you were.

Dr. Hendren announced, "Find your slippers. We're getting up and walking."

He had to be kidding. I didn't have the energy to turn over, much less stand up. Furthermore, there were three fully laden IV poles and twelve drains attached to my body like ravenous limpets. I balked. Hendren growled, "I didn't put all that work into you just so you'd die of pneumonia! I'll go get the team." Voilà: Hard-Hearted Hardly Human in the flesh.

He returned with four nurses, a physical therapist, and a respiratory therapist he'd snagged from the cystic fibrosis wing. What followed reminded me of the Macy's Thanksgiving Day Parade as if I were the Snoopy balloon, surrounded by handlers struggling to get me aloft. Hendren's team handled the poles and drains as we rolled down the hallway at the breakneck speed of .000001 miles per hour. My doctor stomped along, bellowing orders and exhorting me to cough so I'd clear the muck out of my lungs.

. . .

Doug spent his free hours exploring Boston and buying gifts for Susan, Caroline, and Nathan, but eventually it was time for him to return to Ohio. Which was when my friend Audrey flew to Boston.

I'd met Audrey Niffenegger five years earlier when I'd been dating her friend Fiona. I'd thought that Audrey hadn't liked me much. My friends tended to be super-huggy and hyperbole-prone, but Audrey was as cool as her pale blue eyes and ivory complexion, with a habit of pausing before she spoke that let you know she'd thought through what she had to say. I was a noisy mess in comparison, so was pleasantly surprised when we became close.

Audrey had been a stalwart support during my illness, often showing up at two A.M. for yet another frantic trip to the emergency room. Even so, I hadn't quite believed it when she'd promised to come to Boston, but now the door swung open and there they were, my brother and my best friend. For the next ten days, Audrey fetched the outside world into my cartoon sickroom, keeping me well supplied with paperback mysteries, fresh socks, and every flavor of sorbet known to man. She even wiped off her burgundy lipstick when I grumbled that it looked like raw liver.

I'd left Chicago weighing ninety-six pounds; six weeks later, I'd lost nineteen pounds and weighed less than I had in seventh grade. I subsisted on pain meds and pure oxygen, though the cannula rubbed my nose into a bloody mess. Audrey asked what would make me feel better. I could only think of one thing. After a worried pause, she said, "Okay then, I'll go see if we can get permission."

She returned with a wheelchair. It took both of us plus a nurse's aide to get me swaddled in a T-shirt, sweater, hoodie, socks, slippers, jacket, scarf, gloves, hat, pillow, and two blankets, like a newborn crossing the Odessa steppes. Audrey wheeled me down to the lobby and out the glass doors to the courtyard garden.

I'd come in April when spring had yet to arrive in Boston. Now, in early June, the trees were tight with acid-green leaves and flowers popped in bundles at the end of each twig. I held my friend's hand and

said, "I'm not going to die." I really hadn't known. The air was sharp as it entered my lungs. Perhaps I would keep breathing after all.

The season had turned full summer by the time I stepped shaky as a lamb onto a United Airlines flight to Ohio. The airport had been almost more than I could bear—such noise! so much movement!—but I was heading for the quiet of the suburbs, where Doug and Susan waited to feed me and walk me around the block until I was ready for life back in Chicago. A life I had doubted I would ever see again.

And in my luggage was my finished self-portrait. I had brought my easel suitcase all the way to a faraway Children's Hospital, and now it was going home. We both were. Me and *Circle Stories: Riva Lehrer. Portrait of the Artist as Golem.*

Phantom of the Opera

I

I once made a set of gouache paintings of our family: *The Golden Boy. The Shapeshifter. The Chaos Vector. The Little Mermaid. The Luftmensch.*

The word "Luftmensch" combines the Yiddish terms for "air" and "man," but it doesn't mean "flying man," not exactly. Superman is not a Luftmensch, but the Fiddler on the Roof is. A Luftmensch is spacy, dreamy, impractical. This was how our family pictured Dad.

An odd appellation, given that Jerry Lehrer was an actual war hero who supported his family through some very tough years. Despite this, our favorite tales depicted a Jerry who wasn't quite *au courant* with the physical world. Stories about the time that Dad decided to make us a surprise dessert while the rest of the family was out shopping (part of the surprise was that Dad knew where the kitchen was), and we came home to discover said kitchen coated from ceiling to floor with mysterious, Pepto-Bismol colored goo. Or the time on his honeymoon when Jerry trapped a mouse in the bedroom closet, and attempted to kill it by slamming the broom on the floor, declaring that he was "scaring it to death."

Dad was halfway gone even when he was around. Tax season lasted from January to May, months when he'd unload his bulging briefcase all over the dining room table the very minute that dinner was finished.

Family Album
From top, left to right: Jerry, Carole, Riva, Meir, Doug
Circa 1996

This pattern persisted when I moved back to live with him after my first laminectomy. He'd grab us some Frisch's carryout on the way back from the office, and I'd keep him company while he worked from Tom Brokaw through *Hill Street Blues*.

He'd never reclaimed his bedroom, even after we moved from Glenorchard to Greenland Place, but chose to eat, work, and sleep on the couch. I'd have to shove aside a rat's nest of papers, pencils, and dirty handkerchiefs in order to watch TV with him; during his occasional bouts of depression, his couch resembled an archaeological dig at Pompeii.

Not that he ever talked about his emotions. Not to me, anyway, though he was more open with Doug. I sidled past any difficult conversations and told myself I mustn't trigger another heart attack. So, no talk about my sexuality. No memories of Mom. There would have been nothing between us but secrets and surfaces if it weren't for Doug.

By the summer of 1992, I had moved back to Chicago and was living with Laurie, Meir was married and living across town, and Doug and Susan and Caroline were living in Cheyenne, Wyoming, where Doug was the psychiatrist for the nuclear missile base. Doug had gotten his MD through the Air Force and was paying off the military scholarship through four years of service. Jerry went to visit him out west.

My brother called me after Dad had gone home again. He said that they'd been walking around the base when Doug said, "You know that Riva is gay, don't you?"

My father had shrugged. "Yes, I thought as much."

Doug reported there had been no grief, no anger, no negative reactions at all. Dad just said, "I'm glad she's not alone." Which was why my brother had chosen to out me; he wanted Dad to know that Laurie and I were breaking up, and that I was, in fact, alone. I was horrified that Doug had violated my trust, but then, oh my God, after all these years, I could be *honest*.

My father and I had never grown past the kind of relationship that teenage daughters have with their dads—dependent and deceitful in turn—but now I had the joy of hearing him burst out laughing when, a year after the revelation, I told him about my elusive boyfriend-ish

guy, Tom; "I just got used to you being gay, and then you go and do this to me? How could you!"

That autumn, I was awarded a solo show at the A.I.R. Gallery in New York City. A.I.R. is the first all-female co-op gallery in the United States, founded by a collective of legendary feminist artists. This, while an incredible opportunity, was also incredibly expensive. The combined costs for shipping, framing, crew, advertising, travel, and accommodations would eat my meager savings.

Dad always worried about my ability to support myself, so I was surprised when he didn't try to talk me out of taking this chance. I was absolutely speechless when he promised that he and my brothers would come to New York for opening night.

What a sight that was, my distracted, disheveled father in the land of the sleek and the swift. He inched along the gallery, squinting and pushing his glasses up into his hair. He saw the nudes (including my self-portraits, oy), the women kissing, the women in hospital beds.

I quavered, "Dad, do you like my work?"

"Gee, Reev . . . I don't think I get it. Gotta tell you, I'm more of a Utrillo guy myself." (Utrillo? *Vey iz mir.*) "But I'm proud of you."

Dad could've confessed to a fondness for Thomas Kinkade and I wouldn't have cared. He'd come to New York, this man who still sometimes slept at his office so he wouldn't waste time coming home. Dad didn't need to understand me to love me. I didn't need to pry him open to love him back.

II

Sunday, September 26, dawned hot and sunny. I'd been away overnight with Tom, so I didn't check my answering machine till morning. The robot voice informed me I had eleven missed calls. The first message was, "Riva, this is your aunt Sara. I'm so sorry about your father." The next ten were all from Doug. "Call me. It's urgent." "It's urgent." "It's urgent."

My brother sounded exhausted. "Dad was supposed to have brunch

with Susan Freudenthal this morning, but when he didn't show up, she drove down to his house. The curtains were open and she saw him lying on the living room floor. Susan called the police. They broke in and said Dad had been gone for hours. He'd had a massive stroke. He would have died instantly."

"How, how do they know it was a stroke?"

"There were signs of a nosebleed. I didn't tell you, last week Dad had an uncontrollable nosebleed that sent him to the emergency room. His blood pressure had shot up so high it forced blood out of his nose, or he would have stroked out then and there."

Tom overheard enough to know. He went to hold me but I pushed him away. I grabbed the neckline of my T-shirt and tore it to the edge of my bra. Jews rend their clothing on hearing of a death. Grief is a muscle memory. My mother's death told my hands what to do.

By morning I was on a plane.

Doug and Meir and I paced the floor of Weil's Funeral Home, circling the polished coffin and wondering if this could be real. The crowd of mourners grew so large that it spilled out the door and onto the lawn. The director of Weil's said that the last time he'd seen a funeral this packed it had been for a member of the city council.

Weil's was Cincinnati's Funeral Home for the Ashkenazi Community. All our goodbyes had been held at Weil's—Carole's and Uncle Barry's, Grandma Fannie's and Grandpa Sam's, Grandpa Willie's and Grandma Dora's—just as the cemetery in Price Hill was where our people were buried. Jerry's mourners moved through Weil's and out to the parking lot and from there to Price Hill, dancing the familiar steps of our collective pavane.

The remaining members of our family ringed the black rectangle in the grass, a late-period Rothko painted on the ground. Carole's headstone watched as my brothers and I threw spadefuls of dirt on her husband's coffin.

· · ·

Sitting shiva normally follows the funeral, but it was the week of Suk-kot, an eight-day holiday that forbids overt mourning. We couldn't begin to sit shiva till it was over. I was going to have to stay in Cincinnati for a month.

Shiva is held in the house of loss. Mourners came anyway, invited or not, and showed up in droves once the restrictions were over. We primary mourners sat on low hassocks while others brought us food and condolences. That was the theory, anyway. I suppose some woman in the annals of Judaism actually sat still while people caromed through her house in search of napkins and saltshakers and fresh rolls of TP, but I wasn't her. I said thank you to so many of Jerry's friends that my face froze between Comedy and Tragedy. The kitchen was a welcome escape hatch.

Doug had his own house in Dayton, but Meir had come in from Israel, so we had to live together at Dad's till shiva was over. We'd hardly seen each other since he'd moved to Hashmonaim. Together, we koshered the kitchen; I threw out the dinnerware and cookware as Meir ran an acetylene torch around the inside of the oven. I had no idea that we were preparing our very own glatt kosher breakfast café for Meir's Chabad Lubavitcher community.

Religious Jews are required to say certain morning (and mourning) prayers that must be performed by a minyan of ten men. At six A.M. (yippee!) the doorbell would ring and a procession of black coats and black hats filed into the living room. The house rang with the rhythm of davened Hebrew.

I was neither religious nor male, so I was exempt from the minyan but not from kitchen duty. My role was to get up before dawn, help Meir put out a spread, then disappear into my bedroom for an hour, as it is not permitted for Orthodox men to look upon strange women, especially a very strange woman wandering about in a knee-length hoodie and a grumpy demeanor. I listened to Shacharit from behind my closed door, and despite myself, found comfort in the ancient sound.

One evening, Doug read us a letter from our uncle David Horwitz

in Frankfurt, Germany. He was Mom's youngest brother. Uncle David wrote of a difficult period early in his own marriage when he wasn't sure whether he was capable of sticking it out. David had held on to the example that our father had set: Jerry hadn't run away, even when his daughter was born with spina bifida and his wife fell apart.

After Doug was done, I told the story of Dad's last visit to Chicago just months earlier. He'd asked if we could go to the Museum of Science and Industry; "Think they still have the coal mine? And the submarines!"

Soon as we got there, Dad said, "Whoops, better hit the men's before we get going," so I left him by the restroom door. Fifteen minutes went by. No Dad. Twenty minutes. Still missing. After twenty-five minutes, I was out of my mind, certain that he'd had a cardiac arrest and was slumped, undetected, behind the door of a stall. I begged a kindly old gent to go in and look around, but he came out shaking his head—no one matched Jerry's description. A museum guard did a more thorough (and no doubt embarrassing) search of the stalls but came out shaking his head. "Any chance he left through the other door?"

WHAT? There were two exits?

My father the Luftmensch had managed to drift out the wrong door. I found him at the information desk, his hair a Brylcreem tumbleweed of aggravation. As far as he was concerned, I was the one who'd disappeared for an hour.

I was pissed. Dad was pissed. He stomped off toward an out-of-the-way stairwell. We climbed in silence—until I heard him gasp. I dashed up the last steps to the landing. Dad was rooted to the spot in front of a wide glass case.

"Riva, do you know what this is? It's Kungsholm!"

Oh my God. I hadn't heard that word since I was a little kid, but I'd never forgotten my mother's stories.

Mom used to tell us that when she and Dad were newly married, they used to get on a weekend train early enough to be in Chicago in time for dinner, their destination the Kungsholm Scandinavian Restaurant, located on Michigan Avenue.

The Kungsholm featured a classic Swedish smorgasbord, but the real draw was that inside the restaurant was the Kungsholm Miniature Grand Opera Theatre, an exact scale model of the Royal Opera House in Stockholm. And in this theater all the "actors" were only fourteen inches tall. Rod puppets, so lifelike, so exquisitely detailed, Mom said "that when the puppets came out and started to sing, you just forgot that they weren't real people. The music was actually a recording of an opera, but that orchestra looked *exactly* like it was playing the score." There was even a full puppet orchestra, where the violins and wood-winds were smaller than a finger. "You could even see the tiny bows going up and down in time. Kids, those puppets were alive." She moved her fingers inches apart to demonstrate the size of the little wigs and jewelry. "The sets were so elaborate. You can't imagine how intricate. But—strangest thing was that the puppets had no strings! We never figured out how they were able to move like that. It was actually kind of spooky."

My brothers and I would plead, "Can we go to Chicago and see the puppets, Mommy? Please please please?"

Original (undated) puppets from performances of "Carmen" at
the Kungsholm Miniature Grand Opera Theatre. Puppets now
in the collection of the Swedish American Museum of Chicago.
Notice the unusual rod-and-gear construction.

"Oh, kids. I wish we could, but the Kungsholm closed a long time ago."*

And now here was the entire stage, thirty years later. I bent down to read the sign: "This set was taken from the world-famous Kungsholm Miniature Grand Opera Theatre, formerly at 100 East Ontario Street. To see the marionettes perform, press the button below the case."

Dad reached out a shaky hand. Motors and gears purred inside the wall as the puppets sprang to life. The diva glided to center stage. Her red gown was trimmed in black; a lace mantilla fanned from the peaks of her raven hair. Don José and Escamillo took their places, the conductor raised his wand, and Maria Callas began to sing "L'amour est un oiseau rebelle" from *Carmen.* Dad's favorite opera in the world.

And then Jerry began to sing, his voice dry but confident as he serenaded the twirling lady in red. My beautiful father and the beautiful woman with the dark hair and magnificent anger. I will never know whether he sang to Carmen or to Carole.

Much later, Doug said, "Sometimes I think about what it must have been like for Dad in the beginning, when he first met Mom. She was so charismatic, so pretty and talented. He must've thought he'd struck it lucky."

And I thought, Everyone is called on to make sense of love.

* The Kungsholm puppets were controlled via an elaborate mechanism of rods and gears underneath the floor of the stage. The restaurant closed in 1971. Bill Fosser, one of the original Kungsholm puppeteers, revived the theater as "Opera in Focus" in the Chicago suburb of Rolling Meadows. Videos on YouTube show the superb craftsmanship and eerily precise movements. https://news.wttw.com/2011/12/29/puppet-opera

Circle Stories: Brian Zimmerman
2000

Cat People

The silence of the telephone is loudest on Sundays. The day we used to share the news of our week that was. My hand flies for the receiver only to drop again and again like a shot dove in flight.

And so I paint.

I am looking up at the sky. On my face is a miniature version of my father's glasses. A braid trails from behind my ear, woven of my hair, Adèle's hair, and strands of Mom's hair taken from the vitrine in my living room. I carve the Plexiglas facing with a drawing of Jerry and Carole wading into the ocean. That etching casts their shadow-drawing on me.

Orphaned again. Such an old orphan, now.

University of Chicago, May 2000

I clicked the slide remote. Images bounced from the screen onto the audience, painting the viewers with the color of portraits. I was delivering a lecture on the representation of disabled people in contemporary art. Up next were photographs by Joel-Peter Witkin.

"Witkin claims that his work is about 'revealing unseen forms of beauty,' but as we can see"—I gestured to *Un Santo Oscuro, LA,* his

portrait of a person with thalidomide syndrome—"the disabled body is nothing but a prop in his fantasies of Catholic sacrifice. As far as Witkin is concerned, any amputee can be swapped out for anyone with almost any impairment at all. Most significantly, a person can be traded for"—I clicked to a severed head used as a vase—"a corpse. Witkin uses dismembered cadavers in exactly the same manner as he uses living disabled models."

The house lights came on. A few people lingered to ask questions. A young man asked, "Who was that artist you hated so much?"

"Oh, you mean Witkin?"

"Yeah, one of his photos reminded me of Matthias Buchinger. This eighteenth-century German artist. Born without hands or feet. He did these amazing drawings, all done with micrography, y'know, miniature handwriting. Miniscule text that was actually part of the image. Hair and stuff. I mean, not like captions or anything."

"Huh! How do you know about him?"

"Look, why don't you give me your email. I read about him in this book by Ricky Jay—you know him?—cool!—called *Learned Pigs and Fireproof Women*. You want, I'll send you a scan. Oh, by the way, my name's Brian."

The guy seemed harmless enough. I handed over my address. "Um, sure, that'd be great."

By the time I got home, there was an email with multiple attachments, *lots* more data on Buchinger, and a throwaway "Hey, want to get coffee sometime?"

I tried to conjure what he'd looked like. Young. Too young? What the heck. But our schedules didn't line up for several weeks, so by the time we met up at a coffeehouse, it had been a while.

The café was lit up with summer sun like a meet-cute rom-com, but no boychik in sight. I pulled my paperback out of my bag and struck that insouciant no-I'm-not-waiting-to-get-stood-up demeanor practiced by single people everywhere.

"Hi . . . Riva?"

I looked up at a total stranger. The boy I'd met had had a bark-

brown mop of curls and dressed like a preppy. This guy's buzz cut could've been any color at all; his rumpled, sweaty T-shirt looked like he'd slept in it for a week.

Puzzled, I said, "Yes?"

"Um. I'm . . . y'know . . . Brian." He was tilted hard to the left, pulled under by the weight of a book bag slung over his shoulder.

"Really? If you say so." I blew out my lips and said, "Okay. Sit down. That looks heavy."

An hour later, I'd stopped searching for the exit and was happily comparing obsessions: books, books, art, movies (monster, Marx Brothers, Mel Brooks), comic books, books, and books.

During a pause, I asked, "Mind if I ask how old you are?" Thirty-two! I swallowed and confessed to forty-one.

"Wow, I thought you were a whole lot younger." Thank God, he looked more amused than alarmed.

"So . . . should I be flirting with you?"

Brian grinned. "Yes. Yes, you should."

He told me he was in graduate school in English at the U of C. What had he been doing at the symposium?

"I'm working on the grotesque in graphic novels. Mainly in relationship to disability."

"A literally academic interest, then."

Brian colored, said, "Not exactly," then bent down, tugged up his left pants leg, and peeled down his sock. In place of the pasty indoor skin of a grad student was a metal-and-fiberglass contraption, rather like an upside-down fire extinguisher attached to a rubber foot.

"Below-the-knee amputation, about five years ago. I got run over by a train."

You *what*?

"My wife and I were going on these urban adventures—like when you break into abandoned buildings or subway tunnels. But she had a law school exam to study for that weekend, so I went by myself."

I clutched at one of a thousand swirling questions. "Wait, you're *married*?"

"Uh, ex-wife, sorry. Anyway, this guy was going to teach us to hop freight trains. Very Frank Capra. So it was just him and me. We caught a freight up to Milwaukee and spent the day, but when we got back to the train yard, we were late and the train was already moving. I went, 'I guess we're going to spend the night here,' but my friend goes, 'Nah, you can do this.' He grabbed my hand and yelled *'Run!'* And I lost my footing, and yeah. The train ran over my leg. You won't believe this, but I was enough of a Boy Scout that I whipped off my belt to make a tourniquet. He went for help, but meanwhile I was bleeding to death."

"Holy *shit*. Wait, so you're alone in the dark? Why didn't your friend—oh, no cellphones—"

"Right, so I'm losing more than half of the blood in my body when this stranger comes up and says, 'Let me do that,' and he grabs my belt and keeps it tight until the ambulance comes. Or I woulda died for sure. Few days later he shows up in my hospital room—and apologizes to me! Said he was gay, and he was out there cruising, the yard was a pickup spot, and he hoped I wouldn't hate him for being a faggot. I just could not believe it. I told him he'd always be my hero, and anyway, anyone who hated gay people was ridiculous."

He finished with, "I've been run over by a train, and I've gotten a divorce, and I can tell you the train was a lot less painful."

I hadn't even known I was on a date with a crip until Brian showed me his ankle. ("Nah," he'd clarified, "I didn't lose my leg. I know exactly where it is. A landfill in Milwaukee.") No wonder he'd asked me about Joel-Peter Witkin, the man who arranged amputees like still lifes. Anyway, weren't we all lucky that we didn't lose a body part every time we made a stupid decision?

As Brian and I hugged goodbye, he handed me his copy of *Learned Pigs* and said he'd like to see me again.

.　.　.

The reason that Brian had looked so sweaty, shorn, and pudgy on our first date was that he'd been a nervous wreck, having barely dated since his divorce. I found this endearing. I was always a wreck when contemplating taking a new lover. I'd had some unspeakable experiences, including going out with one Mr. Right who broke up with me by explaining I was "too deformed" for him. And people wonder why my self-esteem resembles a charcoal briquette.

After a few dates, I invited Brian over for dinner, even though I still felt way too Mrs. Robinson for comfort. The kissing was more ambitious than in previous encounters. I said, "Let's go lie down."

Few things are more awkward than the walk to the bedroom. Do you hold hands? Saunter nonchalantly? Run ahead in a frantic search for your negligee? Remember that you don't own a negligee?

We perched on the edge of the mattress. He asked, "Is it okay if I take off my leg?" This took me aback; I'd never been with anyone else who had to perform the Big Reveal. I'd always been the one who had to explain my body on pain of being kicked out of bed. Now that the roles were reversed, not only was it eerie . . . it was hot.

He pulled off his pants and leaned over to do something complicated. I heard *snick* and the whole fiberglass-and-footie assemblage slid off his calf. Underneath was a silicone sleeve that ended just below his knee. That was rolled down and slipped off, and there was his leg, a tapered, asymmetrical stump that ended in a tucked fold where his surgeons had fought to retain as much of the calf below the knee as possible, a few anatomically inferior inches that determined its functionality, over which they had wrapped his remaining muscle over the terminus of tibia and fibula. A diamond pattern in the skin showed where they'd resorted to a graft.

At the sight of Brian's leg, something inside me relaxed that I didn't even know *could* relax. His body was nothing like mine—and yet, it was. *Find a nice crippled boy.* Brian was more *like me* than any of my previous lovers. Nothing to do with straight or gay, male or female. The question was human/not human. With him, I was human, too.

Crips are acutely aware of the body, its needs and sensitivities, so

much so that we often pride ourselves on being "good in bed." Sex provides a wellspring of pleasure that offsets the difficulties our bodies present. Like me, Brian was a bundle of self-deprecation; like me, he was erotically intrepid and assured. His hands were warm, steady, confident. I was a horse being gentled, even as I was a horse being ridden.

The morning after, I had to run off to work and leave him in my apartment. Always a touchy moment. What would await me when I got back? Roses? A charred hole where my home used to be? What I did find was a goofball note thanking me for the night before.

What a dork. What a sweetheart.

And yet . . . I kept thinking about *The Bride of Frankenstein*. When viewers first see her, she's only just awakened from the dead. She hasn't seen herself yet, hasn't been exposed to the world's hatred, and doesn't know that she and the Creature are the same. When he comes down the stairs of the castle, the Bride takes one look at her intended and hisses like a stabbed cat. She sees only horror, while he knows that they are each other's only hope. A relationship between only monsters works if they can see each other's beauty. I was afraid that someday Brian might look at me and see a freak.

Especially considering the things that he said—or didn't say.

We were cuddled on the couch, watching *Buffy*, when I cleared my throat and asked, "Bee, do you find me attractive?" It struck me that the guy hadn't complimented me in months.

He mulled this over. "You know, sometimes I think I should want what other people want," and ruffled my hair.

Another time, I was driving us downtown when my car was passed by a shiny red convertible. The pilot was a wannabe Fabio whose long blond hair streamed like a sex-god flag in the wind. Brian mused, "Maybe I should grow my hair long like that. After all, I'm in competition for the same girls."

I almost rear-ended a Honda. "What am I? Your maiden aunt?"

When I told Doug, he snickered. "What a doof. I trust you smacked

Romeo upside the head." The world would be better if we all had a Doug on speed dial.

I loved Brian as much for his brain as for his body. He was distinctly more well-read than I, steeped in a broad range of literary studies, philosophy, history, and multiple languages. Best of all, his favorite saying was "Every story is a disability story." We reveled in all-night conversations; even nerdier, we both enjoyed the hell out of a good academic conference, and attended the yearly Society for Disability Studies conference much as another couple might go to Hawaii.

The conference was held in a different city every year; four days of academic immersion until the very last night. Then SDS always ended with a dance.

The first time we went, we showed up a little too early. The hotel ballroom was empty but for a few dedicated drinkers slugging down the conference-rate booze. Then the music began: *Hallelujah! / It's raining*

SDS dance, 2012

men! Every specimen! / Did you think I'd lay down and die? / Love will keep us together / and we fly just like birds of a feather. The DJ guessed that our taste hadn't changed since we were all in college. He was a good guesser.

By ten o'clock, the dance floor was a tangle of limbs and chairs. Dancers swayed upright and gyrated down on the floor; they spasmed and twitched and tottered to the music, graceful and ferocious and gawky and released. Crutches whizzed by heads; wheelchairs zipped in loop-de-loops or were abandoned at the edge of the floor so that riders might roll unencumbered on the ground. The way we're allowed to move in the world is one percent of what a body can do.

I wanted to fuck Brian right there on the floor, to the beat of canes and unsteady feet. I wanted him. I wanted this. I wanted *them*.

American Horror Story

2006

My portrait work had gotten me invited all over the country, and even as far away as England. I'd met artists, literary practitioners, filmmakers, academics, historians, and performers from Berkeley to New York. Many of us knew each other and cross-influenced each other's work. In 2006, I got the chance to bring some of us together as co-curator for the *Bodies of Work* Festival in Chicago.

I'd begun work on BOW four years earlier, as part of a consortium planning an ambitious, monthlong festival of Disability Culture, encompassing art, performance, film, and dance. Main events were scheduled for the Chicago Cultural Center, a marble palace designed by Louis Sullivan, embellished by his mosaics and carvings, and topped by Louis Comfort Tiffany's stained-glass zodiac dome.

One of my roles was to co-curate *Humans Being,* a survey of work about Disability by professional, academically trained artists with impairments, along with able-bodied artists who approached the subject from personal perspectives. Sofia Zutautas was my Chicago Cultural Center co-curator. It took us four painstaking years to assemble a roster of painters, printmakers, graphic novelists, sculptors, installation artists, photographers, and fiber artists with the right qualifications.

Sofia and I were pushing back against the longtime assumption that

Totems and Familiars: Lynn Manning
2007

Disability Art was either mere therapy or Outsider Art, rather than an academically trained area of contemporary inquiry. Far as I could tell, every major exhibit, biennial, and survey of contemporary art in America had ignored Disability as an important aspect of human life, even while representing a wide range of other aspects of identity discourses. I don't mean that none of their chosen artists had impairments—of course they did—but virtually none addressed it as their subject matter. Our goal was to try to represent the complexity of Disability with fewer than fifty artists; this was laughable, once you considered that "disability" includes everything that befalls the human body.*

The opening-night gala of *Bodies of Work* was April 1, 2006. We assembled under the swirling Tiffany dome, a rainbow of sequins and silver and gold, of silk gowns and satin tuxedos, of gleaming chairs and hearing aids, of phlegmatic guide dogs and graceful conversations in ASL. Our emcee, the British actor Mat Fraser, kicked off a month of work that was both groundbreaking and aesthetically competitive with the mainstream.

Mat Fraser was the biggest star in Disability Culture, famous for his iconoclastic mélange of punk, Shakespeare, and burlesque. (Mat would go on to become a successful television, stage, and film actor.) At the time, though, I'd only ever seen him in photographs and films, all of which had shown him from the waist up. I knew his impairment was thalidomide-induced phocomelia; the kids at Condon who'd had that condition were all Little People, so on opening night I scanned the crowd for a guy my height or shorter. Of which there was no sign.

Oh, no . . . had he missed his flight?

Just then, a tall man strode by, dressed in skintight Levi's and a leather jacket tailored for short arms. *Wow, that guy looks exactly like a six-foot version of* . . . oh, wait.

"Mat? Is that you?"

"Reever? Are *you* Reever?"

While I'd been looking for a Little Person, he'd been searching for a

* A description of the struggle to convince curators, collectors, and gallerists to loan to our exhibit would take up half this book. Suffice to say that we heard "I refuse to ghettoize [insert artist's name here]'s work" more times than I like to remember.

woman in a wheelchair, since all the "biffies" he knew were on wheels (so much for mystical crip connections).

Weeks earlier, I had called him in London and invited him to pose. He drawled, "Well, of course, darling, but only if I can do it naked." I laughed; Mat assured me he was serious. I dropped the phone in my cereal bowl. And so my forty-eighth birthday remains an indelible

Totems and Familiars: Mat Fraser
2006

memory, a day of watching the unclothed Mat Fraser stalk around my apartment.

Later, he sent me this memory:

I met Riva at the "Bodies of Work" Disability Arts festival. I was struck by her fashion sense and style (extended goth?), and of course, her wonderful graphic selected portraits of other disabled people, mostly activists and artists. Thus, I was thrilled when our diaries collided well enough to enable a portrait session.

I of course asked to do it fully naked (my preferred state of dress is undressed), and she of course was in full agreement. I had no idea she would make such a monumentally awesome portrait of me! I'm not sure my penis is actually that big, but I'm so glad Riva decided it is! What I particularly love about her portraits is the referencing and inclusion of disability-meaningful backgrounds, accessories, and we ended up with a great referencing to Sealo the Sealboy, and sideshow. I love the portrait immensely, and am so proud to be a part of Riva's crip stable.

Totems and Familiars: Gordon Sasaki
2007

The Pit and the Pendulum

Chicago 2006

Once all the *Bodies of Work* artists had left town, I ripped my home down to the studs in a much-planned ruination.

Back in the early nineties, Dad and Doug and (to a very minor extent) I had pooled our resources and bought the condo from the owner, who'd said, "Eh, this place is a pain in my ass, pay cash and I'll give you a deal." Without my father and brother, my housing options would have been limited to Lego bricks and superglue.

My meager income made it hard to repair the place, or even maintain it, so by 2006, the holes in the floor were the size of root cellars and the walls were cracking continents on their way to oblivion. The plumbing leaked, mice lived under the baseboards, and the kitchen appliances sounded like asthmatic dinosaurs. I had saved up for eleven years, so as soon as the festival was over, I moved in with my boss, who taught a half-time gig at the Iowa Writers' Workshop. She let me kitty-sit in exchange for shelter while my own home was taken apart.

I mooned over paint chips and door handles and pastel linoleum tiles. My contractors repositioned the kitchen cabinets a foot lower, installed countertops that didn't hit me mid-nipple, dropped the closet

rods, even redrilled the peephole in the front door to match my height. After eight months, my apartment fitted me like a carapace and looked like the inside of my head.

Or maybe Carole's head. My mother's aesthetic glittered from every corner of my home. Hers were the glass tiles and bright brass fittings and woodwork painted in sunrise colors; she was behind my decision to take the iridescent chandelier from Jerry's house and make it the centerpiece of the kitchen. Mom's candlesticks, Dad's mezuzah, and Grandma's teapot anchored my refulgent home.

An autumn morning in 2006. The phone rings at seven A.M. A patrician New Englander voice announces that I've won the 2006 Wynn Newhouse Award for Artistic Excellence, fifty thousand dollars in unrestricted funds. I think I'm dreaming until I hear myself shrieking into the caller's ear.

I'd never had anything like this kind of money, certainly not money that I could spend on my career rather than on doctors and disasters. First, I thought, an extended stay in New York, then I'd travel across the country and work with collaborators from coast to coast. Then off to England to draw Philip Pullman, whose His Dark Materials trilogy had been the inspiration for my series titled *Totems and Familiars** (and who had said a provisional *yes*). The Newhouse Foundation was going to make all my dreams come true.

My friend Nadina LaSpina agreed to let me sublet her Union Square apartment for several weeks, starting in July of 2007. I imagined planting my seven-league boots on Broadway for good.

. . .

* *Totems and Familiars* followed *Circle Stories* (many portraits in this book are from *T & F*) and explored the use of symbol and metaphor during times of trauma. My collaborators chose an animal familiar (as in a witch's familiar), an object invested with "magical" powers (for instance, an heirloom), or a hero who acted as their alter-ego role model.

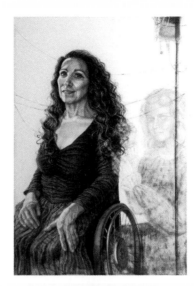

Totems and Familiars: Nadina LaSpina
2008

Nadina's condo was on Fourteenth Street, across from an electronics store that lit up my bedroom at night and woke me at sunrise with blasts of Timbaland and Lil Wayne. The kitchen was the size of a pillbox, the bathroom just big enough for the radius of a wheelchair. She hadn't left much kitchenware, so I'd fry a slice of millet toast for breakfast, choose a direction, and start to walk. Would it be west, toward the Chelsea galleries? South, to kiosks along Canal? North to the Met, or swing by New York Central Art Supply, home of *the* most glorioso paper department in the world, and finish with a meander through the labyrinthine aisles of the Strand?

My afternoons were spent with portrait subjects. Nadina herself, then Rachel Youens, followed by Gordon Sasaki, who took pictures of me while I drew. I served them cookies from the natural foods shop down the street and talked about how badly I wanted to stay. In the evening, my friends took me to gallery openings, performances, parties at strangers' houses, and rambles down side streets I'd never have stumbled on alone.

I was happy, people. I was happy.

CHAPTER 54

The Fall of the House of Usher

Doug came to New York that July on his way back from a conference. We were sitting at brunch when I said, "D, I can't believe how well this trip is going! I'm having the most wonderful time."

My brother lunged across the table and grabbed my hands. "Shut up! We're Jews! We don't *say* things like that!"

I snickered. And just like that, my cellphone rang. It was my next-door neighbor, Don, back in Chicago. He asked if I was sitting down.

"Heh, of course, I don't usually eat standing up. What's going on, kiddo?"

"Look, doll, you better brace yourself. There was a stupendous thunderstorm last night. Rained some historic amount. Made the news. . . . No? Not there? Anyway, you know we have a flat roof? Thing is, the roof drain is right above your front door. And . . . see, the drain broke and a lot of water got dumped into your condo. A *lot* of water. Gotta tell you—it's pretty bad. My unit, too. Our neighbors ran around the building all night trying to rescue what they could. But look, doll, you got the worst of it."

Doug saw my face. "What? What's happening?"

Well, he did warn me.

That day, I didn't get off the phone longer than it took to pee. If I wasn't interrogating the condo board president, then I was weeping at my insurance agent or howling in Brian's ear. He went over to my place

and tried to soft-pedal what he saw, but the hiss of disaster wafted from the receiver.

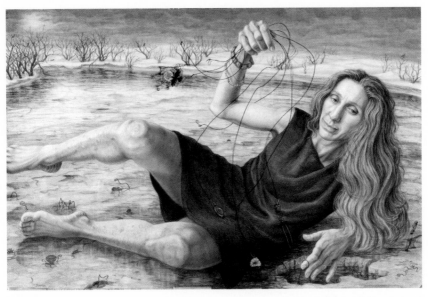

Totems and Familiars: Deborah Brod
2009

My friend Debbie was already scheduled to visit me in New York, but she promised to fly out right away. I was brushing my teeth just before she was due to show up when I turned the wrong way and heard my ankle snap. I had popped the peroneal tendon out of its socket. Again. Now I couldn't even stand up. I'd planned to take Debbie on a decadent New York romp, but this plan disintegrated into a frantic repack of Nadina's studio so I could get back to Chicago. I was determined to take us to at least one museum, so poor Debbie pushed me up the Guggenheim ramp while I crabbed like a maiden aunt in a nineteenth-century novel. The rest of the evening was spent shoving my belongings into U-Pak-It cartons while I hobbled and groused.

We were eating a greasy diner breakfast the next morning when I declared, "I feel like crap." I dashed to the ladies' room, threw up my eggs 'n' grits, threw up a few internal organs, threw up toenails and

belly button lint, and then it was off to the emergency room of St. Vincent's Hospital.

I had had small-bowel obstructions before. Usually, doctors inserted a nasogastric tube up my nose and down my throat, and a few days later I'd be discharged, several pounds lighter and sore as a donkey kick, but over the worst. Not this time. After nine days in St. Vinny's, I was still obstructed and was skating near cardiac arrest. The surgeons prepared me for abdominal surgery; Doug dropped everything and came right back to New York in order to convince St. Vinny's doctors they didn't understand what they were up against. The night before the lysis was scheduled, the Gods of the Gut took mercy on me at last.

Debbie had had to go home, so Brian flew in from Chicago and half-carried me out to the taxi rank. The ride to Nadina's was dazzling, a kaleidoscopic last look at my perfect city. We flew back to Chicago and my warped front door.

I turned the key and beheld a condo corpse. The floors were a roller coaster of twisted oak, buckled linoleum, and shattered tile. The walls had crumbled. On the other hand, I was well-supplied with destroyed furniture, wrecked artwork, ruined studio supplies, and mildew-covered clothing. My library was decimated, including every irreplaceable art book that had featured my work. The stink of mold was an invasion of beetles up the nose and water still ran from the ceiling. Every inch of my redesign had been lost, and a decade of savings wiped away.

I couldn't even camp in the ruins. Everything had to be stripped down to stud and lath. I learned far too much about condo insurance and water damage—there was so *very* much that State Farm failed to cover. I had to use all of the Newhouse money just to rescue my home. Not to improve it, just to go back to the beginning.

I'd built a Golem refuge, a crip career, and had fallen in love with a charming fellow monster. But monsters are only safe when they have sanctuary. I said goodbye to Scotland and London and California and dreams.

The Invisible Man

2008

I felt stupid. I'd let myself hope. I'd forgotten that the best course of action was to brace for disaster rather than expect happiness.

Lehman Brothers filed for Chapter 11 bankruptcy protection on Monday, September 15, 2008, three days after my solo show opened at Printworks Gallery. The recession bombed the bejeezus out of my career. Printworks had had a waiting list of collectors; by Friday, every single one stopped returning my dealer's calls. I'd lost thousands of dollars in framing and photography; we'd been sure the show would sell out.

All this tsuris hadn't done my relationship with Brian any good. I was such a mess that I wasn't dealing with his disability. I don't mean the leg—I mean his invisible impairment, the one that had caused intractable problems between us for years.

I'm sitting in my living room. Dialing him again. Brian hasn't answered his telephone or doorbell for ten solid days.

I lose it. I go over to throw rocks at his windows. Who cares if I take out a pane or two, as long as he sticks his head out and confirms Proof of Life. I call 911 and ask the cops for a well-being check, though it's debatable who

it's for, him or me. Brian often loses his jobs during episodes, so no one expects him to show up for a morning roll call.

Mirror Shards: Tim/Owl
(Tim and Temma Lowly)
2011

The cops pound on his door. He turns the knob, peers out. Gaunt and unshaven. The apartment smells of unchanged litter, rancid sheets, and archived garbage bags. His cat yowls in the background like a car alarm. Nonetheless, he answers the officer's orientation questions and refuses trans-

port to the hospital. I beg them, "Can't you tell he's in terrible shape?" The cops reply, "Lady, there's nothing we can do."

*When they leave, Brian lets me in. I drag him over to my house, where a warm shower and clean clothes await.**

We'd broken up more than once, when things were at their worst, so it was hard for me to trust when the situation began to turn around. Brian found a new therapist, new meds, a job he really liked. All of a sudden our relationship was all helium rainbows and hope.

That is, until a friend of ours offered Brian a job in Disability Studies at an East Coast university. The friend wanted me to encourage Brian to accept. I didn't get it. He knew my boyfriend well, so why couldn't he acknowledge his mental health issues? Our friend maintained that this job would be the making of Brian, that his current position as a paralegal was far below his capabilities. True enough—and beside the point. My partner was finally stable.

Brian came over one evening and told me he'd turned the job down. Then he said the words that I never thought to hear—never even looked for in eight years of coupledom.

"This offer made me think about what's important to me, y'know, like what's really important in my life. What're my values. And, like, I— it's you. You're the most important thing in my life. Let's get married."

It's true: if you're really in shock, you really do fall off your chair. I struggled to my feet and slid onto his lap. Brian's thighs were warm against mine. Brian of the moss-green eyes, the run-on sentences, the tendency to eat with his fingers, and the shelves of comic books I just *had* to read. My leg hit the mechanical curves of his prosthetic, and I felt where his prosthetic ripped through his jeans. Did I want these things forever?

* All these years later, I'm grateful that the cops turned me down. I violated Brian's autonomy in ways that could have led to involuntary holds and involuntary psychiatric admittances with no clear release date. I had succumbed to flashbacks of helplessness around my mother, to fantasies of rescue I'd never been able to offer her.

Yes.

As happens with love, the future turned on a single word.

Our friend's new pitch was that I'd be part of a couple's hire at East Coast U, despite my protests that I had a job in Chicago, a home, and an art community, and no interest in leaving any of it. Our friend was being remarkably generous—and in a better world, I would have been grateful—but I didn't trust Brian's solidity. What would happen if he left his web of support behind?

But the temptations of salary and prestige ground down Brian's resistance, until he changed his mind and said, if I really loved him, I'd bolster his aspirations. What could I say to that?

He said he'd find us an apartment, after which I'd come out for a six-month trial. I gave notice at my job, got ready to drop my health insurance, called a real estate agent, and prepared to bring my Chicago years to a close.

Brian's U-Haul pulled away loaded with ten thousand books and a jumble of ramshackle furniture. We visited back and forth for months. He rented a roach-infested, dilapidated horror in Philadelphia, not exactly a good sign. We half-ass-half-planned a basic ceremony at City Hall for February, but my actual New Year of 2009 was spent in Northwestern Hospital, half-killed by another bowel obstruction.

It was a nasty cold afternoon when I finally came home. I lay flat in bed and dialed his number. My voice was raw from the tubing and the vomiting and dehydration, and I'd dropped back down to seventy-nine pounds. I rasped, "Bee, can we hurry things up? I really need your insurance. And I'm scared."

His next words emerged much too slowly for such a fast talker. "I'm still willing to marry you, I mean I want you to have insurance, it's just . . ."

"Just *what*?"

"It's not. I mean, I don't . . . That is, it's not about romance for me. I, I just want you to be safe."

"Brian, I don't understand. What are you trying to say?"

"I guess I'll just say it. . . . I don't love you anymore."

The universe exploded, stars fell into the toilet, the walls pulsed with locusts and boils and flies, with hail and frogs and darkness. So much darkness. The firstborn died of the plague of love.

At three A.M. I got out of bed and took a razor blade to his tuxedo. We didn't speak again for years.

Adult hope seems so realistic. You've examined the risks, weighed the factors. *Yes* is no delusion, right? Not by the time you're fifty. But then again, what does realism have to do with monsters?*

* Looking back, I see that sometimes I dealt with Brian's depression by becoming condescending and dismissive, in a toxic mother-and-child dynamic. No matter what your disability may be, it doesn't give you automatic understanding about a different impairment—or even, frankly, a condition that the two of you might share.

Zora
2000

The Company of Wolves

I'd lost my home; I'd lost my lover; with the next loss, my life completed a country-western trifecta.

Back in 1994, my girlfriend, Fiona, drove to North Carolina to attend classes at the Penland School of Arts and Crafts. The area around Penland was rural, hilly, and populated by residents who were wont to dump unwanted pets in the fields around the school. Someone discovered a litter of puppies under a broken-down truck, and Fiona volunteered to take a puppy back to Chicago.

I lost my shit.

"*NO*. Absolutely not! My mother was mauled by a Dalmatian when she was a kid. If we passed as much as a Chihuahua on the sidewalk, she'd flatten herself against the wall. I do *not* like dogs!"

Fiona shot back, "No one else can take it. It'll just go to the pound. I always thought you were *kind,* Riva. Guess I was wrong."

"Oooohh. Dammit. Fine, fine, fine."

Fiona wisely kept the gloat out of her voice. "She's six weeks old. Black and gray with white toes. Listen, why don't you name her?"

This was some masterful manipulation. A name popped into my head. "Zora."

"Great, great, great! Zora it is! Gotta go, bye!"

One week later, she showed up dragging a hastily purchased pet carrier. She knelt and opened the carrier door. When Fiona had said "little

puppy," I'd expected something the size of a hamster. Out rocketed an eleven-pound beast, more pig than dog, composed of blunt snout, curly tail, and sharp teeth that promptly latched onto my arm. *"Ow ow ow owwww gedditoffameeee!"*

I demanded that until we found another home for this demon, we were going to dog training. Fiona grumbled. *She* was strong enough to yank Zora anywhere she damn well pleased. The first night of class, I asked Kathy, our trainer, if she could get me a wild-animal-handling leash (a length of PVC pipe with a noose on the end) so I could control the dog without having to touch it. Kathy gave me a look that told me I'd set a new low in her Annals of People Who Don't Deserve Dogs.

By the time Zora was four months old, we'd had no luck at finding a new owner, so it was time to get her spayed. I was alarmed when the puppy didn't rally on schedule. All she wanted was to lie in my lap. This had never happened before. And just like that, I WAS MOMMY. THIS WAS MY BABY. NO ONE SHALL FUCK WITH MY BABY.

My baby, it transpired, had pancreatitis. I lay by her dog bed and poked pills down her throat. How Mom would have laughed; I finally had a glimmer of an understanding as to how it felt to mother a sick child, and it came courtesy of a dog.

My love for Zora was overwhelming in its purity. No ambivalence, no human complication. Which was nice, since I was awash in plenty other human complications. Fiona was disappearing into the bedroom for muffled phone conversations. (*Who are you talking to, dear? Oh, no one.*)

Dog training became my new religion. Kathy suggested that Zora be my service dog. We taught her a number of commands, focusing on how to pick me up if I fell down. The dog's only intractable bad habit was eating stuff off the ground; I was forever shoving my hand inside her muzzle and wresting chicken bones out of her mouth, convinced that a KFC prop plane flew over our neighborhood every night and dumped poultry refuse out the window.

One afternoon, we were out at Foster Park when Zora's head snapped

up in the manner I'd come to dread. Foster Park is bisected by Lake Shore Drive; a steep verge runs up to the highway on either side. Zora frolicked straight up the incline to within a foot of the speeding traffic, where she commenced to chow down on some no doubt execrable crap and blithely ignore the blaring horns. I knew that if I tried to catch her, and she backed up two inches, she would die.

Inspiration hit. I staggered around like Sarah Bernhardt and screamed "HELP, ZORA! *HELLLPP!*" And then I fell down as if shot through the heart. Zora ran to my side; she was understandably (and volubly) piqued when I tied her to a tree. I climbed up the verge, and indeed, a bucket of KFC lay scattered hither and yon, biscuits, mashed potatoes, ketchup, and napkins included.

Yet Zora's best trick was one I didn't teach her at all: like a magician, she could turn me from Golem Girl into the Invisible Girl. When we walked together it was as if I didn't exist. Who'd pay attention to me when she was around? Zora grew to be an impressive animal: fifty-five pounds, tall and long-legged with a thick coat that bulked up her size. Her fur was everyblack: red-black, blue-black, iron-black, with a smoky undercoat that swirled through her mane and up her plumy tail. When she was a puppy, people begged to pet her, but as she matured, they were more likely to cross the street. People asked, "Lady, is that a *wolf*?"

In truth, Zora was a wonderfully gentle dog. (A two-year-old boy once stuck his entire fist into my dog's mouth. She spit out his hand—*pthui*—like a lump of heartworm medication.) But I stopped laughing at the wolf question the day my neighbor across the hall was murdered, and a stranger's body was found in a dumpster two doors down. Edgewater had its share of drug deals, prostitution, shootings, and muggings, not to mention men with unfortunate attitudes about women, so I started saying, "Yes, she is a wolf," and tightening my fist on her leash.

When Zora was two, Fiona invited an old lover to visit. Said they were "working on a project" together. Right. When Old Lover went back home, I told Fiona she was moving out.

At the time, I was running a pet portrait business called Fur Face. A guy called and said he'd written an essay about climbing Mount Hood with his dog. Could I paint their adventure? When Tom O'Dowd came up in the elevator, I thought, *That's an odd-looking guy,* followed by a bemused *Huh. He's kind of cute.* His dog, though, was an absolute total knockout, a pedigreed, long-haired black German shepherd. By the time I finished his painting, I'd fallen for him and his owner, too.

One day we were driving through Indiana when I asked, "Remember that article we saw in the *Trib*? About Wolf Park? It's not far from here. Want to swing by, check it out?"*

We blundered down rutted roads, passing fields of prairie grass and miles of chain-link fencing, until we reached a scatter of prosaic buildings. Wolf Park was founded by Erich Klinghammer, a prominent wolf behaviorist who had studied with Konrad Lorenz. The park was huge: seventy-five acres, including a small lake, and also housed coyotes, foxes, and a herd of bison.

Three hardy, sunburnt animal handlers guided us around the grounds. Wolves paced us from the other side of the chain-link fence. *(Sir, please, don't touch. Ma'am, your little boy REALLY cannot put his fingers through the fence. Please, ma'am, tell your daughter that whatever she just took out of her pockets is definitely not on the wolves' diet!)* Visitors sat on bleachers for the main show. Handlers called the wolves by name, and one by one, beasts materialized out of the thickets like fairy-tale phantoms.

Wolf Park hit Tom with the force of a—well, a herd of bison. In two weeks, he was back, then back every weekend. Tom was a photographer and videographer; soon, the park crew had trained him to videotape the animals' activities from inside the enclosures.

In the spring, the wolves gave birth to a litter of puppies (no one called them cubs). Tom finagled an invitation for me to go inside their pen. I was sternly advised of the rules: pin up my hair, don't wear jewelry, wear long pants, no food in pockets, no tugging games. Within five minutes, the pups had unlaced my shoes, turned my pockets inside

* http://wolfpark.org/

out, pulled the band off my ponytail, run off with my glasses, and sat on my head. I was ecstatic.

I figured soon I'd get to go in with the adult wolves, the way that Tom did, and said as much over dinner with crew. Erich furrowed his brow. "Out of the question. We can't even let an employee go in if they're sick. Monty had a broken arm and had to stay out for weeks until the cast was off."

"But I'm not sick."

"Yes, but the wolves will see you as vulnerable, because of the way you walk. Don't forget, they're predators. They might very well go for you."

That night, in our motel room, I couldn't sleep. Erich's words made sense of a phenomenon I'd noticed when Zora and I took our walks. Dogs were so *judgmental.* They'd take one look at me and growl and lunge while their startled owners protested, "But Spike is usually so friendly!" Erich's remark confirmed that even canids had categories, and mine was "abnormal." My gait was unpredictable, and dogs don't like unpredictable. Even Zora bridled at other crips, much to my chagrin.

Dogs, like wolves and humans, are social animals who evolved to notice the different, the sick, the maimed. They cull the vulnerable prey from the herd and eject failing members from the pack. Social animals were never going to stop staring. Stop judging. All I could do was manage my position in the hierarchy.

Still, I looked down at Zora, asleep on the floor, and thought, *Et tu, Brute?*

When Zora was young, I made a drawing in which I hold her with my eyes closed, while a glass eyeball hovers in the upper corner. It was an homage to the way that she interceded between me and the world—or so I thought, until the night that she woke me up by crashing all around the bed. I switched on the lamp. Zora was pawing at her left eye and rubbing her face on the side of the mattress. Nothing seemed to be sticking out, so I judged it safe to wait till morning to call the vet.

Family: Tom O'Dowd and Buddy
1999

Dr. Palmer diagnosed her with uveitis, an inflammation of the inside of the eye, and gave us a vial of drops. That afternoon Zora ran straight into the wall. The vet was chagrined to discover she'd misdiagnosed the problem: Zora actually had glaucoma and was now irretrievably blind in her left eye. Glaucoma is produced when the eye cannot drain its own ocular fluid. This dangerous level of pressure

destroys the optic nerve. It's ungodly painful and incurable. My dog was eight years old.

For every ailment of the human body, there's an animal equivalent. The emergency hospital on Clybourn housed veterinary cardiologists, oncologists, dermatologists, and neurologists—one galactically expensive congregation. The ophthalmologist warned that most dogs went completely blind within six months. I shelled out for laser surgery to burn away fluid-producing cells in both of Zora's eyes, and watched as glaucoma medications efficiently drained my bank account.

Mom would have understood all the repeated surgeries, the shelves of medication, and how hard it was to make decisions when I couldn't even ask the most basic question: How do you feel?

I consulted with our trainer, with Wolf Park behaviorists, with Lighthouse for the Blind. They all had the same advice: blindness just required more training, but start *now,* while Zora still had some vision. There were lessons on directionality, on sound-targeting, on body-part identification. I scent-marked the house: the bedroom door was vanilla, the hallway cinnamon, the back door lemon. (The bathroom, I figured, had plenty scent of its own.)

Zora went totally blind in 2004. She had been my service dog. I was now her service human.

Alison Bechdel and I had been friends for years. In 2007, I went to see her read from her graphic novel memoir *Fun Home* at the Women and Children First Bookstore. After the throng of groupies drifted away (crushed at having failed to wangle invitations to Bechdel's hotel room), I offered her a ride downtown, sans hotel ambitions, yet curious about how it felt to be surrounded by women who ached to follow you home.

Alison looked alarmed. "Jeezum, I guess I don't really think like that."

Ha, I thought, you're the only person in the room who wasn't.

We stopped at a red light. I ventured, "You think, next time you come around, you might make time to sit for me?" Surely she'd say no.

What she said was, "Wow! That sounds like fun!" I nearly drove up a telephone pole.

Alison didn't come to town often, so I grabbed her for sittings when I could. We scheduled an all-day sitting for Sunday, October 4, 2009, the day after she was to headline the thirtieth-anniversary gala of Women and Children First. The gala was the highlight of the queer social season, so I didn't get home until one in the morning.

Zora was almost sixteen and had been failing for months. She'd had repeated laser surgeries and took more meds than I did. A week earlier, I'd pulled myself together and called the Compassionate Veterinary Hospice to schedule home euthanasia. The hardest decision I'd ever had to make.

I called Fiona so she could come say goodbye. She exploded, "This is such an overreaction! You over-medicalize *everything*. The dog is *fine*." My convictions dried up in an onslaught of guilt.

I got home from the gala, opened my door, and stepped into a horror film. A trail of blood led from the front door, streamed down the hall, and laced in spatters across the bedroom floor. Zora was making sounds I'd never heard before as blood dripped from her eye. I bundled her into the car and drove to Clybourn. Zora yowled and shit and peed and bled all over my car. The Honda was a slaughterhouse. I called Fiona a million times but no one picked up the phone.

The vet took her from my arms. All three of us stretched out on the concrete floor while he gave me our options. Zora's left eye had ruptured; steroid drops had thinned her cornea so badly that a bump or scratch was all it took. He could enucleate the eye, but given her age and health, she wouldn't make it through the surgery. I curled myself around her as the vet and his needle did their work. Then he carried my beloved's body away.

I drove home through four A.M. traffic. I scrunched into my mattress and cried until the sun was high enough to call Alison. She showed up armed with a bucket, cleaning supplies, and rubber gloves. I'd told her about the state of my car, only because it meant I couldn't pick her up.

Alison Bechdel
2010

I never expected such kindness. She said, "You try to get some sleep. Let me do this, then later today, if you're up for it, we can try to work." I passed out for an hour or two, then we worked through my addled state.

These days, Zora's ashes rest on top of the cedar chest that holds my grandmother's flapper-era cocktail dresses, Mom's braid, and Hollis Sigler's purple suit.*

* Charissa King-O'brien's documentary traces my work with Alison. *The Paper Mirror* can be seen online: https://www.kanopy.com/product/paper-mirror.
 In 2016, my portrait of Alison Bechdel was accepted into the Outwin Boochever Portrait Triennial at the National Portrait Gallery of the Smithsonian. Since then, the National Portrait Gallery has purchased the drawing for inclusion in their permanent collection.

Zora: How I Understand
2009

I See Dead People

I'd never gotten my BFA or MFA—too many hospital interruptions—so I figured I'd never get hired at a Big-Time Art School. I was teaching at a community art center in the spring of 2001 when I got a surprise call from Tony Phillips, a former professor of mine at SAIC. He had a one-semester hole to fill. Did I want to sub a class? He couldn't offer anything further, but I'd have fun.

Eighteen students sat slumped and bored over paper cups of cafeteria coffee as I entered the room. They sat up in confusion; whatever they'd expected as an instructor, it sure wasn't me. My spine curved like McDonald's golden arches as I shrank to the height of a yardstick.

"Hi, I'm your teacher." No response. I repeated it in a manner only dogs and bats could hear.

When I was a student at SAIC, I'd studied anatomy with professor Elizabeth Ockwell, a tall blonde with the wind-cutter cheekbones and sturdy frame of a Viking figurehead. Elizabeth could draw with both hands simultaneously, like an angel with pinwheeling wings. I dug up old Xeroxes of her lectures on how to teach students to look through the skin, and see the meat-pulley system that makes the body move.

I taught my students to determine the shape of someone's teeth when their mouth was closed; how to tell if a person was right or left

handed, right- or left-eye dominant; how to tell that our model was a violinist, based on her trapezius muscle. We discussed the biology of animal social behavior, practiced the kind of warm-ups used in improv classes, and went to the Art Institute in order to examine the nuances of portraiture.

The students wanted me to teach the "standard" rules of proportion, but I felt that those very rules obfuscated the ability to see what was really there. The last thing I wanted was to encourage them to fit the body into a system of conformations and failures. God help anyone who crammed our model into that damned Vitruvian circle.

Instead, I tried to convey a love of morphological variance. I even used my own body as exemplar, and taught the mechanics of walking by narrating how my own gait worked. This was pretty off-the-wall, so I was amazed when SAIC offered a permanent position (though my hospitalizations made it unfeasible to try for a tenure-track position).

There were days when I'd be heading to school and some jerk would jump out in front of me and start the sidewalk rigmarole: Was I a midget? What was wrong with me? Was my condition fatal? Or, simply the ever-popular "Shit, are you ugly." I had to struggle to glue myself back together by the time I unlocked the anatomy closet.

I'd been adjuncting at the School of the Art Institute for six years when I got a call from Suzanne Poirier, director of Medical Humanities at the University of Illinois at Chicago. She asked, "Have you ever taught drawing for medical students?"

"You mean like anatomical illustration? I'm not really trained for that."

"No, no, that's mostly digital these days, anyway. What we do, we offer seminars in the arts for first- and second-year med students. A respite from nonstop science, you know, that 'well-rounded' thing we used to think was an important part of education. We offer classes in writing, theater, cartooning—and maybe figure drawing? What do you think?"

My Figure Drawing/Anatomy class, at the School of the Art Institute,
circa 2016. Photo by an unidentified student.

I laughed. "How very liberal artsy. Can I give you a call in a couple
days?"

"Certainly, but let me throw out one more sweetener. How would
you like to be the visiting artist in the Gross Anatomy Lab?"

Would I—*yeeeehawww!!!!* Once Suzanne's ears stopped bleeding, I
had a job.

But . . . what *about* med students? Would I be diagnosed the min-
ute I showed up? Exactly how unwise was this gig?

Instructors for the Medical Humanities program were introduced to
the students in a tiered medical auditorium, the kind you see in movies,
in which an anatomist wheels a specimen in on a gurney and breaks out
the knives. Dr. Norman Lieska was director of Gross Anatomy, nearly
seven feet tall, a man with the fleshless mien of Ichabod Crane and the
grace of Fred Astaire. He explained that I'd be guesting in Gross Lab.
This earned a few confused looks from the students, who apparently
assumed I was Case Study of the Day.

I followed along as Dr. Lieska led a group of med students through
the tile-lined maze that led to the lab. Dr. Lieska unlocked a heavy steel

door; chemical smells billowed out and burned our nose hairs to a crisp. Gross Lab was a long, window-lined room in which dozens of steel autopsy tables were ranked in orderly rows. Each held a preserved cadaver resting in its black rubber cocoon. September light streamed in diagonal shafts, gilding the body bags and glinting off the plastic wrapping. An odd serenity filled my head. I thought, If this is what Meir feels in synagogue, I finally understand.

And so began the business of death in the service of life.

Dr. Lieska reviewed the sequence of dissection over the year: front of the torso (chest, abdomen, internal organs); rear torso (spine, ribs); the limbs; saving the hands and head for last. Heads and hands are wrapped separately, since they are perceived as the most intimate parts of our bodies (not in the genital sense, but as symbols of personhood). Faces are obviously difficult, but so is unwrapping a woman's hands and finding the remnants of her fingernail polish.

Cadavers do not look like the "dead bodies" we see on TV. Embalming produces a fakey gray-pink hue that helps our students forget that what they are cutting into was once a living person. Our cadavers came via the Anatomical Gift Association of Illinois, and were identified only by age and cause of death. Otherwise, anonymity prevailed.

Each team worked on a single cadaver over the entire year. I was issued scrubs and a lab coat, but lamentably, I was always the shortest person in the lab, unable to wedge myself between the students' scrub-clad shoulders as they leaned in to perform the cutting. When I was granted a turn with the scalpel, I was *blown away*. I knew that surgery was a physical process—who hasn't wrestled with a recalcitrant chicken?—but the exertion needed to separate muscle and tendon was *astounding*. I appraised my scars with new respect.

Most cadavers were those of elderly people who'd been confined to bed rest. Their muscles were thin as gum wrappers, their bones pocked with osteoporosis like secret flutes. The few younger individuals had died of heart disease or cancer. Some cadavers retained their pacemakers, artificial hips, stents, dialysis ports. When a body still had its chemo ports, I'd think of Hollis and of other friends I'd lost.

Medical schools want "normal" bodies for their trainees, but elderly

bodies are what they can get. Time transforms us all into unique narratives. It's not easy to find the line between "normal" and "disabled" in a Gross Anatomy Lab. Live long enough and normal is a joke.

A current trend in medical schools is to substitute computerized simulacra of cadavers (table-sized horizontal screens that render the body in layers, without all those unpleasant aromas). I despise the use of computer bodies. Our Gross Lab taught from actual bodies because humans *are* so different from one another.

I have attended the infamous *Body Worlds* exhibit several times. Gunther von Hagens, the bizarre anatomist behind *Body Worlds,* utilizes "normal" bodies for his surrealist dissections, but he puts the anomalous body parts on display like curios, such as a de-fleshed, scoliotic spine twisting alone on a shelf. The way he uses disability as further titillation, beyond his fantasias of death, reminds me of Joel-Peter Witkin and his decapitated urns.

That said, I didn't know how to feel about the lack of congenitally variant bodies in Gross Lab. Could I have endured the dissection of someone with spina bifida? Would it have been the most profound experience of my life, or sent me reeling into despair?*

In Gross Lab, there is no "normal," only "average." I guided our students from table to table so that they'd see the "normal" variations: the differing positions of the organs, the wayward veins and arteries and tendons, the unpredictable anastomoses, all the small—or large—anomalies that in no way matched the pages of our textbooks. None of it indicated disease; just variance.

I was well aware that my own history of surgery was rooted in just such rooms as this, where doctors dissected the normal so that bodies could be made normal. I was the beneficiary of six hundred years of exploration; my body floated on an ocean of blood. I was understanding my own construction more than I ever had. Still, the first time I witnessed the dissection of a woman's spine, I saw Carole and not myself.

* Among the many articles on the *Body Worlds* controversy is this NPR report by Neda Ulaby: https://www.npr.org/templates/story/story.php?storyId=5637687.

I'd look around at all the baby doctors and think, Someday I'll see you in my hospital room. Will we remember each other? Will we admit it if we do?

A year of Gross Lab ends with a memorial held by the anatomy community. Some students read letters of thanks written to the families of the donors (families are kept anonymous; letters are forwarded only if the family wants them), while other students recite poems to their donor, or reflect on the meaning of the year. Candles are lit, farewells said, then the bodies go on to cremation.

I was left with a disturbing aftereffect. The wall between life and death had thinned, become diaphanous. I felt as if the people I loved might tumble into death without clear reason. What kept *anyone* alive, much less what made us die? I needed for that veil to return to opacity, for the delusion of safety that keeps us sane.

In 2010, Norman Lieska and I performed a lecture for the Chicago Humanities Festival. Our topic was "Beauty and Variation." We argued that "normal" was an illusion; we projected slides of the thirteen "standard" positions of the appendix, and described the sporadic absence of the palmaris longus muscle until we had the entire audience staring at their wrists like pot-addled undergrads.

When Norm and I had walked out onstage, we'd each held a large, brightly colored sign. His said HUMAN. Mine said VARIATION. As we turned to go at the end of our performance, we stopped, looked at each other, and switched signs.

Invasion of the Body Snatchers

Philadelphia, November 2006

November on the East Coast was autumn in its original factory settings. The air was sharp and clear as beveled glass, the sky a glaze of luminous blue. Audrey and I made our way along the tilting sidewalks of Philadelphia, where the buildings warped and sagged as if begging to lie down after centuries of upright behavior. Our route bristled with plaques on poles: NEAR HERE, SILVERSMITH PHILIP SYNG, JR., CREATED THE INKSTAND USED TO SIGN THE DECLARATION . . .

After an hour of touristy lostness, we fetched up in front of a somber hulk of red Georgian brick. Above the door was carved THE COLLEGE OF PHYSICIANS. This was confusing. Audrey jogged my arm. There, concealed amid the welter of pilasters, scrollwork, and dentate cornice lines, was a square bronze sign:

THE MÜTTER MUSEUM

We traded wicked grins. *Here we go.*

The Mütter's white-marble lobby serves as a cooling-off place in which visitors can pause and consider what lies ahead. A scholar friend of mine told me that in the nineteenth century the lobby held a large

vat of formaldehyde. Physicians stopped by to deposit the most intriguing specimens they'd gleaned during the day's surgery. At night a technician fished out these offerings and preserved them for collection.*

These days, there was no font, only benches and a rather fatuous gift shop.

The Mütter Museum began as the private collection of Dr. Thomas Dent Mütter. In 1858, Dr. Mütter donated it to the Philadelphia College of Physicians, to be used as a teaching tool for the medical school. The collection remained private for decades, but in the 1970s the museum was opened to the public. It now claimed to host over 130,000 visitors a year.

The website tantalized with images of the famous exhibits, including the plaster death cast of Chang and Eng Bunker, the original "Siamese Twins," the skeletons of Harry Eastlack and of the so-called "Kentucky Giant," and the Megacolon, a body part that seemed to have escaped from the Marianas Trench. Some exhibits featured normative bodies, but the focus of the collection was on disabilities, primarily those resulting from injury, disease, and birth anomaly.

I was there in my guise as anatomy instructor. Audrey was doing research for a book. Neither of us was motivated by the Mütter's reputation as one of the "Ten Creepiest Museums in the World." Of *course* not.

The Mütter couldn't decide whether to be a teaching museum or Roger Corman's House of Horrors. The ambiance encouraged a desire for the outré, while reassuring the viewer that such desires were respectable by making feints toward education. These attempts were unserious in the extreme. The labels were so old and spidery as to be indecipherable, and a general air of boogety-boo pervaded what information there was, as shock value took precedence over deeper knowledge. It came as no surprise that the Mütter's big yearly event was an all-night sleepover on All Hallows' Eve.

The upper floor of the Mütter Museum was dominated by the Hyrtl

* The academic is Megan Bayles, PhD.

AT 54
2012

Skull Collection, 139 skulls that lined one entire wall. I couldn't help showing off. "See that lump sticking out along his jaw? The mandible was broken at some point and healed badly. . . . And those thin zygo-matic arches? Bad nutrition. . . . That skull is female; men have a heavier brow ridge. . . ." Audrey raised an eyebrow. Pedantic much?

We viewed the "Soap Lady," the saponified woman in her Sleeping Beauty coffin. Goggled at the ghastly collection of objects that people had swallowed and then had retrieved from their gullets by the (no doubt) ghastly Dr. Chevalier Jackson.

Where upstairs was a "dry" boneyard, the lower level was replete with "wet" items in jars, as well as more bony spectacles. The air reeked of chemicals. Audrey turned a whiter shade of puke. A large specimen vitrine had cracked down one side; we suspected that the Mütter was trying to stealth-embalm a visitor or two.

We stood in front of the skeleton of Harry Eastlack, whose fibro-dysplasia ossificans progressiva had caused webs and streamers and sheets of calcium to form inside his body as if Eastlack was growing a suit of armor from the inside out. Audrey pondered, "How does something like that even happen? It's like he was attacked by malevolent spiders."

"Not sure. Some immune system thing? Maybe his bones kept thinking they were broken and never stopped trying to repair themselves. Like a car alarm that won't turn off."

"Sometimes I wish I didn't know about these things. Now I'll probably have nightmares about ossification. That looks *extremely* uncomfortable."

I snorted. "Ten bucks says Harry's going to show up in your next aquatint."

On the one hand, the Mütter was a matchless compendium of human variation; a primer on the intersection of nature and chance, on biology as half order, half chaos. But too many exhibits stank of the sideshow. One floor-to-ceiling case held the skeleton of the so-called "Kentucky Giant"; it stood between an unidentified male skeleton of "normal" height and the Little Person skeleton of Mary Ashberry. This was no benign comment on human morphology. The "average" male skeleton was only there to emphasize the "abnormality" of the other two on display. Most gallingly, the skull of Mary's stillborn infant

(Mary had died in childbirth) had been plopped on the floor at her feet.*

When disabled bodies are displayed in public, they usually fulfill one of two purposes. Some, such as the Mütter's head of a woman with a cutaneous horn, illustrate a condition that medicine claims to have "cured" out of existence. The viewer is "safe"; that is, they'll never be beset by that particular impairment. Others bodies—like Chang and Eng's—represent conditions that medicine promises to eradicate. Modern medicine assures us that such impairments will be left in the past, or be gone in the imminent future. The Mütter's specimens exist in a split timeline—a tempus bifida—that flows around us on either side, leaving us, the viewers, untouched in the present moment. A pressure to cure that amounts to eradication.

A school group poured into the museum with their shrieks and giggles of "No way! Is that *real*? *Grrroooosssss!*" They stared at me as if I were an exhibit come to life.

I'd lost Audrey somewhere in the maze of cases. As I wandered off in search of her, I passed a sizeable cabinet in the middle of the room. Its shelves were laden with jars of preserved fetuses and stillborn infants. I stopped. I'd never really looked at such specimens. These seemed to have either significantly more or rather less than the regulation number of parts. Their labels were redolent of Greek mythology: *Phocomelia, Sirenomelia, Hydrocephalus, Anencephaly, Polydactyly, Holoprosencephaly, Gastroschisis.* I saw multiple pairs of conjoined twins, merged at the head or the heart or the spine. All specimens had long ago lost their baby-pink coloration and had bleached to an aqueous ivory.

I concentrated on what embryology I could remember, and thought I was being wonderfully objective. Which stopped as soon as I reached the middle of the case.

* The "Giant" had been purchased in 1877, with the seller supposedly stipulating that the museum never ask whose bones they had been, a situation that seems more plausible in the reverse.

. . .

I was standing in front of my own body.

To be exact, *bodies*. Two entire shelves of jars dedicated to spina bifida. One fetus had my precise version: spina bifida lipomyelomeningocele.

There I was. The infant who had emerged from my mother's body. This infant, this astonishment, this red birthday balloon. This me in taxidermy. This me.

The specimens were much older than I was. Immersion had swollen their bodies until they'd become too big for their containers; inmates pushing against the bars of their cells. Their faces were turned to the wall, but even so, their eyes pulled me straight through the glass.

I, the anatomy professor, had never gone looking for photographs of spina bifida. Deep down I'd wanted not to know. I leaned my forehead against the case. Audrey found me and wrapped her hand around my arm, worried that I might faint.*

A century had passed since the Mütter fetuses were preserved, yet still they floated inside their round glass houses, naked and ancient as cavefish, their only biographies the medical details of their anomalies. Museum labels told us where and how to look, in texts written for the able-bodied as they looked upon the abnormal. Where had they come from? Why was the Mütter their final resting place? Of this, nothing was said. The fetuses were perfectly ahistorical bodies.

Like the jar children, my body was a marker in time. In a way, I too

* My talk on the Mütter Museum for the Chicago Humanities Festival: https://www
.youtube.com/watch?v=obJaZtu3Ams.

had no history. No spina bifida elders to show me how to age. The jar babies *were* my ancestors.

The bleaching action of chemicals made it impossible to know a fetus's racial or national origins, much less if they'd come from affluent or impoverished families. Had their mothers given them away? Had the women even known the nature of their offspring, or what it meant? Mine had known, and said yes, I will keep her, but these fetuses had been gathered at a time when doctors routinely withheld the truth from their patients. It was entirely possible that the mothers were told only that their infants had died.

And yet—and yet—the jar children relieved me of a loneliness that I never even knew I had. They brought me to a place past words, past analysis or politics, or even beauty. I longed to slip a jar of siblings into my purse.

I leaned my palms against the chilly glass and wished, for the ten thousandth time, that I could ask my mother anything at all.

Totems and Familiars: Lawrence Weschler
2008

Freaks

When Elizabeth Ockwell retired, I was awarded the position of adjunct professor of anatomy at the School of the Art Institute. I inherited her anatomy closet and its treasures: the lion skull, the deer legs and antlers, the boxes full of human skulls and femurs, humeri and ribs. The closet was also home to three fully articulated human skeletons—two male, one female—most likely those of desperately poor people from India or China, whose bones showed evidence of meager diets and unhealed injuries. I taught my students to see these marks and to reflect upon the reasons that a powerless body might end up in Chicago.

My position as an anatomy professor was bringing me closer to Carole's years in medical research. In 2014, my mother and I came full circle.

The Medical Humanities Department at University of Illinois at Chicago converted to a bioethics program, and defunded the program in which I'd taught. Some UIC faculty joined the Medical Humanities Department at Northwestern University. Their director, Catherine Belling, offered me a job teaching figure drawing and anatomical self-portraiture. I taught at Northwestern for two years before asking to go

on a tour of their Gross Anatomy Lab. Which was when everything changed.

Their lab is much like that at UIC, save that it's located in a basement rather than in a sunny upper floor. I was toodling around and reminiscing about my cadaver years when I noticed that one wall was lined with glass cases—and in those cases were vitrines containing fetal specimens. A sign identified this as the Arey-Krantz Collection. One-third of the vitrines displayed fetuses in standard prenatal development, but the rest were pure Mütter Museum: *Anencephaly, Conjoined Twins, Gastroschisis, Holoprosencephaly, Hydrocephalus, Omphalocele, Phocomelia, Sirenomelia, Spina Bifida.**

The rest of the tour moved deeper into the lab, where a professor was demonstrating dissection techniques, but I stayed behind, hypnotized, almost nose-to-nose with the fetuses. I was overcome with the need to be close to them, to see them as often as possible. I thought I could get permission to draw the collection, but that didn't feel right.

Instead, I proposed a Medical Humanities course called "Drawing in a Jar," in which first- and second-year med students would learn to draw the Arey-Krantz fetuses as portraits. I reached for language that might allow us to discuss the fetuses without stumbling into the lexicon of ableism—or of the abortion debate, for that matter. I rejected "specimens" in favor of "entities" or "individuals"; later, some students would call them "companions," a choice I found very moving.

I am still teaching that course. At the start of the semester, we slide open the doors to the cabinets and gingerly pull down the heavy rectangular jars. Some fetuses are veiled in a milky moss; the fluid inside has to be changed every term, or it grows a bacterium that drapes their bodies in gauze. The entities are so fragile that I fear they'll pop and evaporate like a punctured balloon.

Our students are so young, so smart, eager and sleek as greyhounds; at the same time, they're visibly ambivalent as they confront the collection. Students aim for that much-vaunted scientific detachment, but

* The Arey-Krantz: https://www.bioethics.northwestern.edu/docs/atrium/atrium-issue1 .pdf.

don't yet have the armor to pull it off. The technical demands of drawing allow them to get used to the sight of their fetuses and to sort through their feelings. They're surprised by how beautiful the entities are, how peaceful the faces, even as intestinal organs erupt from bellies, or legs fuse into a single terminus, or brains extravasate from skulls. The fetuses force us to ask ourselves why we tolerate only a narrow range of morphology. Science fiction films, books, and games posit hominids with as many limbs, eyes, wings, hooves, and heads as can fit on a body—beings that we claim to want to meet—but we recoil at the reality of human divergence.

For their final assignment, students present a fifteen-minute biography of a person who has the same impairment as the fetus they've drawn, and who has lived within the last twenty-five years. (Some conditions, such as anencephaly, are not survivable, so the student researches someone with a similar impairment.) The subject must have had a public presence, whether in the form of a career, a documentary, or a memoir or biography. Medical data is limited to five minutes of the presentation. I want our students to think about the issue of the historical specimen; that we're taught to see the Disabled as tragedies to be eradicated, as temporary "mistakes," rather than bodies that have a real, present life.*

Students have said that after taking my class, their ideas about genetics and diagnoses moved toward an inclusive vision. For some, it changes how they would speak to a prospective parent, or a patient with a variant body.

I am many years older and many inches shorter than my students. I may dress like their professors, in a lab coat and exam gloves, but I limp and lose my balance as I weave between the gurneys. The single most important thing I do in Medical Humanities is to present our students with a Disabled person long before they encounter us in clinic. I break the wall between medical professional and patient, and insist on respect

* Every semester, some student presents a project on an actual friend of mine. They somberly lecture me on Mat Fraser or Tekki Lomnicki or any one of my portrait subjects (*few* of my students take the time to look at my website) while I bite my lip in suppressed laughter.

Northwestern Medical School student
Jeanne Quinn's drawing of a sirenomelia
specimen from the Arey-Krantz Collection

for both. (Though I do feel as if I've escaped from a jar only to end up as a teaching specimen after all.) Ironically, it is at this hospital, Northwestern Memorial, where I get almost all of my care.

Some bioethicists insist that there's no purpose anymore for collections like the Arey-Krantz. They say we can get all we need from digital sources (disembodied images . . . sigh). I agree that there are important ethical questions, as there are about *Body Worlds* and the like, particularly in regard to where specimen bodies come from and how they are presented. Yet it's obvious that my students are affected by actual, physical presences. I doubt they'd attain the same level of empathy if the fetuses only existed on the students' iPhones. This is crucial: our students are tomorrow's physicians, destined to pick and choose which disabilities will persist and which will be wiped away in the disability extinction known as modern medicine.

For myself, I want a new medical language. One that lets us describe ourselves (and be described) with clinical accuracy *and* as fascinating

and wonderful phenomena. I want to revel in Latinate words of plea-sure: *Lipo* (fat), *Myelo* (spinal cord), *Meninges* (membrane), *Cele* (swell-ing); an efflorescence, a disruption, an excrescence from the secret to the known. Might I describe spina bifida as a poetic occurrence? Can I say that my spine is awe-inspiring? Nature is wayward and perverse: there is wild inside what we call abnormal.

I slip on my white coat and step into the lab. Carole and I press our fingertips against our separate sides of the jar. I am close to my mother. I am whole.

Carrie Sandahl
2017

The Skin We Live In

From the online *Cambridge Dictionary:*

FREAK: a thing, person, animal, or event that is extremely unusual or unlikely, and not like any other of its type.

Am I a freak?

Is there a freak spectrum in which I tip into *yes* or away from *no*? I am extremely unlikely. Let's say that I am a freak. Am I "unlike"? What is "like"?

A freak has a real human body. A monster's body is imaginary. The monster is a space in which we consider the boundaries of the acceptable. What is proper behavior? What is allowable desire? What is condonable appearance? A freak show takes a person and makes it into a monster; I work to take the freak and make it a human being.

These things make me a freak: Bone. Height. Skin. Gait. Of these, bone and skin are crucial to portraiture. The scaffolding of bone determines most of our appearance—but bone is nowhere near as fraught as skin.

Mom used to tell me that the color of my skin was "olive." She thought it was beautiful, but what I heard was that I was green, just like Frankenstein's Creature. (It's weird that we think of the Creature as green, considering that Mary Shelley describes his skin as yellow, and

the James Whale films were shot in black-and-white. The origin of the green Creature seems to have been a cover of *Mad* magazine from 1964; green was reiterated in a 1960s series of Dell comics, and in that cultural milestone of 1988, *Scooby Doo! and the Reluctant Werewolf.*)*

My bones are obvious, but most of the rucks and punctures and stitches of my skin lie beneath my clothing. People with unscarred skin are a mystery to me. I don't know how it feels to be inviolate. Unmarked. Marks aren't just scars, and unmarked isn't just un-punctured. The complex spectrum of skin tones—anything but "white"—has been marked as *other*, as less. American culture tends to recognize race before any other aspect of a person's identity, before gender or age or affluence, so the first question a portrait artist must answer is skin. And skin demands color, even if that means choosing the right shades of charcoal gray.

Will I get it wrong? Yes.

None of my painting classes in art school employed models of color. I don't know why. Both schools had them, but I only saw those models in my drawing classes. All of my painting training focused on white skin, whether how to lay down an underpainting, how to gauge warm tones and cool shadows, or how to indicate the veins, bones, and fat under the skin. I unwittingly internalized and absorbed the racism of my training. As with every form of racism, it has proved difficult to undo.[†]

Here's a strange thing: I know what people look like without skin, having seen it peeled away from dozens of cadavers. I can look at a living person and let my eyes slide underneath to the anatomy, deep to the skeleton itself, an X-ray program that plays in my head without my volition.

My own skin is aging. Wrinkles are changing how people treat me

* Alice Sheppard reminds me that "olive" as applied to some people is another word for "not white."

† Artists who work in computer-generated imagery say that skin is incredibly hard to digitize. The algorithms are nightmares of physics, owing to the fact that light moves through skin in much the same way that light bounces inside a glass of milk. Skin "transluces" above its subcutaneous fats and liquids. As light shines on us, we faintly glow.

on the street. The shape of my spine, my gait, my shoes, are becoming subsumed into the category of "old." Perhaps, instead of Golem Girl, it's time to call myself the Crone of Frankenstein.

Skin defines where we begin and end. Fear of monsters and disabled people stems from the idea that they are contagious; monsters violate boundaries by biting or oozing or infecting their way past the wall of the self. Oddly, I have come to see portraiture as *also* an act of boundary violation, but not in the way one might think. It's not about getting my subjects to disclose their secrets; it's about the collision between my boundary and that of the other.

My subject is separate from me. We rarely look anything like each other; on the contrary, I'm most interested in people who don't resemble me. I depict the person I think I see, and unless I put myself (literally) in the picture, I seem to be invisible to the viewer. The subject is present—and the artist is absent.

This is not true. The brush marks or pencil marks that make up a portrait describe the artist's body as well as the subject's. The way an artist paints or draws is a record of their height, eyesight, motor skills, cognition, endurance, wingspan, and muscular strength. A handmade artwork is the product of the body (or bodies) that made it happen.

That makes a portrait a species of monster. A chimera, built of illusions—that the subject is present and the artist is absent. In reality, the two bodies blur into one. (Add the viewer, and you get a three-headed Hydra.)

Consider the *Mona Lisa*. She's been consumed and digested millions of times, a different creature understood differently by every viewer. Scholars have speculated that *La Gioconda* is actually a Leonardo self-portrait. Who knows who lurks behind her face?*

* https://abcnews.go.com/GMA/leonardo-da-vincis-mona-lisa-self-portrait/story?id=9662394

Also see https://en.wikipedia.org/wiki/Speculations_about_Mona_Lisa.

The Risk Pictures: Lennard Davis
By Riva Lehrer and Lennard Davis
2016

With pencil drawing Lennard did of me
during our collaboration.

There are artists who depict their subjects as (probably) subconscious mirror images. I've seen an artist's physical resemblance reflected in portraits of their subjects—that is, in works that are *not* self-portraits. I notice it, because I do it constantly. Over and over, paint the subject's hands and nose a little too big, the rib cage out of proportion. My mind uses my body as a reference for theirs. I am the poltergeist in my own work.

I used to call these mistakes, but now I call them by another name: leakage.

The body of the artist leaks into the body of the subject. You can see this in Leonardo da Vinci as well as artists such as George Tooker, Suzanne Valadon, El Greco, Egon Schiele, Pablo Picasso, Maxfield Parrish, Julian Schnabel, Remedios Varo, and Fernando Botero.

Leakage is a disability state. A monster state. Disabled bodies are thought to drool, slime, bleed, and infect, if not in truth, then in the public imagination. When we hallucinate or speak incoherently, others avoid us as if we radiate contagion, and make us ashamed of our lack of bodily control. But perhaps we might think of leakage as a reaching-out, a desire to join the tribe of humanity.

When I teach figure drawing, I begin the semester by instructing my students to draw our classroom mascot, a plastic man who goes by the retail name of Bucky the Budget Skeleton. After they're done, I show them that almost everyone has drawn themselves. Tall people made the bones too long; short people condensed them; wide people went horizontal. I once had a student who had an elongated occipital bone. To my delight, she gave Bucky her own skull, yet when I remarked on this, she was surprised; she had no conscious awareness that there was anything unusual about the back of her head. And yet she drew it anyway.

Leakage is unconscious. We all measure the world against our own bodies.

That said, leakage is a problematic idea, at a time when historically erased identities are trying to represent themselves through their own truths. My attempt to see *you* will always risk blurring *you* with *me*. If my collaborators were able to impose the delineations of their bodies

on mine, it would be a fairer struggle. For now, my "mistakes" can look like the cluelessness of privilege.*

Leakage, for me, remains a paradox. Leakage is unintended and below my conscious awareness, yet it alleviates the sense that I am alone in my body. It happens because I want to understand my subject, see through their eyes, but it's just as true that leakage is a fantasy taking place in the hothouse of my brain, and that you, my collaborator, may not share that sensation in the least. Maybe you've raised your walls and shields and I can't even tell.

I do know that whether you create a portrait or a child, you can't make another's body except by pulling it through your own.

* See the discussions of *The Risk Pictures* in the Portrait section at the end of the book. That project is the closest I've come to letting others impose their lineaments on me.

Gollum

I

His skin is winched tight over his bones, bones that have never grown past adolescence. His skin is jaundice yellow, the smeared, waxen gray of a spent candle; his smile one of neotenous yearning, though he resembles an ancient, poisonous lizard. Gollum moves in jerks and scuttles. An eldritch fetus. A puppet of forces outside himself.

Gollum's movements are *uncanny*, from the Middle English word *canne*, meaning "to know or be able." *Un*knowable, *un*able, *un*predictable, not in control, the antithesis of the mastered body.

Here is one not to be trusted, even if he seems so breakable, a see-through corpse. His appearance is the result of corruption in which his emotional, physical, and moral conditions converge. Gollum is another's creature. No mind or will to call his own. And as always, the disabled body is a symbol of evil.

What else is new.

II

A painter tries to capture one perfect moment within a quantum of gesture. One step of a dance that encapsulates the whole: essential, but not essentialist. I look to dance to understand the body at rest.

66 Degrees
2018

I have always loved dance. In the 1980s, Laurie and I collaborated on music and sets for the Wilder Milder dance ensemble. I was props-and-costume master for their gig at the Merce Cunningham Theater in Manhattan, and was dashing through the lobby with an armful of leotards when I ran smack into Cunningham himself.

He narrowed his eyes. "Are you a dancer?"

Flustered, I said, "No, of course not."

He lifted a leprechaun brow. "Well, you should be." Had I known about physically integrated dance troupes, I would have joined up that very minute. Those were the days when I could dance. Unfortunately, my spine has gone one way, my desires another.

III

June 2015

My doorbell rings. I go downstairs and hold the doors for Alice Sheppard as she wheels in from the street. She wedges her chair inside my

ancient elevator (just like the ones at Condon, same brass scissor-gate, same worn buttons for each floor). She shrugs off her coat, drops her workout gear, and shifts from dance rehearsal mode to our collaboration.

There's food, there's gossip, and there's the tumble into work. We explore the societally constructed intersections of skin and race. With Alice, I allow shame to crack me open (*my pain my pain my pain*) again and again.

I first saw her perform with the AXIS Dance Company, a physically integrated troupe in Oakland, California. She was a professor of English and comparative literature at Pennsylvania State University when she happened to attend a performance by legendary Disabled dancer/choreographer Homer Avila. He dared her to take a dance class. This was such a powerful experience that she left academia to see what she might do.

After six years, Alice struck out on her own as a solo performer. She worked with Sara Hendren of Olin College, where Hendren heads a team of students and artists at the forefront of engineering. Their projects span the gamut from prosthetics to furniture to tools. For Alice, they devised a parabolic wooden ramp that, as she says, "was designed for the maximum natural expressions of wheeled movement potential." Her resultant performance, *DESCENT,* was set on this architectural sculptural ramp, earning a 2018 rave preview in *The New York Times.* At the moment, she's in town to collaborate with a Chicago dancer.

I ask how she wants to pose. Her response is . . . well, worrisome.

"I've been thinking," she says, "I want to do something airborne. In flight."

"God, Alice, do I need to rent a trapeze? I'm not sure my plaster ceiling is up to this."

"Ha! No. I have some ideas, though. Let me put my wheelchair down . . . like this . . . I'll just climb . . . Wait, give me a minute. . . ."

Alice takes a wheel off her chair, lays the chair on its side, and hoists

herself atop the remaining wheel. All her weight is balanced on one muscular hip. She's wearing only her thin rehearsal clothes—then she makes it way *more* ouchy by shedding those, too. I can see the wheel attachment dig into her skin. Should I break out the Band-Aids, just in case?

"Holy shit, aren't you afraid you're going to bleed all over the floor? I know we're supposed to suffer for art, but you don't have to go all Saint Sebastian on me."

She snickers. "Actually . . . you know what would work better? That!" And points to my dining room table.

"Are you— No, really?"

I'm directed to bring pillows and move chairs. She arranges her limbs as if gravity is an afterthought. I get out my camera and pray we don't land in the emergency room.

I decide that Alice's portrait will occupy the front and back of two large sheets of double-frosted Mylar film. Mylar is translucent, not transparent. The back of each sheet will be painted in strong, bright colors, which will appear cooler on the front. Pencils and pastels will render delicate tones on the surface.

Alice pushes her muscles to new extremes. Her body is so responsive that I notice micro-changes between sessions. Each time she comes into town, I'm presented with such an altered body that I'm put in mind of those time-lapse films so beloved of PBS, as if Alice is the sped-up scene of a blooming flower, or the hatching, molting, and fledging of an eagle chick.

When she comes back after an unusually long hiatus, my heart sinks. I've misremembered her. Alice's skin is a shade darker than I've drawn, and there is no technical way to correct the error. Once again, my art school training bites my butt. I began with too light an under-layer and now I'm stuck. Alice's portrait—much as I love it—is also a record of what I fail to see. I fix what I can. To my relief and gratitude, Alice lets us push on.

IV

After my last solo exhibit in 2011, I had burned out. Portraiture was starting to feel like a sack of rocks on my back. I was overfull of the freight of others—their egos, their loves and pain—and tired of our small negotiations. Some nights I'd sit down at the easel and then just walk away.

I'd never been comfortable with the traditional power dynamics of portraiture, in which the artist is the one who stares—who is in control—and the subject is the one who agrees to submit. I worked to give my collaborators control, yet I still made the major decisions; my hand made all the marks. I wanted to equalize the dynamics of portraiture. I hoped that, if I relinquished *more* control, we might reach a more fruitful engagement.

I wanted to make myself as vulnerable as my subjects were, so I decided to start each portrait with a three-hour session that would include not only the usual two hours of me drawing while they sat, but also something entirely different. At the two-hour mark, I would leave my house for one hour. During that time, my collaborator would have the run of my house. They'd have my permission to explore without interference: eat my food, sleep on my bed, log onto my computer (I wouldn't sign out, though I'd let them discover that for themselves). Do anything at all, even steal my belongings, and I would never ask what they did while I was gone. In exchange, they would have to alter their portrait while I was out. They could draw or paint or write or cut or collage or erase, it was their choice entirely, I wouldn't guide them in any way.

This was a terrifying proposition. What if they burned it, tore it to bits, scribbled over every inch? Or plain old walked off with it? Not to mention that I was risking my very home. Yet the only way this project could work was if I deliberately jeopardized the portrait. I called the project *The Risk Pictures*.

I had worked with four collaborators before Alice. The results had been uneven. Some had been too restrained, too deferential ("You're the artist! I can't mess up your work!") to make the project a conceptual success.

Alice, I knew, was not one to hold back.

V

September 2016

I've drawn for two hours. It's time to hand Alice the reins. She's supposed to call me in an hour to let me know I can come back.

I wander the neighborhood. An hour, an hour twenty, hour thirty. Has she torched my house? Then *brringg bbrrinnggg*. A small voice says, "Riva . . . I don't know how to tell you this, but I think I fucked up. Please don't be mad at me, but I didn't do what we discussed." Huh. I gallop all the way home, imagining everything from giant, random scribbles to beholding the contents of my refrigerator spattered all over the easel.

Not quite. Alice has, indeed, not held back. Little hands are fondling her skin; wheelchair riders creep along her body, apparently heading directly for her crotch. She's surrounded by wild, twisty limbs that end with contracted feet (*also* arching toward her crotch). And then there's the puzzlingly empty rectangle just above her hip.

Yep, I risked, and it is ruined.

I inhale like a deep-sea diver. "Those are some powerfully interesting choices. You've certainly given me a lot to work with here. I think I need to sit with it, like overnight." (Like for a month.)

Alice's mouth lifts in a comforted smile. "Oh, I'm *so* glad. I thought you might be upset."

Either I'm a better actress than I think I am, or she's pretending for the both of us.

Alice and I had begun our work in the summer of 2015, when the news was grappling with the death of Michael Brown, following on the heels of Eric Garner, Freddie Gray, and Trayvon Martin. This is much on Alice's mind and threads through her works in progress. One evening, as she shows me video of that day's rehearsal, I'm caught by a passage in which she curls into a fetal ball. I draw that shape as a silhouette on a sheet of black cardboard about three feet long, cut it out and slip it

between the two sheets of Mylar. The quasi-shadow animates Alice's body: open, closed, open, closed, a contracture against the exuberance of her pose. Alice herself snips a dancer out of paper and pastes it into the blank rectangle on her belly. I see: she meant all along to turn her body into a theater.

The drawing snaps into focus; electric, erotic, Alice.

The Risk Pictures: Alice Sheppard
By Riva Lehrer and Alice Sheppard
2017

VI

New York, November 2018

Alice asks if I'd like to be part of choreographing a work. Even better, this involves a trip to the motion-capture lab at NYU. I bounce like a little kid in the back seat of our Uber as we cross the Manhattan Bridge

to Brooklyn. I've been mesmerized by motion-capture technology ever since the first *Lord of the Rings*.

The Integrated Digital Media lab at the NYU Tandon School of Engineering is herpetological: cables and cords snake everywhere like pythons hunting rats. Alice and I are met by a couple of sweet (and mammalian) techies who guide us through their warren. The lab is a windowless square with a black floor and dark gray walls. They scramble about in search of motion-capture suits sized for our frames (mine so short and wide, Alice's so strongly built). At last, a medley of bodysuits, booties, gloves, and headgear are cobbled from the supply closets. I shuffle out of the ladies' restroom dressed like a disco gecko.

A "mocap" suit is a spandex bodysuit covered with silvery reflective sensors. Lasers are bounced off the reflectors, which allows a computer to track the position of your body as you move. The more sensors, the more detail. For Hollywood productions, there are sensors on every joint, as well as tiny reflectors glued to the muscles of the face. This produces a digital "wire frame" version of one's body; NYU techies will project ours up on the wall.

Alice moves around the floor, deliberate and thoughtful. She frowns and instructs me on the positions and gestures she requires. I cannot believe it: I am being choreographed by Alice Sheppard! This is the obverse of the *Risk Pictures* project: here, in *this* space, I am as vulnerable as I've ever been. The thought stops me cold. What *does* Alice see when she looks at me? Her expression is one of deep assessment. I suppose she looks at me the way I look at her—that our bodies are impetus for art.

My discomfort intensifies as she asks me to walk without my boots, something I avoid at all costs when I'm among strangers. I had my movement analyzed years ago, in a digital gait lab at the Rehabilitation Institute of Chicago, but that had been meant to diagnose my failings. I had been so ashamed by the juddering of my limp. Here, at NYU, judgment is irrelevant.

The digital display turns us both into stick figures. Alice is taller and moves with more grace, but on-screen we are almost the same. Stark avatars of stripped-down humanity. Gone are gender, race, and the specificities of our actual forms. That twindom I long for beckons onscreen.

(Later, when we talk about the day, Alice reminds me that we are absolutely not the same. Those green symbols were designed by white, able-bodied men who think that signifiers can be disposed of. I must never forget that there is a limit to what Alice and I can know of each other. Equivalency is a fantasy.)

But in the moment, I am hypnotized by this bright green Riva. She has a cartoon-straight spine, but here is her right arm, still cantilevered above the invisibly scoliotic bulge of her ribs. Here is the lurch-and-stomp way she walks.

I glimpse my reflection in the laboratory mirror. Those suits are merciless. Every jut and bulge of my bones is on full display. I am the shape of my own stark shadow, my noontime doppelgänger preceding me on the sidewalk.

I am Gollum.

In *The Lord of the Rings,* Andy Serkis put on a mocap suit and puppeted Gollum to his igneous doom. I am small as Gollum and as misshapen; in photos of that day, I am liverish yellow and look older than my grandfather.

Yet I am not alone. I am not the same person who used to walk around in a self-induced myopic fog. I have been brought to this place, this lab, by everyone who's ever shared the seesaw of my easel. I am with Alice, ferociously brilliant, implacable, transformative Alice, who makes me see myself anew. I have been changed through the bodies of others. Here, now, I am my own Maharal.

I touch the silver sensor that illuminates the Creature. She is glowing green.

In that bare and callous space, I step into the body of the monster. I wrap myself in the skin of the monster. I am a warning and an omen. I am the girl who lives. A creation, making myself.

I am me.

Golem I

The Rabbi scrabbles his fingers through the mud and rocks. Somewhere in the muck must be a coherent form that can contain God's will. He scoops up worms, clods, a lumpy, four-part tuber with one long trailing root, and puts aside a notched branch that curves like a spine. His palms slap against the vast wet earthen doll, imprinting its skin with a spiderweb of the Rabbi's own heart lines, head lines, and life lines. He pushes these finds into the body of the creature. Cattails blow by the water's edge; he plucks them from the riverbed to do duty for its hair.

The Rabbi is overcome by the life in his hands. Not just the life-to-come of the monster, but the liveliness of his own hands as they feel their way through the slippery flesh of the earth. Rabbi Judah Loew ben Bezalel, known as the Maharal, has only ever dealt with words. Now he thinks, *No wonder Jews are admonished against making idols, lest they imagine themselves as gods.* This muddy enterprise is almost more ravishing than he can bear.

Judah stiffens his fingers and carves EMET into the rough forehead. *Emet* means "truth," only one of the burdens laid on the monster's fictile brain. The Rabbi fishes an inscribed scrap of parchment out of his pocket and slips it into the cavern of the creature's mouth. The scroll tingles against Judah's fingertips, sparking with the secret names of God.

See the Golem rise from the banks of the Vltava River. See it unbalanced as an uprooted tree. The monster is taller than the Rabbi. Judah startles to realize his creature is ugly. All along, it had looked like hope incarnate.

The moon illuminates the mass of the Golem, thick and clotted, asymmetrical and uncanny. Is that a suggestion of breasts, a raised mound at the joining of the thighs—who can say? The Rabbi is not allowed to look upon women other than his wife, and utterly forbidden to touch one, lest she be menstruating and render him unclean. He might be forgiven for not knowing quite what he's wrought: whether

he's placed a vase-shaped hollow deep in its belly, or if it sports the coiled suggestion of a cock.

The creature leaves the river to stumble through the human crowds, where it causes the napes of necks to bristle upright as porcupine quills. The Rabbi has bidden it to wander the streets of Prague, to learn where torches are carved and dipped in creosote, where sticks and knives are sharpened, dogs kept hungry, and loaded rifles strapped to saddles. The Golem senses the restless stir of humans in bars—Cossacks, peasants, Nazis, the alt-right—all the weaponized keggers looking for something to do on a Saturday night. It listens at windows as voices call out for beer and blood.

The Golem kidnaps these conspirators out of their very beds. Each dawn, the local jail is mysteriously full of those who still tremble with the memory of the monster's touch.

Every act of justice inflates the Golem. Overfull of itself now, this vessel was built to contain the Rabbi's will, but there's less and less room inside the monster. The Maharal's purpose isn't enough to welcome it into the community of humans. The monster will only be allowed to exist as long as it remains useful to men.

The Golem grows and grows. Each time it comes back to its master, the monster is bigger than it had been on its way into town. Taller than a tree, than a house, than the hills themselves. The Rabbi must bellow like a lion to get his child to bend within reach. Judah Loew ben Bezalel raises his hand and wipes away the aleph in אמת: now the word reads מת. *Met.* Dead. He plucks the prayer scroll from between the lips of his creature (as in "created," as in "creator"). What had been a warrior is now a pile of dirt.

The villagers gather the soil before it can blow away and hide it in the attic genizah of the Old New Synagogue of Prague.

Golem II

Two paintings, each gouache on paper, each fourteen inches square.

The top painting: the head of a woman in her thirties. She wears a pair of silver spectacles and a dyke-style braided tail. Her forehead is emblazoned with pink keloid Hebrew letters that spell תמא.

The bottom painting: a pair of feet clad in orange cotton socks and heavy black shoes. The shoes are planted in a circle of dried mud ringed by ordinary grasses.

The two paintings are meant to be hung with a gap in between, so that the top of the upper panel hangs exactly five feet from the floor and the bottom panel rests just above the baseboard. From hair to soles, the Creature is exactly four feet nine inches high.

But the center of her body isn't there. From neck to ankles, all we see is a blank stretch of wall. The part of the body that connects head to feet—the explanation—is a mystery.

Her painted mouth mocks her insistence at calling herself, a queer crippled Jew with peculiar shoes, a dreadful, grievous monster.

Circle Stories: Riva Lehrer
1998

EPILOGUE(S)

Monstrum monstrare. Monsters reveal. They strip away our assumptions about reality and unveil the fears of our era. Disability is the great billboard of human truth. Add it to any discourse, and we can see what humanity truly values.

I wrote that preceding paragraph at the end of 2019, in what I thought was the final version of this epilogue. What I said—then—was that this book was a picture of the past; that attitudes were changing, and that Disability Culture was dazzlingly alive and well. I described all the ways that art, literature, film, and performance were breaking through. I was excited for the future.

I turned in my final manuscript.

And then March of 2020 happened.

Almost immediately, the news became unbearable. It wasn't just the horror of the coronavirus itself, or the fact that I, along with many of my friends, had impairments that made us acutely susceptible. It was that when I read the paper or turned on the radio I'd hear our government announce the imminent need for resource "triage" and "health care rationing." These decisions would restrict care for the elderly and disabled. It seemed we were to be deliberate casualties of the pandemic.

From a March 21, 2020, article by Sheri Fink for *The New York Times*:

> ... the Washington State Health Department last week suggested that triage teams under crisis conditions should consider transferring patients out of the hospital or to palliative care if their baseline functioning was marked by "loss of reserves in energy, physical ability, cognition and general health.

It was blazingly clear what humanity really valued.

This pandemic has revealed the machinery of the world. This is the brutality of ableism on full display: a government willing to sacrifice human lives for the sake of the illusion of economic growth, via the assumption that only able bodies are productive, and that all others drain our country's strength. I can hardly believe that seventy-five years after WWII, we are once again defined as a disposable population. Who will be the next group deemed too weak to live?

Coronavirus, awful as it is, must be understood as a dry run for global upheaval. Our planet is changing. Populations are destabilized on every continent on Earth, and will be on the move for decades as they search for safety, for resources, and for livable destinations. We're already seeing our politics warped by warnings of resource scarcity. No wonder the calumny of the "useless eater" is once again heard in the land.

I fear that unless we work on radical visibility, this current era may be looked back on as the Golden Age of Disability.

And yet, what defines strength, in a time of crisis? In the coming decades, humanity must reimagine how to do every damned thing in the world. Disabled people are experts in finding new ways to do things when the old ways don't work. We are a vast think tank right in plain sight. A bottomless well of ingenuity and creativity.

I saw this ingenuity play out on social media as soon as coronavirus dominated our lives. My able-bodied friends were apt to share political posts and medical information about the virus, while my Disabled friends, by and large, went straight to the daily practicalities. How do

we get groceries now? What do we need to have on hand? Who is out there to help? They were used to the strategies of survival.

If we must argue for our worth, then this is worth incarnate.

Let me step back a moment from my anger and sense of betrayal. I ask you to think about the people I've written about in this book. Perhaps they've changed how you see the world, made more space for who you are and for those you love. Unveiled the depths of human flexibility. We must not be shoved back to the eugenics horrors of eighty years ago. We, together, must not lose all we've gained.

And so now, I say: Sometimes the monster is the one who saves us. It takes a monster to face down the dark.

Riva Lehrer
Chicago
May 5, 2020*

* https://www.nytimes.com/2020/03/21/us/coronavirus-medical-rationing.html
 https://dredf.org/the-illegality-of-medical-rationing-on-the-basis-of-disability/?fbclid=IwAR097SKEmWnfdsm2bo7qMBbCJ1ymd5kgjpQ1H7gT9_3MIdQwzQM4HM7B5Hg

THE PORTRAITS

In order of appearance

Totems and Familiars: Nomy Lamm

Nomy's T-shirt proclaims: FAT. SO?

Her wardrobe lends a schoolgirl-like air (hair in two pigtails, pleated plaid miniskirt, the shiny, round-toed Mary Janes), but the illusion of childhood shatters when Nomy begins to sing. She wields her accordion as if it's part of her body and roars above its calliope blare.

Nomy used to live here in Chicago, but moved to Oakland, California, in order to join Sins Invalid, the radical crip performance collective. She's in town to perform, so I ask if she'll sit for my *Totems and Familiars* project.

Her totem is the seal. Which is perfect. Seals seem like cute and winsome critters— like undersea puppies—but are, in fact, aggressive carnivores equipped with formidable teeth and claws. Nomy may dress like a manga princess but her music is ferocious as any stalking beast.

In my studio, Nomy dons her bathing suit, takes off her prosthetic leg, and angles her body as if swimming.

The siren and the seal in duet as bubbles of song rise from their throats.

http://www.nomyteaches.com/

Totems and Familiars: Neil Marcus

Hey Neil—
 Here's your drawing in progress—it'll probably take another 2 weeks to complete. It's about 28 x 40, charcoal on paper. I hope so much that you like it. And that's Jerry the Mouse on your leg.
 With bated breath and crossed fingers, toes, and eyes,
 Love, Riva

dear riva,
 heres my take. i think gene kelly revolutionized the way we see dance because he filmed it in a new way. never before had been done.
 he knew how to show/interpret dance on film.
 it follows that you interpret disability similarly on your canvas
 AND IT SHOWS IN THE BEAUTY or whatever you call it.
 love neil

people have asked me about this painting. The meaning of my legs in the river of water etc.
 I think I answered gene Kelly. water.dance.
 He was singing in the rain. Im a dancer in a flood. i like the idea.
 The flood doesn't necessarily connote something negative.
 Im honored to be represented with mr Kelly in mind. wow.
 What I know of the mouse on my leg was that gene Kelly really wanted to dance with disney's mickey mouse but Disney wouldn't grant that. So gene got jerry the mouse. As far as I know it was the first time

live action was combined with animation. The music they are singing I think is called *don't worry*

/\/eil

http://www.disabilityhistory.org/people_marcus.html

Mirror Shards: Sheri/Dragon

We walk our dogs together, you with your two golden lions, me with my plush black wolf. Every morning, the pack of us at the lake, where our dogs swim after rubber lumps that in no way resemble fallen ducks. Do they do it for themselves, or for us, in honor of a fifty-thousand-year-old mutual infatuation?

We walk each other home, debating if we'll stop upstairs to visit your painting studio or mine. I prefer yours. The ebullience of your work—the scale, the hot hot color, the brushstrokes like martial arts—well, it all makes me want to see what I can do. The biceps under your rolled-up sleeves flex in anticipation of the brush; I should leave you to it. Leave you for the great unleashing.

https://sherirush.com/

Liz Carr

Dear Liz,

I first met you at a Cabaret night at the Society for Disability Studies conference. You rained down punch lines like a shower of razor blades, so scatological, eschatological, thanatological. I was delighted that we Americans could still be shocked.

I didn't even have to search for your portrait image. You are a tornado of lights and spikes.

When Anne and I were in England, you treated us as if we were the most delightful companions imaginable. I will never forget our visit to the Castle. Even though she and I are no longer together, that day still makes me giddy with memory.

Now you've become a major TV star, heading for Hollywood, where I hope you'll effect the same kind of transformation regarding Disability representation as you did for the BBC. (I'm sure they're still quaking at the Beeb.)

Love, Riva

https://lizcarr.co.uk/

Circle Stories: Rebecca Maskos

Rebecca sits on the windowsill of her dorm room at UIC. She only has a few months left on her Fulbright scholarship. In between semesters, she's been driving all over the country, trying to see a lot of America before returning to Bremen. People are taken aback when she gets out of the car. Women like Rebecca are read as otherworldly—not as multilingual, tough, socialist firebrands.

Rebecca's email name is Undine, so I call her Mermaid. She laments how much she'll miss Chicago, miss her friends. She's described what it's like in Germany. The situation for crips sounds rather . . . historic . . . but she says it's changing fast.

I ask what she wants in her portrait. She replies without hesitation. "I want to be free in my picture. This is why I travel—to never feel constrained by people thinking I can't do something, should not do something. All I want is to keep making my life wider and bigger no matter what."

I glance from her expressive hands to the winter trees outside her window, where branches twist and curl in the same graceful cadence as

her bones. I ask, Can I look at her palm? She startles. "You too? Did I ever tell you my sister is a palm reader?"

"Mmm, I can't claim to remember anything anymore, but I used to do it in college, you know, make a few bucks at parties."

I tip her hand toward the light. It's not the hand of a sea creature at all, but a wing.

Rebecca draws a new set of lines across her palm—the head, the heart, the life—with the tip of a blue jay's feather, charting her own map of the sky, for the bird who flies headlong into the spikes of the bare tree. The bird decides for herself where she will go, what she will risk, and what she will be when she lands.

https://rebecca-maskos.net/

Mirror Shards: Nicola/Snow Leopard

The following is excerpted from Nicola Griffith's blog, nicolagriffith .com.

I was contacted late last year by artist Riva Lehrer, who wanted to do my portrait for a series she's creating, *Mirror Shards,* about the use of animal metaphors.

Riva and I had talked back and forth via email for a couple of years (I admire her work). But now we talked for over an hour on the phone. I told her that as far as I know I don't think of myself as an animal. She pushed me just a bit, asked me to imagine what animal I might be. Eventually I said I could possibly see myself as an Arctic fox. She said, no, she didn't think that was quite me—how about a big cat of some kind. By this time, I was attached to the notion of snow and ice, and thought that a snow leopard might be kind of cool.

A month later, Riva came to Seattle. She asked—delicately—if I minded my crutches being in the picture. I said no, but that I hadn't

 the faintest idea how they could be incorporated with catlike things. So we talked about that, a lot—crutches as arm extensions, as life extensions, as big claws . . . Next day, Riva came back and we did it all again. This time it was grueling: posing is work, especially the kind of thing that looks like a snapshot of an animal caught in mid-(twisting) leap. Especially when holding heavy canes and then crutches. But the conversation was extremely interesting. We talked about empathy and characterization, about reader and writer experience and communication—how we talk, sometimes, across a gulf of centuries.

We agreed that we liked the notion of the dimension and texture, but I thought the crutches were kind of wrong and the rocky background didn't give the right feel. Too static. How about a frozen waterfall? I said.

Oooh, said Riva.

Yes, I said. Do it.

Posted on September 21, 2012, by Nicola Griffith

https://nicolagriffith.com/

The Risk Pictures: Finn Enke

RIVA: I'm at dinner at the University of Wisconsin, where I've just given a talk. A stranger drops into the chair next to mine. Scandinavian cheekbones, hawklike mien, and waist-length braid of hair like an emergency rope; this person could scale a tor at a moment's notice. Meet Finn Enke, professor of history and gender studies and women's studies.

Finn visits me a couple years later. The tawny braid is gone; in its place is an insouciant crop worthy of that other Finn, Huck. And in place of "she" is "they."

Finn is overawed by my studio and flits from shelf to shelf. I am charmed by the sight of such a formidable scholar turning into Tom Hanks in *Big*. Finn is enchanted by all my supplies; they're in the initial stages of *With Finn and Wing: Growing Up Amphibious in a Nuclear Age,* a graphic memoir of a transgender childhood.

September 1, 2015

FINN: The opportunity to work with Riva in 2014 was irresistible; I was on the cusp of an unpredictable physical and social gender transition. But what might emerge when a professional artist and an untrained artist share a canvas?

Irresistible, and also intimidating. The collaborative process accentuates all the ways that life unfolds from and into uncertainty. It's a choice, I guess, to live with the awareness that life is always uncertain, that everything we do might be considered "risk" and "art" and "wreckage" and "survival," and that most of the rest of it is out of our control.

I sensed a few of our risks: What if it "doesn't work" to work together? My own visual art is intuitive and accidental. Of course I worried that I would wreck the portrait. And what of our young friendship?

RIVA: Finn sprawls—as much as any human can—on one of my heavy oak chairs. There is something about this person that is reminiscent of seaside vacation posters from the 1940s, of *Boys' Own Magazine* and of silkscreen prints of lifeguards reigning over a vista of bathing beauties.

FINN: I began to understand that the risks involved were considerable and daunting, and they could not be symmetrical. Riva was living with this portrait and spending untold hours putting color on canvas—and this is how she makes a living. I work as a professor—the portrait has no bearing on my livelihood. Riva chose the materials—the pencils and pastels, the colors, the paper—and she drew in most of the portrait first. My personal "studio" con-

sists of an ink pen, random paper that is never larger than nine by twelve inches, and two cats who are always in the way; I've never worked on an easel, don't know how to keep from smudging things, and I didn't know there could be over a hundred different "black" pencils until I tried to select one to draw on the near life-size portrait. I had one day in Riva's studio to put something on paper.

RIVA: Finn tells me that they are thinking—ambivalently—about testosterone. They say that there is nothing wrong with "this" body, but there is another one, somehow. When I ask if they can show me this waiting body, Finn raises their hands and hovers them two inches from their sternum. *Here. My body is this much bigger.*

FINN: I thought I would feel self-conscious "being drawn." I did not. I thought I would be invested in how Riva's drawing portrayed "me." I was not. The portrait is not me; it is of me, and it captures something Riva saw and I saw it, too. It is Riva. It is Finn. It is neither of us but something else entirely.

RIVA: We laugh about which toys we'd been allowed to play with (or not) as children, when I'd snuck upstairs and messed with my brothers' Erector Sets. Finn's face lights up. I realize, oh right, *gender* is a construct. I'd drawn them seated, without any visible support—I was debating between a ladder, a boulder, or the side of a mountain—but suddenly I see Finn sitting on one severely rickety chair.

FINN: I loved interacting with the portrait, though I was also terrified. She had drawn in a twig; I answered with a trans-species cricket-praying mantis. She drew Big Finn barely supported by an impossible structure; I thought he looked parched, so Little Finn makes an impossible journey to bring him water. Nothing makes resting sense; monsters say what we cannot.

RIVA: Finn's next trip to Chicago coincides with my upcoming trip to out of town. I take a deep breath and offer Finn the keys to my home.

When I get back from the East Coast, I run into my studio before even taking off my coat. My first impression is that Finn has done nothing at all, they've so perfectly adapted my style. Then I see the child standing on Finn's kneecap, balancing two buckets of water; the sail-

boat darting out from below the chair; the emerald insect clinging to a stick. And, oh, monsters are everywhere, cavorting in the Tinkertoys, hanging in midair from a postage-stamp cage.

FINN: It occurs to me that symmetry and asymmetry is the wrong geometry for describing collaborative risk. That, in fact, risk is shared in a far more dynamic way; risk passes back and forth between us too rapidly to fully negotiate, morphing as it goes, and morphing us as individuals and collaborators. I do bear risks and outcomes that most directly impact Riva, and she bears risks and outcomes that most directly impact me.

Like any communication, it changes all parties involved in unpredictable ways.

https://finnenke.com/

The Risk Pictures: Hillary Chute

Hillary Chute has organized a destined-to-be-celebrated conference on the graphic novel. She's a professor at the University of Chicago, and author of *Graphic Women: Life Narrative and Contemporary Comics; Outside the Box: Interviews with Contemporary Cartoonists; MetaMaus;* and other surveys of the form.

It's May 22, 2012. For this conference, she's enticed luminaries of the field: Chris Ware, Phoebe Gloeckner, Alison Bechdel, Art Spiegelman, R. Crumb, Aline Kominsky-Crumb, Lynda Barry, Joe Sacco, and Françoise Mouly; should a meteor land on Hyde Park this weekend, the entire field of graphic novels will evaporate.

"Comics: Philosophy and Practice" is both wonderful and unintentionally hilarious. Hillary labors womanfully to maintain a U of C level of discourse, but she's dealing with comics (in both senses). Perchance she asks something along the lines of whether Foucault has influenced the panelists' work (knowing that

for some, the answer is yes), but the cabal explodes with deviltry (Lynda Barry, I blame you) until it's all just slapstick and double entendre. Hillary drops her forehead into her hands. I feel bad for her. She's the model of a young academic, poised as an April swan. She doesn't deserve this brattiness.

A year later, I invite her into the *Risk Pictures* project. I'm choosing people I'm a bit intimidated by, in the hopes this will make the risk more acute.

Hillary comes in, tosses her massive leather handbag, and unbelts her coat; underneath, she's wearing a black dress bordered with curlicues of thick black lace, swoops that make me itch for my pencils. She sits down and leans forward. Her hair falls in a downrush around her face. I remember having hair like that, hair that is your portable retreat and your wild daemon all at once. Hillary looks at me from inside her cave of hair and I see her, the real woman, not the symbol of perfection I had lodged in my brain.

When two hours are up, I walk out and leave her to work on her drawing. She adds color to her jewelry and thickness to her mascaraed lashes. I wanted abandon but what I got was a precise femininity. She sends me comic panels that are of special importance. I carve dialogue balloons into a Plexiglas sheet in front of the drawing, and fade the panels like private thoughts; Hillary, in conversation with her artists.

https://en.wikipedia.org/wiki/Hillary_Chute

Suspension: RR

Rhoda and I are having tea just before our first posing session. She's telling me about her childhood in South Africa, where her father ran a small-town inn that catered to diamond merchants. She describes the way that white families used their black female servants when it came time for the white children to be photographed. "They'd sit the child on the woman's lap because it was her job to make them sit still. And then they'd make her go like this"—Rhoda swivels her head sharply to the

side—"so that she wouldn't be looking into the camera. The black woman didn't really exist—she was just a piece of furniture." Rhoda was propelled into anti-apartheid activism. Later, as a curator, she focused on South African artists.

She is that rare collaborator who *wants* to make pain explicit in her portrait. Her physical pain is the result of arthritis, but she has other reasons to make pain visible.

She tells me, "I feel like I can never be part of my homeland. That I don't belong. Jews came to South Africa mostly around the gold rush in 1886—later, they also came to get out of Europe, but in the nineteenth century they entered the diamond and gold trade, which was like, 'Oh, the Blacks don't know what to do with their land, *we* know how to use it. So it's ours.' And I used to look at the African women, they were so beautiful and I wasn't anything like that, I was just little and scrawny. I always feel like I can only hover over my homeland. There's no place where I can rest." Her accent sounds to me like poetry inscribed on hard soil.

Rhoda's physical pain intersects with her displacement. I propose an image in which she hovers over the embrace of her country. She asks, "Do you have, like, blankets or a yoga mat? I could do—*this*—if you have something I could lay on." I dig out the requested items, and she demonstrates *this* by contorting herself into something between a pelvic tilt and a headstand. "There," she says, "that puts the pain at the top of the picture, right?"

Rhoda decides that she shouldn't be wearing a blouse, provoking much fretting about what kind of brassiere is right for the composition. Next session, she brings quite the mélange of choices. I know that serious lingerie exists, but mine always comes from Target.

Her portrait is on a piece of white illustration board that's clamped to a slab of Masonite that rests on a mammoth crank easel. Each time I raise or lower the drawing, the crank goes *clack clack clack* like something on a ship. She emerges on the board, from her feet to her head.

Afternoons melt away to sunsets and nights. I emerge sore and wobbly and hungry just in time for Colbert before bed.

Rhoda Rosen's specialty as a curator is conceptual cartography: the methods by which humanity controls and deciphers the world through maps and imposed boundaries. We define ourselves, she says, by defending those imaginary lines. And unlike traditional maps, GPS orientation centers the map on you, so that reality moves with you, and not vice versa. Why confront the fact that you're only a small dot in a big world?

http://www.saic.edu/profiles/faculty/rhoda-rosen

Circle Stories: Tekki Lomnicki

Tekki Lomnicki takes off the towering froth of blond curls and changes her wig for a nun's wimple. I've never seen anyone change costumes right onstage, but each time she morphs from one character to another

she strips down to a simple satin slip—in full view of the audience. Her show is *Alchemy,* a series of character studies in which she plays roles including a talk-show host, a country-and-western star, and Sister Mary Stella. Tekki is a Little Person; one of the themes in her work is the way that she's treated by men. Guys don't seem to understand that she's an adult woman and not a perpetual child. Or, worse, a toy.

The noise level of her after-party forces me to shout my proposition as if we're on the tarmac at O'Hare. "I have an idea for your portrait: How about if we incorporate those fantastic costumes. Do you make them yourself?"

Tekki screeches, "WHAT?" but after a prodigious amount of yelling, she hollers, "OH MY, THAT WOULD BE WONDERFUL. THERE ARE A LOT OF THEM, THOUGH."

"WELL, WHAT IF WE TURN THEM INTO PAPER-DOLL DRESSES? BECAUSE GUYS TREAT YOU LIKE A LITTLE GIRL."

Tekki beams as if she's won a Tony.

Alchemy took place in 1996, but my health problems prevented us from starting our portrait work until 1999.

We discuss plans at a Greek restaurant where waiters yell "Opa!" like punishment for tourists who order flambé saganaki. Each plate sears a little more mustache from under a waiter's nose.

She's brought a list of the *Alchemy* costumes. Yes, she does make them herself. Tekki's mother insisted she learn how to sew so she wouldn't be stuck with bad options for life. I tell her my mother tried to teach me, but all I retained was a passionate love of clothing. Tekki and I both hated to outgrow anything our mothers made.

We're waiting at the valet stand when I remember to ask, "Oh, hey, don't forget to bring that satin slip. It'll be a joy to paint."

"The . . . slip?" For some reason, she seems a little wistful. "Okay, if you're sure."

There are too many costumes for her to schlep to my house, so I go to her place with my camera. She lives in a towering glass condo on a part of Randolph Street that juts far into the lake. Panoramic windows frame a limitless span of glittering water. All the furnishings are scaled to her body, from light fixtures to doorknobs. *I* want a house that curls like a spiral shell against my skin.

Tekki's garments hang on racks like a short-story collection. I kneel on the carpet and pile up the marvels: a velvet smoking jacket, a full-skirted frock. Surely there's some pressing reason I need to try them all on.

I decide to paint her fully life-sized. A bad idea, but I can't talk myself out of it, so I commission a four-by-three-foot panel that is *way* too heavy to pick up. I take the jack out of my trunk and wedge it under the cradling bars. Painting has never been so satisfyingly butch.

. . .

I normally dislike smiley portraits (there's a hairbreadth between grin and rictus), but to not paint Tekki smiling is to not paint Tekki. Her portrait is the centerpiece of my 1999 solo show at Lyons Wier Gallery. All evening, Tekki and I are mistaken for each other, so we step out to the sidewalk to escape the silliness. She says, "I hope you won't be mad, but I have something to confess. Remember that after-party? I thought you wanted me to pose in the nude. But when you told me to wear the slip, I assumed you'd changed your mind and that you were afraid to see me naked."

Oh my God, that she thought this all along! How it must have hurt. I would have *loved* to do a nude, but I tell her I never ask anyone to pose that way, unless that's the story they want to tell. Naked crips easily become specimen images, reduced to sensationalized, medicalized details. She looks vastly relieved. I shrug and say, "Well, Tekki, I guess we've just added to my list of lifetime regrets."

http://www.tekkilomnicki.com/

The Risk Pictures: Lauren Berlant

The following piece, entitled "Showing Up," is by Lauren Berlant, literary scholar and cultural theorist, who is the George M. Pullman Distinguished Service Professor of English at the University of Chicago.

Riva and I had talked for years about her desire to include a portrait of me in her "Risk" series, which I understood to include people whom she finds a little overwhelming. I liked how she collaborated with her subjects by overlaying a body image with writing: but I wasn't sure what I would want from being a fixed body. Nor was I sure how to caption myself. I'm a writer, not a figure, a voice, an icon; most alive in the conceptual space my fingers produce beyond the

body, trying to stay with relationality, trying to get into the rhythm of the world like a novice jump roper risking being slapped in the face by the ropes of love and social friction. I couldn't sit still for a portrait.

But in 2017 when again we spoke of it, I had just had a hysterectomy that showed significant tumor involvement. I thought if I were ever to do the portrait it should be then, to document either a bad summer I had or the opening scene of my death. Riva had first thought she could draw me holding her mother's dictionary but I rejected that: I never wanted to be anyone's mother and, you know, English teacher=dictionary is depressing.

I wanted to document the scar. Riva uses color brilliantly in the portrait to mark the two places of intense activity I walk around with now—my eyes and my carved body below the neck, each generative sites I pay attention to. The sittings were fun and open. I was learning to be a disabled person and Riva was writing her autobiography. I was learning to let my death in and she was learning to let her life in. Both of us needed skills in avoiding the genre lure of dramas, panics, and all the other pressing premature closures. I called the portrait "Showing Up," because that's what I like doing, because I'm constantly learning how to do it, and because that's what Riva and I did for each other.

https://en.wikipedia.org/wiki/Lauren_Berlant

Family: Douglas and Nathan Lehrer

My brothers have produced eight new Lehrers between them. Meir has six children: Tikva was born in 1992, followed by Ezra, Devorah, Ze'ev, Matan, and Josefa. Meir used to bring his mob to the States every few years. I adored being with them, but couldn't be much of an aunt given the distance from Chicago to Hashmonaim.

Things were easier with Doug's kids, since they lived in Ohio. Caroline was born in 1988. Nathan came along in 1992.

It took years for impairment in Nathan's infant brain to reveal itself. Doctors said he was a little "behind the curve," then the curve got longer and longer. Nate was six before his symptoms became evident: a

variety of intellectual disabilities, on top of neurological impairments. Doug is a forensic psychiatrist and hospital administrator and Susan is a nurse, both vastly more medically educated than our parents were. The search for medications and therapies began.

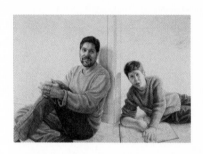

I visit their family once or twice a year. Their house is a haven, full of the souvenirs of a long marriage; not the kind of place where you expect to open the guest room and step into pitched warfare. But by the time Nate was in first grade, each morning was a battle royale as Susan or Doug struggled to get him ready for school—or at least get him dressed. Susan and Doug had a not-really-a-joke that should either one of them ever file for divorce, *that* person would get custody of the kids.

By the time Nate was in school, ADA compliance and Individual Education Plans were standard practices, but the lack of a simple diagnosis complicated their efforts to get Nate the services he needed. This quest became Susan's full-time job. She'd hoped to go back to nursing, but how could she maintain a work schedule when she had to bring Nate back home after every meltdown? Susan and Carole both had the "luxury" of staying at home based on their husbands' incomes, but both gave up hard-fought careers.

Recently, Susan reflected, "I'm really not a fan of mainstreaming. I mean, the idea is good, I guess, but it wasn't a good situation for Nathan. Too often, I think the way it's executed is not well done. They tell you they're going to adapt the curriculum, but I remember this time that his math teacher said that Nate only had to do three problems on his homework—then she handed him a full sheet of problems! I think that his frustration caused a lot of his behavioral issues."

By the age of ten, Nathan was taller than me. ("Give Aunt Riva a *gentle* hug, Nate. *Gentle*.") I should have been the one person who *could* bond with Nathan—I was the only other disabled person in the whole

family—but I didn't, and felt distinctly schmucky about the whole affair.

As should be patently evident, I deal with my disability by intellectualizing and aestheticizing my experience. But there I was, with the other crip in the family, having no idea how we could share our experiences.

In 2002, I asked Doug if I could do his portrait. I whipped up a bunch of sketches, of which far too many depicted my brother squinting meaningfully at a brain in a jar. He blew out his lips. "That's not how I think of myself."

"Who are you, then?"

"In essence," he said, "I'm Nathan's father."

He leaned back into his overstuffed armchair. "I used to imagine that we'd find a cure for Nate. We've had him on so many meds—mostly to prevent seizures, but we hoped something might click. But I don't feel like that anymore. I mean, Nate's just Nate. He's who he's gonna be."

Doug's hands rose and fell. "I'm really okay with that. I'm at peace."

I visit a few months later. Susan and Doug arrange to run a bunch of errands so that I can have alone time with Nate (though Susan repeats her cell number five times and makes sure I write it down).

Nathan can't sit still for live posing, so I'll have to work from reference photos. I snap a bunch of frames, then Nate and I go upstairs to review the pictures on Doug's computer. The boy at ten years old has his father's frame, topped with his mother's rose-petal freckled face. His round blue eyes are portals of sky.

"How many more, Aunt Riva?"

I'm impressed by his patience. In fact, I've never seen him so focused on anything that didn't have batteries and wheels. "You getting tired, Skate? Should we knock off?"

"Maybe soon. I wanna watch my Mary Kate and Ashley video. But I can go a little longer."

"Thank you *so* much, Skate. I super appreciate it. You know, your pictures are getting better and better. You're really good at this."

He pipes, "Yeah! I like your camera." Nothing makes Nate happier than permission to push buttons on any mechanical anything, so I have him work the camera remote. We take a break to review a sequence of shots.

"What'd you think, Skate? I'm having a hard time deciding. Tell me, which one's your favorite?"

He puts an unerring finger on the most luminous, emotive, and introspective photograph of all. I reel back in surprise. How have I failed to recognize his artist's eye? Nate has just shown me that I'm not the only one of my kind in the family at all. We are both impaired, both visually oriented, and both capable of flow.

When I show this chapter to Doug, he calls with one major criticism. "You've emphasized the past, but I want him to be seen clearly for who he is now. Nathan is the gentlest person I know. He rarely even raises his voice. I hardly can think of anyone kinder than Nate." I blush. I know perfectly well that my nephew treats me like a cross between a rock star and a porcelain princess whenever I visit. This memoir kept me in the past so long that I forgot there's a present. These days, my nephew is learning to live independently and moving toward a future good life he deserves.

Doug tells me that if his house was on fire, he would save the drawing no matter what.

http://wrightstatephysicians.org/physicians/lehrer/

Totems and Familiars: Lynn Manning

When I close my eyes, Lynn's voice resounds as if in a cavern, as if it contains its own echo. He is intoning lines from "The Magic Wand," in which he describes the abrupt transformation from—as he says— *Black man to "blind man" as he flicks open the length of his folding white cane.*

The poem's final lines are:

I only wield the wand;
You are the magicians. *

Lynn is in town for *Bodies of Work*. Tonight, the festival is taking place at the Victory Gardens Theater—the place where my own crip life began. We've arranged for him to come over tomorrow to pose. I've never collaborated with anyone who can't see my working sketches. Nonetheless, theater is collaboration. I'm betting Lynn will have strategies.

He fills my studio from wall to wall: Paralympic medalist, World Champion of Blind Judo, actor, playwright, sculptor, founder of the Watts Village Theater Company. When he removes his shirt, I'm mystified by the pale zigzag runnels that tiger-stripe his skin. He chuckles. "Oh, those are stretch marks from my weight-lifting days." What is it like, I wonder, to make yourself so strong that muscles burst from your skin?

I find myself narrating all I'm doing, not unlike stage directions. I explain that I normally work by sharing thumbnail sketches. He says that if I scan and email these sketches, he'll bring his wife and friends into our process.

For me, this is the eeriest part of Lynn's story: he was so afraid of blindness as a child that he used to "practice" when alone at home by putting on a blindfold and turning off all the lights. Then, when he was twenty-three, he was at a bar celebrating his promotion as a youth counselor when he was shot by a hyped-up drunk. The bullet destroyed his optic nerves. Lynn had been a sculptor, but he refashioned himself as a performer, writer, and activist.

· · ·

* Lines from Lynn Manning's poem "The Magic Wand."

Lynn holds his cane upright: a bō staff, an antenna to the gods. The drawing is in two parts: on the upper is an arcing bullet, and trailing from the bullet is a comet embedded with raised Braille: "Born April 28, 1955: Transformed October 18, 1978." Embossed constellations encompass the sky from Taurus to Libra, from the month of Lynn Manning's birth to the month of the gun.

http://lynnmanning.com/About.html

Totems and Familiars: Gordon Sasaki

I am living in New York for the summer and inviting friends to come sit. The one I know the least well is Gordon. We only met briefly a few years ago, when I curated his *NY Portraits* (photographs of New York's community of performers, writers, and visual artists with disabilities) into my *Humans Being* exhibit. He accepts my invitation, though he seems reticent, even chary.

This watchfulness prompts me to picture him behind a screen—a lens—of water. He asks if he can photograph me as I draw. I say yes, but inside, I freak out. Gordon is giving me the opportunity to be mutually vulnerable, and to share the experience of being seen, but I'm not ready yet. Deep down, I still need to control who looks at whom.

But when he raises his camera, what I'd read as reticence was revealed as restraint, the ability to put his subject at ease. I saw how I might dial myself down and make space for the other.

Sadly, those photos were lost to history.

Gordon remembers:

Though it has been a few years, I found the process of sitting for a portrait by you overall very calming. Sitting was a remarkably shared experience. While few words were exchanged between us, I felt a level of communication that is usually overlooked in the hustle and bustle of city

existence. Perhaps it is this difference between looking and seeing that art brings us closer to and together.

https://www.saatchiart.com/gordonsasaki

Totems and Familiars: Nadina LaSpina

Nadina speeds down the middle of Fifth Avenue, a Fury, wheeling so fast that her hair streams behind her like a savage banner. We are at the New York City Dyke March. Women run to touch her, ask to take a picture together, saying, "Weren't you in that movie? *You* know the one," sure that she's someone famous whose name they can't quite place. Nadina laughs, says, "Sweetheart, of *course* you can." But Nadina isn't a dyke; she's there to guide me, and because she loves the sound of joyous women.

Nadina mentors crip women. She's taking care of *me* by letting me stay in her condo, instead of selling it as soon as she'd moved in with her husband. Her protégées interrupt every portrait session: her cell rings with a call from a young woman who can't find a doctor, or one who doesn't know how to pick the right college, or even what to study. Or someone who longs to move to New York. Like me.

Nadina was born in 1948, in a tiny village in Sicily, where she contracted polio as an infant. She was thirteen when, at her father's insistence, the entire LaSpina family immigrated to America so that Nadina could be treated at the New York Hospital for Special Surgery. Her father was convinced that the right operation could restore his daughter's ability to walk.*

She told me, "The consensus was that walking was preferable to

* The procedures she received did not work, and led to the loss of both of her legs. For the full story, read Nadina's memoir, *Such a Pretty Girl,* NYU Press, 2019.

using a wheelchair—more normal. I felt it was my duty to walk. My parents had sacrificed so much to bring me to America. There were no wheelchairs in my village, so my mother carried me everywhere. Then the hospital gave me my very first wheelchair. All of a sudden, I could go wherever I wanted, all by myself!"

The hospital introduced her to the first disabled children she'd ever seen. Her roommate was a girl with spina bifida, a blue-eyed blonde exactly her own age. Nadina had thought she was the only disabled child in the world. Now, she had a best friend with whom she could share a hospital childhood.[*]

Visitors exclaimed, "How pretty the two of you are. What a shame, what a waste." The girls' beauty was regarded as a cruel joke, since cripples were disqualified from love or marriage. A fairy-tale curse that became more bitter with age.

Nadina said, "The Girl convinced herself she was better off dead. She checked into a motel not far from her home and swallowed sixty Seconals." The Girl was twenty-two years old.

Nadina cares for her flock as if rescuing each woman from a date with a bottle of barbiturates.

http://www.nadinalaspina.com/

Totems and Familiars: **Deborah Brod**

We met when we were still forming (at 18 and 19 yrs). But Riva, encumbered and enriched by life experiences, was already full of momentum, fearless. She seemed unafraid of her desires—both admirable, to me, and formidable!

[*] Nadina's pseudonym for her friend is "The Girl."

We mirrored each other.
We let each other all the way in.
We blocked each other.
We raised each other up.
Again, again, and again.
Riva listens, receptive like the moon, and simultaneously, like the moon goddess, wields her searching arrows with emotional and intellectual depth, sometimes zany humor, and overarching beauty.

—Deborah Brod

Mirror Shards: Tim/Owl

I first met Temma at an opening thirty years ago when she was five or six years old. Tim and Sherrie Lowly brought her in a stroller, because—due to a cardiac arrest she had had when she was only two days old—Temma is profoundly disabled. She experiences frequent seizures, cortical blindness, partial paralysis, severe spasticity, no verbal abilities, and the apparent inability to remember or learn. While responsive in her own way, she seemingly exists almost entirely in the moment.

Whereas I've portrayed dozens of subjects, Tim primarily examines a single life. Tim has painted Temma in miniature and large as a billboard; he's sculpted her in plaster and drawn her on handmade paper; depicted her as a blur and in scientific detail. Tim gives Temma a presence in the world she would not otherwise have. These works ask what it means to parent a child who is seen as not worthy of love—and why we demand reciprocity in our relationships.

Tim is so dear to me—my painter brother—that of course I want to do his portrait, but then he asks that it be a portrait of the both of them. Here's the problem: my practice is based on informed consent, meaning that my collaborators must be able to fully participate. Temma cannot give consent, therefore I have no right to her image.

Still and all, I want to honor his request, so I go for a visit. Tim

holds Temma on his lap; I take pho-
tographs as golden afternoon light
spills over their forms. The daughter
curls into the father in a yin-yang
circle of completion.

And there's the answer. Rather
than depict Temma directly, I will
make a portrait of their relationship.
It'll be part of my new series, *Mirror
Shards,* which examines the ways peo-
ple use animal metaphors and sym-
bols as human reflections. My subjects select an animal—*not* a pet—but
a creature that represents some essential aspect of their inner selves.
Temma is nothing less than fully human, but as soon as Tim chooses
"Owl," everything falls into place.

The Owl has glass-lined eyes, talons of clay, and fragile, textual
wings made of Bible pages. Tim cradles and dons the Owl as an act of
transubstantiation. An immersion in Temma's endless moment.

Tim and Sherrie are committed to love without the "normal" rewards
of parenthood, steadfast in the belief that human beings do not have to
"earn" love in order to be deserving of love. When Tim and I discussed
his ethics of love, I didn't think it pertained to me. To the contrary, I felt
driven to prove my worth. Carole had worked so hard to save me. Had
I done enough? *Tim/Owl* helped me understand that for my mother,
my existence was its own purpose. I was saved, because for her I was
enough.

Tim wrote about this portrait in an essay titled "Regarding the Other:
The Portrait Projects of Riva Lehrer." This is an excerpt:

Portraiture as Research: With the *Circle Stories* series, Riva began a
process of engaging a subject, not simply as a person to be depicted,
but as a life and vocation to be made present via symbol, material,
and narrative. I know from having been one of Riva's subjects that

her process of constructing an image involves a complex examination/consideration of her subject and their life and work. Riva does not simply see her task as rendering a likeness of a person in front of her. She considers deeply the vocation and other facets of her subject, employing a range of research. From this research she assembles a proposal for an artwork that she only pursues with the consent and input of the subject. . . . There are of course risks in making art that is collaborative. A potentially "negative" implication of this practice is that the resulting works are complicated by the collaboration, perhaps stilting the work for those who would prefer a monolithic aesthetic. As such it seems fruitful to suggest thinking of these works as research: corporeal research that evinces not simply the artist's vision but an amalgam of her intentions with those of her subject.

http://www.timlowly.com/

Family: Tom O'Dowd and Buddy

Tom is knowledgeable about submarines and ultralight airplanes; a sailor who crews for the yearly Mackinac sailboat race; a Marlboro Man complete with baritone voice, leather jacket, and perpetual cloud of unfiltered smoke. Tom is the butchest man I've ever known—though perhaps *all* men wake up their partners at four A.M. to talk about airplane struts. He once roused me from a deep sleep for a lively discussion of avionics. I was pleased with myself for coming up with two or three actual questions— none of them being "What are airplane struts?"

Buddy is Tom's pedigreed, long-haired black German shepherd, a beast with luxuriant, blue-black fur and a tail like a Vegas showgirl's ostrich-plume fan. Where my dog bounces, Buddy undulates. Where Zora is sarcastic,

Bud is a comedian, fond of trampolining off the furniture like a toddler. I met Tom when he wanted a painting of Buddy atop Mount Hood; now, they are posing for a much larger charcoal drawing, in which Tom lies peacefully at Buddy's feet.

https://wolfpark.org/about/people/

Alison Bechdel

As a memoirist who writes about real people in my life, I got a taste of my own medicine when I agreed to sit for Riva. It turns out she didn't want me to just sit, but to participate in some way in the process. I admire the principle behind this, that it's a way of evening up the power imbalance between the artist and her subject (that is, object). It would have been a lot easier to just pose passively for her, but no, Riva insisted that I be involved in the conceptualization of this rather complicated piece. This entailed not only dredging up my deepest feelings about my mother, but making a drawing of my own that Riva incorporated into

her portrait. Not to mention doing a lot of shipping of things back and forth in mailing tubes.

When I finally saw the finished piece, I felt a bit exposed and unnerved. I'm accustomed to drawing myself a lot as a character in my own work. But it was jarring to see Riva's minutely textured charcoal representation of me in that laboriously contorted position. She's captured something very uncomfortable about my relationship to my own creativity—how painful and mediated it is, how I impose so many obstacles for myself. It's uncomfortable to have that not just seen by someone, but shown. Uncomfortable in a useful and productive way, but uncomfortable nonetheless.

—Alison Bechdel

http://dykestowatchoutfor.com/

Totems and Familiars: Lawrence Weschler

A birthday offering

April 2019

"And what have we here?" I found myself thinking the first time I met Riva. Not "who?" as she would no doubt (and—okay, already—rightly) point out, but "what?" This corkscrew fireplug, this Lautrecian spitfire.

It was, as I recall, at the tail end of one of the events I had curated for the Chicago Humanities Festival in my role as its artistic director (a conversation with Philip Pullman, perhaps) and she just up and cornered me with comments and thoughts, and I was happy to invite her out for coffee: she veritably exudes charisma and resolve. But very quickly the *what* gave way to *who,* for the point is that what this who emanates more than anything else is *heart,* which is to say, *Coeur,* as in courage, not just in the physical fact of her ongoing existence, but in the heartening vigor of her presence, her way of being in the world, a sly wry gleam, which in turn gets refracted in the quality of her eye and hence her art.

So, anyway, what, she now asks me, was it like to sit (or as it happens, stand) and pose for her? Well, it was a continuation of what it is like to be with her more generally (I can't really say I recall which part was the posing). Which is to say a fast and funny and often feisty exchange of views and convictions (I tease her a good deal and she gives as good as she gets) (we argue some, mainly around my exasperation at what I sometimes take as her insistence on certain political correctnesses at the expense, I feel, of more free-flowing immediacies—and, again, she gives as good as she gets, which is what makes it fun). We talked about how I might like to be portrayed, it was a spirited negotiation (that makes it sound more confrontational than it was, for it was more of a harmonizing improvisation, a meeting of her sense of me and my sense of myself, I suppose),

and we hit on various themes, my taste for marvel (as evinced by my ironical veneration of Athanasius Kircher, the great seventeenth-century Wondercabinetman, Jesuit keeper of the Vatican collections and compiler of every odd thing on earth and inventor of all sorts of marvels, not least including the slide projector, the last Man Who Knew Everything—from acoustics through volcanology on out to the interpretation of Egyptian hieroglyphics—even though he was wrong about a lot of it, though not always so [viz, the slide projector (in the seventeenth century!)]; and likewise my sometime orientation toward the Kabbalistic) and her sense of me as some kind of whirling dervish, a generator of sidewise connections (among ideas and people and occasions), hence the cat's cradle (for which she commandeered and sliced up a sheet of yellow legal pad raw copy from a piece I once wrote about, I believe, Poland). And she took me to one of her classrooms and had me sit, stand, pose, prance in the sidewise glare of a slide projector as she took dozens of photographic notes, and then same deal on the roof of her apartment building in the sidewise glow of the setting sun— arguing with me about this and that all the while, though it's always hard for us to keep a straight face in our arguments (as I say, they just end up being too much fun).

And then she went off to her art burrow, I headed back to my own such burrow in New York, and the next time we reconvened, some months later, there I was, butterfly-splayed in the graphite-graphic splendor of her capture: a thing of marvel, if you ask me. She'd up and nailed me.

—Lawrence Weschler

http://lawrenceweschler.com/

Carrie Sandahl

CARRIE: You are not your pain.

RIVA: Pain is the enemy.

CARRIE: I feel like I *am* my pain. My pain is *me*. My body is responding. That's *me*. That's who I am. There's always this urge to say you're more than your pain.*

Pain has been a nearly verboten topic at the Disability Studies conference—at least, in the academic sessions. The field has been understandably intent on pride and change, survival and redefinition, yet afraid that if we say one word about pain, the outside world will retort, "See, we knew you were miserable. Why *don't* you want to be cured?"

Nonetheless, as soon as conference sessions let out, everyone heads to a quiet corner, orders a bucket of booze, and rates doctors and hospitals as if they're ski lodges in Vail. It was at one of these secret conclaves that Carrie Sandahl taught me to talk about pain. For her, pain was political and aesthetic. Neither of us wanted to create a Disability Culture that rested on a lie—that pain was irrelevant to our experiences.

I first saw Carrie Sandahl in David Mitchell and Sharon Snyder Mitchell's film *Vital Signs,* in which Carrie wears a lab coat and white scrub pants inscribed with her medical history. She's drawn her spine on the back and scars on the front, along with text denoting, as she says, "which doctors they belong to." There are words all over her body: *Do you ever dream that you're normal? Are you contagious? No, my disability's not genetic. Yes, I can have sex and bear children.*

* Carrie's boyfriend, the sound artist Christophe Preissing, brought recording equipment to archive our conversations. This dialogue is taken from edited verbatim texts from our sessions.

RIVA: People ask me how I choose people, and I say, "You know, a lot of it is who do I want around in my house for a while." [*Carrie laughs.*]

Carrie had studied to be an actress, but directors and casting agents are the most literal-minded creatures in the world. They couldn't imagine Carrie as anything but a freak, monster, or patient-of-the-week. She joined acting troupes with other crip performers, but most important, she also turned to the academic study of performance. Carrie is now an internationally regarded expert on theater and film.

RIVA: I have to say, I still feel like your face is the best, absolutely best, one I've ever painted.
CARRIE: I take all the credit for that, for being so lookatable.
RIVA: Well you should, because you know, if you didn't have—
CHRISTOPHE: So whatable?
CARRIE: Lookatable
RIVA: You are! You're very lookatable.

Though her impairment is not spina bifida, we bear a certain resemblance, being about the same height, of similar shapes and with similar gaits. I was eager to paint someone who could be my doppelgänger, but Carrie didn't have the time. Then, in spring of 2017, she called to tell me she was going on medical leave. And that the reason for this hiatus was pain.

RIVA: What did I see?
CARRIE: There's a scar here.
RIVA: I could just radically repaint here.
CARRIE: Oh, the glamorous life of an art model.

It's a rainy afternoon in the Loop. Cars shloosh through rain-filled gutters outside the café window. I say, "I'm imagining a pale palette, very Flemish. Cold, pearly light, like Saenredam."

"Huh, I'll have to look him up. How do you spell—what was it again?" Carrie's grin is full of mischief. "But I was wondering. What do you see me doing?"

"That's up to you, isn't it? You still have that lab coat, from your monologue?"

"No, remember, somebody stole the pants when we showed it at *Bodies of Work*."

"Oh, yeah, those rat bastards . . . too bad, that costume would've been amazing." I stir my mocha. "What else you got?"

"What about nothing?"

"You mean regular street clothes? Or . . ."

"*Or.*" Up went an eyebrow.

"Oooohh! Yes please, pretty please! No backsies!"

"And I thought I'd wear my BDSM gear."

"YOUR WHAT?"

"What do you mean, my what? I thought you knew. I mean, I've written about it enough."

"Where would I—? Wait, I don't, uh, what kind of gear are we talking about?"

"Oh, you know, nipple clamps, leather bondage ropes, stuff like that. Nothing too weird."

Jeez. How had I missed this?

Carrie waves a chunk of salad like a frilly baton. "I'm lucky that pain linked up with my erotic life."

"I wish to hell *I* could be turned on when it hurts. But soon as there's pain, that's it for me. All systems gone."

She shrugs. "Who knows why it works for me. I know people think it's dangerous, but it's not. I've met these incredible guys through the BDSM community. Really respectful. They know they have to listen, it's part of the deal."

"How long you been doing this?"

"Not as long as I wanted. My ex wasn't into it." She chuckles. "But after the divorce . . . well, hey."

Wow. All I owned was a demure pair of leather handcuffs, and those

were so roomy I could slip out of them at will. I *was* truly envious. Pain was getting in the way of my love life. For my girlfriend's sake, I would have loved to eroticize my pain, to want something more than a hand-ful of pills and an ice pack the size of Alaska. A BDSM proclivity would have been just the ticket.

Starting Day. Carrie shows up with a Whole Foods shopping bag full of *stuff*. Out come the straps, the clamps, the rubber jewelry. I pile the couch with a snowdrift of pillows; she stretches out on my couch, a kinky odalisque. I bind her wrists and ankles with long leather straps and start shooting reference. Nothing works. Nothing works. Nothing works.

RIVA: I can tell you're getting pretty uncomfortable. I want to make sure I'm not torturing you.

CARRIE: Maybe I like to be tortured, that's part of my problem. That's how I've dealt with my pain, just turn it into something . . .

RIVA: Pee-wee's Playhouse.

I sigh. "Time for a break. More tea? Cookies?" Carrie gets up and shakes out her limbs. Black straps fall around her feet as sun pours through her skin. One of those moments when a composition is just handed to me.

RIVA: Your palms remind me a little of my mom's. She had very square palms.

CARRIE: I have square palms? Who knew?

RIVA: Or this part is very square. Very defined. So it looks very cut. Your muscles—you have cut muscles there.

CARRIE: Woo-hoo! There's my attribute with the crip strength ex-ceeding the average woman of my age. [*Both laugh.*] That's my only—

RIVA: Arm wrestle champion of the—

CARRIE: More like the thumb wrestle. Just the grip. That was my shining glory. Because no one else could grip anything. They can't open

jars. They're so pained, they can't do shit. I'm like, "Allow me." "Hand it over."

RIVA: I often tell people, "Will you butch this for me?" I'm just going to save you all my jars.

The portrait takes shape, its palette in the nacreous colors of an abalone shell. Sea glass lies scattered at Carrie's feet, shards smoothed by time and impact.

She's enrolled in a monthlong pain-control program at the Rehabilitation Institute of Chicago. The regimen includes exercise, yoga, meditation, gym workouts, swimming, mindfulness, medication, and psychology. She persuades me to sign up as well. We call it Pain Camp.

My agony is located in my right sciatic nerve. I've actually dissected the sciatic nerve in cadaver lab. That thing is a *beast*. Most nerves are thin, threadlike things, but the sciatic runs the length of the leg and is thick as a pencil. No wonder pain is whittling me away. I've sprained my own muscles while lying in bed, just from the brutality of the spasms.

I dream of throwing a party where everyone has to wear one of those inane smiley-emoji pain masks beloved of emergency rooms. No one will be allowed to say whether their pain is somatic or psychological in nature; we'll just know there is more going on than we can see.

I think about Mom all the time.

I think, *Mom, I don't know how you stuck around as long as you did.*

RIVA: The couple people who have seen progress JPEGs, one of them asked me if this is a religious picture. If you were literally doing bondage, or whether you were doing, like, a crucifixion, and I said, "It's not a crucifixion."

CARRIE: [*As Riva*] "That's the only way she could stand and hold the straps." [*Laughs.*]

RIVA: [*Laughs.*]

CARRIE: But it was a submissive pose.

RIVA: I understood what they were asking, and I think it would be

extremely wonderful for you to talk about the value of pain, but I didn't want to paint the times when you've had marks on your body. I've thought about putting them in, but I haven't because it would have made it less enigmatic about what your relationship to pain was.

CARRIE: Mm-hmm.

RIVA: And people, as you know, read the disabled body as a pain body . . . so I didn't want to make it so . . . literal.

CARRIE: Yeah.

RIVA: I thought about it, because . . . it would be an interesting thing to paint, just technically—but the eroticism of pain was gonna be there even if the marks, the actual moment of pain, wasn't present. But do you feel like I lost a possibility there?

CARRIE: Mm-mm, no. I think that may have also been one step too intimate.

When Carrie's portrait is done, it's not just a nude, it's a naked.

Her piece is accepted into an awards show at a local museum. I design an installation that puts our collaboration at the center of the exhibit. I believe that the real product of a portrait is the relationship between artist and subject, yet that's what disappears as soon as the work goes up on the wall.

Christophe designs a way to play our audio files through speakers surrounding the panel. He's even captured the rhythm of my brushes and rags on the portrait. Carrie and I write thoughts on sheets of hand-made paper. I'll install Carrie's Corner—a chair, footstool, table, heating pad, and plate of cookies that I always have for her—along one wall of the gallery. I send a chart to the museum of where everything will go.

And then the curators freak the frakk out.

The museum, it transpires, has a summer camp that serves children ages six through eighteen. Even though they'd awarded me the show based on nudes I'd shown at their biennial, those nudes were not *this* nude. The administration seems convinced that if little children see Carrie's portrait, said children will be transmogrified into sex-fiend, torture-addicted perverts. Parents will then sue the museum for turning their tots into sex-fiend, torture-addicted perverts.

Weeks go by. The museum board convenes, then decrees that I can show my perversion on the upper floor of the museum, where scary Carrie can only be seen by chimney sweeps and low-flying drones.

https://ahs.uic.edu/disability-human-development/directory/sandahl -carrie/

The Risk Pictures: Lennard Davis

Lennard Davis wrote this during our collaboration:

I've never sat for a portrait before, although I have drawn myself at various times, particularly when I was an adolescent. My drawing skills have lain dormant for a long time, expressing itself mostly in doodles and sneaky portraits of people when I'm at conferences or listening to someone who is speaking publicly. I spend a lot of time looking at art, but not much time making art. Visual art is totally important to my life, but writing is what I do.

I decided it would be a good thing to sit for Riva. I've been an admirer of her work, and it felt right to say OK to her request. We've had some great conversations . . . definitely there is an affin- 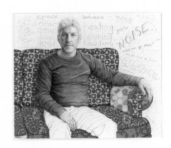ity between sitting for a portrait and being in psychotherapy. There is the vulnerability and the self-expression involved and some kind of mute revelation of the self. It's not always easy to see ourselves as others see us, to quote Robert Burns, but of course remaining curious allows me to see the mastery of Riva's art. One thing I've learned viscerally is that portraiture is a process. Watching Riva rough out the image, then hone in on the details and seeing the image emerge has been a revelation. But also it has made me aware of all the lost conversations that now hover over famous portraits. What were the conversations between Velázquez and the king? Between Leonardo and Mona? Between the

kings, popes, merchants, landowners, and the artists who painted them? I doubt people sat in silence for hours on end. What kind of conversations would emerge? Artistic? Political? Personal? How do these get painted into (or out of) the portrait?

I've had a fair amount of trouble with the idea that I would draw on the picture. I definitely don't want to "mess it up" and don't trust my own artistic skills enough to think of myself as on a par with Riva's. I guess the project brings about a sense of my own desire to be perfect and then falling far short in that regard. I decided that the thing for me to do was to highlight why Riva was drawing me in the first place, which was because of my work in disability studies. Why me? I guess because my parents were Deaf and I was a CODA [Child of Deaf Adults]. In some sense my work is always between worlds since I'm not Deaf or disabled (yet). My idea was to letter in "Deaf" and "Hearing" hovering on either side of my head. I thought it would make sense to use Gestalt lettering so that the idea of both would be "constructed" and not fully expressed . . . open to interpretation. I found myself wanting the lettering to be ruled and precise so I wouldn't "mess up" the picture itself, and my comment would be almost "outside" the picture while of course being centrally about who I am.

http://www.lennarddavis.com/home.html

LIST OF ILLUSTRATIONS

In order of appearance

Blue Veronika
1999
Gouache on Amate paper
36″ x 24″
Private collection

Cauda Equina
2005
Acrylic on Amate paper
36″ x 24″
Private collection

Totems and Familiars: Nomy Lamm
2008
Charcoal on paper
44″ x 30″
Private collection

Totems and Familiars: Neil Marcus
2007
Charcoal on paper
44″ x 30″
Private collection

Coloring Book
2011
Mixed media, organza, paper collage, thread, and needles on Amate paper
24″ x 36″
Private collection

In the Yellow Woods
ND
Acrylic on panel
12″ x 16″
Private collection

Mirror Shards: Sheri/Dragon
2011
Charcoal, mixed media, collage, papers, metal, and watch parts on Schoellershammer board
30″ x 40″
Private collection

Liz Carr
2011
Acrylic on wood
24″ x 12″
Private collection

Cissy Inventing the Pantheon
1976
Pencil, acrylic, and glitter on paper
12″ x 16″
Collection of the artist

Chorus
1994
Acrylic on panel
6″ x 8″
Private collection

39″ x 29″ x 4″
Private collection

If Body: Dress
2004
Graphite on Schoellershammer board
40″ x 30″
Collection of the Illinois State Museum

Woven
1993
Acrylic on panel
6.5″ x 6.25″
Private collection

Red Birth
Acrylic on steel, with wire, pearls, gold, and jewelry findings
2.5″ x 3″ x 0.3″
Private collection

Suspension: RR
2014
Charcoal, mixed media, and acupuncture needles on board
28″ x 38″ x 0.25″
Private collection

Aftermath
1992
Acrylic on panel
8″ x 6″
Private collection

Corner (Terra Incognita)
1994
Acrylic on wood
24″ x 18″
Private collection

Circle Stories: Jeff Carpenter
1997
Acrylic on panel
18" x 24"
Private collection

Circle Stories: William Shannon
1997
Mixed media on paper
38" x 24"
Private collection

Circle Stories: Susan Nussbaum
1998
Acrylic on wood
16" x 26"
Private collection

Circle Stories: Mike Ervin and Anna Stonum
1998
Mixed media on paper
22" x 21"
Private collection

Circle Stories: Hollis Sigler
2000
Acrylic on panel
18" x 36"
Private collection

Circle Stories: Tekki Lomnicki
1999
Acrylic on panel
48" x 36"
Private collection

Circle Stories: Eli Clare
2003
Acrylic on wood
29″ x 37″
Private collection

The Risk Pictures: Lauren Berlant
2018
Charcoal and mixed media on paper
44″ x 30″
Private collection

Family: Douglas and Nathan Lehrer
2002
Graphite on Schoellershammer board
30″ x 40″
Private collection

Family Album
From top, left to right: Jerry, Carole, Riva, Meir, Doug
Circa 1996
Gouache, collage, thread, and gold on Amate paper (various)
Each 6″ x 8″
Private collection

Circle Stories: Brian Zimmerman
2000
Charcoal on paper
18″ x 36″
Private Collection

Totems and Familiars: Lynn Manning
2007
Charcoal on paper
Two panels: upper drawing, 15″ x 44″, lower drawing, 44″ x 30″
Private collection

Totems and Familiars: Mat Fraser
2006
Charcoal on paper
44″ x 30″
Private collection (currently lost)

Totems and Familiars: Gordon Sasaki
2007
Graphite on Schoellershammer board
40″ x 30″
Private collection

Totems and Familiars: Nadina LaSpina
2008
Charcoal on paper, three framed drawings
Total installed size, 50″ x 120″
Private collection

Totems and Familiars: Deborah Brod
2009
Charcoal and pastel on paper with dimensional collage of wire, Mylar, acrylic, and thread
30″ x 44″ x 0.5″
Private collection

Mirror Shards: Tim/Owl
(Tim and Temma Lowly)
2011
Charcoal, glass, clay, papers, Bible pages, wire, twigs, and collage on board
40″ x 30″ x 3″
Private collection

Zora
2000
Graphite on paper
12″ x 20″
Private collection

Family: Tom O'Dowd and Buddy
1999
Charcoal on paper
44" x 30"
Private collection

Alison Bechdel
2010
Charcoal and dimensional collage on paper and board
30" x 40"
Collection of the National Portrait Gallery of the Smithsonian
 Museum, Washington, DC

Zora: How I Understand
2009
Mixed media on Mylar
40" x 50"
Collection of the artist
The leaves around our feet hide the eyes of critically endangered
 species. Zora taught me that every animal is an individual, and
 that almost every animal dies ungrieved.

AT 54
2012
Mixed-media collage on paper
12" x 10" x 2"
Private collection

Totems and Familiars: Lawrence Weschler
2008
Charcoal and mixed media on paper
30" x 44"
Collection of the Chicago Humanities Festival

Carrie Sandahl
2017
Acrylic on wood
48" x 24"
Private collection

The Risk Pictures: Lennard Davis
By Riva Lehrer and Lennard Davis
2016
Mixed media and collage on paper
30" x 44"
With pencil drawing Lennard did of me during our collaboration.
 6" x 4"
Private collection

66 Degrees
2018
Acrylic on wood
24" x 36"
Private collection

The Risk Pictures: Alice Sheppard
By Riva Lehrer and Alice Sheppard
2017
Mixed media on two layers of Mylar, plus paper collage
40" x 50"
Private collection

Circle Stories: Riva Lehrer
1998
Gouache on paper
Two paintings, each 14" square
Private collection

RESOURCES

A resource guide for disability culture, including artists, writers, dancers, actors, filmmakers, academics, and others can be found on my website:
www.rivalehrerart.com

Below are additional websites for portrait collaborators. An asterisk (*) denotes that they are not in the book, but do appear on my website.

Eli Clare, http://eliclare.com/

Mike Ervin and Anna Stonum, http://smartasscripple.blogspot.com/

Tekki Lomnicki, http://www.tekkilomnicki.com/

Susan Nussbaum, http://www.susannussbaum.com/

William Shannon, http://www.whatiswhat.com/

Hollis Sigler, https://en.wikipedia.org/wiki/Hollis_Sigler

* Jan Carmichael, https://twitter.com/carmicjan

* Don Kimpling, http://www.marquardtplus.com/MP/uncategorized/don-kimpling-2/

Mat Fraser, https://en.wikipedia.org/wiki/Mat_Fraser

* Chase Joynt, https://www.chasejoynt.com/

* David Mitchell, https://www.penguinrandomhouse.com/authors/20870/david-mitchell/

Alice Sheppard, http://alicesheppard.com/
* Theresia Degener, https://en.wikipedia.org/wiki/Theresia_Degener
* Jason Pickleman, https://www.jnldesign.com/

In progress:
* William Fugo Jr., https://sites.google.com/site/williamjfugojr/
* Achy Obejas, https://achyobejas.com/

ACKNOWLEDGMENTS

My professional life would not have been possible without the support of Esther Grisham Grimm and Sara Slawnik of 3Arts Chicago, one of the only arts organizations in the United States primarily dedicated to funding women, people of color, and people with disabilities. In 2017, I was awarded the 3Arts MacDowell Colony Fellowship; for the first time ever, I had a solid month to write. My MacDowell cohort treated me like a real writer—a strange experience for a lifelong painter.

Golem Girl is the result of bright luck indeed: while I was at MacDowell, Rosemarie Garland-Thomson encouraged me to write an op-ed for *The New York Times.* This was subsequently accepted by Peter Catapano, editor of the Opinion section; Audrey Niffenegger then sent the column to agent Markus Hoffmann, of Regal Hoffmann & Associates. Markus (who should *really* be writing a memoir) brought my nascent book to the attention of Christopher Jackson and Victory Matsui of the One World imprint of Penguin Random House, which was when my luck totally caught fire. Victory left to follow their own dreams. Publisher and editor Christopher Jackson brought me through the final, hard months of work.

I owe you all more than I can ever express.

Thank you to Robert McRuer, Anna Mollow, Caitlin Wood, Alice

Wexler and John Derby, S. L. Wisenberg, *Triquarterly*, and *McSweeney's*, all kind enough to publish my earlier writing.

Thank you to Audrey Niffenegger, my dearest friend of twenty-five years, steadfast in your "Go do it already." For years, I've watched you handle your career with the epitome of grace; my writing hero, my model of All That's Right and Good.

This book would be nothing but papers under my bed but for Goldie Goldbloom, brilliant novelist, my teacher, friend, and first editor.

Versions of *Golem Girl* were read and/or edited by Finn Enke, Jim Ferris, Anne Finger, Miriam Frank, Nicola Griffith, Aleksandar Hemon, Patricia King, Kristin Lindgren, Paulette Livers, Catherine Venable Moore, Susan Schweik, Michael Waugh, Lawrence Weschler, Diane Yasgur, and Brian Zimmerman.

Other readers include Anne Balay, Paul Behen, Ronit Bezalel, Linda Bubon, Louise LeBourgeois, Irish novelist David Mitchell (versus Disability scholar David Mitchell), and Andrew Solomon. Sarah Hollenbeck, Rebecca Makkai, Kathleen Rooney, and Zoe Zolbrod let me pick their brains about the craft.

The Randall J. Condon School isn't my story alone. Thank you to Donald Allgeyer, Rayne Dabney, Melanie Davis, David Johnston, Debbie Madlener, Philip Moore, Juliana Steel Spitzig, and Kathy Woodbridge, who filled in memories I'd lost. And to the research librarians of the Cincinnati Public Library and *The Cincinnati Enquirer*, for finding Condon School's hidden histories, and to Mark Kaplan of the Bezazian Branch of the Chicago Public Library for help, support, and sotto voce conversations.

Filmmakers who pointed a video camera at me despite my protestations: Drs. David Mitchell and Sharon Snyder Mitchell, Charissa King-O'Brien, Anuradha Rana, Salome Chasnoff, Laurie Little, Carrie Sandahl, and Susan Nussbaum.

These friends helped me better understand art history, Disability studies, Disability justice, Disability culture, embodiment theory, monster theory, and medical history. They include (but are not limited to) Stephen Asma, Julia Watts Belser, Lauren Berlant, Lawrence Carter-

Long, Michael Chemers, Eli Clare, Jessica Cooley, Thomas Couser, Theresia Degener, Beth Ferri, Jim Ferris, Ann Fox, Kenny Fries, Sander Gilman, Ramiro Gomez, Beth Haller, Bill Hayes, Michelle Jarman, Alison Kafer, Karen Nakamura, Lisa O'Sullivan, Katherine Ott, Sharrona Pearl, Benjamin Reiss, Carrie Sandahl, Susan Schweik, David Serlin, Katherine Sherwood, Tobin Siebers, Chris Smit, Sunaura Taylor, Rosemarie Garland Thomson, Lisa Van Arragon, and Susan Wheeler.

Artists, critics, and curators who have supported and influenced my studio career include: Steven Assael, Dodie Bellamy, Michele Bosak, Susanna Coffey, Vincent Desiderio, Bailey Doogan, Ann Fox, Susan Taylor Gescheidle, Ramiro Gomez, Anne Harris, Clarity Haynes, Claudine Isé, Terry Myers, Lynne Warren, Michael Waugh, Michael Lyons Wier, and the late James Yood. For a decade, Bob Hiebert and the late Sidney Block of Printworks Gallery allowed me to produce many of the portraits in this book. I look forward to working with the Victor Armendariz Gallery in years to come. A special thank-you to Dorothy Moss of the National Portrait Gallery of the Smithsonian, for fascinating discussions of portraiture.

Lisa Yun Lee and Carrie Sandahl of the University of Illinois at Chicago gave me a public studio where I produced *The Risk Pictures* project. The Wynn Newhouse Foundation let me know there was a place for pictures of crips after all.

More friends who shared their memories and were there during emergencies: Fern Bogot, Jan Carmichael, Sarah Ettinger, Miriam Frank and Desma Holcomb, Will Fugo, Larry Gerber, Leah Gniwesch, Alexandra Halkin, Don Kimpling, Laurie Lee Moses, Nuha Nazy, Tom O'Dowd, Pam Potter, Allen Sears, and Norman Wald.

Deborah Brod and William Fugo, you have both known me for forty-odd years (and boy, have they been odd). You are my friends of a lifetime.

Thank you to website designers Emma Dei and Stephen Hmiel, and Mac Rescue Rangers, for giving rivalehrerart.com such a lovely setting. Thank you to Sarah Ettinger for bringing the site up to speed, and to Brianna Beck, whose creation of the Resource Guide on my website was invaluable.

Please note that I have changed the names and appearances of a number of people in this book (some by request; others, not) so as to protect their privacy.

Above all, for my family. You shared stories, corrected my faulty memory, and didn't get mad when I bollixed up the facts.

For those who are here: Douglas Lehrer, Susan Leugers Lehrer, Caroline Lehrer Caron, and Nathan Lehrer; Meir Lehrer, Shoshana Nahum Lehrer, and Tikva, Devorah, Josefa, Ezra, Ze'ev, and Matan Lehrer.

Sarah Berss Horwitz, Lester Horwitz, Florence Horwitz, David Horwitz, Diane Stregevsky Yasgur, Howard Yasgur, and Tootsie Radin. And all my many fabulous cousins.

For those who are gone: Carole Sue Doris Horwitz Lehrer, Jerome Lee Lehrer, Esther Fannie Horwitz, Samuel Horwitz, Barry Horwitz, Ruth and Sam Stregevsky, Sarah Lehrer, Ben Lehrer.

I am your loving monster forever.

No matter how we love, we lose each other. Here are only a few of the people in Disability Culture whom I knew and admired, or whose work influenced this book: Katherine Araniello, Adrienne Asch, Barb Bechdol, Larry Bishop, Marca Bristo, Lisa Bufano, John Callahan, Carlos Drazen, Sandra Hagen Goldstucker, Lucy Grealy, Laura Hershey, Ricky Jay, Harriet McBryde Johnson, Lynn Manning, Jude Conlon Martin, Paul Steven Miller, Danny Robert, Oliver Sacks, Tobin Siebers, Hollis Sigler, Anna Stonum, and Kathleen Rose Winter.*

We grieve, we hold on to those we can.

* Two mourning sites:
https://spasticmama.wordpress.com/2016/08/?fbclid=IwAR0_WjOD2vxHmcLaeu_9tvbQd_CKXBq5P-BuKGuJqgfZnwiTirMKDTakPJk
http://www.instituteondisabilityculture.org/martyrs-the-poem.html?fbclid=IwAR3cSe4JYpo7ET0Q9bmvnetNa4VCkDvmRMTtnjV-PXv3RpT0MQmvMb_6eCQ
Robyn Powell wrote this *New York Times* op-ed on death in our community: https://www.nytimes.com/2019/03/21/opinion/disability-death-coping.html.

ABOUT THE AUTHOR

RIVA LEHRER is an artist, writer, and curator whose work focuses on issues of physical identity and the socially challenged body. She is best known for representations of people with impairments and those whose sexuality or gender identity have long been stigmatized. A longtime faculty member of the School of the Art Institute of Chicago, Riva Lehrer is also an instructor in medical humanities at Northwestern University.

rivalehrerart.com

facebook.com/riva.lehrer

@riva_lehrer